I'm a great admirer of Luc and Jean-Pierre Dardenne. When their pictures begin, they appear to be very simple and casually observed. By the time you get to the end, you realize that every single element of the cinema has been carefully integrated and calibrated, converging on a single point of redemptive illumination. This collection of Luc Dardenne's shooting diaries and the scripts of three of their best pictures gives us a very special look at the shared creative process of these truly spiritual artists.

Martin Scorsese

Nestled between the essays of Montaigne, Susan Sontag's diaries and Bresson's *Notes on the Cinematographer*, *On the Back of Our Images* is intimate yet expansive, contemplative yet imaginative, visceral yet dreamlike—a wondrous journey through Luc Dardenne's looking glass, bringing us close to the creative spirit of the Dardenne Brothers' films. You learn from this book, but you also feel it. The films were created in digits or on celluloid; the book seems written in blood. You can learn to make film from a manual; you can be challenged to understand what it takes to make a GREAT film from this book.

Milos Stehlik, Facets

This work is published with support from the French Ministry of Culture/Centre national du livre

Published by
featherproof books
Chicago, Illinois
www.featherproof.com

First edition
10 9 8 7 6 5 4 3 2 1

Library of Congress Control Number: 2018968068
ISBN 13: 9781943888146

Edited by Jason Sommer and Sammi Skolmoski
Screenplay consultation by Mike Peterson
Cover design by Zach Dodson
Interior design by Jason Sommer
Proofread by Sam Axelrod
With many thanks to JH, without whom this book wouldn't be possible

Set in Whitman

Printed in the United States of America

ON THE BACK OF OUR IMAGES

(1991–2005) by Luc Dardenne

Followed by *The Son*, *The Child*, and *Lorna's Silence*
by Jean-Pierre and Luc Dardenne

*fe*atherproof BOOKS

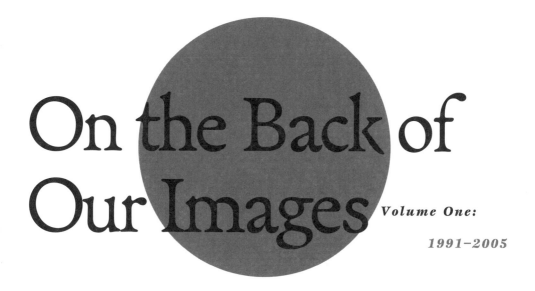

On the Back of Our Images

Volume One: 1991–2005

by Luc Dardenne

translated by Jeffrey Zuckerman

Screenplays by Jean-Pierre and Luc Dardenne

translated by Sammi Skolmoski

Table of Contents

Diaries 1991–2005 9

The Son Screenplay 131

The Child Screenplay 205

Lorna's Silence Screenplay 271

Diaries
1991–2005

December 2, 1991

Resist, with every ounce of energy, the fate of the work of art, the leaden force that stiffens, blocks, walls up, suffocates, embalms. The battle with this fate betokens the true work of art.

December 3, 1991

Make images with broad brushstrokes, not tiny ones. The thing to show is coarse, replete with roughness. The same indelicacy for the sound . . .

December 9, 1991

I suffocate in the images and music of this cinema that can only imagine by freezing the movements of reality's breathing. Fantasies but not metaphors. Transportation stopped, constricted, passage forbidden. Help! Against these stopper-images, these images/music full to bursting yet unable to burst, against these overfull and shut-off images, the irresistible need for images and sounds that resonate, cry out, stamp their feet and pound their fists until the bubble is burst. A hole. A frame.

December 19, 1991

Is it still necessary to shock, to destroy codes? What matters in a film is to succeed in reconstructing human experience. A shock, given the absence of this experience in our present.

December 26, 1991

"'I cannot see any basic difference,' Paul Celan wrote to Hans Bender, 'between a handshake and a poem.'" In citing this line, Levinas opens a text dedicated to Paul Celan.

I would like us to succeed in making a film that would be a handshake.

December 29, 1991

What to do? Is it necessary to keep on wanting to film? Make films? What's the point! The bad film we've just shot should have disabused us of this illusion, this ambition. Can our country, its history, produce filmmakers like us, a cinema like the one we want to make? In any case, everything has already been done, and done better than anything we could ever do. They were right, these old and new filmmakers who heralded the death of film, who commented on its funeral. They were right. And for good reason! It's because they're right that we've been driven to prove them wrong, to believe that we,

my brother and I, can still film, invent, make something new. The *camera obscura* isn't a death chamber for watching over the deceased's corpse. An object lost forever! An object we'll never regain! We don't care! We won't be overpowered by their sadness! We'll spit out black bile! May the dead bury the dead! Live! Long live the cinema to come! We have to be equal to it.

Live in a little land like ours. Never be seen in film circles. A necessary isolation.

January 3, 1992

Must not worry about pleasing or displeasing audiences. Glancing over this hellish speculation is enough to swallow you whole forever. Flee all the mirrors held up to us, make darkness, make a void to get closer to the essential movement, the sense's movement that attempts to express itself, the form's movement that attempts to frame. When we feel that this movement has caught us, when it is felt like something that controls us, that constrains us even as it frees, as it opens, that's the mark of the other's presence, of the other met at the center of our solitude. The work of art that emerges in this movement is an address to the other. Will the audience be there to receive this address and respond to it? This cannot be our question.

January 19, 1992

Escape. Simply escape. Meet something, someone, a material, a surface, a strange, unknown body, I don't know what but to escape myself, to be affected, touched. I can't bear to be inside anymore.

Johan Van Der Keuken is right to say that cinema is not a language but a state. To succeed in transposing, within our films (if we keep on doing so) the coarse, raw, unforeseeable, taut state (the just-in-time economy) of actual reality.

The argument, that a work of art reveals terribleness because reality is terrible, is just a dialectical pirouette.

January 21, 1992

We have to start from the beginning even though we know that's impossible. The need to start, not to repeat. The feeling of an obligation forcing us to say something even when this something has been chosen as a function of what has already been seen or what has never been seen. To descend into our solitude and stay there as long as is needed. Needed to escape all the temptations to use methods, effects, and to feel anew what we have or do not have to say.

January 23, 1992

We'll do what we know how to do. Nothing more. Nothing less.

January 26, 1992

When you no longer know where you are, when you're wholly lost, you remember the one who first showed you the way. In art, in film, this was Gatti. He pulled us out of our torpor, projected us into the poem, in search of man's signs, of his indestructible hopes. He taught us how to invent out of our truth, no matter how paltry our means, he taught us rigor, demystified technique. We remembered, today, this story he told us about the filming of *Enclosure*. It was the first day of shooting. He didn't know that to look at the frame through the camera he had to position his eye at the eyepiece while pressing firmly so that the shutter would open. Each time the chief cameraman asked him to look at the frame, he set his eye in the eyepiece but did not see anything. After some time he would look back up and say, "We can shoot."

February 10, 1992

May our images not be a fate. May they yank open the shutters of the death chamber where we suffocate. May they never fall into the caricature that seals people into a semblance of themselves which hampers all contact with them. May they never broadcast aesthetic force. May they be mangled, ruined, rent apart by what is never revealed. May they never look at themselves. Those eyes raised to the screen utter a violent prayer:

"Deliver us from evil."

May 15, 1992

"If you loved me, you would have changed me." This is the retort of the audience member who wasn't won over by the film. To love the viewer to the point of arousing his or her desire, to open him or her up to the film's time.

Max Picard writes in *Ruined Cities of the Eternal World*: "From love a sense of the present is born, time is born, and in this time born of love, events endure, they do not rush away, they remain." From the film time is born for the viewers who remain, who aren't the medium of the audiovisual product seizing upon them or what within them can be conquered. It seems that this love the film has for its spectators is impossible because the spectators are socially and culturally conditioned not to receive this address. But one of them has to reach out. It's our role to reach out even if failure is more likely than success.

June 25, 1992

Long discussion with Jean-Pierre on the way we will keep on making our films after the horrible experience of *Je pense à vous* [You're on My Mind]. One thing is clear: small budget and simplicity throughout (story, set, costume, lighting, crew, actors). Have to have our crew, to find actors who truly want to work with us, who don't give us trouble with their professionalism, unknowns who won't drive us in spite of ourselves toward what's already known and familiar. Against affectation, mannerism prevails: to think meager, simple, bare.

Be bare, break free of all these speeches, all these commentaries declaring what cinema is, what it isn't, what it should be, etc. Refuse to make cinema and push back against everything that would force us into film circles.

July 18, 1992

Emmanuelle is in Venice to show *Je pense à vous* at the Critic's Week. Doubtless a negative response. Why did we make this film?

August 25, 1992

The Nazis organized a photography competition on the subject of the moment just before death. The photos were taken during executions. There is nothing humanity can do that has not been done, but even in the worst of humanity there's always an artist driven to contest this formidable challenge to his art, a theorist driven to condone this despicable reality.

September 4, 1992

I saw *Liberty Valance* again.

I just read a poem by Henri Michaux titled "Chosen Hands." If the word meditation were synonymous with vision, then that would be how I'd like cinema to be. Not all cinema, but at least one film in a thousand.

Leave a movie theater consoled, healed . . . a pure feeling of being a man among men. Later the memory of this moment like a moment of happiness.

September 6, 1992

The impression that many films are images and music set up for increasingly trivial, blatantly obvious dramatic machinery without a single shade the creator-manager hasn't already planned out to keep customers alert. No true shadow, no mystery, no density, no contradiction, no question unanswered, and certainly none of those questions animating every work of art, forming

the solid core of every artistic expression: what could refuse, resist, fight against this expression?

September 12, 1992

"The tree falling makes more noise than a forest growing."

We film trees falling. Pay attention to the fascination for the movement of the fall, for the landscape of disaster, for the sound of the crash. Pay attention to the silence before the aesthetic force. The death. But is it possible to film the forest growing without filming the tree that falls? A tree whose fall is nothing spectacular, whose noise is heard in the silence of the forest growing. Impossible to forget it. Impossible to silence it. It makes itself heard in the silence of the flower growing on the roadside. The flower bulb is imprisoned within the skeleton of the hand of a body murdered and buried by those who wanted to hide their crime.

September 15, 1992

I remember this woman sitting a few meters away from me at Mokafé, talking to herself, sometimes looking my way without seeing me, caught up in her excitement. I caught some of her words: ". . . what I rue is that the law doesn't plan to punish murderers. I've already been murdered twice and nobody's been punished . . ."

September 25, 1992

A worker became a solitary man, the member of a species on the brink of extinction. That's what we wanted to show with the film *Je pense à vous*. In this process of extinction, is there any inheritance? Of what?

November 7, 1992

Accident and murder. The murky intimacy where murder and sex commingle. The victim's blood and tears. We like that. We delight in being put on a drip, being peddled the blood, sweat, sperm, and tears of others. We commune in their body even as we commune within the larger body of media pulsing intensely, continuously, with bodily fluids.

November 8, 1992

The human gaze, in which we can decipher both the urge toward murder and its prohibition, is that which film makes it its mission to capture. Pay attention: the image's ethical appearance is simultaneous and antagonistic with its aesthetic appearance.

Emmanuel Levinas wrote that "ethics is an optic." Optic of the face, relation of the gaze that the images forbid idolizing by reducing them to a figure. The human face as the first word, the first address.

December 1, 1992

We slowly leave the unfortunate adventure that had been *Je pense à vous*. From the outset it had been constant misunderstanding. We hadn't known what we wanted, and we hadn't convinced ourselves that we knew it. Never again an experience like that. To know to say no to others, and also to ourselves, which isn't easy. The only good memory was the work of writing with Jean Gruault in the Chariot d'or hotel room on the rue de Turbigo. There was plenty of laughter, drinking, and messing around. He showed us how to pull a fictional character out of reality and to mistrust pomposity. To stay clear-eyed, as in *Scarface*.

We are working on a new screenplay. We're looking for a title to frame, delimit, make sense of our ambitions.

I saw *The Killing of a Chinese Bookie*.

December 2, 1992

I'm running a screenwriting workshop at the Free University of Brussels. I don't know exactly why I agreed to this job three years ago. Maybe a desire to teach. But what right do I have? I haven't written anything valuable yet. I feel like an impostor. The kind of character frequently seen in our country. Moreover, when I write a screenplay, I'm not alone. All the long conversations with my brother to find the situation and the character, the general movement. Have to be careful not to bureaucratize students' imaginations with dramatic models/templates meant to resolve the so-called crisis in a screenplay.

December 6, 1992

I'm working on the screenplay. Provisional title: *Le Soupirail* [The Basement Window]. I'm missing some authentic elements, which only proper investigation can help me find. One of the film's interests will be to show the actual paths illegal workers follow. Not to invent that because that would inevitably be clichéd. To invent relationships between characters who are the intensification of what reality offers. We have to push our refusal of aesthetic appeal as far as possible. Not using known actors would already be one way to evade the audience's contempt. We shouldn't feel (re)mediated through the set, the actor, the lighting, etc. All these elements should be rooted in a shared sentiment, a shared impression of raw, unadorned life that unfurls before the

camera, but that could have also unfurled in the absence of any camera. The camera strives to follow, does not wait, does not know.

December 26, 1992

The title of the new screenplay isn't *Le Soupirail* anymore, but *La Promesse* [The Promise].

January 17, 1993

What television now calls a "reality show" proves once again that cinema's vocation is to rip this reality asunder. Out of this ripping comes emptiness. Access to what doesn't exist. The human, true, beautiful evasion! Escape what is, and what isn't too much. Cinema speaks to what doesn't exist, to emptiness, to nothingness, to the Other who is never there. Without it, we'd eat the flesh of our almost-exact counterparts, we'd drink their blood. We'd be sated by the heart of our reality. God is dead. The space is empty. Above all, not to occupy it.

January 20, 1993

The child, his absolute ignorance of the plot. Isaac, the wood on his shoulder, accompanies his father. Doubtless he walks behind him, sees his back, in his hand the knife . . . "Where is the lamb for the sacrifice?" Those who are invested in the plot know, but he does not.

God knows, He who has instigated it. Abraham knows, he who is the heavy-hearted servant. Isaac doesn't know and can ask the true question, the innocent's question, the question of he who does not know the plot.

Maybe being innocent is that: being outside the plot. The very innocence of Isaac's question seems capable of dissolving the plot, of declaring that the sacrifice won't happen. Abraham feels the force of the innocent's question. Caught between the words of God asking him to sacrifice the child and the words of the child asking him where the lamb for the sacrifice is, he answers: "God will provide the lamb." These words announce that the sacrifice won't happen, that the sacrifice will be of the plot itself; they have come out of Abraham's mouth without his hearing them, as if he had pronounced them strictly to reassure the child. Abraham could not have given any other answer. He didn't know it yet, but he had heard God, and answered him. God speaks for the innocent. God has only plotted in order to dissolve the plot.

In contrast to the Biblical text, the story will have the innocent grapple with a plot without any God, a plot where he will deal with the Adversary, the Plotter who will laugh at his question and kill him. In a world without God, nobody is outside the plot, except for the innocent. Alone, he keeps on asking

his question, the true question, by which humanity survives.

How to "inherit" the meanings of our childhood Biblical readings when God isn't to be found there?

January 27, 1993

"Davide: 'You,' he said to Useppe, with an almost bitter gravity, 'are so pretty that the very fact you exist makes me happy at times. You could make me believe in . . . in everything! EVERYTHING! You're too pretty for this world.'"

Elsa Morante, *History*

February 19, 1993

I dreamed that Aïda was parachuting down to the beach. This dream gave birth to all the scenery of the adaptation we could make of René Kalisky's play *Aïda Defeated*.

The sky, the sea, the sand, the tents, a maze of tents, cloths to protect against the wind.

The bodies that would come out of the sand. The beach would be a true living space.

February 25, 1993

In Liverpool two ten-year-old children murdered a two-year-old child. What could they have inherited in order to commit this act? The state of things in our world.

March 3, 1993

"Whereof one cannot speak, thereof one must be silent," wrote Wittgenstein. This applies for writing dialogue as well. Not to make characters say what they cannot say. They cannot step out of their situation to put it in words. They're within it. Our job is to give them the words so that the silence of the words that they cannot say is able to be heard.

March 4, 1993

I finished the first version of *La Promesse*. Reading with Jean-Pierre. The first half and several scenes from the second are good. I've lost the characters' rhythm and sharpness in the second half. Have to keep an eye on my compassion for these characters. Find dialogues where tension emerges. Create a tightening around the core, around the scene that will gradually become inevitable. Go all the way to the end. That's hardest of all. Remembering *Ordet*.

March 18, 1993

"To have no manner has from time immemorial been the one grand manner."

Hegel, *Aesthetics*, Part I

March 28, 1993

"You see what things are like in this country. Everything disappears, people just as surely as objects, the living along with the dead. I mourned the loss of my friend, felt pulverized by the sheer weight of it. There was not even the certainty of death to console me—nothing more than a kind of blank, a ravening null."

Paul Auster, *In the Country of Last Things*

April 15, 1993

Many television shows are made at the expense of a particular lower social class whose caricatured situations and behaviors provoke the viewer's laughter. The closer the viewer is to the lower class (he knows that these days such a fall can be swift), the louder his laughter is, betraying his fear of that fall. The further he is from that lower class, the more amused his laugh is, the more it's suffused with a certain compassion. As for the media employees who think up and make these shows, their laugh is that of a gang of little thugs who have just played a nasty trick.

April 27, 1993

André Bazin writes, in his book on Jean Renoir, that he "grasped the true nature of the screen, which is not so much to frame the image as to hide what lies outside it . . . For the most habitual structure of the image in anecdotal and theatrical cinema, inherited from both theater and painting, Renoir substitutes, in the aesthetic and dramatic unity of the 'shot,' the simultaneously ideal and concrete gaze of his camera. Consequently the screen does not try to give meaning to reality, it provides us with that meaning like a decoding grid that's been positioned above an encrypted document."

Keep in this same vein. Not so much as to frame the image as to hide what lies outside it. To the point of hiding the image itself, of burying the frame within the material. The image becoming material in search of its frame. The grid no longer being positioned, but simply decoding the document.

April 29, 1993

Find, beyond the techniques for creating suspense, pure tension. The invisible, irradiated core, and we don't know what this irradiation will create and

when it will create it. We're not really waiting for something namable, in this interval that arouses the desire to see, to know what there is behind the door. We're in there, in the door, in the core. Susceptible to the smallest tremors in the threads linking words, gestures, gazes. We feel the thread touching our throat, wrapping around our throat, loosening, tightening. We'll only be freed at the conclusion, when the thread is cut, leaving its mark on our body. Oh, beautiful scars!

May 25, 1993

Mossi tale:

> Two brothers leave to farm crops. On the path to the fields, one of them says: "It's sweet."
> They overwinter.
> Returning to the fields, to the same spot as last year, the second brother says: "What?"
> The first one replies: "The honey."
> The story asks which of the two brothers has the greater memory.

June 12, 1993

Meeting with a distributor who's returning from Cairo. He was stunned by the fundamentalist movements' fanaticism and the intellectuals' apathy. I'm afraid, too. The Arab intellectuals' speeches are too vague, they fixate on their humiliations too much, hurriedly explain away the modern day through the eternal past of colonization and Western contempt. If they go on invoking the guilty West to explain their situation, they'll strengthen hateful sentiments against us rather than readying their country's spirits for democracy.

June 13, 1993

Watched on television: the first day of sales in an Australian superstore. The workers behind each door, unlocking them at the same moment, at the department head's signal, immediately taking refuge behind the cash registers while the crowd, which had been growing in front of the doors for the last two hours, surge toward the goods and the escalators, knocking over and sometimes running over the weakest ones. The worst is yet to come.

June 16, 1993

I just read Silvio D'Arzo's *The House of Others*. That's what I would call the creation and transmission of a duration.

June 30, 1993

My brother. I couldn't make this film without him and he couldn't make it without me. Mutual dependence that does not foster resentment. No doubt he could make this film without me, and maybe I could without him, but we'd both know this wasn't the film we could have made together and we'd regret it forever. I may write these notes in the first person singular, but I know they are written in the first person plural. His questions are mine. Often they are what drive me to write these notes, as the transcripts of reflections, of shared thoughts.

It's the same thing for the screenplay. I hold the pen but two hands write it. Hard to explain, especially since a strong, sometimes overwhelming, sense of loneliness exists for each of us during the process of writing.

July 1, 1993

Make films. Don't read any more texts on films. Learn by doing. The danger for autodidacts: being fascinated and therefore leveled by the knowledge needed for what they're doing. And yet.

Screening of *Je pense à vous* in Dunkirk. The stroll Fabrice takes with his son through the industrial ruins and the cemetery of steel tombs where his father is buried is a digression that perhaps says something about the working class these days: a man who shows his son the ruins haunted by the ghost of his father.

August 22, 1993

Last night, I finished the second version of *La Promesse*. I already feel the urge to burn the screenplay in the fire of the film. I hope Jean-Pierre will bring in new components for the character of the father, who is possibly still too abstract. This much I am sure of: this screenplay entails a shooting style in line with what we want to do (small budget, close-knit team, involved work with unknown actors) and many true moments may be present. It's our camera's job to reveal them. I think there's a material destitution that brings spiritual distress into existence. Think of the setting like a desert.

September 9, 1993

"We stand on the last promontory of the centuries! . . . Why should we look back over our shoulders, when we intend to breach the mysterious doors of the Impossible? Time and Space died yesterday. We already live in the absolute, for we have already created velocity which is eternal and omnipresent. We intend to glorify war—the only hygiene of the world—militarism, patriotism,

the destructive gesture of anarchists, beautiful ideas worth dying for, and contempt for women."

Marinetti, *The Manifesto of Futurism*, 1909

"Perhaps history rushes on so swiftly here because man no longer has a sense of the present . . . Only human devotion can capture an event, only through devotion is an event present. From love a sense of the present is born, time is born, and in this time born of love, events endure, they do not rush away, they remain."

Max Picard, *Ruined Cities of the Eternal World*

September 11, 1993

I went to see *Mr. Hulot's Holiday* with Kevin. An immense pleasure. We both laughed, often at the same spots. The child in the bus driver's seat, the fox's snout and the cavalryman's boot spur, the colonel in his jeep as if headed off to war, the tennis match, the boat that transformed into the jaws of a shark, the funeral-wreath inner tube deflating on the grave, the car's noises . . . It's a characteristic of true works of art that they pull together different generations, push away ever-approaching death.

September 14, 1993

A cinema without style. All style is a caricature, a resemblance to oneself, a fate, a mummification, a victory for the necrophiliac within each of us always ready to kill whatever moves, doesn't find its shape, its image. A murder happens. The shape appears. Impossible to escape it. And yet something has to escape it.

September 20, 1993

I saw *Mr. Smith Goes to Washington*. A nervousness I like. We don't linger and we know to stop when we should.

September 23, 1993

I saw Kieślowski's *Blue*. Wasn't receptive to what it wanted to show. Too formulaic, mannered. I didn't find the sharpness, the freedom of the *Decalogue*. What happened? Why would such an obsessive, dense, and restrained filmmaker slip into bombastic aestheticism? As if the power of his art lay in the fact that he was filming the bodies, the faces, the voices, the gazes, the landscapes, the houses, the noises, the colors, the language, the light of his country. Hard for a filmmaker to emigrate.

September 29, 1993

I saw Loach's *Raining Stones*. A magnificent fable. The same movement as in Brecht, apart from the character's "narrow" point of view being mere pretext for discovering what he really is. We're with him, all the way to the end. The scene with the priest throwing the debt book into the fire is extraordinary.

October 17, 1993

At the end of *Civilization and Its Discontents*, Freud writes: "Men have gained control over the forces of nature to such an extent that with their help they would have no difficulty in exterminating one another to the last man. They know this, and hence comes a large part of their current unrest, their unhappiness and their mood of anxiety." He wrote this in 1929, but maybe this unrest, this unhappiness, and this anxiety were already surging forth at the end of the European nineteenth century and paving the way for the birth of psychoanalysis as a new form of knowledge able to reflect this increase in aggressive, self-destructive impulses.

The film projector, born at the same time and in the same Europe, may similarly be an attempt for the human being to find a way through the labyrinth of his destructive impulses in life, a way by which the "eternal Eros" can "put forth his strength so as to maintain himself alongside of his equally immortal adversary." An alliance between the film projector and Eros sealed in this gaze capable of recording the singularities of life's movements thanks to the mechanical objectivity of the recording, infinitesimal and singular movements that weave living time, that are an attempt to arouse within us, within our culture, an astonishment, an emotion, a rare internal movement that can empty, for a moment, the destructive impulses of their energy, that can open our eyes to the silence in which life's movements are born. We know, moreover, that the film projector has shown definitively that it is capable of the contrary.

October 24, 1993

EDGAR: "World, world, O world!
But that thy strange mutations make us hate thee,
Life would not yield to age."

<div align="right">Shakespeare, King Lear, act IV, scene 1</div>

November 24, 1993

"To define force—it is that x that turns anybody who is subjected to it into a thing. Exercised to the limit, it turns man into a thing in the most literal sense: it makes a corpse out of him."

<div align="right">Simone Weil, The Iliad, or the Poem of Force</div>

"The soul, like a gas, tends to occupy the whole of the space left open to it. If a gas were to withdraw and leave a void, this would be contrary to the law of entropy. Thucydides: 'each one exercises all the power at his disposal.' Each one spreads himself as much as he is able.

To stop, to check oneself is to create a void in oneself."

Simone Weil, *The Notebooks*

Images that would stop, check themselves, create voids in themselves . . . Is this possible? Does the image, including the cinematographic image, not belong to the realm of force? Could we project an image that would be like the other's face, just as vulnerable and intense on the other side of its aesthetic? Would this image, if it were possible, leave a trace of intensity in the viewer's soul?

November 26, 1993

Nenen told me the story of a village woman who had a mixed child with an American soldier while her fiancé was still a German POW. The other people in the village turned their backs on her. One night, she jumped into the river. When they recovered her corpse, they found her baby's corpse against her breast, held in place by a rope she had tied around their two bodies.

November 27, 1993

Let's save appearances! The various, separate, multiple, unique, unforeseeable, fragile, changing appearances. They live. Behind them there's nothing that can take their reality away, nothing more essential that we can take pleasure in. Let's devote ourselves to appearances. Let's stop destroying them. Let's stop in front of them. Let's recognize them. Let's live with them. Yes, simply live with them.

They are what come to live on the screen, saved, revived from all our forgetting, our ghosts, our lies, our murders, and as such more alive, more intense, more real.

Against beliefs of every sort.

The bullet that goes right through the body of a living being knows that there's nothing behind. Of this immediate passage of appearances nothing remains, other than precisely the remnants: the corpse, the most radical transformation of appearances.

"Take away everything I see there!" he demanded. We can reply: all we see is bodies piled up.

November 28, 1993

"But she remembered to eat when she was worn out with weeping." George Steiner reminds us of these words Achilles uttered. A welcome reminder for those who invent characters and relationships between these characters. To refuse to indulge our characters in their unhappiness, to leave them alone and remain deaf to their cries, never to rush to them to wrap our arms around them like an abusive mother fulfilled by feeling them cry in her bosom. To know to be a father. Not to let them do everything, not to forgive easily their excesses or scarcities. To be harsh with them and tell them: "That's enough! Stop crying! Go play with the others!"

December 1, 1993

Making films together? My brother and me inventing a film together? How could anyone understand that? Clearly I was far too young to understand. Maybe the day we make this film together about our childhood, we'll have a better understanding of what holds us together. I'd like this film to start with a black screen that lights up to reveal a bedroom with twin beds in which two little boys in pajamas are tucked in. Between the two beds: a light switch. Barely have we discovered this setting when one of the two little boys presses the switch: DARK. The other presses the switch again: LIGHT with the scenery again. The other presses again: DARK. The other presses again: LIGHT . . . Two off-screen voices talk about these on-and-offs: "Each night we fight. One night our fight was so bitter that we turned the light on and off twenty-four times in one second."

This first scene might end, or rather be interrupted, by the father entering the bedroom, yelling: "Turn off the light!"

The two little boys' hands hit the switch at the same moment to turn off the light. In the darkness they start fighting again, talking quietly. The father, now off-screen in the hallway, shouts loudly: "Quiet!" After a few minutes of total silence, one of the little boys can be heard whispering: "Lights." The other's voice: "Camera." Then the two of them together: "Action." The darkness disappears and a waltz plays: a pair of beautiful, attractive women appear, dancing . . . One of the boy's voices off-screen: "Mama . . ." The other, off-screen: "Aunt Nenen." Then a pair of girls, our sister Marie-Claire and our sister Bernadette, then Papa separating the two women and dancing with Mama . . . then nearsighted Richard inviting Nenen . . . then Victor and Victoria . . . then Georges and Maria . . . then Georges and Léa . . . then Gustave and Octavie . . . then Louise and Juliette . . . then Philippe and Jeanine . . . then Monsieur and Madame Levieux . . . Madame and Monsieur Maes . . . Madame Shisha and the priest . . . Rica and her black child . . . Marcel the Yellow and Georgette . . . the Leflot daughter and Robert . . . we linger on Mama and Papa . . . then on Mama alone with the off-screen voices of the two little

boys: "Hail Mary, full of grace . . . Blessed art thou amongst women . . ." Then on Papa's face, worried by these voices he seems to hear: "Our Father, who art in Heaven, hallowed be Thy name; Thy kingdom come, Thy will be done . . ." The music drowns out the two boys' voices . . . With Mama's face looking lovingly at Papa, who isn't visible, we still hear: "Lead us not into temptation, but deliver us from evil . . ." The title of the film appears: *Pater Noster.*

December 27, 1993

Igor, the boy in the screenplay we've finished, doesn't know why he does what he does and he'll discover what he doesn't know.

January 2, 1994

A new year has begun. I hope we'll be able to shoot *La Promesse.*

I read Schiller's *The Robbers.* I finished two Brecht plays. Invigorating.

The temptation of temptations for the artist: lamentation. Resist it at all costs.

January 5, 1994

The Germans shouldn't have knocked down the Berlin Wall on November 9, the day of Kristallnacht. The Wall should have fallen on the eleventh. After commemorating the Night of Broken Glass.

January 10, 1994

Cinema shows what gets closer, what comes closer. It started with a train, it continued through bodies, eyes, mouths. Theater prefers words, keeps a distance. Cinema sees the vapor exhaled from a mouth pressed against the glass, it doesn't hear the voice coming from offstage. The tongue twists, kisses, licks, but does not enunciate. The eyes want, envy, dampen, but do not judge. The lips curve, swell, tremble, but do not speak.

How to imagine Tiresias at the movie theater? This old blind man full of resentment who, bereft of the sight of Jocasta's body, cannot understand the immensity of Oedipus's desire? Tiresias who speaks and who, through his words, suppresses the desire to join in, will drive Jocasta to suicide and Oedipus to ape his blindness. Such a character, such a speech, could not come out of cinema. Jocasta, sensual Jocasta's body is what always approaches the body of the viewer who lowers his defenses and does not attempt to understand. Knowing too much leaves us stabbing out our eyes like this hero of the theater. Not knowing, utter ignorance is what the cinema says yes to. Perhaps it's the echo of this yes that still accompanies me when I step into a dark

screening room, that embraces me at the moment the very first image appears on the screen. Alone at last, forgotten at last, abandoned, freed from Tiresias and from all his knowledge.

January 11, 1994

Saw *Germany, Year Zero* again. Still the same intensity, the same sharpness. That's our model.

January 12, 1994

No doubt Tiresias's theater will always be nostalgic for Jocasta's cinema, but cinema will always have a filial admiration for theater, for the spoken word of the blind face without which cinematic images would only be fantasies incapable of making sense, of addressing an other, of being an art.

January 14, 1994

I watched our documentary *Lorsque le bateau de Léon M. descendit la Meuse pour la première fois* [When Léon M.'s Boat Went Down the Meuse for the First Time] again. I remember we edited the shots, wrote the voiceover texts, and mixed the sound in great haste. Each night Jean-Paul Tréfois called us to see whether the print was ready for the television broadcast. We said "yes" but the reality was clearly not so. The final week, after shooting new accounts, we worked day and night, taking a massive number of pills all the while. The medications' effects are clear in the voice and lyricism of the text.

I have a nice memory of this sleepless week in the room on the rue des Wallons. Jean-Pierre with the video and Luc with the sound! The dream team! We've lost that but we'll find it again.

January 19, 1994

I'm writing the third version of *La Promesse* (almost done). Many problems with the character of the woman who we shouldn't imprison within the image of a victim.

Writing a screenplay isn't straightforward. Nothing comes easily. Always accompanied with groans. Fortunately there are two of us.

January 21, 1994

In his long interview, Welles sketches a relationship among unreality/theatricality/truth. Theatricality is a transition to unreality, which produces a far more significant truth. Falseness as access to truth.

January 22, 1994

"It is, however, a subtle economy of art in the poet that he does not permit his hero to give open and complete expression to all his secret motives. By this means he obliges us to supplement them; he engages our intellectual activity, diverts it from critical reflection and keeps us firmly identified with his hero. A bungler in his place would give conscious expression to all that he wishes to reveal to us, and would then find himself confronted by our cool, untrammeled intelligence, which would preclude any deepening of the illusion."

Freud, *Some Character-Types Met with in Psycho-Analytic Work*

February 1, 1994

The third version of *La Promesse* is finished. I hope young Igor's moral trajectory escapes from the screenplay.

February 8, 1994

In his text "The Other in Proust," Emmanuel Levinas writes: " . . . the very structure of appearances which are both what they are and the infinity of what they exclude." Whatever name men try to give this exclusion throughout history, it is the very structure of the human institution that art goes on recreating.

February 15, 1994

The conversion of an individual in the night of the dark screening room. The secret recipient of our films.

February 16, 1994

On your back
The weight of a wounded body
Its heart massaged by the rhythm of your steps
Your steps on the road
Your steps right in front of the wall
Don't stop
Walk

February 22, 1994

I saw *Free Willy* with Baptiste. Rarely have I seen such exploitation of emotional faculties. These machines, subjugating our souls for profit, destroy the feelings they shamelessly exploit. Advances in the intensive reproduction of

capital in culture. The destruction of these mediations that constitute the human world is well underway.

February 23, 1994

Lucie, Harimalala, arrived at the airport this morning. She was wearing a small, blue, hooded cape. Her dark eyes looked at us. So close. So far.

March 5, 1994

The prevailing angle of the currently reigning ethics of pity draws on an aesthetic of the suffering, wounded, disfigured biological body that media, especially images on television, have never stopped propagating. Rather than focusing on mass graves, biological bodies suffering, TV would do better to scrutinize the motives and causes of these deaths and these sufferings, to look at reality from the perspective of wrongs to be fought, not wrongs to pity. Filming the body of a starving person is, for the media, filming a mute body (photography excels there, and not by chance), a suffering of a living thing with no words to declare its suffering, to declare its rebellion against this suffering, to accuse the responsible ones. The TV cameras do not want these bodies to talk, to exist as anything other than biological matter offered up as sacrifice. They feed on this victimizing gaze established by wide-angle shots (and feed us those) to the degree that they end up making mistakes about the goods, deluding themselves about the victimized nature of the human flesh, as was the case with the Timişoara mass graves (*shoara*, eerily symptomatic signifier of their mistake). The image of the suffering biological body, the victimizing aesthetic was so overpowering that it kept people from seeing what the cameras had actually filmed: human corpses from a hospital morgue that had been cut open and sewn back up, bodies that testified not to the executioners' massacre but rather the doctors' work against death and suffering. Filming a human being who was not a victim, who couldn't be reduced to the living material of suffering, who kept pity from seizing it, filming this being became an act of cinematic resistance against the misunderstandings inherent within man's morbid pity for these images of this victimizing aesthetic.

March 16, 1994

I'd like to find an "optimistic" ending for the screenplay. Not to reconcile the irreconcilable but to battle against the loss of trust in humanity, against this falsely lucid thought in which all man's actions are in vain. Without action, without drama, man would disappear. In drama, "man infinitely surpasses man." That's the significance of Jacob's battle with the angel.

April 25, 1994

I am sick. I read Rimbaud: "What a life! Real life is absent. We are not in the world How many hours of the night, beside his dear sleeping body I kept watch, trying to understand why he so longed to escape reality I! I who called myself angel or seer, exempt from all morality, I am returned to the soil, with a duty to seek and rough reality to embrace! Peasant! . . . Welcome then, all the influx of vigor and real tenderness. And, in the dawn, armed with an ardent patience, we shall enter magnificent cities."

Art is for the peasant. Not for the seer or the angel.

April 26, 1994

For the first time in their life, South Africa's blacks will vote. Armed with an ardent patience, they've won, they shall enter magnificent cities.

May 17, 1994

Dinner with Dirk at La Taverne du Passage. Long discussion. We'll have to shoot with small budgets and people close to us, friends. As Jean-Pierre put it: "Clearly that's our truth." This economic constraint may be a chance for us to find our drive, our relationship to reality at odds with the increasingly crushing professionalism of film production.

May 19, 1994

"Your style is your ass!" It's a mystery! It's stubborn! It's pitch black! You'll bang your head. Nothing to be seen there! Move right along! But what? What? Nothing! Nothing to explain! Shut your huge mouth!

Nothing to see! Nothing to say! There. At night. At the intersection.

May 22, 1994

I just finished rewriting a scene in the screenplay. If I had written it not to-night, but rather tomorrow morning, it might not have been the same. But here it is, I wrote it this evening. This is the singularity of human temporality. Of my life, of every person's life. An individual's life is what it is and cannot be compared to another life that could have been his or her own. I could certainly compare the version of the scene written this evening with the one I'd write tomorrow morning, but this comparison would be skewed by the very fact that I'd already written tonight's version and so in writing tomorrow morning's version I wouldn't be able to act as if tonight's text didn't already exist.

We are all unique beings. This is astonishing. It's impossible to escape that singularity and this impossibility is the stamp of existence, of this existence's reality. What cinema takes advantage of is also the singularity of a gesture, a body's movement, a voice, a silence, a gait . . . Clearly there's a relationship between the body and singularity.

May 27, 1994

" . . . my miserable combinations and the shackles forged link by link . . ." wrote Henri Michaux.

It's out of these lifeless materials that today's cinema makes a new call to solve the apparent crisis of the screenplay. From this point of view, the cinema is a dusty art.

Dance seems far more capable of speaking of the here and now. Its depiction is more alive, more untimely, more liberated, more primitive, less structured, less novelistic, less likely to conjure up the violence welling up in our bodies, our society. It tackles disorder head-on, it dives into disoriented movements, into whirlpools without any certainty of what may result, without safeguarding itself with miserable combinations.

May 31, 1994

Morning. Nine thirty. On my street. Stopped by the sight of a repo man. A truck takes away a couch and two tattered velvet armchairs, a white wooden ladder, a camp stove with a red gas pipe still attached to it, a small shiny particle-board chest of drawers. Everything they had could be worth something. Utter violence.

June 4, 1994

Violence of cinema connected with the violence of reality. What sort of connection? This cinematic violence isn't a representation of the violence of reality, it doesn't transpose that onto another scene, it's happy to just be the duplicate saturated in the effect's violence. The soundtrack the mixers and sound engineers made today exemplifies that effect of phantasmal reality that paralyzes and kills every attempt at representation.

June 5, 1994

The cynical awareness is an awareness living beside its unhappiness. It knows it's unhappy, it knows its ideals are better than the state of the reality that they could transform, but it accedes to being separated from its ideals. That's how it is! That's reality! On pretext of realism, this awareness handles its unhap-

piness and because this handling can't completely erase the awareness of its unhappiness, it becomes arrogant, cruel, contemptuous. We come across this awareness most frequently in the contexts of television and advertising, where growing audience and revenue numbers reinforce the choice of contempt.

June 6, 1994

"Jude could see himself taking shape in her eyes."

<div align="right">Toni Morrison, Sula</div>

Jude can see himself taking shape in Nel's eyes. See himself taking shape. "Bye bye, dear little form," Johan Van Der Keuken says to Herman Slobbe, the blind child. This is cinema's utterance.

June 7, 1994

I just saw the edit of Philippe de Pierpont's *Bichorai*, shot in Burundi. The video and audio recorded the lives of unique individuals and they appear as such on the screen. No slippage toward a hidden mise-en-scène set up to dramatize reality. Have to record and safeguard this recording as much as possible even though it's clear there is by definition a point of view, a structure, etc. I can't bear these documentary filmmakers who pass off their manipulations as documents.

Levinas wrote in *Difficult Freedom* that the soul is not the possibility of immortality (mine) but the impossibility of assassinating (others). So many people consider art as an expression of our possibility of immortality, as a firm desire to endure, as a counter-fate. Could it be a form of the institution of the impossibility of killing? Could it open up to this soul discovering itself as the impossibility of assassinating others? Looking at the screen, the painting, the stage, the sculpture, the page, listen to the song, the music, this would be: no killing.

June 9, 1994

The Rwandan children who endured or saw horrors do not talk anymore. It takes them two, three weeks to find a way to use words again. According to a Doctors Without Borders representative interviewed on TV.

June 12, 1994

"You had a father; let your son say so."

<div align="right">Shakespeare, Sonnet 13</div>

June 24, 1994

Feeling engorged, encumbered. Have to sweep, clear out, uncover a sparer language, a flatter, sharper style suitable for naming again, distinguishing, sorting, cutting rumors short, getting out of the mishmash. There's too much, far too much.

July 31, 1994

"I have often realized, and stressed, that where everything is allowed, nothing has the power to surprise. Chaos and caprice are boring; they are 'entropic': one quickly wearies of their sameness. Art, like the entire 'order of the spirit,' is intrinsically antientropic. Its effectiveness is based on penetrating to ever higher levels of articulation."

<div align="right">Vaclav Havel, Letters to Olga</div>

August 10, 1994

There's something heavy, suffocating in existence. Resulting in this irrepressible need for an opening, an outside. A suction effect created by all our gazes, all our words, all our faces, all our oppressed bodies. This extreme need for what does not exist. Our era has trouble inhaling and exhaling.

August 19, 1994

In *Crowds and Power*, Elias Canetti writes of Stendhal that " . . . he allowed everything that was separate to remain separate, instead of trying to construct spurious unities."

August 21, 1994

We won't be able to shoot *La Promesse* this winter. Funding problems with the Ministry for Culture of the French Community of Belgium. How can our government possibly allow film production to stop for a year? It's appalling.

I try to work on a new screenplay but I can't get started. I'm going to read some of Bond's plays.

I realize I've seen very few films. Fortunately, there's the Musée du cinéma. Without it, I wouldn't have seen anything, I wouldn't have been influenced by Murnau, Rossellini, Mizoguchi.

August 28, 1994

"One day, at age twenty, he underwent a sudden illumination. He became

aware, at long last, of the anti-life he was living and that he had to start from the other end. To go in search of another residence, to leave behind his modest abode. So he set off."

<div align="right">Henri Michaux</div>

August 29, 1994

I focus to no avail. Nothing is coming for the next screenplay. I watch Satyajit Ray's films.

I think back on the Book of Tobit, on what Kierkegaard wrote about Tobit. I read Claudel's play *The Story of Tobit and Sarah*.

August 30, 1994

Disappointed by Claudel. I read Michaux.

"The pellicle of life is delicate, colonel. How delicate it is. Everybody knows that. But one can forget it.

The pellicle of life . . ."
"The man is going into his idea barn. This idea will kill him. No matter, he must go."

<div align="right">Henri Michaux, "The March into the Tunnel"</div>

September 1, 1994

The screenplay for *La Promesse* has been well received by producers. Jean-Luc Ormières thinks it's tremendous but is mistrustful of having two people directing. We're looking for another French producer.

The new screenplay's title: *Rosetta*. A character who's a woman (union representative?) who rejects the discouragement, the fear around her. It'll be a way of continuing to film politics today. Not the disillusions but the daily battles of those who refuse actual injustices, those that hurt.

Emmanuelle was the one to suggest the first name Rosetta because she was reading a novel by Rosetta Loy.

The title of the screenplay for the story of the family or the group ordered to choose which of their own could be put to death might be: *La Décision* [The Decision]. I'll write this text after *Rosetta*, or during.

Have I truly suffered?

September 3, 1994

"Who the deepest has thought, loves what is most alive."

Hölderlin (quoted by Karl Jaspers)

September 11, 1994

"Humour . . . is in fact the most unassuming of all utopias."

Ernst Bloch, *The Principle of Hope*

September 24, 1994

LEONARD: "They say they're not doing it while they do it. Words mean nothing to them: they communicate with signs with blood on their fingers."

Edward Bond, *In the Company of Men*

October 15, 1994

"Only the hand that erases can write the true thing."

Meister Eckhart

November 5, 1994

We're still reworking the screenplay of *La Promesse*. We have to push what we've set up here to the end. The only rule is: all the way to the end, go all the way to the end.

November 6, 1994

La Promesse or how a son escapes his father's murder. An invisible, wholly powerful, wholly stifling, wholly perfect murder. How can you escape the man who you love and who loves you? Who would come to pull you out of that? Who would let the son come to see, to fathom, to create a hole, a void? An other. And he would have to come from far, very far away.

November 16, 1994

I saw *Nanook of the North* again. The igloo-construction sequence, the positioning of the ice window and the reflecting block. May our films be an igloo like yours, Nanook. That's all I wish.

November 21, 1994

All these documentaries that, through concealed setups, dramatize the seem-

ingly recorded document are unbearable. Between the documentary and its viewer there's a tacit contract regarding the status of a camera recording a reality that might have been reconstituted, but not secretly manipulated to dramatize. The makers of these documentaries know that this contract is why the viewer believes in the truth of these images and they also know that dramatizing their images gives a greater semblance of truth to this truth. It is sheer duplicity for them to take their already strong, true, and real images which viewers are led to believe are images of unaltered reality and make them appear even truer, even realer, even stronger. These documentaries do not teach us anything new about the world, do not teach us anything new about our lives or other people's lives. They teach us, in spite of themselves, that dramatizing reality dissolves reality within stereotypes. Once again cinema is trapped by the force of its images.

November 22, 1994

I continue reading Proust. Sometimes hard for me to focus. I don't know why, but I persist.

November 27, 1994

Once again Belgian producers, reporters, and authors are repeating that old saw: Belgian cinema is imaginary. They understand "imaginary" as "not reality." Why does this country refuse to look at itself? What's it afraid of? Why this contempt for social life, for history? Why this escape into what they call the "imaginary"? It's telling that nobody's made a film on the twenty-five thousand Jews deported to the concentration camps. Nobody in this "documentary country"! Nobody! There are eyewitness accounts, there are Frans Buyens's and Lydia Chagoll's beautiful films, but a film about the Belgian Jews' deportation, the behavior of our authorities, the press, intellectuals, the police force, the population, the film we could show our children and our children's children for them to know how anti-Semitism develops in our country. Where is this film? Where is it? Nowhere. We're a country of nowhere, as some Surrealists say. How can something happen in a country of nowhere? Today, just like yesterday, we go on thinking that nothing has really happened in our country. This bit of news that appeared in January, nineteen thirty-nine in the newspaper *Le Soir* was and has remained our way of making sense of ourselves, of pushing back, of shifting attention: "Early in January, the Elsenborn police stopped a group of twenty-four Israelites, including some women, in the Nidrum woods, as they were trying to sneak into Belgium. They were led by two male smugglers, who were local residents. Thanks to their knowledge of the area, the two men were able to flee into the woods. The Israelites were sent back to Germany."

December 8, 1994

"A guy sets alone out here at night, maybe readin' books or thinkin' or stuff like that. Sometimes he gets thinkin', an' he got nothing to tell him what's so an' what ain't so. Maybe if he sees somethin', he don't know whether it's right or not. He can't turn to some other guy and ast him if he sees it too. He can't tell. He got nothing to measure by. I seen things out here. I wasn't drunk. I don't know if I was asleep. If some guy was with me, he could tell me I was asleep, an' then it would be all right. But I jus' don't know." These words spoken by Crooks, the black stable-hand in *Of Mice and Men*, describe our modern-day condition. We've lost touch with reality, we've become incapable of producing, describing, showing reality. We've never been so alone, stuck together in a shared insanity, lost in a world as insubstantial as a fantasy. This worries us to death.

December 22, 1994

"The true variety is in this abundance of real and unexpected elements, in the branch loaded with blue flowers which shoots up, against all reason, from the spring hedgerow that seemed already overcharged with blossoms, whereas the purely formal imitation of variety (and one might advance the same argument for all the other qualities of style) is but a barren uniformity, that is to say the very antithesis of variety . . ."

Marcel Proust, *Within a Budding Grove*

January 9, 1995

"With women who do not love us, as for the 'dear departed,' the knowledge that there is no hope left does not prevent us from continuing to wait."

Marcel Proust, *Within a Budding Grove*

January 11, 1995

I talked to André Dartevelle and Henri Orfinger about making a film on the Jews' deportation out of Belgium. They're interested, especially if there's a focus on the role the Belgian authorities played. That would necessitate someone who speaks Dutch perfectly.

January 14, 1995

More and more 4×4s on the roads and streets. Engines high up on the wheels, with steel bumpers, grilles over the headlights. They express the well-to-do's new stance: protective and aggressive. They drive in the safety of their militarized cars. They don't know where they're going but their car does. They're

headed into battle. Their cars are the tanks of an incipient civil war. One day, the ones seen as 'excluded' will overturn these engines and set fire to them. The well-to-do will see themselves as victims of a sudden outbreak of savagery. Seeing their bloody children in the backseats, they'll suddenly be filled with a murderous rage and find that, attached to the roll bar in the roof of their car there was a gun mount with a machine gun ready to use. They'll fire relentlessly, crisscrossing the town, the countryside in search of the enemy. They'll be pitiless. Their enemies will, too.

January 15, 1995

We met with Gérard Preszow to propose that he make the film on the Jews' deportation out of Belgium. He thanks us for thinking of him but he's just finished dealing with the gritty details in his book on deportation and he's in no state to delve back into them. Too painful. He would feel like he's walled in. Maybe in a few years.

February 10, 1995

"Perhaps that's what all human relationships boil down to: Would you save my life? or would you take it?"

Toni Morrison, *Song of Solomon*

The importance of reading Toni Morrison for writing *La Promesse*. Not only for the character of Assita but for the rhythm, for opening scenes without any clarifying information, for the rough, wild, biting tone.

February 25, 1995

I go back to writing *La Décision*. Must not seek reconciliation. Dare to be cruel.

March 1, 1995

I saw Richard Dindo's film on Che Guevara. The words of the teacher at the school where he was assassinated shook me. The guerrilla fighters' demonstration was that of a failure, but also seemed to suggest that this failure contained something that had escaped failure. It was an error in judgment to think that human beings do what they do as a function of the moment when they're doing it. There's a layer, a component to their acts, which speaks to those who aren't there yet. It's already present in the teacher's face and words.

March 2, 1995

The audiovisual professionals who want most of all to make money will look for something in the product they're developing they can turn into a "slogan." Once they've found this slogan, this rallying cry, they're ecstatic, they feel good, good as if they were immersed in the crowd cheering their product.

March 4, 1995

The screenplay for *La Promesse* was well received by the French Community of Belgium's film committee. It's giving fifteen million to twenty recipients. The shoot will be in October/November.

March 5, 1995

I talked on the phone with Assita Ouedraogo who may be playing the role of Assita in the film. Her voice thoroughly delights me, she's the one I'd always cast as Assita in the screenplay. It also delights me that she's a schoolteacher and "not professional." We'll go to Ouagadougou in May.

April 11, 1995

Rosetta. Maybe the story of a woman (thirty-five years old) driven to correct an injustice. In the face of a reality that refuses this correction and even the idea of such a correction, she sinks into madness.

July 11, 1995

I just saw five films by Peleshyan. Never has the mystery of birth been shown to me like this. Still too soon to interpret what I saw, what saw me. It's a cinema that films crowds: funeral crowds, festive crowds, fleeing crowds, mountains, fires, smoke. Elemental images out of which faces come, into which lone gazes work their way. Impression of disaster.

July 13, 1995

"She passed down the line of windows, offering coffee and milk to a few awakened passengers. Flushed with the glow of morning, her face was rosier than the sky. I felt on seeing her that desire to live which is reborn in us whenever we become conscious anew of beauty and of happiness. We invariably forget that these are individual qualities, and, mentally substituting for them a conventional type at which we arrive by striking a sort of mean among the different faces that have taken our fancy, among the pleasures we have known, we are left with mere abstract images which are lifeless and insipid

because they lack precisely that element of novelty, different from anything we have known, that element which is peculiar to beauty and to happiness."

Marcel Proust, *Within a Budding Grove*

July 14, 1995

I just saw John Ford's *Cheyenne Autumn*. Magnificent. Some have written that this film lacks dramatic construction, rhythm. It's precisely this lack that's extraordinary. Ford's final vision could be through the eyes of the other, the Indian. He could see the plot beyond that.

August 5, 1995

In the media lots of images showing the horrors of Hiroshima. No human experience approaches me. Pierces the aesthetic sphere.

August 12, 1995

Rosetta won't go mad. She fights and gets something. The film needs to be more interested in the reality of this woman's life than in the drama. Filming life: will we get there someday?

August 26, 1995

I went to a multiplex to see one of the latest Columbia productions. During the screening people left to get more candy, popcorn, etc. The posture of a TV watcher transplanted into a movie theater. Art and modern life blur together. The divide disappears. Have to make a film for which viewers would forget to eat and drink.

August 27, 1995

Art doesn't save the world or save anybody. It comes after. Far too late after. It comes after the murder has happened. It makes it possible to remember, but not to prevent it, or to not be committed again. Why go on, then? Why go on filming? Why? Why, if we're sure that a work of art will never stay a murderer's hand? Maybe because we're not so sure.

I just saw a TV series. They talk, they talk. Unbelievable! Every gesture accompanied by words to explain it. The image doesn't exist, it isn't laden with words.

August 31, 1995

There's the sphere and, like everyone, the artist is in the sphere and he fights like a maniac to extract some material and throw it outside. Often what he throws bounces off the walls of the sphere but sometimes it breaks through those walls.

September 22, 1995

There are cruel, evil people. It's difficult to accept that, even draining. It takes tremendous effort. But it's only after that effort that one has the feeling of being a human being. Many images (self-images we ask others to present to us) have to fall away for us to start becoming someone among the other someones.

September 23, 1995

Jean-Pierre found good scenery that will pull the film out of the Walloon imagery others in particular would like to encase us within. We're trying to find a mixture, a vagueness commensurate with our era, in places, faces, bodies, clothes. Nothing is pure anymore, or belongs to a single specific heritage or is untouched by an encounter that has bastardized it. In this context, our era is a *belle époque.*

November 25, 1995

Why retell a story? To remember the drama and thereby take pleasure in escaping it. Every retold story is in the past tense, even the one that recounts what will happen in ten thousand years.

December 2, 1995

End of the second week of shooting *La Promesse.* The actors are very good. The camera doesn't strike a pose. Maybe we're in the process of discovering what we've long been trying to accomplish. We feel like we're directing our first film. We're coming to realize just how much the failure of *Je pense à vous* was a blessing. If not for that, we would never have experienced the loneliness that allowed us to ask the single question that contained all the others: Where to position the camera? Which is to say: What am I showing? Which is to say: What am I hiding? Hiding is clearly the most essential thing.

January 17, 1996

It's 8:50. We've just wrapped the final shot of the final scene. Jean-Pierre and

I are exhausted. The impression of having sought something and partly found it. I was lackluster at the end of the previous shoot. Here, it's the opposite.

January 19, 1996

Emmanuel Levinas died during our shoot. The film owes much to our readings of his books. His interpretation of face-to-faces, of faces as the first conversations. Without these readings, would we have imagined the scenes with Roger and Igor in the repair shop, with Assita and Igor in the shop office and on the train station steps? The whole film can be seen as an attempt to finally come face-to-face.

During this shoot, Jean-Pierre and I really did function as a united pair. It was extraordinary. Just like our first documentaries.

March 2, 1996

"Every person is destroyed when we cease to see him; after which his next appearance is a new creation, different from that which immediately preceded it, if not from them all."

<div align="right">Marcel Proust, Within a Budding Grove</div>

March 3, 1996

Yesterday I got out of the hospital. I'm wearing a belt to support my back. My "vision" of Rosetta still hasn't happened. I thought my stay in the hospital would prompt it, but nothing.

Jean-Pierre is blocked in the same way.

April 10, 1996

In all the scenes where Igor/Assita are looking at each other, Igor is always the one to look away first. Igor can't look at Assita's gaze because there lies the pressure of the moral commandment he cannot follow. Except in the final scene.

April 14, 1996

La Promesse is selected for the Directors' Fortnight at Cannes. Happy. Anxious, too.

April 16, 1996

Against so many speeches championing and marketing the interactive image: an ode to passivity.

To be passive to the point of resenting this call, of going with the flow, of getting lost, of not knowing where I am anymore, who I am anymore. Today everything affirms what we are: kings of our ass, our rights, our images . . . Dark kingdom where we bore ourselves to death, where the only passion that can reign is morbid jealousy, the wish to destroy whatever contests the boundaries of our kingdom. This time Snow White won't survive. No way to find a hunter passive enough to forget the prospect of his own death in order to let the girl live.

April 18, 1996

Could you come do a colloquium about cinema? No, I replied, I'm too busy with our film. What could I have said during this colloquium if I hadn't had this excuse not to come? Maybe the story of the mirror and the traveling merchant I read in one of Ernst Bloch's books. In America, in the fifties, a traveling merchant, a white man, walks into a small hotel asking for a room for the night. There are no more rooms available. There's just one room with two beds, one of which has been taken by a black man . . . For lack of any other solution, the traveling merchant accepts it and, accompanied by the bellhop, goes up to the room, sets down his bags, and enjoins the bellhop, who has to wake him up at five in the morning, to come knock on the door and even come shake him awake, should he not answer the door, at his bed by the window, of course, not the black man's. Before going to sleep, the traveling merchant decides to go down to the bar where he meets several people while drinking then singing and dancing to jazz music. At some point, one of the revelers uses a charred champagne cork to do up the traveling salesman in blackface while he's singing tipsily. Later that night, the drunken traveling salesman's newly-made friends take him to his room and put him to bed. In the morning, woken up by the bellhop at five o'clock, he grabs his bags and runs to the train station where he has to catch his train. He just barely manages to get onboard, stows his bags, heads to the train bathrooms to shave and, when he sees his face in the mirror above the sink, he shrieks: "That idiot woke the nigger after all!"

A vertiginous moment in which, Ernst Bloch notes, the man was "so indefinitely near himself, yet his habitual whiteness fell from him."

Maybe that's the mirror of cinematic art. Allow the viewer to mistake himself or herself. To fail to recognize, to take himself or herself for someone else, to be someone else. To make out in the night of the film projection the other that is yourself and that the light of day obscured.

April 21, 1996

God is dead. We know this. We're alone. We know this. There's nothing after

death. We know this. We know all that today. Who is this "we"? A sort of rumor that has spread across Europe over two centuries. Easy to be lulled by the rumor while being distracted by so many golden calves. Quite a different thing to slip into solitude and come into contact with this fact: I am alone and I am mortal, this is my condition, the condition of us all. Whoever risks this descent will come out of it freer. But will also be tormented by a question that refuses to be ignored: why can't murder become acceptable again?

June 8, 1996

Several hours in front of the TV screen: broadcast of a neutral, muffled, continuous, engulfing flow, of an indefinite, numbing presence. State of torpor. Close to what Levinas described regarding the "there is," the "murmur of the being." No word, no sound, no image slices.

"It is like a density of the void, like a murmur of silence. There is nothing, but there is being, like a field of forces. Darkness is the very play of existence which would play itself out even if there were nothing."

Emmanuel Levinas, *Existence and Existents*

To drown in the flow, in the density of emptiness, to lose the weight of its limits, to dissolve in the rumor of nothingness, not to exist anymore, this is the deep desire of the television viewer. For everything to cancel out, for him or her not to be a participant in anything. For all these images and this noise to produce a darkness he or she can melt into, disappear within. Each individual is tired of being an individual. The desire not to be an individual anymore is what the television feeds on, is what it broadcasts.

August 13, 1996

At the outset, writing the screenplay demarcates an enclosed space, delimits a circle, describes an arena where characters are caught and confront one another. This confrontation becomes a confrontation with the circle itself, with the screenplay, and the film's movement can appear. We need this preliminary circle, this initial enclosure.

August 22, 1996

" . . . the work of art is not reducible to an idea; first, because it is a production or a reproduction of a *being*, that is of something which never quite allows itself to be *thought*; then, because this being is totally penetrated by an *existence*, that is, by a freedom which decides on the very fate and value of thought. That is also why the artist has always had a special understanding of

Evil, which is not the temporary and remediable isolation of an idea, but the irreducibility of man and the world of Thought."

Jean-Paul Sartre, *What Is Literature?*

August 23, 1996

"Man flees suffocation," wrote René Char. That is what we're retelling, nothing else.

August 30, 1996

Back from Montreal. A dull festival. Many films, but nothing new being shown. Fortunately the audience is wholly present and intelligent. That's what saves the festival. In the same way that Montreal's cosmopolitan, welcoming population saves the city full of architecture that arouses no emotion.

August 31, 1996

The greatest danger for the artist: compliments from those around him who, unwittingly, often with the best intentions, bring about his downfall. Reject any welcoming entourage, any sort of royal court. Stay solitary. Solitude within a pair for what affects us both, a solitude that only exists if each of us is solitary for himself, does not become a court for the other. No concession for oneself. No concession for the other.

September 1, 1996

What makes the experience of something? There's the idea of feeling and of leaving. Feeling something is a particular way of leaving this something.

September 2, 1996

Rosetta isn't progressing. Still no structure. I keep on reading Proust but it doesn't unlock anything in writing the screenplay. Nothing on Jean-Pierre's end.

October 31, 1996

Refuse all the offers of financing, casting, "technical comfort," that would allow us to make "a big film." Too young to die.

November 11, 1996

Pathological ability to slip into other people's bodies. To no longer know with certainty if I'm myself, if I can claim to be a self.

November 24, 1996

Lucie's birthday. Family stroll through the Meise Park. Still at a standstill with the screenplay.

November 27, 1996

Without God we'd be able to not kill, but we still live under the control of the God who, being dead, would allow everything. How to find what would be infinite in man without God's help?

Film humanity's appearance, capture goodwill's transference within simple human commerce. Sometimes, art can precede life.

November 28, 1996

Our question isn't: will the viewer like the film? but: will the film like the viewer?

November 29, 1996

A Letter to Three Wives. The back of Linda Darnell's hair, by itself in the frame . . . Waiting for a movement, waiting for a face . . .

December 1, 1996

Against the aestheticism that watches us, the artistry, all this creative junk that keeps humans from shining through.

December 9, 1996

Rosetta, the woman who hardens her heart in order to survive and ends up losing what's most precious for her? She's a workaholic. In that and that alone can she come to recognize others. To belong to the human community. To reject social death with all her strength.

December 17, 1996

I read *Man Equals Man* and reread *Mother Courage*. I read Racine's *Andromaque*. I read Russell Banks' *Affliction*.

December 18, 1996

Why tell stories? In order not to be afraid all alone in the darkness.

December 29, 1996

Rosetta progresses. I haven't written yet but we've talked at length about the character. She exists. The story won't be as articulated as that of *La Promesse*.

I surprise myself making the same gestures my father did. This evening, before going to bed, when I went to the front door to lock it . . . I walked like him, those were his footsteps, his arms' movements . . . There's no escaping that.

December 30, 1996

After Russell Banks, I'll read Vasily Grossman's *Life and Fate* and then Gorenstein's *The Psalm*. There, maybe I'll find the climate, the energy, the nature of the need that we can sense for Rosetta. I don't know why, but I need to read and to listen to music (Beethoven's sonatas and concertos for piano) before I start writing a screenplay. I'm overjoyed to have finished the first version and to rework it with Jean-Pierre. We have the same intuition for Rosetta's character. At the end of the film, she shouldn't be alone anymore.

December 31, 1996

Does Rosetta have a pain, a physical problem? Does she hate the wind itself?

January 7, 1997

I received well-wishes from several respectable people and organizations. They don't wish me a good year but a beautiful year. Aestheticism is thriving. People aren't.

January 12, 1997

We've settled on a preliminary framework for the story of *Rosetta*. We'll follow the character and the shape of the story will be the shape of her life, that is, without being novelistic, without developing a plot. Something invisible will have to develop: Rosetta's fate, which will shut her away and against which she'll fight. She's a girl with no compassion for herself or for others. She wants to get out. Not to climb the social ladder (that's the nineteenth century) but simply exist, not disappear.

January 15, 1997

Not to worry about taking the material for our films from the most sordid things reality reveals.

January 20, 1997

"It is the nature of forgiveness that when you forgive someone, you no longer have to protect yourself from him."

Russell Banks, *Affliction*

January 25, 1997

Rosetta is an angry, furious woman, stuck in the work that gives her the feeling of existing, not disappearing. At the end she needs to leave this job which drove her to betray the boy who wanted to help her, maybe love her.

Explore the complexity of the human being more deeply than in *La Promesse*. As in *La Promesse*, it's also an initiation, a birth, a new beginning. Once again, Hannah Arendt can provide some perspective. In *The Human Condition*, she writes: "The life span of man running toward death would inevitably carry everything human to ruin and destruction if it were not for the faculty of interrupting it and beginning something new, a faculty which is inherent in action like an ever-present reminder that men, though they must die, are not born in order to die but in order to begin . . . The miracle that saves the world, the realm of human affairs, from its normal, 'natural' ruin is ultimately the fact of natality, in which the faculty of action is ontologically rooted. It is, in other words, the birth of new men and the new beginning, the action they are capable of by virtue of being born."

Without insisting on it, without spelling it out, let the film's matter itself find the miracle that will save Rosetta, the gesture, the look, the word that will give rise to a new Rosetta. Like Igor, she'll sense the human fact of beginning. It's still unclear but this is what it has to come to.

January 26, 1997

Rosetta is in a state of war. The violence in her body and her words, her steps and footsteps, to get work, her inability to open up to Riquet, the furious hatred between her and her mother, the death of her frozen brother as she tries to warm him back up with the only heat she has at her disposal, that of her body, her campground-style lodging, all these things together amount to a climate of war between the camps of Rosetta and of society. So society appears for the one who has been cast out: like a fortress that prevents entry. The fear racing through Rosetta's veins dissipates with the scenes of reconciling with her mother and absolving her betrayal by giving up the job she had

stolen from Riquet. She won't be afraid of disappearing anymore. She had to undergo betrayal and murder.

January 29, 1997

Rosetta is haunted by the fear of disappearing. This haunting is what sparks the idea of murder. Kill her mother, the one who gave birth to her? Riquet, the enemy? Fear is at the forefront, stronger than love. It immediately drives the human being back to its animal state.

January 31, 1997

We're making this something instead of some other thing. This other thing is: killing. The moment of forgetting this other thing is what we call a moment of happiness.

February 8, 1997

Rosetta, the surplus.

February 9, 1997

After *Rosetta*, maybe we'll make a film that will meditate on the parable of the prodigal son. This isn't like Ulysses's return. Why would he come back and why did he leave? Why does the father fete him? What relationship is there to the Father of Cain and Abel?

February 10, 1997

Leave . . . Exodus . . . Escape . . . Will we go out tonight? . . . Will we go to see a film . . . Which film? . . . A comedy, of course . . . Will we end up making a comedy someday?

February 18, 1997

For *Rosetta*, a title connected to war? Disappearance? Importance of bodies and words whose brutality, whose animality simply confirm the anguish of disappearance.

February 20, 1997

See the same film several times at long enough intervals to bring about the experience of election. I am elected by this film, I am its elect, it remembers

me, in its images, its sounds, among the images, among the sounds, among them both, I don't know where, I remain within it, it has kept my gaze in its memory. To be able to remain within the other is to be loved.

February 21, 1997

The violence of the hatred separating and connecting Rosetta and her mother is a form of resistance to their disappearance.

March 13, 1997

Not to construct a plot, not to retell, not to orchestrate a development. Be with Rosetta, be with her and see how she arrives at things and how things come to her. Situations come, overwhelm when she's unprepared, as unforeseen events. Which will call for meticulous construction work for the framing and the editing.

March 17, 1997

In *Rosetta* there'll be more compression than in *La Promesse*. Compress feelings, compress space, compress bodies, compress words. Convey the imminence of an explosion.

March 19, 1997

The "*visage armé*," the "specially prepared face" of Rosetta. Found in Marguerite Duras. In thinking of Rosetta, I sometimes think of Suzanne from *The Sea Wall*, and sometimes of Sashenka from Gorenstein's *Redemption*.

April 3, 1997

No use trying to capture evil up close, as tightly as possible, front and center. It appears there, like that, for no reason, in the corner of a shot that's already gone on too long, that's framed too widely, that doesn't see well. It's in this imperfect gaze that the inhuman human arises and some measure can be taken of its reality. When we filmed Amidou's body being buried beneath rubble in a fairly wide, "poorly lit" shot, which framed a space dotted with obstacles that reduced visibility, this was the reality of evil that we wanted to convey. No doubt there are other ways but each of them, it seems, should avoid a perspective that purports to take the place of its light, its expression. Evil is unimaginable, it doesn't appear as an image.

April 12, 1997

Thoughts about origins come back to the surface. Still this logical, terribly logical madness to say what one is and what one isn't. But man is what he isn't, he never is what he is.

April 14, 1997

Some adult persons express their hostility toward other persons in words and mimicry that give a glimpse of that part of childhood that clearly never dies: cruelty.

April 22, 1997

A radio reporter tells us, after an interview where he had asked us many off-topic questions: "Our listeners want to know everything about everything so they don't have to think about anything."

While working on the *Rosetta* screenplay, I think back to what we told ourselves: not to recount a story, not to shape a story, not to sketch a strong dramatic art that would hamper Rosetta's life. But there is still a story. Reread Dostoyevsky. The stories of *Notes from a Dead House* are not constructed like the story of *Crime and Punishment*.

May 5, 1997

Isn't Rosetta overly terrible? And isn't it her life that's overly terrible? Must not be satisfied with mimicry. Find the other. Maybe it isn't as terrible as she thinks, as what she's socially determined to think? As if society were plotting against her, driving her toward death. Suicide or murder.

May 9, 1997

Rosetta withdraws from everything, from others, from life, from herself. She's adapted (overadapted) out of fear of not being up to confronting what she has to. She doesn't want to sink. She wants to preserve an image of herself which has to do with a faithfulness to the (idealized) image of her father? Sometimes I think that a father needs to appear one way or another and sometimes I tell myself that he'll inevitably come as the ultimate psychological explanation for Rosetta's behavior. Which absolutely has to be avoided.

May 10, 1997

Contemporary paradox: aestheticizing reality requires deaestheticizing art.

Why such characters that suffer and cause suffering? Sometimes I tell myself there's something sadistic in our gaze. Sometimes I tell myself we want to bring forth real, living bodies, and that suffering attests to this carnal existence, this embodiment. Sometimes I tell myself that maybe we think that only people who suffer can bring forth a story, or even that there's no story without suffering, without alteration, change, passage; and so suffering is necessary but not always sufficient. Sometimes I tell myself that deep within myself (and maybe within my brother as well) there's a fear of the humans we are, a fear of the evil we're capable of, that I'm capable of. Maybe it's to exorcise this fear that we show the work of evil. It's certainly to show that . . . and also the moment where a human being, a character, escapes the grip of this work.

May 11, 1997

"Spiritual life is essentially a moral life and likes to operate in the economic sphere." Levinas's observation here is also our cinema's.

May 15, 1997

Rosetta has no psychology because she has tasks to complete, things to do. Her whole being is busy, obsessed, fixated, besieged by what she has to do, seek, find.

May 16, 1997

I've just read two of Arendt's texts on Kafka. Rosetta, too, is a pariah who merely asks for the fundamental rights of every human being; she, too, is skeptical of her reality.

"Nevertheless, even the pariah, who is excluded from it, cannot account himself lucky, since society keeps up the pretense that it is somebody and he nobody, that it is 'real' and he 'unreal.' His conflict with it has therefore nothing to do with the question whether society treats him properly or not; the point at issue is simply whether it or he has real existence."

Hannah Arendt, "The Jew as Pariah: A Hidden Tradition"

May 26, 1997

We aren't trying to tell a story but to describe the behavior of a person whose entire being is overcome with the obsession of existing normally, of being part of society, of not being ostracized, of not disappearing. Charlot who would be ashamed of being Charlot, a beggar who would kill to escape his condition. No humor. Anguish.

May 31, 1997

The entrepreneurs currently reigning in the American and European film industry produce films belonging to a framework of needs and tastes where those who love film find the mark of generalized, satisfied servitude in the film credits. For them it's charming, it's wonderful, it's astonishing, it's nice. For him, it's vulgar, it's kitschy, it's easy, it's horrible.

June 1, 1997

Escaping cinematic reproduction starts by not reviving those bodies used for this reproduction. Find new bodies. Do not participate in this vast cloning industry ensuring that nothing new achieves cinematic existence.

June 20, 1997

" . . . in everyday language we approach our fellow-man instead of forgetting him in the 'enthusiasm' of eloquence . . . But it is also in the proximity to the neighbor, remaining totally other in that proximity, that—beyond the distantiation of rhetoric—the significance of a transcendence is born, going from one person to the other, to which metaphors capable of signifying infinity bear reference."

<div align="right">Emmanuel Levinas, Outside the Subject</div>

June 23, 1997

Food. Drink. Housing. The economic life, which is the site of moral, that is, spiritual life. It's out of this that the film *Rosetta* will be made, and work and money will connect these three elements.

June 25, 1997

" . . . this face-to-face relationship in which the Other counts as an interlocutor prior even to being known. One looks at a look. To look at a look is to look at something which cannot be abandoned or freed, but something which *aims* [*vise*] at you: it involves looking at the *face* [*visage*]."

<div align="right">Emmanuel Levinas, Difficult Freedom</div>

It's this look of Rosetta's that we try to show for the viewer. That she comes to exist as a face, that she is the interlocutor prior even to being known, and that she can never be knowable. We won't give information explaining her past, her story, her behavior. She will be there, face aiming at the eyes looking at her in the night of the movie theater.

June 26, 1997

In writing the screenplay with Jean-Pierre I realize that we may be uncovering something new. We aren't working with causal relationships, sequences. We show Rosetta as she is here, as she is there, as she acts here, as she acts there, and this being here, this being there, this acting here, this acting there construct a universe, a density, a world that appears like *that* which she wants to get out of, like what ought to disappear (or even her). Battle between this world and the character of this world where the ultimate stake is the disappearance, the death of one of the enemies. Movement outward against movement toward enclosure.

July 22, 1997

Being with the character (Rosetta) means, for us the authors: refusing to differentiate ourselves, to gain some distance through a conversation, another character, a scene construction that would provide a point of view that the character could not have. If Rosetta is completely busy, obsessed by a thing, we have to stay within this business, this obsession. Likewise for the camera: it has to be within as much as possible. This heavily delimits the possibilities for writing and it may be impossible. So much the better.

Being obsessed by something means having that thing in front of oneself, facing oneself without any prospect of moving it somewhere else. Whatever movement you make, it'll still be there, in front of you, right by you, it won't let you go, it besieges you. It's there, irremediably, irrevocably, perpetually there. And you, you can't take being there any longer.

I just read Gorenstein's *The Psalm*, Annie Ernaux's *Shame*. I'm reading *Madame Bovary*. After, I'll read Proust again. I finished reading *Life and Fate* and *The Sea Wall*. Suzanne responds to Rosetta: "I want to be in the arms of nobody."

August 4, 1997

Good discussion with Jean-Pierre on the Thalys train. I think we have the final part of the screenplay. I don't know what film will come out of it but we have these intense long movements that we'd like to film.

August 10, 1997

C., who lives in Brussels and is unemployed, walks around the city all day. At night, she comes home exhausted. Rosetta is also someone who walks. In Dostoyevsky the characters walk without ever stopping. Physical movement that's mental movement. Quest for a place, a spot to go to. To rest her head at last!

August 17, 1997

I saw *The Young and the Damned* at the Musée du cinéma.

Before Rosetta enters the film, she existed, and after the end of the film's final shot, she'll go on existing. As if she were a documentary subject who existed independently of being filmed by our camera. We're filming a moment in her life.

August 19, 1997

Alain Berenboom told me that in *La Promesse* he sensed an ambiance of survival as in some science-fiction novels. It's the same ambiance in *Rosetta*. Our characters have to relearn how to exist beyond their will to survive, relearn "what is human in man," as Vasily Grossman put it.

August 20, 1997

Freedom doesn't start where need ends. Without need man gets bored, loses his relationship to reality and ends up looking for it in acts of destruction. Rosetta is a resolutely contemporary character, a representative of a new species doomed to forced leisure, to freedom stripped of all need. Her struggle to gain some work is also dictated by the fear of emptiness that she feels. She knows that one day men and women will have to fight to regain some sort of work.

August 29, 1997

"It must not be forgotten that each person's history unfolds through the need to be recognized, and recognized without reservation."

<div align="right">Robert Antelme</div>

Finding work is, for Rosetta, what will give her recognition, what will allow her to feel herself living, to exist in the eyes of others, in her eyes.

August 30, 1997

"Ultimately," the reporter asked me, "what do you feel like you are? Do you feel Belgian? Walloon? Brussellian? European? . . ."

I replied: "I feel uncomfortable when I have to consider this sort of question."

September 2, 1997

First version of *Rosetta* finished. I reread. It seemed terrible to me. Jean-Pierre's

thoughts were the same. The fiction hasn't started. Shouldn't we figure out the plot's constraint, its dramatic closure? What we're trying to do is the opposite. The one good thing: Rosetta's character.

September 7, 1997

A full day of discussion. We're refocusing on Rosetta and her mother. I get back to writing. Hard not to think back to *La Promesse* when we're looking for Rosetta's trajectory. However we should clear our minds of Roger, Igor, and Assita. The infernal trio!

The problem remains: find a way to give birth to a fiction starting from an ordinary reality.

September 9, 1997

I think back to the screenplay drafts of *La Décision* and *La Tentation*. In both of them there's the violent death (the meditated or completed death) of a child. I get the feeling we'll return to that after *Rosetta*. It bothers me, it nags at me.

September 23, 1997

Q: Why do you make these films?

A: We make what we know how to make.

Q: What does that mean?

A: Only the films themselves can answer that question because what we're making might not be what we believe we're making.

An essential principle for and against everything: "Make what you know how to make and don't claim to know what you're making."

September 25, 1997

Good day of work yesterday with Jean-Pierre. We maintain the circle of the story in which Rosetta carries out her battle to the death. It's the origin of a murder. How Rosetta, in order to get what she's looking for, ends up killing. The girl she was at the beginning comes back, but too late. She represents what could have not happened, but she comes too late. Rosetta gets rid of the other to take her job, and this behavior situates her as an authentic product of the brutal competition that the ultraliberal economy of our era has necessitated. No new jobs (work becomes scarcer) and so battle to the death for existing, already occupied jobs. At first people want the job and then, unable to get it because it's taken, they want to get rid of whoever has it.

In all the scenes where it's possible (without the screenwriting being too

obvious) we'll introduce the situation of someone who's taking someone else's job. Taking the other's job so as not to disappear.

October 1, 1997

"There's no art
To find the mind's construction in the face."

<div align="right">Shakespeare, Macbeth, act I, scene 4</div>

October 24, 1997

Social and economic determinism have once again become the arc of fate for fifteen percent of the Western population joining the South's populations. The contemporary arc of the tragic. This is what Rosetta battles against.

They're going to say again that we don't have any sense of humor. How could Rosetta, entrapped in her fate, gain any distance from that fate?

November 4, 1997

I just read *Madame Bovary*. Rosetta's fate resembles Emma's. One is searching for true work, the other true love, unobtainable work, unobtainable love. A search all the more obsessive because its object is nonexistent.

This passage in the novel, which admirably, dreadfully summarizes fate's handiwork in Emma's frantic quest: "And yet, on that brow covered in cold drops, on those murmuring lips, in those wild eyes, and in the clasping of those arms, there was something excessive, something empty and lugubrious, which Léon felt sliding, imperceptibly, between them, as if to push them asunder."

This something excessive, empty, and lugubrious sliding between them, imperceptibly, as if to push them asunder is the mark, the symptom of a new era that is still ours, the exit from the era (which I still feel when I read Stendhal) in which bodies can exude a warmth that envelops them and bears them, if only for a moment, into the heart (what a word!) of passionate love, its ecstasy, its eternity, its bliss. Emma cannot experience this anymore and she dreams of it, dies of it, in fact.

As a reader, I see this separation of Léon and Emma's bodies as well. It comes between me and the novel. I am caught by a gaze that forbids sympathetic identification. Between it and me remains this something cold, excessive, empty, and lugubrious.

Rosetta is Emma's great-granddaughter, Berthe's granddaughter. Berthe who worked in the cotton mills and who found, in working-class life, a few moments of fraternal warmth that allowed her to forget the cold something

that had brought her mother down low. In these past moments (the ones Zola described), Rosetta finds Emma's something. Neither love nor work give her warmth. You are so alone, Rosetta. So alone.

November 10, 1997

Following Jean-Pierre's comments, I made a new structure. I feel that we're getting closer to the shape and state that we're looking for. Rosetta won't kill. Riquet, who has finally started to exist, is someone who wants to help Rosetta, nothing more, independently of any plot. His way of appearing within the image, of being framed, will not allude to any hidden schemes, to any secrets. He's there, wholly there. Rosetta's mother becomes lively, she comes out of her abstraction. The phone conversation on Sunday morning with the woman from Alcoholics Anonymous really helped me to give her life. Jean-Pierre is afraid that she won't be very present with her therapy problems, etc. He's right. He also thinks that what happens between Rosetta and Riquet doesn't fit within the parameters of romantic wooing. He's also right on that point. The film happens elsewhere. We don't know where, but elsewhere. Somewhere where we plunge into the origin of the human being. A manner of speaking because we're filming on the surface, among the clues, the traces of human passage. Perhaps it's the viewer who will plunge (if the film warrants it).

November 16, 1997

"He shivered, seized by a nameless anxiety."

Flaubert, *Sentimental Education*

How to film it? Is it possible? Where to position the camera?

November 18, 1997

"Let the dead bury the dead." That is to say: "Do not let the dead bury the living."

November 22, 1997

Rosetta once again becomes a character who discovers, comes out of herself, desires at last. Three losses at the end of the screenplay. The (voluntary) loss of her work, of her job. The loss of her life (the suicide halted by a lack of fuel, her poverty). The loss of images she had been immured within (she sees the other, Riquet). Birth of a new Rosetta.

In *Rosetta*, the story is less evident than in *La Promesse*. Less construction, more space for what happens to and comes together for the fate of the character (who tries to escape it, to resist it).

November 26, 1997

Brecht wrote that realism doesn't consist of saying true things but of saying what things truly are. While his plays say what things truly are, a gulag prisoner collects facts, true things that say that these plays say false things. When saying what things truly are requires false things to be said, saying true things becomes the way to say what things truly are.

November 27, 1997

This afternoon I go to Aubagne to meet an old friend who's organizing the Méridien festival. We've asked him to screen Rainer Werner Fassbinder's *Ali: Fear Eats the Soul*.

If Rosetta is a prisoner of her fate, of what obsesses her, should she also be a prisoner of this frame? Remember that a human being takes by surprise. Isn't only taken.

December 1, 1997

It seems that Mozart said of some of his concertos: "They are brilliant . . . but they lack poverty."

December 2, 1997

Reading the Bible teaches about taking things literally. Filming letters. Not wanting to film the spirit. It will emerge on its own. And not too high, because the letter has to stay visible. It's with its sustained contact that the spirit gains its depth.

December 22, 1997

The resurrection of bodies. Why bodies? Because only the body can die and so only the body can arise again. And as only the body can be filmed, there's a special relationship between film and resurrection. It's dumb when put that way, but it keeps on astonishing me.

January 5, 1998

Jean-Pierre read the fourth version of the screenplay. He finds that it doesn't

have any aim, that it's still too documentary. I agree. I'll focus it on Rosetta's discovery of Riquet, her guilt, her request for "forgiveness," her childbirth. Which was already embryonic in this version.

January 7, 1998

The father comes into the screenplay. Connected to Rosetta's need for recognition.

January 18, 1998

Rosetta's father isn't there to give the plot some movement, to advance the action. He's someone who Rosetta wants recognition from, solely in the moments when she isn't doing well, when she's no longer recognized, when she doubts her existence.

January 19, 1998

I'm rereading *Hamlet*. Just when he has every reason to take revenge, to avenge his father, Hamlet thinks about the emptiness of human affairs, thinks about dying. This isn't a momentary detour his soul takes before pursuing the goal it had for itself. This isn't a dramatic trick. This thought genuinely comes to him and invades him completely. Why? Why does Hamlet hesitate to become part of the dramatic sequence, part of the story, part of History? Why does he yearn to withdraw, not to be? Revenge shapes the story, it gives the character motives and objectives, it provides a purpose that sustains the character. A goal to accomplish! A goal grounded in good reasons, in an elevated idea of justice, of morality! Hamlet hesitates, doesn't want to shape the story, doesn't want to accomplish the goal. Nor can he forget the wrong done by his uncle and his mother. But what then? . . . In the face of such human depth most stories ring hollow. Not to shape the story, not to become part of the story, to abandon his mission, to quit the infernal games of intrigues, to finally be outside the plot, to start another, new, truly new life, and as such not to be.

Hamlet does what he can not to shape the story, not to become the protagonist of a story, but the tragedy is precisely in this impossibility of not shaping the story.

January 22, 1998

Hamlet again. He imagines the theatrical representation of the murder his uncle committed because the assassin might, when confronted by the spectacle of his crime, betray himself and perhaps recognize the evil he committed. When he imagines this, Hamlet declares the essence of tragic representation:

to repeat the transgression of taboo in order to reestablish it. Claudius's condition, the murderous (and incestuous) viewer's condition is that of every viewer watching the most entangled human machinations. Another thing: if Claudius, bothered by the spectacle of his crime, came to recognize it and to abandon the position gained by his crime, Hamlet would no longer need to avenge his father by killing him. Art would have brought about the culprit's conversion. A new murder would not need to be committed. But thinking does not make it so.

February 6, 1998

Jean-Pierre is enthusiastic about the fifth version of the screenplay. We're headed out to Casteau to make the sixth version. I think we'll hold onto the character and the plot will come out, will come together without being a story. Understand it who may; I understand myself.

"The only philosophy which can be responsibly practiced in the face of despair is the attempt to contemplate all things as they would present themselves from the standpoint of redemption."

Adorno, *Minima Moralia*

February 7, 1998

E. is still unemployed. Hard to live and so few people realize what this could mean for whoever suffers this.

February 15, 1998

We've finished the sixth version of the screenplay in Casteau. We realized that it was a set of variations on the dramatic situation of shame. The final form of shame is moral shame (the shame of what Rosetta did to Riquet). Riquet helps Rosetta to break free of shame.

February 17, 1998

Q: Why isn't there any music in your film?

A: So you won't plug your eyes.

March 2, 1998

After Léon Michaux reads the screenplay, we cut the character of the father. Not only already seen too much, but also he explains Rosetta. Thank you, Léon.

March 7, 1998

Almost finished the seventh version of the screenplay. Good choice to cut the father. Although he seemed essential a few weeks ago. I also thought he risked explaining Rosetta. That was the danger.

I believe we have the character/situation matrix that will allow us to delve deeper while shooting. Delve into the human material. Strip bare, naked.

April 18, 1998

The ninth version of the screenplay has been delivered to the film selection committee and will then be delivered to Canal+. Let's hope they "understand" it. We shoot in October.

After talking with Jean-Pierre, I start working on another screenplay. We'd like to depict a group, a family with two or three children. Maybe pick up, in another way, the story of the woman who struggles to the point of madness to reinstate the dismissed worker. Senseless hunger strike, tent in the parking lot. She has to go all the way. Mutual support between a woman and her husband. At the outset the husband is afraid. A film about fear.

April 19, 1998

What should be the director's statement accompanying the screenplay of *Rosetta*:

Exploration of an existence, of a character, which aims to be the portrait of an era.

The character: Rosetta, a young woman, seventeen years old, in search of a job, a place, an existence, a recognition.

The era: that of today, of survival necessitated by the scarcity of work which results in difficulties with money, housing, food, health, exclusion . . .

It's a war film. Rosetta goes to the battle front in search of a job, which she finds, loses, regains, has taken from her, takes back, always on the lookout, obsessed by the fear of disappearing, the shame of being displaced, held hostage by her pride, hardened to the point of betraying the one friend who comes to help her. Only victory matters: having some work, finding a job.

We'll film Rosetta's body on the brink of exploding, compressed, tense, at war, untouchable, framed by long movements sometimes suspended in shots where her face breathes, rests its gaze . . .

Our camera will never leave her, attempting to see, even if it's invisible, the night Rosetta struggles within.

April 20, 1998

We need a title before starting to draft the screenplay. Absolutely necessary to frame, to determine the film's stakes, the "what do we actually want to film?," the "what is it actually talking about?"

April 27, 1998

"Dr. Rieux resolved to compile this chronicle, so that he should not be one of those who hold their peace but should not bear witness in favor of those plague-stricken people; so that some memorial of the injustices and outrage done them might endure; and to state quite simply what we learn in a time of pestilence: that there are more things to admire in men than to despise."

Albert Camus, *The Plague*

May 6, 1998

We reflect on a new screenplay to film after *Rosetta*. Olivier Gourmet will play the main character. New way to start, new experience because we've never set out with an actor in imagining a film. We would like there not to be a subject, just people and their relationships.

May 10, 1998

"Much that is unutterable would hardly be worth uttering if one could utter it outright."

Lichtenberg

May 12, 1998

Sometimes the need to make others suffer. It's thus. Have to know it.

May 31, 1998

Phone conversation with Jean-Pierre about the next screenplay. We talk again about the union representative's distress when confronted by a team of workers that gave its approval to management to dismiss a worker whose negligence at work loses them their production bonuses. A man who's among those getting kicked out everywhere. An angry man who, for no reason at all, has reason to get angry.

June 1, 1998

Night in a police station in Charleroi. A policeman finishes questioning a

fourteen-year-old boy who's just been brought in for theft. He calls the teen-ager's parents to let them know and to ask them to come pick up their son. The father replies: "Keep him" and hangs up.

July 26, 1998

I just read Marie Balmary's *The Forbidden Sacrifice*. She concludes: "The human conscience is formed not by ownership and mastery, but by loss and liberation."

Rosetta liberates herself, is liberated. Riquet is the stranger, the "first comer" to help her in this escape, this transition, this liberation.

July 27, 1998

I just saw Bill Douglas's first two films. Ellipses that build a tension to the point of making the shots explode. The acute sense of what ends abruptly, without any explanation, to accept thus, like that, as if life were speaking to Jamie.

August 14, 1998

Rosetta is alone so that the viewer can be with her. She suffers and whoever watches her can have the experience of suffering for the one who suffers. So that this experience is not purely narcissistic, Rosetta has to resist anything that would allow the viewer to project himself or herself and to weep for her-self or himself. She has to escape him or her, sometimes displease the viewer, not seduce her or him, not become a victim seeking easy sympathy. Creating the experience of the viewer suffering for others, of suffering in the sight of others' suffering: this is a way for art to reconstruct the human experience.

"Poor naked wretches, whereso'er you are,
That bide the pelting of this pitiless storm,
How shall your houseless heads and unfed sides,
Your looped and windowed raggedness, defend you
From seasons such as these? O, I have ta'en
Too little care of this! Take physic, pomp;
Expose thyself to feel what wretches feel,
That thou mayst shake the superflux to them,
And show the heavens more just."

<div align="right">Shakespeare, King Lear, act III, scene 4</div>

"I should ev'n die with pity
To see another thus."

<div align="right">Shakespeare, King Lear, act IV, scene 6</div>

August 30, 1998

Rosetta is the first name of a character we'll film, this is a film about some-one. Almost a "documentary" about a modern-day girl. I think the unknown young woman who's going to play this someone will become Rosetta.

October 15, 1998

Riquet is elusive. I can't figure out who he is and I think I shouldn't try any-more. Settle for the simple "he's there." Is he a kind of idiot? The actor (Fab-rizio Rongione) asked us who Riquet was. We answered that we didn't know, that we just know he's there.

October 16, 1998

Jean-Pierre suggested deleting all the retorts and attitudes that still make Riquet a seducer. A mysterious boy. Waiting. Waiting for a Rosetta who isn't there yet. A confidence, a connection for the lonely Rosetta looking at him . . .

October 25, 1998

Rosetta or birth. Her stomach pains are the contractions of a childbirth with no child in sight.

November 18, 1998

The more we shoot, the more we feel that *Rosetta* is a film without a subject. The actress (Émilie Dequenne) and the actors are in this restrained, scorch-ing game we're trying to capture.

December 7, 1998

Rosetta could be a silent film. All her energy is balled up to keep her alive. There's none left to utter any words. And besides, what help would it be to speak?

December 23, 1998

We've just finished shooting *Rosetta*. Physically grueling. There's a strength, an energy there, even if we don't know what the rhythm of the film will be. Everybody has helped to create the tension needed on set. We reshot the scenes we weren't happy with, which we hadn't done for *La Promesse*. We rewrote scenes during the shoot. We didn't do that either for *La Promesse*.

January 3, 1999

An element for the next screenplay: the loose door that nobody fixes.

January 10, 1999

The true realization: the absence of the man within the man. The absence of God was an interpretation of this realization, a way of carrying out the battle while refusing to recognize our loneliness. Today, art faces off against this true, terrifying realization. Out of that battle come art's works.

January 29, 1999

A young man in Charleroi dependent on the Public Centre for Social Welfare tried to set himself on fire in the Centre's building. It took him two tries. That is the violence of the response to the violence of diminishment, offense, social humiliation. We who ought to be looking cover our eyes in hopes that this will pass and the next day we're surprised by the violence of the blow that strikes us. By the degree of the violence we've committed or allowed to be committed.

January 30, 1999

Benoît Dervaux's film *Gigi, Monica . . . & Bianca* is very beautiful. I was deeply touched by the scene under the glass canopy. The water, the rain flowing from those panes that Gigi and Monica collect in their hands to sprinkle on each other, to play at getting wet, watching, loving. A moment of love that saves everything, them, us, cinema, the world.

February 3, 1999

Editing *Rosetta* is difficult. How to find the right rhythm for this portrait? The rhythm, the breath, is our cinematic form. I often think of the rhythm that Schumann manages to give particular movements. A sort of fever, of panting, of frenzy, of enthusiasm halted by calm breaths still shot through with a frisson that can't be erased. Rosetta moves, moves, moves. She doesn't know where to lay her head down. She wears herself out looking for where to lay her head down. If you're hungry or thirsty, there's someone running after you. A single shelter, a single night during which her head can rest: on Riquet's makeshift bed, on the sweet words of her baby monologue.

February 7, 1999

Amid money, work, water, eggs, bunks, waffles, gas, Rosetta walks. Geography

of fundamental economic needs. She walks on the edge of the hole, she walks in order not to fall. When he comes, she doesn't recognize this other, he who has come to help her. She throws him into the hole, him and everything that's hurt her, everything gnawing at her belly: money, work, water, eggs, bunks, waffles, gas.

February 13, 1999

Rosetta. We're starting to find the rhythm, the breath.

Every night, I think of Olivier Gourmet. He occupies my mind, the main character of parts of unrelated stories. It's the first time I'm surprised to dream of imaginary situations resulting from an actor. He pursues me, he haunts me.

I read Malraux's *Man's Fate.*

March 14, 1999

We may have found a way forward for the new screenplay. The man doesn't take revenge; he saves or tries (to the point of madness) to save the murderer. In the way of his son's death, is there anyone other than the murderer he's focused on? Be mindful of forgiveness. Still no title yet.

March 20, 1999

Evil has conquered analysis. It draws close to the art awaiting it . . .

March 21, 1999

The Wolf and the Lamb. If, to the rageful animal, the lamb's reply were: "Yes, your majesty, my brother slandered you last year. Take him and eat him. Take all my brothers as well and eat them. They're over there, hidden behind the shrub." Confronted with such a reply, the reader judging with all his or her moral conscience would think that this was a truly terrible lamb. Offering up his brother and all the others like that! Whereas the reader trying to understand would see just how the wolves' reign could turn a lamb into a worse breed of wolf. He would also notice that there was a subtle complicity between the morally judgmental reader and the wolf. Once the wolf had eaten the lamb's family, it would come back and devour the lamb despite its final pleas because it was thinking: "It's a terrible lamb that betrays its brother and family. It deserves to die." And it would eat the lamb without any further consideration, with the feeling of having accomplished a moral act.

March 22, 1999

Next screenplay: revenge/forgiveness. Without sentimentality. Confront the moment of forgiveness without sinking into human, all-too-human bathos. Confronting this moment doesn't mean inevitably reaching forgiveness. To feel in writing, in filming. Sometimes I tell myself: "yes, it's possible," then something holds me back and tells me: "no, it's impossible."

March 27, 1999

Maybe it isn't forgiveness that the father of the murdered child will discover but the impossibility of killing. The human soul according to Levinas.

March 30, 1999

We think back to the police-blotter item from Auderghem. The man ordered by his mistress to kill the young child she had with her husband. The man drives off with the child to go drown him but cannot convince himself to do it. Finally he abandons the child on the side of the highway.

March 31, 1999

In a folder where I keep dialogue snippets and story ideas, I found this note dated August 20, 1997: "A man kills the husband of a woman who the murderer's brother will sacrifice his life for to offset his brother's act as well as his own shortcoming: having let his brother become a murderer. The question asked of Cain is transferred to Abel: Why did you let your brother become a killer?"

Be careful of this self-sacrificing brother's narcissism. Deep within the one who sacrifices himself to save someone else could be the image of himself he absolutely has to save, not to sacrifice. This willingness to sacrifice for someone else has to force him to be overpowered by what he has decided to do.

April 1, 1999

Discussion with Jean-Pierre in Brussels. No title yet for the next screenplay but the movement. Around the murdered son, the father's revenge, the forgiveness. We've found the venue: a training center for reintegrating children (transmission, heritage). A job connected to food? The third person will be a young woman. The living third "against" the dead third (the murdered son) asking his father to avenge him. Without this living third, how could the father not kill his son's murderer? Moment of the father's vengeful fury before the scene between the murderer and this young woman. We can't talk

about forgiveness because the murderer doesn't ask for forgiveness but thanks to the young woman he comes to confess what he did. He falls apart. The murderer killed when he was eleven or twelve. Think of the first murder (Cain and Abel) even if they aren't brothers. The father's character will make them brothers. Inevitably.

April 9, 1999

The film is selected for official competition at Cannes. The festival's general delegate, Gilles Jacob, said that *Rosetta* was an Exocet missile.

May 13, 1999

Screening of *Rosetta* at the Dames Augustines screening room in Paris to check the calibration and sound mixing. It's a film about someone who tries to stay upright. Nothing more.

May 15, 1999

We drop the story about the father's revenge and forgiveness. As we think about it, we get the feeling of having done it already. No risk, no gamble, no adventure. The impression of starting *La Promesse* again some other way?

May 31, 1999

Back to earth after Cannes. We try to think about Olivier again, about the next film.

There should be something there about food.

June 1, 1999

The *Rosetta* adventure has worn us out. I feel empty. Impossible to concentrate. Same for Jean-Pierre who I just talked to on the phone. She's taken us beyond. Beyond what, I'm not too sure, but beyond. Now we have to come back and get back to work, calmly, consistently.

June 20, 1999

I'm going to sleep. Delighted to think about Olivier Gourmet, about the character he'll become in our next film. Still "the night in which, as the saying goes, all cows are black."

July 30, 1999

Film or create the frame. The gaze sunken, caught, lost, stifled, drowned in the material. It tries to escape, to create the hole, the frame. Rosetta embodies this movement of evasion, this breathing of a drowned woman.

August 1, 1999

My father. I fought a long time with him. Unceasingly. I wasn't alone. My brother was always with me and vice versa in struggling against him. We never said it out loud to ourselves but we knew that our bond was unshakable. Maybe it sealed our fate as a two-headed filmmaker. I don't know. What I do feel like I know is that in our films we talk a great deal about our father, about his sons, and about him. I've never talked with my father. There's nothing special there. It might even be a rule. It took me many years to understand what I owed him, what we owed him, to feel what, in all his clumsiness and obsessiveness, he tried to convey to us: moral obligation, which evidently impelled him to engage in the Partisans Armés when he was seventeen. He's never spoken of that.

August 7, 1999

"[The parents] recognize themselves in it as genus, [i.e.,] themselves as other than they themselves are, namely, as achieved (*geowrden*) unity. But this achieved unity is itself a consciousness in which the coming supersession of the parent is intuited, i.e., it is a consciousness in which the consciousness of the parents comes to be; in other word[s], the parents must *educate* it. As they educate it, they posit their achieved consciousness in it and they generate their own death, as they bring their achievement to living consciousness."

Hegel, *First Philosophy of Spirit*

I understand from this text that parents do not eat their child. They die in being survived, they draw back as they are continued. To educate is to die.

August 13, 1999

A few lines in a *Le Monde* article about the cult of the dead steer me toward Hamlet: he would like to escape the cult of the dead (and knows he cannot). Revenge requires a dead body, requires another killing, and as long as the dead body has not been avenged by the death of whoever killed it, the body won't truly be dead. It will return like the ghost of Hamlet's father, an undead being who never stops haunting his son so that he will kill. This situation (with other genealogical relationships) could be that of the next film. How to live with a dead body that insists upon reparation? Return to the father and his murdered son.

August 15, 1999

Several days in Rome. I saw the Morandi paintings again. The bottles, the glasses, the carafes, the jars, the bowls . . . They're there on the table, like small columns, small temples erected to our hand-to-mouth, fragile humanity, bereft of the utility that makes us forget their presence. They're there, many of them, on the table, sometimes taking shelter against one another as if a threat was coming, and they watch me . . . And their vulnerability disarms me, trembles, makes everything tremble and cracks my eyes. Yes, they exist, they're there, they address I who had never seen them, those gazes on the table . . . The table that one well-aimed kick could knock over.

August 17, 1999

The cult of the dead at the heart of all revenge, all vengeance, maybe even all resentment. How to escape it? What to do with the death that keeps you at a remove, insists upon reparation? And why isn't vengeance required? Why is revenge not more just than justice?

The film could (in taking up the father, the murdered son, the murderer, the father's daughter or wife, meaning the murdered son's sister or mother) look at a family filled by the need for revenge and which would regain life by breaking out of the straitjacket of this inevitable need. Focus on forgiveness, the illusion of itself that it exudes (narcissism of the one who forgives, as if he could be above the others, above his human condition). The title, if it isn't already that of some masterpiece, could be *Vivre* [To Live]. The first part of the film would show a time governed by the death to avenge and a second part would show the journey through this frozen sea which would warm over and which would free the family. A journey nobody would come out of unscathed.

See if a father/daughter pair rather than a father/wife pair would keep murder from being connected with incest. The murder of the son's killer (from the daughter's perspective, the brother's killer) by the father and his daughter would be the incestuous act. If this contrived murder ultimately isn't committed, life can run again, the daughter can turn toward someone else.

The father will only become a father in not committing murder, in becoming in a particular way the father of his son's murderer. None of this would be possible if this murderer were not a teenager.

Life is more fluid, more outsized, more alive than all the images in which the others entrap themselves/are entrapped/entrap others. At the same time, wounds cannot be wholly healed by plunging into the flow of life. Something remains of what hurt them. They live with it. Life goes on and the one who is no longer there finds a place. Not a prominent place, but a place. Life is outsized, more outsized than we can imagine.

August 19, 1999

I read Daniel Sibony's *With Shakespeare*. After that, I'll read André Green's book on *Hamlet*. Jacques Taminiaux sent me his article on forgiving and promising in Hannah Arendt's work. I look forward to talking to Jean-Pierre again about the screenplay at the beginning of September. Should we keep on writing it? It might force us into a deadlock that will take us time to get out of. If we do get out of it.

August 24, 1999

A freer, more colorful film. Movements that carry life along. Movements into which slips the evil to be overcome.

August 27, 1999

Emmanuelle comes back tomorrow from her birding trip in the Danube delta. She has a secret relationship with the details, the many distinctions of life. She opens me up to this gaze.

"In [cinema], it's better for a shiver to come from a drop of water falling to the ground, and for this shiver to be passed on, rather than for the best social aid program to be laid out. This drop of water will instill more spirituality within the [viewer] than the loftiest exhortations to take heart could, more humanity than any humanitarian verse could."

Henri Michaux, "The Future of Poetry"

August 29, 1999

I just read Michel Houellebecq's *The Elementary Particles*. We're in prose. It does good. It's been a long while since literature fought like this in our era. Anesthesia of our mortality. Extinction of sexes. Rise of soothing neutrality. Nothing's really coming anymore. Be born, die, kill, suffer, love, hate—illusions dissolved within the great liquid finally-achieved reign of nihilism. The ape, having lost his head, will regain it and, in a civilized way, without sound or fury. The horror! The pleasure!

November 6, 1999

"And the king shall live without an heir, if that which is lost be not found."

Shakespeare, *The Winter's Tale*, act III, scene 2

November 22, 1999

We've stopped working on the screenplay about vengeance and the impossibility of murder. Too linear. Too mechanical. Lacks life. Too-obsessive character who moves toward and away from everything (even if he stops at the final moment). There would need to be a character caught by others, overwhelmed by their needs (family? home? workplace?). Someone wavering, torn, brought low by the various situations he feels forced to deal with. This character is borne by a feeling of fury against the way things are. He doesn't accept them, he rejects them. He's someone overburdened, who experiences moments of fatigue, withdrawal. And amid all that, a central story has to come together. A group, and, in this group, a more important character.

December 5, 1999

Still nothing new for the screenplay. Waiting. Stopped.

December 10, 1999

We get back to working on the screenplay about revenge, about discovering the impossibility of killing.

December 16, 1999

How life returns and how respect for the murder taboo preserves this return of life. The avenger who goes to kill and refrains from killing rediscovers the murder taboo and loses his justification for murder.

December 22, 1999

We can explain how he comes to kill but we cannot ever explain why he necessarily had to come to kill.

December 23, 1999

A film that would take on the story of Oedipus again. The myth from the beginning (Laius who was kept from his rightful place as the son of the king of Thebes and his flight, the rape of Chrysippus, his suicide . . .). Not to be in his place, not to know his place, to be wrested from place, to mix up the places, confuse the generations, that in and of itself is the transgression of law, the erasure of the taboo.

Now the father and the mother no longer forbid (what exactly? who?). They leave their son by himself, for himself, as himself, with himself. A way of devouring him so he won't devour them. That's their fear, their terror: to be

devoured by those they brought into the world, those who came from them. So they don't tell them where they came from, they make them believe that they didn't come from some other, that they came from themselves and only have themselves to ruin. So these accursed children will devour each other!

December 24, 1999

A title that would make it possible to describe, to show us, the movements for escaping a repetition, the cycle of revenge. Something in common with *La Promesse* and *Rosetta*. A similar movement of escape. Three passages. Three births. A sort of trilogy.

January 1, 2000

New title: *L'Épreuve* [The Test]. The young assassin comes to where Olivier is. He doesn't know who Olivier is but Olivier knows who the young assassin is. Olivier accepts this test. He is torn among several sentiments, several desires. How can these two human beings, this "father" and this "son," approach each other, face each other? Temptation of murder, need for revenge, impossibility of murder, moment of forgiveness, illusion of forgiveness, insanity of forgiveness.

January 11, 2000

Several people have told us about Dogme 95 and our connections with the Danish movement. When we were shooting *La Promesse*, we did not know that it existed. Our work with the camera corresponded to a search tied to the rhythms and angles by which our two main characters could see the world and each other. There was also our wish to free ourselves from the weight of the approach that had paralyzed us in *Je pense à vous*. Wish for freedom that is also inherent in Dogme. These are filmmakers from two small countries who made a virtue of their poverty of means in order to find the form of their cinema.

January 13, 2000

Yesterday, meeting with Jean-Pierre in Brussels. We're starting to see the character, his relationship with the young assassin. This becomes simpler. Maybe the situation is too powerful?

January 14, 2000

I'm hearing again about the French quarrel about criticism. This quarrel seems uninteresting and unnecessary to me. The true critic isn't involved in

the film industry's processes. That the filmmaker himself is sometimes forced to share a strategy for selling his film with the producer and the distributor is a necessity he must accept. The true critic doesn't need to be part of this strategy. He can be the outside perspective that audiences and we filmmakers absolutely need. The critic who becomes involved in this strategy is himself industrialized and has nothing to say about cinema anymore, either to audiences or to filmmakers. It's painful to see that filmmakers supported by industrialized criticism want true critics gone.

January 20, 2000

Find the word that says the silence of other words. Find the shot that frames the invisibility of other shots.

January 26, 2000

Rosetta (and *La Promesse* as well) is a backward-traveling shot to come out of the material that encloses, stifles, absorbs all attempts at framing. Rosetta or the birth of a frame. A frame or the birth of Rosetta.

January 28, 2000

The actor doesn't have "interiority" that he might want to express. In front of the camera, he's there, he carries himself. When he tries to pull something out of himself, he's worse. The pitiless camera records his will, his acting to pull out this something. He has to cut himself off from all will and return to the involuntariness, the automatism of a machine, of the camera. What Bresson noted about automatism in quoting Montaigne is absolutely true. Our directions to actors are physical and most of the time negative to stop them every time we feel them coming out of the behavior they have for the camera. Recording this behavior that they have, the camera could record the appearance of gazes and bodies more interior than any interiority expressed by actors acting. For the camera, actors are revealers, not constructors. Which requires a great deal of work.

They talk to us about Rosetta. They see her strictly as a brave woman who fights, who does not give up, who touches them with her stubbornness. They don't see how Rosetta's fate is like Galy Gay's in Bertolt Brecht's *Man Equals Man*.

February 3, 2000

We're in Tokyo for the interviews before the release of *Rosetta*. Last night I was thinking again about what we told a young actor in *Falsch* who was full

of naïve trust in the methods his professors had taught him. He was playing a character who was gassed to death in Auschwitz. He said: "I wonder if there's something in me that could give a voice to his suffering, allow me to perform it." We replied: "There's nothing." He said: "It's impossible to play it otherwise!" We replied: "Yes, it is indeed impossible."

February 7, 2000

Tokyo, 8:40. Last few minutes in my hotel room. I think we shouldn't make the film about the murder and the possible/impossible forgiveness. Focus on a man and a woman, a family, a group again. A more colorful movement than that of *Rosetta*. I've slept badly all these nights and have been assailed relentlessly by doubts. Jean-Pierre has, too.

February 8, 2000

Discussion with Jean-Pierre about the new screenplay. A love story. The story of a man who saves his wife who has lost the respect of others and the respect she had for herself. She would have been dismissed with her coworkers' approval. Again the work, the factory, the solidarity. Isn't this a way of starting *Rosetta* again? Must not remake *A Woman Under the Influence* either. The man (Olivier Gourmet) would be a cook at a school; she would come sit in the kitchen, stolid, would tell him the bad news. He'd be busy with the food to cook, wouldn't be able to give her the attention she needs, would be apologetic. She would understand. He'd tell her that he'll find her as soon as he can at home. She'd go. He wouldn't find her at home. Story of a disappearance? People who disappear themselves, who internalize the social euthanasia that distills the subconscious of our system of widespread individual competition.

Jean-Pierre recalls Bonnard's words: "It is not a question of painting life, but of making the painting live."

February 11, 2000

We stop writing *L'Épreuve* [The Test]. It's missing something. Too psychological. The situation is too good for fiction and isn't a document of our era.

February 15, 2000

Cinema is overly in the image of what exists, overly and strictly visual, as Serge Daney wrote. Resemblance to and caricature of a being wholly obsessed by himself, with himself, no longer containing any cavity, any cache for desire, the dream of another, better life. Could the images of our films create a rift, a hole, in what is? Could they make the spiritual acoustics of a look, a

gesture, a voice heard? Films with a vision that would be hearing a music that brings the man back to himself.

In collecting the materials for our film *Ernst Bloch ou Enquête sur le corps de Prométhée* [Ernst Bloch, or Enquiry into the Body of Prometheus], I took note of this passage from *The Spirit of Utopia* (written in the wake of World War I): "Only sound, this sensory riddle, is not so laden by the world, is sufficiently phenomenal for the end, that . . . it can return as a final material moment in the fulfillment of mystical self-perception, laid immaculately on the gold ground of receptive human latency."

February 18, 2000

Saw, in a magazine, an ad for 4×4s: "Built to cross the most hostile environments. Like the Champs-Élysées."

February 24, 2000

Meeting all day in Liège with Jean-Pierre. We come back to the story of the father and the young murderer of his son who himself becomes the "son" of a "father" tempted to kill him. A title that comes to mind: *Le Fils* [*The Son*]. How can the young assassin reach awareness of the evil he committed and how can the father not succumb to the wish to do evil? What is killing? What can bring us out of this fatality? Two nearly-absolute solitudes. Confrontation of two bodies. Olivier's trade would be carpentry, a job in measuring. Measuring lengths, widths, thicknesses, angles, and measuring the distance between himself and his son's murderer.

March 24, 2000

I went out to buy cigarettes. A man walks toward me and asks for a cigarette. I answer that I'm headed specifically to buy some, if he can wait two minutes. I come back with my packet of cigarettes, offer him one. He asks me if I know the "Sanita" psychiatric institute. I reply that it's close to my place. He walks with me and, on the way, tells me: "My wife has gotten into hard drugs again, I can't take it anymore, I have to go somewhere. I've heard that this institute was a good place to go for a bit of time." He rang the bell at the institute. They opened the door. He went in and disappeared behind the door. I should have told him to come to my place, to talk a bit if he wanted to, or to have some coffee.

April 6, 2000

They ask us why we stopped making documentary films and each time we

reply evasively by saying that we sensed a limit, a resistance from the people we were filming and the way events played out. Resistance that can be partly overcome by a particular mise-en-scène and way of editing, but resistance even so and a constant temptation to manipulate. Constant dissatisfaction as well. It's not inaccurate to say that, but I think that deep down the real resistance was the impossibility of us filming murder, whether the preparation thereof or the perpetration thereof. What we want to film is this death that the documentarian loses the right to look at. We used to think it would allow us to uncover a more fundamental truth. The camera of fiction, too, could lose such a right to look when faced with the reality of death in the extermination camps. Claude Lanzmann's film *Shoah* is unique because its gaze does not show anything of what happened, not because there isn't any image, but as a matter of principle. It shows traces, places, and faces which speak. Out of their interrelations, which are established in the absence of the image, emerges a word, a poem, a truth that no fiction nor documentary could reveal. Not seen in images are the exterminations of Jewish men, women, and children. Beyond the image. In the spoken word. To listen beyond all image. The word. Their sanctuary.

April 11, 2000

With *La Promesse* and *Rosetta* already, with this new screenplay as well, we're in the circle, the bullring of the question: what does it mean to be human today? Look at how to be human, not in general, but in concrete, extreme situations that society creates today.

April 13, 2000

The hand, the hands will be the film's characters, its matter.

"Lay not thine hand upon the lad, neither do thou any thing unto him."

<div align="right">Genesis 22:12</div>

April 14, 2000

The possibilities for the hands are countless, unforeseeable, contradictory. Paws that scratch and tear. Wings that graze and caress. Nothing is ever said ahead of time. Warm and wide in grasping. Cold and clenched in hitting. Give, take, open, close, protect, strangle, let go, hold, push, keep, catch, throw, show, hide, tie, untie, pray, hit. The hands' eternal and unnerving suspense.

In contrast to the hands' inextricable duplicity, the male member has a disarming candor.

April 16, 2000

The network of senses that the film pulls together consists of numerous elements (frames, games, colors, clothes, accessories, words, scenery, sounds . . .) which act through contamination and which shouldn't reify themselves in symbols. They're like fish in the water and the view we have of them is disrupted, fluid. If they emerge from the water, the better to show themselves, they'll die.

April 27, 2000

"In this way, man finds himself the heir of the mission of the dead God: to draw Being from its perpetual collapse into the absolute indistinctness of night. An infinite mission. When Pascal writes: the eternal silence of these infinite spaces terrifies me, he speaks as an unbeliever, not as a believer. For if God exists, there is no silence, there is harmony of the spheres. But if God does not exist, then, yes, this silence is terrifying, for it is neither the nothingness of being nor Being illuminated by a look. It is the appeal of Being to man; and already Pascal takes himself to be a passion caught up *alone* into these spaces in order to integrate them into the world."

Jean-Paul Sartre, *Notebooks for an Ethics*

Endless mission for the filmmaker: to make the world exist, to make the man exist in seeing him, in making him see. His solitude is greater than in Pascal's time, his fear as well because the silence of endless spaces is now in men's gazes.

May 5, 2000

The words our lips pronounce, the images our eyes see, tell and see what we aren't saying or seeing. Words and images that come from far off and go farther off. Of course, said the psychoanalyst, but what do you mean by "go farther off"? He may be an old friend, but here I don't want to answer him because I know that for him what goes far off won't ever cross the boundary established by what came from far off. I'd like to tell him that, maybe, there's a way of going far off that's like experiencing mad love that drives away death, all fears. A love that doesn't fight them, that would mean still having a relationship with them. No, it simply exists, there's nothing but it, it reigns, it has driven them away, they can't reach it anymore. I'd like to tell him that particular films have transported me to this far-off kingdom. But what use would it be, he'd end up urging me to look back anyway.

May 17, 2000

Rogier Van der Weyden painted *Saint Luke Drawing the Virgin*. The birth, the time of beginning (the Child in the Virgin's arms). The time that goes by, flowing toward the time of ending (the two walkers on the bridge, from behind, looking at the river flowing toward the horizon). The art in Saint Luke drawing, like the art of the painter, who would like to stop time, to draw out the moment of life.

June 14, 2000

Our desire for a movement, a line, is more fundamental than any image we might imagine. Rhythm, breath, "music" precede images. Starting from images we imagine makes it difficult for us to maintain our desire. There's a rhythm, an intensity, a tension that seeks its images and frames the shot. We come to the set and work with the actors to find this tension, without a shot list, without the camera. Of course, searching for the frame with the viewfinder, then with the camera, is part of constructing this rhythm, this tension, but I think our search for the frame is also a search to find the tension, the rhythm which was foremost and still unclear. Jean-Pierre is very good at creating a tension on set that, in its contagiousness, helps us in this search.

July 17, 2000

Leaving tomorrow for fifteen days in Extremadura with my family. I'm letting the screenplay sleep. I hope I'll be able to sleep, too, without thinking about it too much. May it secretly think of me and dream up a good surprise for my return.

Two questions in this screenplay: What happened? What's to come?

How can we make these two questions meet? How to make them play out together without playing the part of a traffic-controller filmmaker who follows his expertise in merging, combining them? How to stay innocent of what happens? Or even how to avoid all the mannerisms, all the plot contrivances, all the screenplay's subtle cuts? Or even: how to stay asleep? Find the sleeper's position that senses his dream and lets it come out and imperceptibly alters its course with a slight, involuntary, benign shift in his body's position.

September 6, 2000

I saw Mizoguchi's *Portrait of Madame Yuki*. When, near the end of the film, Madame Yuki, all alone, in a wide shot of pure emotion, goes up to the café near the lake where she'll commit suicide, she sits at a white table with two white chairs around it. Two! That's the sheer tragedy of Madame Yuki. Unable to live with someone else, either with her husband or her impossible lover or the child

she carries in her stomach. This is what her servant Hamako chides her about, for not having tried to live with someone else. But maybe something within Madame Yuki already knew that this attempt to go on living in the world was in vain. Impossible for her, the aristocrat of a bygone era, to bind herself to someone else, to create anew. Maybe this is a part of Madame Yuki's secret.

September 10, 2000

The screenplay progresses slowly. I'm afraid of hiding too much, of constructing too much off-screen. After *The Son*, we may need to take a breath because it's so grueling to press onward into such a labyrinth of emotions. I hope that the film will be understood and that we won't be sidelined in a wrongheaded argument about forgiveness, etc. What we want to film (the what and the how are inseparable) is the origin of a seemingly impossible genealogical connection.

September 11, 2000

After *The Son*, maybe a film that would be a fairy tale, a film for children, without clearly designating by such a term a specific age group.

Many scenes (because of the carpentry, the apprenticeship dynamic) where a character stands in the other's place. Taking the other's place? Is that possible? Does our imagination have that moral strength? Those are the stakes of the relationship between Olivier and René.

September 20, 2000

I just cut all the scenes that put Olivier and his father in relation. Too screen-writerly. I figured it out while talking to Jean-Pierre on the phone. Each time I write scenes with the main character's father, it's ultimately to figure out that they're too much, that they should be taken out. That was already the case for the scenes with Rosetta's father. As if I had to go through that for him to disappear. Go through that for him to become the ghost of our films?

October 5, 2000

The words that Olivier and Francis exchange are infrequent, almost impossible. They emerge with difficulty, almost suffocated. They utter the silence that connects them, the thickness, the density, the immensity of the night in which they find themselves. Lost, waylaid, in shock, unable to understand what happened to them, they speak one last time to try to find themselves, to find the human beings they could be, will be, can't remember being but which their words still believe in.

October 10, 2000

I finish the final scene of the screenplay for *The Son*. Is it good? I don't know. I may be too emotional, as my grade-school teachers used to say. Fortunately there are two of us.

"Evil is not a mystical principle that can be effaced by a ritual, it is an offense perpetrated on man by man. No one, not even God, can substitute himself for the victim. The world in which pardon is all-powerful becomes inhuman. "

Emmanuel Levinas, *Difficult Freedom*

Forgiveness should not be total between Olivier and Francis. It isn't forgiveness but the impossibility of murder. At the same time, how not to see forgiveness there? We don't know how the end of the film will go, but we shouldn't fall into a reconciliation where there is nothing unforgivable left. Olivier cannot replace his son completely. The film's question is that of fatherhood and not forgiveness. Olivier, in not killing Francis, who might make it possible for Francis to reacquaint himself with life.

October 20, 2000

I saw Arnaud Desplechin's *My Sex Life . . . or How I Got into an Argument*. A masterpiece. The cinematic material is there, like the truth, without any deviousness. Esther's loneliness is the most beautiful movement.

November 3, 2000

I'm working again on the second version of the screenplay. Jean-Pierre's comments on the first version: more long movements, get to the Olivier/Francis meeting more quickly, less forthrightness for the confessions, more life for Olivier because the situation remains overwhelming. Be careful about eliding Francis's face. Maybe it should be seen earlier on?

I listen to Beethoven's sonatas. They help me to write, to live. If our films ever do likewise, we'll have succeeded.

November 7, 2000

In beginning *The Son*, I thought that maybe a sort of reconciliation through forgiving would have been possible but the further I get in writing, in living with and within Olivier's character, I felt the impossibility of this forgiving. Still, there's something to be found.

December 10, 2000

Murder at Disneyland is the title of our reality. Under the turbulent waters of general distraction are the calm, dark waters of tedium, secreting murder.

December 15, 2000

The spirit of our era tries to liquidate this feeling of guilt. What does it do to carry out this liquidation? It searches the guilty for the existence of this feeling of guilt. The smells of sacrifice return. In total innocence.

December 22, 2000

The film's movement and Olivier's movement: go/come back/go. Enigmatic hesitation. Labyrinth. Even more enigmatic if his gaze is elided.

The film has to be the imminence of murder and, at the same time, the impediment thereof.

January 8, 2001

Why characters like Roger, Igor, Riquet, Rosetta, Olivier, Francis? Is it because they resist interpretation, assimilation? Because they're tough, unforeseeable, unfathomable kernels that embody the inconceivable violence of disaffected people in our era? They're in withdrawal, waiting for another.

January 10, 2001

The plot is the character: opaque, enigmatic. Maybe not the character but the actor himself: Olivier Gourmet, his body, his neck, his face, his eyes lost behind the glass of his spectacles. We cannot imagine the same film with another body, another actor. That's the third thing for my brother and me, what we share in order to want the same film.

January 14, 2001

Jorge Luis Borges would have written: "I don't invent fictions, I invent facts."

I read Shalamov. His criticism of fiction's methods bears some relationship with what we're trying to do.

January 19, 2001

It's said more and more often that animals on the brink of extinction must be saved and everyone, from families to expert scientists, along with political

leaders, expresses their enthusiasm for such a project, better: such a mission. Indeed, how could anyone not sympathize with an approach aimed at protecting life, saving ecological heritage, stopping the process of "minority" species unadapted to or overexploited by this immense predator known as the human race from extinction, to prepare for the discovery of future remedies that could protect species on the brink of extinction against tomorrow's diseases? All is well and good. Except perhaps for the setup, which seems slow, dumb, malign from the point of view of the humans whose devastating effects we don't suspect yet. Religion, more clear-eyed in this case than scientific rationality, teaches us that evil proceeds in disguise, but we don't like to acknowledge that, even if we always have to bear the costs and always react too late. What will our response be to those who will ask us tomorrow about figuring out whether, confronted with the intermixture of all human populations, we should save unmixed individuals, "pure individuals" on the brink of extinction? We can hope that such a question won't be met with the same spark of sympathy that, today, lingers over saving animals on the brink of extinction, but such evil will enter our culture because the question could have been asked. We're seeing committees of all sorts arguing about necessity or lack thereof, of legitimacy or lack thereof, of keeping alive or freezing such or such a human specimen (what a fitting word!). A panoply of arguments, including those tied to preserving the diversity of the human species, will be mustered against a panoply of moral arguments, including those considering the instrumentality of human beings, and the debate will end in favor of the former which will have convincingly proved, in the name of the unshakable divinity that life has become, that there is a strong likelihood that these human specimens, these "pure types," harboring still-unknown components that will allow us "mixed types" to prolong, protect, immunize our life against specific still-unknown illnesses. So we'll be in a state of extreme perversion but we won't figure it out right away.

January 26, 2001

The lines in the first scene of the screenplay (*The Son*) demonstrate the stakes of the film. "Want to see him?" asks Catherine. "I can't . . . I have four already . . ." Olivier replies. It doesn't have to be clear that Francis would be unwanted not just in terms of too many apprentices but also in terms of the excess he creates within his gaze. Olivier can't see him.

February 13, 2001

The piles of logs and plans in the sawmill scene increase the feeling of Olivier's strength. Possibility of murder increased. Authorization to kill is granted.

February 15, 2001

The next film. The story of a young woman who plays with light, who burns herself, who wants to melt herself. She's a pyromaniac. She lights fires, looks at them, describes them on the phone. Stripper? Supermodel? A more arcane career? One job by day and another by night? Being seen, being exposed to death is her ne plus ultra.

February 16, 2001

Musée du cinéma with Baptiste. We saw Fritz Lang's *You Only Live Once*.

It's constructed (screenplay, setting, editing, the main character Eddie) so that the viewer loses all belief (except in the cinematographic image) and operates solely on his or her own projections. This loss of credibility centers so wholly on the character of Eddie that at a certain point the viewer can no longer trust him (thereby falling into the trap created by the filmmaker) and drives him to commit the murder that he hadn't committed, and that he commits in not being believed. At the end of the film, the viewer who has believed in the character's guilt—in opposition to Jo, who loves him—has ended up on the roadside, with the horde of "policemen" opening fire on those who, throughout and despite everything, have believed in innocence and love. That's their victory. This belongs to them. To them alone. That's our defeat, the viewer's defeat.

February 19, 2001

I saw *Les Dames du bois de Boulogne*. Everything seemed enslaved to Cocteau's text, starting with the voices. Suffocating. Impossible to find there what just the physics of Bresson's shots had already allowed me to experience. The final shot of *A Man Escaped* immediately left me wholly feeling outside, free, having escaped.

February 20, 2001

This insight from Dostoyevsky: "Strangely enough, all the executioners I've happened to see were developed men, with sense, with intelligence, and with an extraordinary vanity, even pride."

March 3, 2001

Construct, construct, construct the surprise that cannot be constructed.

March 4, 2001

True story to contemplate. A woman, eighty years old, dies surrounded by her three daughters. With a final burst of energy, near unconsciousness, she says the names of two of her daughters leaning close, holding her hand . . . She dies. She didn't say the name of the third one who feels denied, abandoned. She, the faithful, loving daughter, who had always helped her mother during her time as a widow, in her old age and throughout her long illness, why didn't her mother name her? How to accept this injustice? Maybe she should concede that she had something to do with this distancing from her two sisters. Whether or not she had anything to do with that, maybe she should understand what mattered most for her mother in that last moment was to reconcile with her other two daughters, her prodigal children?

March 5, 2001

We're reworking the third part of the screenplay. We're introducing something to do, something physical, something the two of them have to do together. Not just going into the sawmill to see the varieties of wood. Jean-Pierre suggests that they carry some planks, some beams that one man wouldn't be able to carry alone. That would make it possible to distill the father/son relationship through the actions of work. Knowledge transmitted through learning the actions of carpentry. Not to fear filming these actions, recording them, seeing them, and, in seeing them, seeing the genesis of an invisible bond, a paternity, a filiation. For us filming, the image is not the incarnation of the invisible nor a disincarnation of the visible; it is visible and by dint of being visible gives speech to the invisible.

March 11, 2001

We have finished the eighth version of the screenplay for *The Son*. Already other construction possibilities are coming up, especially for the end. We'll try them while shooting. We set the screenplay aside. It's good for reading. It's time to go immerse ourselves in the locations, the scenery.

I read Dostoyevsky's *The Double*.

March 19, 2001

Jean-Pierre advised me to read Laurent Mauvignier's two novels. In *Far from Them*, after the accident Céline survived, but in which her husband died: "And as for me it wasn't that I wasn't touched by what was happening, but I thought of Céline, where she was, what she was doing, and I wasn't just thinking about her, it was also because I was wondering, when it happens and you're the one

who gets away with a bump, what do you think about, where do you put your hands, what do you do afterwards?"

"Where do you put your hands?" What a surprising, perfect question.

March 27, 2001

In *The Son*, we have to find a slowness that isn't there in the previous two films. Another silence. The silence of a waiting. A silence that's deeper, obscurer, farther-away than those that the character and the viewer experience, a waiting that slowly develops through all the other waiting, all the other suspense, a waiting that awaits nothing and which will have its target appear by surprise, in addition, and will seize the character and the viewer who won't manage not to feel deep within themselves: so that's it, that was it, yes, that was it! Don't kill it! You didn't kill it! You shall not kill!

The impression, for Jean-Pierre and me, that with this film we're reaching the end of something, that we're completing a cycle.

March 28, 2001

The film is the character, is the actor, is Olivier Gourmet, is the heartbeat of the enigma that is what appears to be the face, the gaze, the body of Olivier Gourmet.

April 2, 2001

Two bodies separated by something we don't know about. Two bodies brought together by something we don't know about. Actions, words, looks that never stop measuring the distance separating them at the same time as the power of the secret bringing them together. That's what we should try to measure with our camera.

April 11, 2001

Olivier's body in eternal imbalance. The Minima camera may be able to help us film this state of suspension. This little camera will also allow us to film, in a single shot, the car scene where Francis moves from the front seat to the backseat.

May 1, 2001

The wall corners, the steps, the corners, the hallways. Break the straight lines. Walk forward/walk backward. Hesitant movements. Labyrinth. To be in Olivier's head.

May 21, 2001

Olivier's pride. "Who do you think you are?" he asks Magali. In his prideful arrogance, he believes himself able to forgive, to reconcile with his son's murderer. He believes he's above humans. He thinks he's God.

June 27, 2001

Olivier's arrogance but also the desperate man's mad hope. He doesn't know where or why he's going, much less what for, but he goes there. It never becomes clear. Maybe something's waiting for me, something I can't imagine here and now but which will be there where I'm going. Maybe something that could make it so that what happened had never happened, maybe something that could bring my son back.

June 28, 2001

We've just settled on the actors who will play the roles of Francis and Magali. Casting took a very long time. Isabella Soupart, the actress who will play Magali, is very sharp, resonant. Morgan Marinne, the boy who will play Francis, is opaque, troubled/troubling, like Olivier. Between Francis and Olivier, there's a shared, unknown, invisible past that's there in the two bodies, in the troubling opacity that the one's body and the other's body manifest. Something didn't happen, stays powerless to find its place in their bodies, doesn't leave them in place, doesn't allow them to find their place. It's this something that connects the two bodies and on which the viewer will project a paternity, a filiation.

June 29, 2001

We think about the film we'll make after *The Son*. A film whose character will be a group. We were already thinking about that after *Rosetta*.

July 18, 2001

I saw Nanni Moretti's *The Son's Room*. The final trip is beautiful in its simplicity, simple in its beauty. An invisible water flows through the shots, it slowly waters everything. A fragile, very fragile life comes back. Return of life. Return to life. Feeling alive again among others is one of the most difficult transitions to film and he succeeded. *Grazie*.

September 8, 2001

We're getting close to the shoot. Lots of hesitation with each decision. Jean-Pierre, like me. The film will be hard to make. Neutrality is the state to achieve.

September 18, 2001

On September eleventh, we were in our office on the boulevard Émile-de-Laveleye when our assistant, who had just heard on his car radio, told us that an airplane had hit one of the two World Trade Center towers in New York. Half an hour later, he called us to tell us that another plane had hit the second tower. Over the course of the day we learned that it really was an attack planned out by Islamists. That evening, as we came out of our office, we ran into a university professor who didn't seem unhappy about this Islamist attack. "It's a bit David and Goliath," he said. Two days later, I got a letter from him asking me to forgive his blithe remarks considering the gravity of the attacks, which he hadn't fully realized during our talk. This morning, in a paper, a writer tells us that, despite the horrors of the situation suffered by thousands of people, she had to suggest that the image of the towers into which the planes had plunged and exploded was beautiful. Where ever did the professor's utterly spontaneous words sympathizing with the Islamist terrorists as well as this writer's utterly cynical interpretation erasing the suffering of those in the towers so as to enjoy the image and its spectacle come from? What's going through Europe's mind that this professor could take this kind of pleasure before feeling guilty, for this writer to be able to take pleasure in suggesting that this work of barbarity is also a work of art?

October 29, 2001

We film Olivier from behind. Often. Maybe too often? I don't know why exactly but Jean-Pierre and I feel that this is how he should be filmed. It wasn't planned. It resulted from shooting the film's first shot, which also happened to be the first shot we filmed (and which we just reshot to give the film's beginning a slower pace and to make it possible to run the credits on the back of Olivier, who isn't recognizable at first). What we're hoping for in using these shots of his back, of the nape of his neck, these back-and-forths between Olivier's back and his neck's nape, in constructing the shots is to set the viewer in front of the mystery, the impossibility of knowing, of seeing. The face, the eyes shouldn't try to express the situation which would be enough to prompt the viewer's self-projection. This expression would end up doing too much, limiting or even preventing this projection, whereas the back, the nape of the neck allow him or her to sink in, the way a car sinks into the night. Another thing we also felt with the first shot: the threat, the one Olivier poses for whoever ends up within his view and, inversely, the threat to Olivier himself as his back, the nape of his neck, are offered up to anyone who approaches from behind.

November 23, 2001

Fifty-third day of shooting. Physical exhaustion for everyone. There's something impossible in what Olivier does. Magali clearly has reason to say: "Why do you do that, then?" and he clearly has reason to reply: "I don't know." We don't know either.

The team and the actors are close with us. If not for that, we'd never manage. Olivier is a truly great actor. He's communicated the restraint and the intensity of his acting to Francis. We sometimes feel like the story is very closed-off. The next film will be more open.

December 7, 2001

We wanted to call the film *L'Épreuve* [The Test] in thinking of Abraham being put to the test. The end of the film we've shot brings us back to this. Maybe it's this test that's guided the entire film, from the start, from its writing. Abraham does not kill Isaac. Olivier does not kill Francis. Olivier becomes the "father," Francis becomes the "son," and the rope can be used to bind the planks, just as Abraham used it to bind the ram.

December 8, 2001

Have to leave our life to give life to the film, to the characters. On set we can't bear a crew member or an actor alluding to his or her personal life. It's like a deprivation of intensity, an irrevocable loss for the film. I remember Alain Marcoen, our director of photography, while shooting *Rosetta*, telling someone on the crew complaining about the cold: "How do you expect us to bring these fictional characters alive when you're reminding us the whole time about our own life?"

December 11, 2001

While shooting the scene in the café where Olivier and Francis eat their apple turnover, I realized that the frame wouldn't be able to include the woman serving them drinks. I thought back to the parking-lot scene with Magali, who's managed to get herself out of Olivier's life as well as out of the film. Odd "necessity" that this woman be excluded for the story to progress. Is it because of the murder and its vengeance that the story demands it? Because of the forgiveness? Why is the story unimaginable for us unless it's between a father who has lost his son and finds another "son" and not between a mother who has lost her son and meets another "son"? And why not a mother and a daughter?

December 14, 2001

We just saw the rough cut of *The Son*. Olivier and Francis are alone. We hadn't imagined just how alone they were, cloistered in their past.

We realized that Olivier has been filmed from behind far more than we'd imagined while shooting. Clearly that's also due to nearly all the shots being present in the rough cut. Something actually happens with his back. Film the back. The human enigma that resides in the darkness of the back. The huge elision.

December 16, 2001

In filming Rosetta we also thought about filming her back, being behind her to give the viewer the impression of being behind a soldier in war. No doubt also as to not film the too-seen, too-framed, too-coded, too-sold, too-"publicized" face. Against the images which no longer manage (no matter how great the actor or actress's acting) to shatter the image the viewer has already seen and known, the image of the smiling face, the scared face, the absorbed face, etc. The singularity of each face no longer manages to overcome stereotypes. It's terrible.

For Olivier's back, it seems that there's also the possibility of seeing it as a face, as if this back, this nape of the neck were speaking. Several times during the shooting, I had this impression and even now during editing, especially the changing-room scene when Olivier closes his locker door and Francis (off-screen) whistles in the bathroom then comes out and walks in front of Olivier's back.

December 17, 2001

One similarity between Olivier and Rosetta: the secret. As we filmed Rosetta looking through the gap in the door of the waffle stand, we tried to position the camera's eye in such a way that it couldn't see everything that Rosetta could, despite staying very close to Rosetta's point of view, almost seeing what she sees. For the viewer, the gap between almost seeing what Rosetta sees and actually seeing what Rosetta sees establishes the tension of the secret. As this gap shrinks, despite never quite closing, the force of the secret connecting them grows greater and greater. When Olivier, standing on his tiptoes, looks through the window of the director's offices, he sees Francis, his hand signing a document, his arm, his stomach, his face. The camera's eye, unable to be exactly where Olivier's eyes are due to part of the window frame or the mass of Olivier's head standing in the way, can see part of Francis's body but not his face. As the camera's eye takes in Francis's hand signing the document, the tension of the secret that the spectator feels increases, because clearly seeing

what Olivier does without being able to see the face that he does increases the desire to see this face. Finding the "wrong place" for the camera, making sure that even as we attempt to situate it properly, where the character's gaze is, we fail to do so because of the character's position, or an obstacle, or a delay: this is our way of creating the secret for the viewer all while bestowing the secret, and consequently an existence, upon our characters. Kieślowski initiated us, through *The Decalogue*, into this gaze.

December 29, 2001

The moral imagination or the ability to put oneself in another's place. That's a bit of what the film asks of the viewer. And this "other" surprises. And the surprised viewer realizes that the other brought him here and he's ashamed not to have imagined that the other could bring him that far, could raise him up this much. And he thanks him.

For the next film: the story of the boy who discovers the murder his father committed and becomes the witness to get rid of. Jean-Pierre thinks we should dispense with murders. I think so, too, but something in me disagrees.

December 30, 2001

We go back over Olivier's shots in the workshop, in the car. Sometimes I feel his son's breath on the nape of his neck.

January 8, 2002

I saw Fritz Lang's *Rancho Notorious*. Mythical. Connects seemingly casually, effortlessly with the farthest representatives of humanity. The film starts with the shot all the others of its ilk end on: the kiss of the future couple destined to have children. And so it starts backwards, as if time could run in the other direction, as if Chronos could eat his children again. The tragic battle against this inversion, this terribly human butchery, is the old and still young Marlene's work. In sacrificing herself to save her old lover, she spares the young one, she saves him, she gives life back to life.

February 17, 2002

Daniel Pearl was executed by Islamists. Before cutting his throat, they made him say he was Jewish and the son of Jews. This anti-Semitic murder was filmed. To prove what? The sacrifice of Isaac performed at last? The revenge of Ishmael's humiliation? A snuff film against the book of the genesis of humanity. They cannot win.

February 18, 2002

Problem with the night scene (Olivier's happenstance meeting with Francis). I have the impression that it's deadening the whole film. Surely I'm wrong. Jean-Pierre sometimes has the same feeling. We feel at the same time that this scene is intense, odd if considered in isolation. Maybe we should accept that we haven't made a mechanistic, compact film.

February 26, 2002

Does our film have a concern? Is it successful? We have no idea anymore. Isn't the situation just too big?

March 14, 2002

Finally the film has taken shape. We hope that Denis Freyd will like it. His comments on the first cut show that he's a great producer we can develop a real bond with. We've met our third gaze.

March 22, 2002

He has disappeared into a distant country. He's hiding. Those looking for him end up finding him anyway and they kill him. This is the eyewitness's short report.

April 4, 2002

The film is called *The Son*. It could have been called *Le Père* [The Father].

April 7, 2002

I talked to Gérard Preszow again about the film on the Jews' deportation from Belgium. I don't think he'll do it.

May 14, 2002

What I thought in coming back from the latest screening of the film: there's something legitimate in revenge and also something illegitimate in the pleasure of this legitimacy.

May 29, 2002

Back from Cannes. Happy for Olivier, for our film. We feel like something's ended with these three films. We have to keep going, and, in that same movement, change. Several characters? A group?

June 2, 2002

The camera is near then not so near, as if focusing without managing to get it right, as if trying to find the vibrational node of Olivier's body. The distance changes, modulates to be prepared for this moment when, as Jean-Pierre said to a reviewer, the body becomes a membrane. It's not the skin and its texture that interest us but the invisible body emerging from within the visible body.

July 2, 2002

We start working on the new film. Nothing comes out. I feel dry, sterile, too nervous, hemmed in, taking up all the space. Nothing can get in.

July 3, 2002

This image comes back of the young woman pushing a stroller with a sleeping baby. She was going down the rue du Molinay, dressed shabbily, looking straight ahead, not greeting anyone, steering brusquely, as if there weren't a baby in the stroller. Where did she come from? Where was she going? . . . I saw her later, at nightfall, going back up the street, with the same determined gait, the same wild gaze, the baby still unmoving and quiet in its sleep. It also seemed like she was fleeing, that she was fleeing, that she was fleeing the baby she was pushing.

August 11, 2002

I'm doing part-time immersion in English. Next week will be total immersion. Each morning I have the same trepidation as I do when I have to go to the pool. I don't want to get into the water. Something in my stomach tugs at me, keeps me from breathing normally, automatically, without thinking about it. I wonder if I'll get into it. I did get into swimming. I watch and watch *The Searchers*.

August 12, 2002

" . . . But when these calamities happen among friends, when for instance brother kills brother, or son father, or mother son, or son mother—either kills or intends to kill, or does something of the kind, that is what we must look for."

<div align="right">Aristotle, Poetics</div>

Why is it precisely these cases we have to research? Because it is within families, between father, mother, son, daughter, brother, sister that love and hate are the strongest. Between them arise the first strong desire to kill themselves, the first strong desires to kill one another, the first terrible and

fatal rivalries. Between them arise the first taboos, where the denials of these desires and these rivalries play out. In the beginning there was the family. We must return to them each time we attempt to create a story.

September 9, 2002

Back from Switzerland, where *The Son* had its first screenings for a non-festival audience. The reactions bore witness to the film's ability to make them live an intense experience. Some people were irritated by the camera's movements. They told us: "Look at Oliveira or Kiarostami, they're intense and they don't need these movements. Why are you including these movements?" What should we have told them? Of course they're right. It isn't necessary to do these camera movements to achieve an intensity. Static or close-up or wide shots can do so as well. We replied: "That's how it is, that's our way of seeing, of filming, of directing. There's no explanation to give, especially not from us." I do think there's no explanation to give. Yet their question still troubles me . . . Impossible to answer why. Maybe possible to explain the intention, what it is we're looking to translate through and in these movements . . . A shot is above all a flow of energy over and through bodies and objects, not to set them in place, not to compose a scene, but to surround them, to put them in an identical state of tension, of vibration, so that the whole film would be a body vibrating and so that the viewer's eye, so that the viewer as a whole, would tremble with this vibration. Energy, flow, vibration, continuous movement that's taut, sometimes rushed, close, sometimes almost against bodies and objects, to cause a tailspin, a loss of spatial coordinates, to catch the viewer in the eddy of a movement that sticks him, presses him against filmed bodies, objects, a movement too fast, too total for him to have any time to get some distance. Something physical that could be conveyed, an experience, a feeling, a dance, a fever. The camera is like a blowtorch. Heat bodies and things. Be very close to reach a state of incandescence, an intensity that burns, sets outside oneself, in a state of reaching what would be the pure human vibration. Sex isn't filmed by our camera. Our camera is sexual. It films, plugged into bodily impulses, communicating it to things, seeking in its movements what will appease its state of excitement, of extreme tension. A sort of trance. A moral trance. If by moral we aim at what the ancestral and current and inextricable battle between our impulses and the law repeats. Battle during which the immured, burned, aroused being escapes through another, passes into another state.

September 15, 2002

Back from Montreal and Toronto. Montreal seemed different from my first visit. I liked its colorful side, its raw connections. Lots of homeless people on the streets.

November 5, 2002

Still no starting point for the film. Doubtless several bodies. One or two women? Film a woman? Is that possible for us? The two of us? On set, we'll call Rosetta Rosetto.

November 6, 2002

In Abraham's silence, there's the hope that the murder won't happen, that God will provide. In Olivier's silence, there's the increase in desire to murder.

November 16, 2002

I think of the nape of Olivier's neck again in looking at a photograph by Dorothea Lange showing a woman, already of a certain age, sitting on a bench, the back of which takes up almost a third of the image. The two thirds above it are taken up in the foreground by the nape of the woman's neck, the scarf poking out of her coat collar, her head turned slightly to the right revealing her ear, the profile of her wrinkled face, without showing her eye but the edge of her eye socket toward which, like lines of perspective, the wrinkles of her crow's feet converge. Atop her hair she wears a nearly invisible net. In the background a street where cars go past fluidly. The woman isn't looking at them, her gaze seems to be turned toward something lower, something closer, which leads my gaze back to the bench's dark-white back, the coat collar, the end of her scarf, the wrinkled nape of her neck . . . The nape that exists apart from the world, the body, at a remove from all activity, stripped of all possibility of taking, participating, seeing, the nape, the body's innocence, so secret, so vulnerable as she's seen by the other, necessarily the other, the nape of her neck isn't seen, the nape, pure passive flesh in which all the suffering of a life is written.

November 17, 2002

To invent in art, it's sometimes interesting to try to do the opposite of what the majority is doing. As when we construct a scene and when it doesn't satisfy us, we try to redo it, but the other way. The heuristic virtues of the other way around are immense.

November 23, 2002

I'm in Hanoi to try to convey something of our experience as filmmakers to young filmmakers here. I watched our films again. Our camera's movements were necessitated by our desire to be within things, on the inside of the relationships between gazes and bodies, bodies and settings. If the camera

films a body in profile, unmoving, with a wall behind it, and this body starts walking along the wall, the camera will go, moving in front of the body, slipping between the wall and the body in a movement that will have framed the body in profile and the wall behind, then the wall and the body facing the left side of the frame, then the body (its other profile) fills the frame (the wall having disappeared on the right side), then the body's back, then the back of the body and the wall on the left side. The camera will have made a 360° movement around the body at the same time that it's walled it off. Why this desire to be within things, on the inside? Why this desire that my brother and I share completely? Why don't we distance ourselves from bodies? Why don't we see them within a landscape? Why these lonely, uprooted, nervous bodies unable to inhabit a landscape, unable to exist in a wide shot, a shot of land and sky, a nature shot? We would like that, we would really like that, but something in us resists, gives us the impression of forcing us, the feeling of lying as soon as we widen the frame too much, as if we wanted to make viewers believe in a reconciliation between humanity and life. Maybe we find there, close to things, between bodies, a presence of human reality, a fire, a heat that irradiates, that burns and isolates from the sad chill that reins in emptiness, the far too great emptiness of life. Our way of not losing hope, of still believing.

December 5, 2002

Social euthanasia. The homeless, the junkies, all who are ostracized from society can die of cold, of hunger, of an overdose . . . That's the order of things, almost a relief. Nobody dares to take joy in it, but nobody protests either. It's understood as a natural process of elimination.

December 11, 2002

"Ye are of your father the devil, and the lusts of your father ye will do. He was a murderer from the beginning, and abode not in the truth, because there is no truth in him. When he speaketh a lie, he speaketh of his own: for he is a liar, and the father of it."

<div align="right">John 8:44</div>

This text seems to talk about what's at the beginning. It seems to connect the father, the murder, the lie, and the desire to imitate the murderous/lying father in the figure of the devil. I think back to the fiction we've already contemplated (the boy who discovers the murder committed by his father). It's not just a matter of filming the connections between the lie and the murder which are numerous and constitute the motives for so many plots (the murderer lies in order not to be uncovered as the agent of murder, he lies so that

his victim won't uncover his plan to murder, a lie needing not to be uncovered leads to the murder, etc.), but of filming a murder that is a lie, a homicide that is also a murder of the spoken word. For that the murderer/liar needs to be a father. In other words, the devil is a father who cannot be a father anymore and yet goes on being one and the son has to accept it because he can no longer find in this diabolic father what would allow him to tell the truth, to escape this father, to challenge him in the name of the truth, of the law. This terrifying plot should lead the son to kill/lie like his father or, better yet, to kill his father, because that ultimately is what the diabolic father wants: to kill the father. Thus the little boy of our fiction will enact his father's murder, in this way wishing for what his devil of a father wants.

December 13, 2002

We start talking about the characters in our next film. A young (Albanian?) woman and a thin young man with little money or drugs. Jean-Pierre thought back to the story that a street worker had told us about her brother, a heroin addict who some Albanians had suggested marry a young Albanian prostitute for two hundred thousand Belgian francs (about five thousand euros) so that she could get Belgian nationality. Part of the sum was paid before the wedding and the other part (the bigger part) would be paid as soon they got divorced a few months later. In fact this divorce didn't happen and the second portion of the total was never paid out because the junkie was killed by an overdose. It's possible to imagine that the woman fell in love with the junkie and asked the Albanian mafia not to kill him. At some point they fled. Have to be careful about fetishizing the Albanian mafia. Also have to be careful of potentially melodramatic situations. Every so often we dream up a character who's a female doctor. A recurring scene is that of the outcast asking the doctor to help her take her own life. She brings her back to life. A connection with modern-day social euthanasia.

December 14, 2002

Gérard Preszow replied that he wouldn't make the film about the deportation of Jews from Belgium. I thought that after his phone call and our lunch he'd say yes. I do understand his response. Who'll do it?

December 16, 2002

Why hasn't Mike Leigh's *All or Nothing* been seen? It went by just like that, without any gaze really stopping on it, on the actors' heavy bodies, so heavy, so proper in their falls, their silent battles, their wounds, their words they never manage to say, to say to us. It's these people who are dying in our streets, our

ghettos, our outskirts. We don't see them anymore. Film, which could make us see them, doesn't want to see them anymore. A few filmmakers here and there are trying to. Our era is sick of the poor and the outcasts. Charlot is perfectly old-fashioned.

December 18, 2002

I just saw Chantal Akerman's *From the Other Side.* Long face-off with the wall. The camera stays close to the ropes, watches, observes its enemy, then starts fighting . . . It comes out the winner, with the help of a sound, a voice. The viewer will remember the gazes and voices of those that the wall forces into waiting, exile, abandonment, loneliness, fear, death. As for the illegal immigrant who made her way past the wall and disappeared, which the camera couldn't see, could never see, who remains unknown forever, the filmmaker's voice saves her from forgetfulness. Not an image. No image. A voice, the timbre of a voice for the unknown illegal immigrant. This final blow is one the wall will never recover from.

December 20, 2002

"A value debased and an illusion unmasked have the same pitiful form; they resemble each other and there is nothing easier than to mistake one for the other."

Milan Kundera, *The Joke*

Film the pitiful form of a value debased in a way that sets it apart from that of an illusion unmasked. A new life for this body, a life overcome against the tide of our era of cynical confusion. Art cannot save the world, but it can remind us that it's possible to save it.

December 30, 2002

When we gave Olivier Gourmet acting notes, we ended up telling him, jokingly, that there was nothing to act because it wasn't he who was talking but another, someone in him. Filming Olivier from behind, filming his back, his neck, is clearly the way we've found to let this someone, this unactable, unconscious movement speak to and be heard by Francis.

January 10, 2003

We talk about the next film. Hard work. Fear of repeating ourselves, of becoming systematic. A danger that is increased because there are two of us, because we work together like a system? Have to change, but that should

correspond to something felt, a form of necessity, a necessity that isn't false. Await everything while talking.

January 26, 2003

Back from German-speaking Switzerland where we met film critics and debated the film with audiences. One viewer said that the film's particularly violent tension came from the coexistence of continuous long shots and quick cuts. The more that continuity grips the viewer in its long, uninterrupted movement, the more the subsequent cut is shocking, disarming.

Instead of a character who we follow, become invested in, we're thinking of two characters, a couple. How to find what would be less easy to frame? Should we write less with our camera? Allow more to come, to appear. Record. Careful of boredom as well, the entropy that seeps into the recording of life.

January 30, 2003

A film about Jesus? I reread what Dreyer was saying about his project. Should the Passion be filmed? I think not. Take interest in the concrete person he was within his community. Film the life of Jesus, not the story of Jesus. A title: *The Life of a Man Named Jesus* or *The Life of a Jew Named Jesus*.

February 5, 2003

In a movie theater, I saw an ad showing a stoning in images. A boy whose cell phone is stolen by a (fat) man who, at the moment he steals it, gets photographed by the phone. This photo is instantly sent to the phones of people using them in the area, meaning everywhere. These people recognize the thief as he enters their field of vision, run toward him, and surround him while brandishing their phones showing the accusing image like so many hands casting stones. This ad demonstrates the principle of ads: to establish unanimity. In this exact case: through the designation of a guilty party, of a scapegoat. Resurgence from the time of myths. I'm reading *I See Satan Fall Like Lightning* by René Girard.

February 6, 2003

Nothing for the screenplay. No character. No situation. No beginning. No end. We show the story of a woman, a mediator for the electric and gas utility who, after negotiations, settlement proposals, would sign off for the meters at a poor family's house to be shut off. She would learn shortly after that the family "committed suicide." She feels guilty. She is perhaps the only one to feel guilty. Around her (coworkers, friends) nobody understands her feeling of

guilt. They comfort her in saying that she did her job, that she did everything she could to reach an agreement between these people and the utility company, that she couldn't have foreseen such a disproportionate, insane response, etc. What becomes of this woman? What does she do to "redeem" what she has done? Something reminiscent of *Europe '51*. What are the choices available to this guilty woman? Cynicism? Political activism? Activism on behalf of the "poor"? What then? What's interesting is having a character who's the only one to feel guilty.

February 21, 2003

I saw Sjöström's *The Wind*. A tale of reaching womanhood. Magnificent. The wind scares her, oppresses her, cloisters her. At the end, she says "I'm not afraid of anything now." I felt it physically. I felt her freedom, her entrance into love, into desire. A storm of the senses! Finally the sigh of her body is strongest of all, it carries her, it carries the sand brought by the wind, the pile of sand that blocked the door of her house, of her body.

February 25, 2003

We talk again about our story of a child sold by its parents. Sold then bought back? We think again about the girl with a stroller in Seraing. The title could be: *La Fille au landau* [The Girl with the Stroller].

March 30, 2003

I'm discovering Gilles Deleuze's thinking. Man is always entrapped, absolutely has to escape, to reach the vanishing point. Like a rat! He absolutely has to ferret out the traps—of the other, of negation, of transcendence—which always reappear wherever he isn't expecting it. Radical, endless battle, immanence's unending strategy to remain unto itself and itself alone, manifold, deterritorializing, horizontal. Every height hides a watchtower! Man, being free, having completed his mourning for the death of God, holds a fearlessness that commands respect. Is constantly on the lookout, always ready to brandish his ideas, there might be something especially blinkered to his battle. As if he feared an encounter that he knows is inevitable, knows would force him to stop and look up. Not to God. Simply to others. To those through whom evil and good come. The height not of power but of law. The height that hides no watchtower.

April 5, 2003

Musée du cinéma. I saw Maurice Pialat's *Naked Childhood* again. François disconsolate. Grammy and Grampy try anyway, and the very old Grammy

with her songs, her stories. The child's revenge comes from a too-deep wound. Nothing can scar it over. I wasn't loved, you can never love me, and I don't love you. A hellish cycle that love has no hope of fighting its way through. A bundle of raw, nervous, lonely flesh that rolls, rolls to do evil and only to reach what does evil.

But sometimes Grampy and Grammy allow François to attempt a childhood, they allow him to attract their attention, to worry them, without hitting him or chasing after him.

The first couple to take in François had nothing to convey to him, nothing to give him. During the workers' protest, the woman bought a jacket for her husband, who, rather than being with the others at the protest, bought a toy for his daughter. For them, François simply represented more money. Grampy tells François his story as a resistance fighter, the story of the moment when he was with the others. He has something to tell him, to convey to him, to give him, something that was the greatest moment of his life and which still feeds him today, something inestimable, priceless. Two couples, two generations of the working class between which nothing truly essential was passed down. Nothing of childhood dreams, nothing of a taste for adventure, nothing of communal life, of mutual aid, of the hopes of those who experienced the factory, the union, the strikes, the Resistance. Nothing.

Huge montage sequence with the shots of fighting then of unmoving bodies, especially those of the family around the table with the two backs in the foreground. As well as the two static shots of François alone in the bed: the sheets, the pillow, the child's head. As if the wound could only stop hurting there. As if little François, alone in his bed, could find his mother's gaze and arms at last. Some love at last. At last. Go to sleep, François. Sleep, sleep as long and as deep as you can. When you wake up, the hate will be there. It'll seize you again. You'll kill. It's inevitable.

April 10, 2003

We have a title for working on our screenplay: *La Force de l'amour* [The Power of Love]. This won't be a relationship that's intergenerational, but between two people, a young man and a young woman of the same generation. The father is still there, though, with the child he doesn't recognize, who he'll sell as if he were an object just like any other. This title doesn't establish any plot, it leaves us free to develop movements. We've already written the outline of the first half-hour. We keep thinking about *Sunrise*. This film must have a firm hold on our shared "unconscious" because we talk about it every time we start on a new film. Jean-Pierre thinks the movement of reconciliation between the boy and the girl should take a lot of space, a lot of time.

April 16, 2003

La Force de l'amour [The Power of Love]. Maybe it's a title that says too much, especially about the end of the film. Maybe we'll change it. For now, it helps us to find the movements, the wide shots and the characters' concrete actions. We've written almost the entire setup.

April 26, 2003

Sonia and Bruno, the names for the characters of *La Force de l'amour*. We're still wavering about the (newborn) child's name. Selling his child, what does that mean? That he can't see that the child talks to him like his son, the son he's the father of? That he can't become the father? We don't really know where we're going with this new film but we sense that we're in the material of our era. The idea of selling a child that Jean-Pierre proposed came out of a small news item he read in the paper a few months ago. The context is different but there's still the fact that the parents are making money off of their child.

April 27, 2003

A potential ending for the film: Sonia, Bruno, and the child (in the stroller? by Sonia?). Bruno cries . . . then Sonia . . . They cry a long while . . . Their tears, each of them, both of them . . . We think of this ending after reading Catherine Chalier's book, *Treatise on Tears: Fragility of God, Fragility of the Soul*. At the end of the book, she writes: "But when each of them discovers the water of dew at dawn, traditionally associated with awakening and rebirth, do they not rejoice? This fragile joy, this trembling before all the possibility of life, in their pure nakedness, sometimes it is human tears that make them feel all this." Bruno and Sonia's tears. Perhaps those of the viewer. The water of human tears. Bruno's resurrection.

April 28, 2003

It's a Monday. I start writing the first version of the screenplay. After two months of conversations, we have the outline of the story and the main characters. The third movement will be the longest one. I think about the film we'll make after this one, and, seeing a book by René Girard on one of my bookshelves, I think back to our conversations about the scapegoat. I don't know why, but, whenever I start writing a screenplay, I can't keep from thinking about the one for the next film. Have to believe it reassures me.

April 29, 2003

In this film, maybe there'll be a softness there hadn't been in the others.

May 26, 2003

It's not working. No strength. Heavy. Disappointed. I opened *Uncle Vanya* . . .
I read it here and there . . . Slowly life comes back, fragile, fresh, like water at
the edge of a spring discovering its first pebbles.

June 24, 2003

Musée du cinéma. I saw several Hawks films. A unique rhythm. Something
that walks, speeds up, slows down, stands still, lies down, lets through
gestures, gazes, words from situations outside the plot, like a meal, a pause
around a fire, a song accompanied by a guitar, a wound to care for, then leaves
again in a sudden rush . . . As if it weren't the rhythm dictated by the plot that
interested Hawks but something more difficult to film, something that would
be like life. Yes, we could call that life. The life of a herd in migration. The
rhythm of the life of a herd in migration. That of *Red River.*

June 27, 2003

I'm going to reread Faulkner's *Light in August.* Something strong and dark
stayed with me after I first read it (May 1986). Something about fatherhood.
Maybe that will help us to become Bruno, to enter him.

June 30, 2003

After this film, I'd like us to make a dry film, its logic unrelenting, on a scape-
goat phenomenon.

July 2, 2003

In trying to imagine Bruno and Sonia, I end up seeing Eddie and Jo in Lang's
You Only Live Once. Should I try to construct the plot to film a pair of fugitives?
Talk to Jean-Pierre about it again. Bruno's tears at the moment of their flight?
Before the death that would come to surprise him? Surprise them? Would
the child be saved? That would clearly be too constructed, too polished of a
relationship, a plot. Not to lose life. Nor the world.

July 11, 2003

First time in my life in Jerusalem.

I met some men afraid for their lives, those of their people, and who genuinely want to make peace with the Palestinians, a true, potentially lasting peace, without any cries of victory or any bitterness in defeat for one side or the other.

Conversation around the Jew named Jesus. If we ever make a film about his life, we'll shoot it in Israel.

July 15, 2003

Jerusalem. The screening of the film *The Son* went well. Lots of lively discussion in the theater lobby, as much about the moral movements as about the formal movements in the film. We had the feeling that the film's flow had entered the viewers, and that they had to return it to us or return it to each other. The energy and depth of these conversations reminded me of the discussions after the screening of *La Promesse* at Lincoln Center in New York. Moments where we could tell ourselves (vanity?) that the film truly existed for people apart from we who made it, that it would matter for them, in their life, that they would show it to others, to their children, that they would re-member it.

July 16, 2003

Tel Aviv. We spent the night driving around town in Raphi's car. We got out to see the bottom of the staircase where Yitzhak Rabin was murdered.

August 11, 2003

I saw Lars von Trier's *Dogville*. Grace is a strange scapegoat. She never says "no," not even to the child asking her to spank him so he can accuse her of this scandalous act later. Why does she commit this act? Why doesn't she refuse anything? Why doesn't she reproach any of Dogville's inhabitants? Where did this passion for acquiescence come from? Is it a form of seduction so that evil comes out of all these people in Dogville and contaminates them all? Would Grace be a daughter of Satan, a temptress made all the more dangerous for having taken the role of scapegoat? Has she only come to Dogville to drive these villager dogs and bitches to display their shamelessness openly? Not to love them, civilize them, or save them, just to set them at war with one another and bring out their bestiality. Saying yes endlessly to the other so he'll debase himself seems to be Grace's diabolic method. The final reunion between Grace and her father wouldn't surprise us anymore. She came to Dogville the better to find him. She worked for him. She worked to please him and he came to thank her. He scolds her for her arrogance: having believed that she could love and save these dogs and bitches of Dogville. Simulacrum

of scolding that reveals the supreme complicity between the father and his daughter, who pretended to love the ones he pretended to scold her for having loved. In this game they're playing, Grace wins back what she pretended to have lost and which makes her even more thoroughly delighted. Her father alone loves her! Her father alone is not a dog! And to seal such a love, her father offers her the extermination of all these dogs and bitches that have made her suffer. Nobody will be spared, because in Dogville, Grace hasn't met anyone who wouldn't gang up against her, not even the one who thought he loved her and ended up betraying her. And for good reason, nobody is able to get between her and her father. Oh, Grace! Small, perverse woman who, just to play at tricking herself, has almost succeeded at making us believe that her father had abandoned her. As if the setting that is Dogville could have been anything other than her playground.

August 20, 2003

I come back to a title we'd thought of: *Le Rachat* [The Redemption]. It seems more appropriate because it's both a financial redemption for the sold child and a moral redemption for Bruno. Sonia's love, which Bruno would regain as they flee, would crown Bruno's redemption as he died anyway. His group (of thugs) can't be involved in a traitor's redemption. He who betrays must pay, then die. Violence has to break out just before or during the scenes leading to Bruno's death. Must not trap Bruno in the dialectic of wrongdoing and redemption.

Bruno's betrayal of his group: not the fact that he sold them an unsellable child, but failing to do what he should have done to repay them for this child in addition to repaying their money. What he should have done could have been to kill someone or to lure this someone to a place where the thugs would kill him. Murder again? Murder again and its refusal, the impossibility of committing it as Bruno's repayment? We're repeating ourselves. Jean-Pierre thinks we definitely need to find something else. I do, too, but I don't know what. It would be better if Bruno didn't have to go through evil and resisting it again to change. Find a situation that would push him to come out of his moral coma without the evil deed acting as this pressure to come out. A situation that would put him in a position to do something good, a gesture of goodwill that would surprise himself.

I feel that we should shoot a violent scene, a very violent one (Bruno's death? His betrayal of the group before his death?) This scene would take place in a back room of a nightclub, a dance club, a very noisy place with music that's very shrill (or, on the contrary, very soft, languid). I'm thinking of the scene with Lee Marvin in Boorman's *Point Blank*.

August 30, 2003

Lies require lots of construction. Evil is a captivating construction (and captivating for the viewer) that needs to have its machinery, all its interconnections shown. Thus truth, goodness appear as a revelation. Revelation that is liberation from all the plot.

August 31, 2003

Bruno does this . . . then this . . . then stops . . . then does yet another thing . . . He goes from one thing to another, he's here then suddenly he goes there, where he can giggle more easily . . . It seems like nothing truly interests him, it's as if he's tired of everything.

September 3, 2003

If he cries, he should cry while eating, for example while eating a slice of bread. This way his tears won't be sorrowful.

September 11, 2003

We're in Tokyo for the interviews before the release of *The Son* in November. To the question of whether we'd chosen Olivier's profession as a reference to the profession of Jesus's father, we replied that there had to be a murky relationship between working with wood and fatherhood. The story of Pinocchio, too, bears witness to this murky relationship.

September 12, 2003

Still in Tokyo. Screening of the film followed by a discussion during which a man whose son had been killed spoke up to describe how he had endured this impossible grief and how he had become an opponent of the death penalty, which hasn't been abolished in Japan. Talking about the film, he said: "In Japan, we say that a child grows up seeing his father's back."

September 14, 2003

Back from Tokyo. In the plane we went over the entire structure of the screenplay that we're now calling *Le Rachat* [The Redemption]. Jean-Pierre suggested some simplifications for the selling of the child and fears that the scenes of the couple in flight might be too voluntarist. We could indeed ask why Sonia runs away with Bruno. What would this reversal bring about? Why take such a risk? A couple running off is beautiful. Maybe for another film. We both feel that the moment of crying over the redemption and reconciliation have to be

captured in the movement of something else. A thing to do, and while this thing to be done is being done, the tears come.

September 17, 2003

Bruno's exhaustion. It's unfathomable. No desire to live, not even out of fear of dying. Nothing affects him. Nothing's worth the trouble. Nothing has any price. Nothing counts for him. Except himself? No, not even himself.

September 22, 2003

Bruno's path leads him into tears because nobody can decide on tears. They will just come, as will Sonia's, and this will be an abrupt, unforeseeable reconciliation. The viewer will experience, with them, a moment that escapes fate, escapes death.

September 30, 2003

I'm working on the screenplay. Jean-Pierre called me to make some suggestions about the scene of the child being sold. The building's elevator would be broken, Bruno wouldn't be able to get up the stairs with the stroller, he'd have to take the child in his arms. As the apartment is completely empty, no armchair to put down the child, Bruno would take off his jacket and set the child on it. He also told me about a bit of news that just happened in Liège. A young thief who had grabbed a lady's purse was pursued by people who saw the theft. To evade them, he hid on a bank of the Meuse. He must have hidden by slipping partly into the water, his hands gripping the plants on the bank. He must have drowned because the plants couldn't have been strong enough to hold him (he didn't know how to swim). The paper reporting this also hinted at the possibility of stones being thrown by the pursuers. This death could have been Bruno's death.

October 10, 2003

I just wrote the scenes where the baby is sold. Bruno takes the infant in his arms for the first time when he sells it. The leather jacket as swaddling works rather well. We see the child in toto for the first time. Mysterious density in Bruno's behavior. Lots of potential associations that don't have enough time to reach the viewer's awareness (much less Bruno's). The cell phone he forgot in the jacket and which he comes back to look for. Sudden distance created by this concern. Distance where I behold the asymbolia in which Bruno lives.

October 11, 2003

If it weren't already the title of one of Bergman's films, we could call our film *Le Lien* [The Touch].

Bruno and Sonia's baby is named Jimmy.

October 13, 2003

Morgan (Francis in *The Son*) is back on the roofs as an apprentice zinc worker. His mother, seeing him in front of the computer screen all day, made him get a job again so he'd have regular hours and a social life. He acted in a film and a TV film after *The Son*, then nobody called him anymore. He's waiting.

Bruno doesn't scheme, doesn't calculate, doesn't have any strategy. He's in the now. He wants, he takes, he doesn't want anymore, he throws away, he forgets. Something in his pleasure has a connection with an attraction to death.

October 21, 2003

Focus on Bruno again as he cannot become a father. He doesn't know why (I don't either) but it can't be a part of him. In the film's third movement, he would experience something with one of the boys from the group who works for him. Maybe (connected to that little news item from Liège) he'd commit a theft with this (twelve- or thirteen-year-old) boy and they'd be pursued by men who had seen them. They'd go hide on a riverbank, their bodies partly in the water, their hands gripping plants. The plants the boy had grabbed would come loose, he'd float away, nearly drown. Bruno would help him, save him, and with this gesture he'd change, become a father. It's a bit rough but maybe there's something to explore there. This moment has to be quick, just glimpsed, it can't appear (in Bruno's eyes and in the viewer's) to be the tipping point. Bruno shouldn't realize what's happening, what's just happened, he has to keep on doing as he did before. The movements of his soul remain invisible, subterranean. His action with regards to the boy shouldn't appear heroic. He didn't decide to do it. He's surprised by this action that came out of him. Does he die after that or has something indeed secretly begun and does he keep going? What connection between that and Sonia? Won't she have disappeared from the screen for too long? Is she still necessary? Do Sonia's love and the love for Sonia still have some power to push Bruno toward redemption? Am I just erasing Sonia's role, erasing the woman?

October 23, 2003

Bruno sells his son. He chooses death. How to find life again?

The screenplay is still too in the ideas, in the characters' psychological movements. We have to find objects, small concrete actions, accessories, manipulation of accessories, things, stratagems. In *La Promesse*, we found the White-Out that Igor covered his decayed teeth with, in *Rosetta* the bottle for fishing, the wire to lock herself in the waffle stand, in *The Son* Olivier's leather belt, the meter stick Francis uses to measure the distance between his foot and Olivier's. Here there isn't any thing, any accessory like that. That's a bad sign. Cinema is filming very concrete things like Charlot's cuffs on which the little girl had written the words to the song, like the escape rope that Lieutenant Fontaine braids with the strips of bedsheets and bits of box spring wire. Cinema takes interest in accessories. The essential thing in cinema is the accessory.

October 24, 2003

Who is Bruno? What does he want? What is he looking for? I have no idea. Jean-Pierre doesn't, either. He escapes us. More than all the other characters we've invented thus far. How not to push him toward death? It seems like that's what he's looking for.

October 26, 2003

I saw Clint Eastwood's *Mystic River*. No catharsis for this tragedy. The heroes' wives, Dave's wife especially, keep the process of recognition from taking place, keep the truth from coming out and putting an end to the cycle of evil. At the end of the film, Dave's child on a carnival float that goes past all the protagonists brought together by the local festivities. Imprisoned in his suffering and atop the float, this child shows us that evil has not run its course and that it has already ensnared the next generation. Nobody can stop it. Jimmy will not talk and will never be a new father for the child. His wife urges him toward dreams of power that ought to be more joyous. The child's mother will not talk either. Her gaze already reveals the insanity crushing everything. Sean will not talk either. He's happy to have regained his wife and their baby. He will keep silent. He is capable simply of a childish gesture that has no effect on things. Who will save this child, then? Who will deliver it from evil? Who will deliver them, him and those who come after him? Who? Only the child himself could. The child who will commit suicide. Maybe that's why he's ended up on the float.

November 1, 2003

The film we're writing isn't about another family. It's like the last three films. As such, should we need to change, that'll be with the next one, or after. We'll

see. Rather surprising, we'd set out with the desire to make a different film. As Michaux said, the artist is not even master in his own house. Fortunately.

November 4, 2003

While talking on the phone with Jean-Pierre about Bergman's *Scenes from a Marriage*, about the way he avoided the clichés of argument scenes, I thought again about the hospital scene where Bruno gets close to Sonia who's lying on a bed, unconscious. Even though he's done what he's done, he could still demonstrate some love for her. From his perspective, the fact of having sold the child hasn't diminished his love for Sonia or the love Sonia has for him. He could stroke Sonia's face or kiss her. That would reinforce the insensibility, the irreality, the irresponsibility he floats in even as it would be a demonstration of his love for Sonia. Take seriously the fact that Bruno does not understand that Sonia could be suffering from the loss of her child. He loves her and he sells their child and he doesn't see why Sonia wouldn't love him anymore.

November 6, 2003

I just reread Shakespeare's *The Winter's Tale*. I needed to go out searching again for Mamillius, the young prince, the child of Leontes and Hermione. I never understood why his death was forgotten in the final reconciliation. Why doesn't Hermione remember the death of her child? Leontes does have a few words for him before meeting the young Florizel, but they're so few, so few for the one who died innocent. Something new came to the fore during my latest reading. If Hermione doesn't say anything about Mamillius, maybe it's simply because she doesn't want to say anything, because she knows that silence alone makes it possible not to associate Mamillius with the general reconciliation, that silence alone, which isn't the silence of forgetting, can say amid such beautiful reunions, that forgiveness cannot wholly redeem the death of her innocent child.

The scene (3 of Act III) of the newborn (Perdita) being discovered by the shepherd, while his son describes the spectacular scenes of death and murder that he's just discovered, is magnificent, vibrant with contrasts. And it surreptitiously also describes the filmmaker's art, his gaze. To his son describing these terrible spectacles he's just seen (an old man killed and dined on by a bear and the poor souls of a ship flap-dragoned in the sea), the shepherd replies: "Would I had been by to have helped the old man!" His son replies: "I would you had been by the ship side, to have helped her. There your charity would have lacked footing." And the shepherd adds: "Heavy matters, heavy matters. But look thee here, boy. Now bless thyself. Thou met'st with things dying, I with things new-born. Here's a sight for thee." A child who has just

been born, the birth of a movement, that's a sight! That's a sight to film! Our way of having helped the old man. If cinema ever loses this illusion, it will lose its reason to exist.

I saw Pasolini's *Accattone* again (DVD). Accattone is tired, on the verge of exhaustion. He walks, he walks quite a bit, always wavering, on the verge of collapse. Bruno, too, is tired. Something brings these two young men, these two thieves, in proximity. Caught by the police during his final theft, stealing the mortadella, Accattone manages to run away. A policeman shouts: "Stop. It's useless to run. We know who you are." The film's final shot is a response: death. Will Bruno die? Often I think so, and Jean-Pierre does, too. Sometimes I think otherwise. Accattone dies but there's Johann Sebastian Bach's music. Mouchette dies but there's Monteverdi's music. What if Bruno dies and there isn't any music?

November 7, 2003

"He thought that it was loneliness which he was trying to escape and not himself. But the street ran on: catlike, one place was the same as another to him. But in none of them could he be quiet. But the street ran on in its moods and phases, always empty: he might have seen himself as in numberless avatars, in silence, doomed with motion, driven by the courage of flagged and spurred despair . . ." Like the Christmas of *Light in August*, like Accattone, Bruno is doomed to motion, driven by the courage of flagged and spurred despair . . . Like Christmas, he might come to think: "This is not my life. I dont belong here." Like Accattone at the moment of death, he might say: "Ah, now I'm fine!" Could he imagine this was his life, that he belonged here, could he say that now he felt good without this life, this place, this now being those of his death? Could he save himself from himself, be saved from himself without going into death?

I couldn't say why, but I've come to realize that the farther I get into writing this screenplay, the more central the river (the Meuse) becomes. Jean-Pierre says it's good to have set Bruno's hideout along the river.

November 21, 2003

Discussion with Jean-Pierre about the film's third movement. We can't follow a straight line. Have to be more convoluted. Be in the matter, not in the dramatic structure, in the gaze, not in the plot.

November 30, 2003

Long phone conversation with Jean-Pierre. I'm in danger of going too far into the dramaturgy of the redemption. Come back to the body, the accessories,

the locations, the walls, the doors, the river. Set out from the concrete, not from ideas, or else wait for the idea to be forgotten and eventually it will come back as something concrete that's the trace thereof. The crucial moments in writing our screenplays are those spent forgetting ideas. This is why it takes so much time.

December 4, 2003

The film could be called *Le Garçon au landau* [The Boy with the Stroller]. This title harks back to an accessory. Even if this title is terrible, it's set off a realization about the stroller. Although this stroller was there, abandoned on the quay where I came back with Bruno, and I didn't see it. I called Jean-Pierre who had the same thought. The stroller could save us. Another accessory that takes up a lot of space and makes it possible to construct scenes: Bruno's cell phone.

December 8, 2003

Musée du cinéma. I saw Valerio Zurlini's *Girl with a Suitcase*. Very beautiful. Intense. Aïda (Claudia Cardinale) is full of desire in the stairway scene, when she stops, takes off her turban, and looks at Lorenzo (Jacques Perrin). I had the impression of taking root right on the spot. I also liked the beach scenes. It's scenery, but it's still alive, unexpected. The end of the film with the scene of the envelope is astounding. Poor Aïda. Beautiful, lively Aïda. I thought about Sonia and Bruno, the desire attracting them to each other. I shouldn't forget that their bodies are sexual, that they attract each other, are attracted to each other. Desire flows through them, it doesn't stop flowing, otherwise the film would be a failure. Forget the Sonia of Dostoyevsky. Sonia is a woman's body, an erotic nature. Remember the Sonia of Dostoyevsky anyway because Sonia's eroticism isn't enough to bring about Bruno's conversion.

December 12, 2003

In the end Bruno and Sonia cry. They cry. Tears, tears, and yet more tears. And it isn't sad.

December 30, 2003

My eyes landed on a photo of Semira Adamu in the paper. She looks at me over her hand, her long, beautiful, fragile hand . . . She would have been twenty-five today. She would have lived here in Belgium or Nigeria or maybe somewhere else. She was killed in Brussels on September 22, 1998 on the plane that was going to deport her to her homeland. She was killed by three

law-enforcement agency members who held her down in her seat and covered her face with a cushion to stifle her screams of protest. She would have been twenty years old.

December 31, 2003

Every time I describe Bruno's behavior, I want to write: as if what he did or what was done to him didn't affect him, as if he weren't there.

I meet more and more people who aren't there. I don't know where they are (maybe in their images?) but they aren't there. Odd society that produces individuals who aren't there, who aren't there for an other, who aren't there for themselves, for whom nobody is there. At the end of the film, Bruno would be there.

January 2, 2004

I'm changing the entire third part of the screenplay. We're too inside the love. Bruno's trajectory also goes through the law. Bruno doesn't change thanks to Sonia's love alone. He needs to experience something that causes the law to start existing for him, causes things to gain solidity, causes him to finally be there, stopped, indebted, seeing for the first time what he's done, finally able to say: "It's me." When we wrote a preliminary outline of the screenplay, we noted that Bruno could be ill, that this could keep him in one place and force him to be alone. We felt that he needed this return to himself to change, to rid himself of this whirlwind of images where he loves himself and which keeps him from loving. Illness isn't enough to stop this whirlwind. Moreover, it allows Bruno to present himself as a victim to Sonia who will become his nurse, his mother. Horrible melodramatic slop. Sonia has to stay resolute in her rejection of Bruno and he has to be the one to experience a concrete, unexpected situation that transforms him (maybe with Steve when he pulls him out of the river, carrying him on his back, making a fire in the fireplace of an abandoned house to warm him up again?). It's only after this transformation that Sonia will be able to come back to him. Transformation that the situation undergone with Steve shouldn't explain. It stays opaque, mysterious.

January 3, 2004

At the end of the film, it's a reconciliation like the one Joseph had with his brothers who sold him and lied to their father. Except here it's the guilty one, Bruno, who cries first. Won't the scene sink into sheer melodrama? We'll see during the shoot. To see if it works, to find out, we have to be on set, shooting the shots.

January 6, 2004

Bruno will turn himself in. A long movement after having pulled Steve out of the water, after having seen him arrested by the police. It's the missing movement that Bruno needs, his relationship with the law. Just have to find setups that don't express this movement but allow it to unfurl as if within themselves, invisibly, secretly.

We called Jérémie Renier. He could be Bruno. We'll see each other soon in Brussels. He has the insouciance, the lightness, the laugh of Bruno. It's astonishing that we hadn't thought of him before. Maybe it's Bruno we owe for thinking of him. I'm delighted to see him again.

January 10, 2004

In the end, Sonia will wait for Bruno alone, without Jimmy. He'll loosen his lips to talk. He'll name his son for the first time, he'll say "Jimmy." It'll be even more powerful if the child is absent. Maybe the scene should be shot with the child as well? We'll see in the process of shooting. For this film we'll also shoot the scenes sequentially in order to feel the characters' evolution, to be imbued by them, to become them to be able to decide what they can or can't do or say, whether or not we should shoot in one setting or another as the screenplay suggests. Shooting sequentially has been our method ever since *La Promesse*. The farther we get in the shoot, the more the characters take shape, the more their words and their behaviors establish themselves (for the actors as for us), the more we dare to rewrite scenes or erase them.

January 12, 2004

Maybe we should do a shot of Bruno pushing the scooter with the burst tire through the Seraing market? Walking it past all these fruits, vegetables, clothes, colors, languages, noises, all this multicolored life, would bring to the fore the life he's perhaps in the process of leaving, or, on the contrary, that he's trying to find. A whole life that would still accompany him in his lonely crossing over the bridge. Seeing him among the people then with nobody around him could be good for the rhythm. We've been hoping for twenty-five years to film this market in Seraing, to find a place for it in our films.

January 16, 2004

I just read the last pages of Gaston Bachelard's *Water and Dreams*. He writes: "liquidity is . . . the very desire of language. Language needs to flow Where is our first suffering? We have hesitated to say . . . it was born in the hours when we have hoarded within us things left unsaid. Even so, the stream will

teach you to speak, in spite of the pain and the memories . . ." I think again of Renaud Victor's film *Ce gamin-là*, of Janmari, the autistic boy who lived with Deligny in the Cévennes. Bruno would watch the water flowing, he'd like to talk, he'd like to cry. Maybe do a scene with Bruno and the Meuse's waters. Maybe it's not wrong that he has his hideaway on the edge of the Meuse. Careful not to do a scene in which Bruno would "express" his interiority.

January 23, 2004

I finished the first draft of the screenplay but I don't have a title. Jean-Pierre doesn't, either. Strange, because we've always found a title very early on to frame our story, to help us get to the essence. It's true that we worked with three titles which enabled us to progress: *La Force de l'amour* [The Power of Love], *Le Rachat* [The Redemption], *Vivre* [To Live]. The last title allowed me not to get trapped in developing a constrained plot. Well, I hope so.

February 3, 2004

Jean-Pierre read the first draft of the screenplay that we're provisionally titling *L'Enfant* [The Child]. The first long movement up to the scene where Sonia kicks out Bruno charmed him, but the second movement all the way to the end seemed too constructed to him, especially the way Sonia comes back to Bruno. The character of the mother seemed to come too willingly. He thinks the overly rigid construction of the second movement comes from the presence of the bandits demanding their money. This introduces a dramatic necessity that keeps the character of Bruno from existing the way he did in the first movement. He's right. I also think that the mother needs to come in a different way, called in by things Bruno deals with, because he needs her, he'd ask her for money, for an official document, or something else. I don't think she should disappear. For Sonia's return to Bruno, this has to happen in a different way from the cafeteria scene where Bruno comes to watch Sonia at work. No point giving Sonia a job. It's too removed from the story and too focused on Bruno to warrant this new element. Something for Sonia before going to turn himself in, but what? Going by Sonia's place when she isn't there? We'll meet on Friday to go over the scenes again one by one and make a new plan for the second movement. Fortunately there are two of us.

February 9, 2004

I'm writing the second draft of the screenplay. I'm trying to avoid "I" and "you" in the conversations between Bruno and other people while exchanging objects and money. Everything is done for nobody's sake. Nobody is responsible. Nobody is guilty.

March 14, 2004

I just finished the fourth draft of the screenplay. I think the title *The Child* is right even if it's a bit abstract for a film title. I wrote a new scene between Bruno and his mother, with the fleeting appearance of a "stepfather." A banal, terrible scene.

March 26, 2004

I'm working on the sixth draft, while keeping in mind Jean-Pierre Denis's comments on the scenes following Steve's drowning. I cut the scene in the abandoned house with the fire that Bruno lit to warm Steve back up. Too long and moreover a setting that isolates them, protects them. If they stay on the wharf, they're in greater danger, the police could catch them by surprise. Bruno rubs Steve's feet and wrists to warm him back up. I come back to the previous draft for Bruno's departure at the moment of Steve's arrest. There's no need to make viewers believe that Bruno would make off with the money when he sees Steve arrested by police. No need to add this further betrayal. It doesn't have a place here and would be interpreted as an abandonment that mimics the abandonment of Jimmy and pushes Bruno toward repentance. This would give some explanation to Bruno's evolution, make what modifies it explicit, visible. I think this wouldn't be a new moral failing and therefore a reinforcement of that feeling of guilt that pushes Bruno toward redemption. In experiencing what he experiences with Steve, he discovers himself to be other than what he had been, he comes out of his despair.

June 2, 2004

I saw Ingmar Bergman's *Saraband*. Filming women, not actresses but women. Only Bergman knows how to do it. The body of a woman filmed by Bergman. There's more body in this body than death in death. The last shot of his last film is of a woman. Not of an actress, but a woman. Will we ever know how to film a woman's body? Maybe that's our impossibility.

June 11, 2004

I talked to Morgan on the phone. He isn't working on roofs anymore. He has two ideas for shooting.

July 6, 2004

The main comment the screenplay's first readers had was noticing that we were filming in less compact shots that consequently moved less. This wish indeed must be there. No doubt because of the river or maybe it's the other

way around: the river because there was this desire to expand. I don't know. In any case, we'll do what we feel needs to be done at the moment we do it. It'll reassure distributors to think that we're filming bigger, calmer. It doesn't reassure us at all. Worried about industrial landscapes that stifle faces, bodies. Not filming settings. As soon as a crew member says "It's nice," we should tell ourselves: "We're wrong." Worried more than ever about the *Je pense à vous* syndrome, where the story was also between a man and a woman in the industrial settings of Seraing.

July 11, 2004

I saw François Truffaut's *The Wild Child* again. Each time I'm touched by the image of the wild child running through the rain in the garden. His final run as a wild child. His final drunkenness. Image seen through the pane of a window in the house. Memory. Paradise lost. Necessarily through the window pane. Mandelstam's joyous "crowds of children." I hear their shrieks and laughter through the pane.

July 16, 2004

We filmed several potential shots with our DV camera in the scenery of Bruno's hideout on the edge of the Meuse. A sort of small, abandoned bunker protecting the sluice gates that hold back the water from a stream running through the cleaning or cooling machinery for a rolling mill. It's mostly covered with creeping plants: a dense thicket of lianas and morning glories falls from the roof over the rusting iron door. We get the feeling that we're in a place of origins. While writing the screenplay and during our earliest location scouting, we hadn't imagined such a place. It's reality's own contribution.

July 18, 2004

In London with Emmanuelle to see the Edward Hopper exhibit. The light falls in rectangles on the floor, on the walls. It falls flat. A bad joke. Nothing to receive it. Nothing to send it back. Bodies, like on a stage, strike poses to warm themselves but they feel no warmth, give off none. The painter would like to paint but cannot anymore. He doctors. He has become a taxidermist. Houses, bodies, spaces between bodies, sky, ground, everything is full, stuffed with a thick silence. Nobody screams anymore, will scream anymore. No child got out. It's too true. It brings me down.

July 21, 2004

Narcissus never found himself so beautiful as when he could despair of himself.

July 22, 2004

I saw (on TV) Claude Lanzmann's *Sobibór, October 14, 1943, 4 p.m.* An act of revenge. An act of justice. Indistinguishable. A human act, so honorably human.

July 27, 2004

We keep talking endlessly about the way we'll film *The Child.* We'll try not to freeze life in our shots, to let it pass, overflow. We'll see. Especially not to shape the film before we've made it. Stay at the intersection! At the intersection! In there!

July 29, 2004

Will our images be able to escape the first image, the corpse? How to escape the paralyzing force of this first image? Isn't it what, at the heart of all the images, keeps on holding us at its mercy? Isn't it what keeps on fascinating us, freezing our images and our gazes, pushing us to seek "style," perfection? Only death can be perfect. Something in me that strives for rigidity and that I battle against.

July 30, 2004

For a month we've spent hours and hours on location discussing everything and nothing, sometimes the film. Sometimes we shoot with our DV camera, Jean-Pierre or me making the characters' movements. Necessary to imbue us with the location, the characters. Also necessary the better to share the film's very instinct.

August 3, 2004

We've looked at all the practice shots that were done with the DV camera in these locations. The kitchen of Sonia's apartment is too big. We come back to what Igor Gabriel (the set designer) built: a windowless kitchen a meter and a half long. If the kitchen is too big, then Bruno and Sonia's fight wouldn't need to play out in the kitchen first and then in the living room. The kitchen alone would suffice. We'd rather have the fight start in the kitchen then continue in the living room, in a wider shot, the camera staying in the kitchen. The door frame might interest us.

August 10, 2004

Small news item in Liège. Two thirtysomething individuals got into a fight over the price of a PlayStation that one was reselling to the other. They came to blows. One killed the other.

August 11, 2004

Told by a schoolteacher: after school he drives a child home. The family is poor, the house is small. The father welcomes him into the room that's for him alone, that's forbidden to the children. In there, he's set up a hi-fi system with headphones, a TV screen with a PlayStation, and a computer.

August 20, 2004

The actors (Jérémie Renier and Déborah François, soon Jérémie Segard) are with us. We'll start the rehearsals on location and spend time together with the chief costume designer (Monic Parelle) to find the characters' clothes. For us, the fitting sessions are essential to discovering the characters, to seeing them. We waver a great deal, a long while. The fact that the actors spend hours and hours with us trying on clothes helps them to become their characters, to free themselves of the images they hold of themselves and their characters. We rarely talk about the characters with the actors except during these fitting sessions. We talk about them while choosing this skirt rather than that one, this t-shirt color rather than that one, this fabric rather than that one, and keep coming back to them in these choices.

We've decided to shoot over twelve weeks (thirteen or fourteen if needed) and in Super 16mm. We'd rather spend our money on time. Time is what we'll need to shoot this film. We'll try to shoot each scene in several long shots even if some of them have uninteresting moments. Accumulate material, try not to trap ourselves within a single long shot even if it seems to be the best, the only way to film the scene.

August 26, 2004

We rehearse the big scenes. The first thing we try to do with actors (whether professional or not) is to shatter the images they're imprisoned within and the images, closely connected to the first ones, within which they imprison the character they're going to play, to become. When these images fall away, it's like a deliverance. They can finally be there, simply there. We also try to carry out this work upon ourselves with the images we could trap the characters within.

We called Jérémie Renier to find out which last name he'd like to have on Bruno's ID card which will be used in the scene with his recognition of fatherhood. He spontaneously replied: "Michaux." That was Igor's last name in *La Promesse*, Roger's son.

September 18, 2004

We start shooting Monday. We shouldn't be prisoners of our experience in listening or in wanting to stay deaf. Easier said than done! Having experience is bad for the filmmaker. It sterilizes him, saddens everything he sees. He thinks he can rely on it, but it traps him in a form his art had started to evolve into.

ROSALIND: "And your experience makes you sad. I had rather have a fool to make me merry than experience to make me sad—and to travel for it too!"

Shakespeare, *As You Like It*, act IV, scene 1

As our filmmaking experience is shared on this point, it is clearly impossible for me to be my brother's fool or he mine. Who or what will be our fool for this film? The actor? Jérémie Renier? Peter Brook wrote that the actor can be the director's fool or jester or clown. The fool, being lighter, senses the direction to take more quickly and better, and unthinkingly guides you.

September 29, 2004

Good day shooting along the Meuse. Yet another experience of a shot invented by the group (with the actors, the cameraman, the director of photography, the sound engineer . . .) being better, more alive than the one we'd suggested at the outset.

October 1, 2004

Benoît Dervaux (the cameraman) carries the camera, and his body's movements are more subtle, more alive, more aware, and more complex than any movements done with mechanical assistance. His chest, his pelvis, his legs, his feet are those of a dancer. With Amaury Duquenne (his assistant) accompanying him and supporting him during his movements, they make a single camera-body.

October 10, 2004

We've already shot several scenes with "small roles" played by actors who show up on set in the morning without our having gotten to work with them beforehand. It's a shame for them and for the film. Not enough time! We noticed that with these actors who, due to circumstances, tend to act their character by using their methods, we've had to give them, at very precise moments, directions that disconcert them so that they'll be more alive, so that they'll find what their methods have covered up. Above all the scene has to be rehearsed a dozen times to let them find their place, get stuck in their methods, then give

them a direction that cancels out their method while making it clear that the rehearsals are done and shooting is starting now. This morning we worked with an actor (a good actor) who over the course of rehearsals kept aiming his gaze at his partner at a specific point during his reply. Right before shooting, we told him: "Don't fix your gaze at this word but at the preceding word." He was disconcerted and he was very good, very alive. His partner was, too. The shot was, too.

October 11, 2004

Lots of laughter in the first scenes between Bruno and Sonia. Far more than we'd imagined when writing the screenplay or rehearsing. Bruno's laughter has to exist in the scenes where he's alone, without Sonia. There's the farting scene with Steve but that isn't enough.

October 23, 2004

We shot two versions of the moment when Bruno tells Sonia he sold their child. They're both terrible. The next day we tried a third which starts with Bruno hidden in the shelter waiting for Sonia to come. When we started the rehearsal, Jérémie went into the shelter. Shortly after, we came into the shelter to talk to him and we found him sitting on the ground, his knees close to his face. This bodily position betraying a mixture of shame and defiance could only be a position of Bruno's body. That struck us immediately. Bruno was there in front of us, as we'd never possibly imagined him. Jérémie had become Bruno and was going to lead us through this new version, which would be the right one.

November 17, 2004

Words don't come when he needs them. Only looks do. They can lift him up. At the intersection! The asphalt! At the intersection! He begs you. Take him. Take all of him in with your eyes. His lips quiver. Your eyes! The sigh of your eyes! His mother's blood flowing again over his body. Your eyes! At the intersection!

December 9, 2004

It's six in the evening. We finished shooting at 3:40 PM with the shot of Bruno crossing the Ougrée bridge while pushing the scooter with the burst tire. The same shot (done a month ago) as the one of Bruno pushing the stroller. The same shot as the one of Igor carrying Assita's bag in *La Promesse*. Jérémie had just turned fifteen, he had breathed life into Igor, Roger's son. He's just

breathed life into Bruno, beyond our expectations. He's never stopped suggesting, trying out variations. Never any rigidity. Always complexity, life. Thank you, Jérémie.

January 6, 2005

Meeting in Liège with Jean-Pierre Limosin to prepare his film on our work. He reminded us that we must have said when *Rosetta* came out that Rosetta's character echoes a character from one of Johan Van Der Keuken's documentaries, a young girl from Groningen who appears in *The New Ice Age*. I had forgotten this but it's true. This young girl is a worker in an ice-making plant and Rosetta, at the start of our film, also works in an ice-making plant. She's illiterate, her parents and her brother are, too. A humiliated, diminished family. Like Rosetta and her mother. I remember this moment in the film where she's in her tiny bedroom, sitting on her bed, trying to read a love letter from a young boy she likes. She suffers in not being able to read. She struggles with each letter, each syllable, each word. The director's camera, as if it were duty-bound to watch, to provide assistance in this suffering, this silent effort to decipher the inaccessible words of love, starts to move with small, taut panoramic movements, then these movements expand, come to bang against the walls of this room to the rhythm of the letters, the syllables, the words that come with difficulty, with victory out of the young girl's mouth. The director's gaze was beckoned by the distress of the person he was filming. Out of this beckoning was born a shot, a new, unique form that otherwise would never have seen the light of day.

January 21, 2005

This Sunday, January 21, 2005, *Le Monde* published a special section titled "From Auschwitz to Nuremberg," and, within, George Rodger's photo showing Sieg Maandag, a young Jewish survivor from Holland, around April 20, 1945, walking down a road with corpses of Bergen-Belsen detainees along both sides. Clearly there's no particular reason that this little surviving Jewish boy should be walking all alone so close to the side of this road littered with detainee corpses apart from what the photographer wanted. What the photographer couldn't ask him and what belongs to Sieg Maandag is his way of being there, of walking next to these corpses, his head turned slightly as if to show us his suffering in walking past all these dead. He walks toward the photographer while trying to look at the lens, squinting, grimacing, as if bothered by the sun or perhaps the corpses' smell. He's there, the horror is there, as is the respect for all these corpses he's giving a face to.

André Green writes in "Why Evil?" that "For me, the most eloquent image from a film about the Warsaw Ghetto is one showing the supreme indifference

of two Nazi officers crossing a street strewn with corpses, which they appear not to see. A sadist cannot but identify with the masochism of their partner (and vice-versa). Here, the evil resides in the executioner's indifference to the countenance of his fellow man, whom he considers an absolute stranger, and even a stranger to humanity."

January 27, 2005

Sixtieth anniversary of the liberation of Auschwitz. Sixty years after, how can we stand before Auschwitz? The emotion that overcomes us when faced with such images, such accounts by the survivors, is a moment of genuine compassion for all the Jews who were victims of genocide. Genuine and astonishing compassion that seems to allow for a new surge of mistrust, resentment, hatred toward Israel's Jews, who are escaping that imagery of victims. Anti-Semitism exists in the bottomless depths, it comes from far off, very far off, so far off, even farther off. Sixty years after, how can we stand before Auschwitz? To descend as deep as possible, as far as possible within ourselves, our families, our religions and traditions, our nations, our haziest genealogies to try to make out how and why "the Jew" is perpetually identified as "guilty." What we are guilty of is not making this descent. Sixty years after, how can we stand before Auschwitz? Never to imagine ourselves liberated from Auschwitz is never to imagine ourselves liberated from anti-Semitism.

February 5, 2005

We live alone, barricaded within our images, on the lookout, ready to defend ourselves, to attack, to express ourselves, as if unnerved by our imminent death. We'll die older than we might have fifty years ago but we live with the increasingly oppressive feeling of imminent death. We can't take having to exist in front of others, in front of ourselves anymore. Sometimes, in the evening, alone in our bed or in our bathroom, we start sobbing.

February 8, 2005

For the next film, maybe a young woman who has every reason to despair and who goes on believing that everything is possible. A believer of sorts, even if God is dead. Exploring these lines by Kierkegaard in *Sickness Unto Death*: "The believer has the ever infallible antidote for despair—possibility—because for God everything is possible at every moment To lack possibility means either that everything has become necessary for a person or that everything has become trivial." In opposition to everyone around her, she refuses to consider everything necessary or trivial, she goes on believing that everything is possible. Maybe she succeeds in instilling this belief, this "possibility" within

someone else. How can a woman who does not believe in God believe that everything is possible? Where does this mad hope come from? She is strange, she bucks trends. A fictional character always fighting against the current.

February 12, 2005

Eleventh version of the edit of *The Child*. The film will run ninety-two minutes. Of course we should edit several more versions but the rhythm seems to be there. We see that what we've filmed is Bruno waiting (often with a wall behind him) and apparently we like filming him this way (Bruno, that is, the actor, Jérémie), while waiting, standing or sitting. He waits for the man who should leave the bar, he waits for the money, he waits for his cell phone's ring tone, he waits for the bus doors to open, he waits for the elevator, he waits for the storekeeper to go by to steal her purse, he waits for his mother to open the house door, he waits for the policeman to come to the front desk, he waits for Sonia, he waits for the child, he waits for Steve, he waits for the traffickers, he waits for the nurse . . . What does he wait for during all these waits? What does he wait for? He waits for tears, he waits for failure, the loss of his strength. Not the movement of a redemption, of a resurrection, but the rupture of a movement, the stop, the failure that allows him to see Sonia who is there, facing him, and to see Jimmy who isn't physically there but who is there all the same, facing him, Bruno, in tears.

Screenplays

The three screenplays published here are the versions used for rehearsals and shooting. As such, all modifications that arose over the course of rehearsals, shooting, and, of course, editing are not present here.

For Le Fils [The Son], *the final scene in the screenplay isn't the one we originally wrote but one that grew out of rehearsals and which, as the shoot was drawing to a close along with the film itself, gradually became evident to us. One of the benefits of shooting sequentially (that is, starting the shoot with the first shot of the first scene and ending it with the final shot of the final scene) is that it brings about an ending that has had the duration of the shoot to ripen.*

For L'Enfant [The Child], *we realized during the shoot that Bruno's little leather hat trapped him too much in a character, an image. We rewrote scene 14 so as to do away with this little hat and thereby give Bruno back his freedom.*

For Le Silence de Lorna [Lorna's Silence], *Lorna's French-language lines were modified based on the way the actress, who was from Pristina, used French during the two months of rehearsal preceding the shoot.*

The Son

1. Int. Woodshop/Job Training Center—Day

Off-camera, noise from a planer and a jointer. A sheet of paper with printed text is held in the hands of Olivier, forty years old, in carpenter's overalls speckled with wood shavings, wood dust. Around his waist: a wide leather belt supporting his back and compressing his stomach. In one hand, under the paper, a pair of woodworking scissors. He wears glasses, as well as protective goggles raised onto his forehead. His gaze is fixed on the paper, absorbed by what it says . . . Suddenly, the noise of the planer becomes more shrill. Olivier does not react . . .

AN APPRENTICE (RAOUL) *(off-camera, yelling)*
Olivier, Olivier!

Olivier turns around, runs to the planer, leaving behind the woman of about thirty who was facing him, Catherine, the director of the center. He approaches the planer, where it seems a plank has become lodged. Two apprentices (sixteen years old) are next to it, unsure of what to do. While energetically turning a crank, Olivier says something to the apprentices that is covered by the noise of the machines . . . He goes back to the door of the workshop, where Catherine is still standing. He approaches her while keeping his eyes fixed on the letter . . . Between him and Catherine is the frame of the door . . . He lifts his gaze to Catherine, rubs his eyes with the back of his hand as if bothered by the light coming from the windows in the hallway, again looks at the letter . . .

CATHERINE *(off-camera)*
He's in my office with his caseworker. Do you want to see him? . . .

Olivier doesn't respond, his gaze still fixed on the letter . . .

OLIVIER
I can't . . . With four already, I can't handle it.

CATHERINE
I'll see if there's a place in welding . . .

She reaches out a hand to take back the letter . . . which Olivier gives her. She leaves, closing the door. Olivier returns to the machine where the apprentices are busy working, a glazed expression as if lost in thought . . . He is near the jointer, watches a plank go by. He lights a cigarette, goes to a workbench on which he finds a toolbox, there he takes out a thermos, unscrews the cup, pours in coffee . . . takes a swig . . . An apprentice (Omar) holding a planed plank in his hands approaches . . .

OMAR
I think it's OK.

Olivier takes the plank, puts his cup down on the bench, examines the plank by bringing the edge up to his eye . . .

OLIVIER
OK.

He gives the plank back to Omar, taps the ashes from his cigarette into the chest pocket of his overalls, brings the cup of coffee to his lips . . .

2. Int. Hallways/Staircases/Job Training Center—Day

Olivier walks down a hallway . . . climbs a staircase . . . puts his cigarette out on the sole of his shoe, puts the butt in the chest pocket of his overalls, walks down another hallway, slows down as he approaches an office window, the bottom of which is covered by a translucent adhesive strip. Hidden by a cabinet: the body of a teenager sits facing a desk. Only part of the boy's legs and occasionally his hands are visible. Beside him, the body of a man, also hidden by the cabinet. Olivier watches . . . Suddenly, the body of the teenager makes a move to stand up. Olivier pulls his face away, makes an about-turn into the hallway . . . Off-camera, he hears the door of the office open and close . . . He glances back . . . retraces his steps, walking quickly to a staircase . . . Partially hidden by the corner of a wall, he has just enough time to see the hand and arm of the teenager disappear behind the bathroom door . . .

3. Int./Ext. Car/City—Day

Olivier behind the wheel of his car. Next to him: an apprentice (Steve), his toolbox on his knees. In back, another apprentice (Omar), his toolbox also on his knees. The car stops near a bus stop . . . Omar gets out. They say goodbye while shaking hands . . .

4. Int./Ext. Car/Worker's Housing—Day

The car moves along, Olivier behind the wheel, Steve seated next to him . . . The car slows down, stops, Steve gets out saying goodbye and shaking Olivier's hand. The car drives away.

5. Ext. Parking Lot/Front of Apartment Building—Day

Olivier opens the back door of the car and bends over to pick up his toolbox. A man whom he had not seen approaches him . . .

> **MAN**
> I'm Steve's father . . . He's at your training center . . .

> **OLIVIER**
> Yes . . .

> **MAN**
> I would like to know if it's normal that what he earns goes into an account for him, because . . .

> **OLIVIER**
> Completely normal. It's to teach him how to manage a budget.

Olivier slams the back door of his car.

> **MAN**
> Yes, but he's at my place and, well . . . it costs me . . .

> **OLIVIER**
> He told me he gives half of his pay to his mother. Considering what he earns, that's good, isn't it?

Olivier locks the front door, starts to walk away . . .

> **MAN**
> His mother, that's not me, me I . . .

> **OLIVIER**
> Arrange it with his mother, sir.

Olivier has left, leaving the man, who still had more to say to him, behind. The toolbox on his shoulder, he crosses the square, passing a group of teenagers and children playing a game of soccer . . .

6. Int. Elevator/Apartment Building—Day

The sound of the elevator ascending. Olivier is alone, the toolbox on his shoulder. He nibbles on a small callus on the palm of his right hand, tears off a piece, spits it out . . .

7. Int. Hallway/Apartment Building—Day

Olivier, the toolbox on his shoulder, walks to the end of the hallway, passing several apartment doors . . . pushes a door, enters.

8. Int. Apartment/Apartment Building—Day

The kitchen, small, next to the dining room. Off-camera, the voice of a young man from the answering machine explains how it went on the first day at a job-site. Olivier, while listening to the voice on the answering machine, is in front of the stove, still dressed how he was at the wood shop, opening a can of soup. He pours the soup into a pot. We hear knocking at the door. Olivier doesn't hear it. He turns on the faucet, fills the can with water . . . They knock again.

> **OLIVIER** (*yelling*)
> Yes!

No one enters. Olivier pours the water into the pot.

> **OLIVIER**
> It's open!

No one enters. He goes to the door, opens it. The voice on the answering machine continues. He opens the door.

> **WOMAN'S VOICE** (*off-camera*)
> Hello.

A beat.

> **OLIVIER**
> Come in.

A woman, Magali, thirty-five/forty years old, enters . . . Olivier closes the door. Olivier goes to the phone, turns off the answering machine.

> **MAGALI**
> I was in the lobby downstairs when you got in.

> **OLIVIER**
> I didn't see you, sorry . . .

Silence. Olivier goes to the stove.

> **OLIVIER**
> Do you want coffee? . . .

> **MAGALI**
> No, thanks . . .

Silence. Olivier lights the burner under the pot.

> **OLIVIER**
> A bowl of soup?

> **MAGALI**
> No, that's all right . . . Are you still working at the center? . . .

> **OLIVIER**
> Yes . . .

He picks up a spoon and stirs the soup.

> **MAGALI**
> Do you still have back pain? . . .

> **OLIVIER**
> No.

Olivier goes to the toolbox, sets it down on a single bed, unmade.

> **OLIVIER**
> Sit down.

> **MAGALI**
> No, I'm OK . . .

Olivier takes his thermos and lunchbox from the toolbox. He returns to the stove . . .

> **MAGALI**
> I'm going to remarry . . .

Olivier doesn't react, he opens his thermos, rinses it, sets it down to dry . . .

MAGALI
. . . I need . . . I need to start something new . . .

OLIVIER
That's good . . .

He washes the cup of the thermos, wipes it dry . . .

MAGALI
And you . . . You haven't met anyone? . . .

OLIVIER
No.

Olivier turns the spoon in his soup . . .

OLIVIER
You still at the gas station? . . .

MAGALI
Yes . . .

Olivier takes the rubber lid off his lunchbox, opens the box, rinses it, sets the lid down to dry, starts to wipe the inside of the box . . .

MAGALI
I also wanted to tell you that . . . that I'm expecting a baby . . .

Olivier continues to wipe the lunchbox, the lid . . .

9. Int. Staircase/Olivier's Apartment Building—Day

Olivier rushes down the stairs, races across a landing, rushes down another flight of stairs . . .

10. Int. Staircase/Olivier's Apartment Building—Day

Olivier rushes down the final steps of the staircase, races through the lobby to the front door.

11. Ext. Street/Olivier's Apartment Building—Day

Olivier races to a car about to drive away, catches up to it. The car, driven by Magali, stops. She opens the door.

> **OLIVIER**
> Why did you come today?
>
> **MAGALI**
> Well, to tell you . . .
>
> **OLIVIER**
> Why today and not another day?
>
> **MAGALI**
> I'm off on Wednesdays . . .
>
> **OLIVIER**
> But why *this* Wednesday?
>
> **MAGALI**
> I waited for the gynecologist to tell me it was definite . . .

12. Int. Elevator/Olivier's Apartment Building – Day

Olivier, alone in the rising elevator . . . For a moment, his body shivers without cause . . .

13. Int. Olivier's Apartment—Day

Olivier drinks a bowl of soup, squats near the phone, listens to his messages.

> **ANSWERING MACHINE VOICES**
> . . . If I can't sleep here, I might come to your place. Goodbye.
> *(it hangs up)*
> . . . Hello, it's Alex, all is well on the jobsite, the boss said he would call the center to hire me. Goodbye . . .
> *(it hangs up)*
> . . . This is . . . this is Romain . . . it's not working . . . well . . . it's . . . I went to Halleux's place, like you said . . . They asked for a character reference . . . so . . . that's it . . .
> *(it hangs up)*
> . . . Mr. Riga, Copy Service here, I am waiting for your last pages to photocopy the manual. The color reproductions came out very well. See you soon.

(it hangs up)

The answering machine rewinds. Olivier takes an address book from his toolbox . . . searches for a page, finds it, picks up the receiver, dials a number, waits . . .

> **OLIVIER**
> . . . Mr. Halleux? . . . This is Olivier. I'm calling about Romain, the boy who came in today . . . yes . . . yes . . . if he hadn't screwed up, he wouldn't have come through the center . . . yes . . . no, it wasn't anything serious, you have my word . . . thank you . . . goodbye.

He hangs up, dials another number . . .

> **OLIVIER**
> . . . This is Olivier, the carpentry trainer, can I speak to Romain? . . . Tell him that he can resume work tomorrow at Halleux's place. At seven thirty. Goodbye . . .

He hangs up, looks at the phone for a moment . . . gets up, goes to the table on which there is a computer, some scattered sheets of paper marked with carpentry sketches. He takes a folder from his toolbox, places it on the table, turns on the computer, takes a swig of soup, lights a cigarette . . . gets up, goes to the phone, takes it off the hook . . . keeps the receiver in hand, hesitating to dial the number, taps the ashes from his cigarette into the chest pocket of his overalls . . . silence . . . starts to dial the number . . . Off-camera, we hear a cough. He hangs up . . . goes into the corridor.

14. Bedroom/Olivier's Apartment—Day

Olivier is in the doorway of the bedroom, looking at the bed . . .

> **OLIVIER**
> Who are you?

No response. He bends down, touches the shoulder of a woman, apparently asleep, with her back to him, covered by a coat serving as a blanket. She doesn't react . . .

> **OLIVIER**
> Who are you? . . .

A beat.

> **WOMAN** (*without turning around*)
> Sephian's mother . . . He told me that I could come to your place . . .
> that it would be open . . .

A beat.

> **OLIVIER**
> Do you want something to eat? . . .
>
> **WOMAN** (*off-camera*)
> No . . . just to stay the night . . .
>
> **OLIVIER**
> . . . No problem. I'll turn the heat up a bit.

He goes to the radiator, turns the valve and leaves the room, closing the door
behind him . . .

15. Int. Living Room/Olivier's Apartment—Day

Olivier comes from the corridor, goes to the table, takes a swig of soup . . .
takes a drag from his cigarette . . . crushes it into an ashtray . . . goes to the
phone, squats, takes it off the hook, closes the sliding plastic overlooking the
corridor . . . dials the number . . . waits . . .

> **OLIVIER**
> . . . Catherine? . . . It's Olivier . . . the boy who . . . who wanted to
> come into carpentry, what happened with him? . . . Yes . . . Oh . . . He's
> interested in welding? . . . No, no . . . See you tomorrow.

He hangs up . . . Suddenly, he falls back, lies on the floor, takes off his belt,
and starts a series of exercise movements faster and faster, raising, lowering,
raising his torso up almost to where he can touch his feet with the tips of his
fingers . . .

16. Int. Changing Room/Wood Shop—Day

From an overhanging window, Olivier watches a group of apprentices in
welding overalls cut a steel pipe with an angle grinder underneath a plastic
awning . . . Footsteps approach the changing room, Olivier quickly climbs

down from the top of a metal locker he had climbed onto in order to reach the window.

> **AN APPRENTICE (PHILIPPO)** *(entering the changing room)*
> It's noon, can we go eat?

Olivier has gone over to his locker, taking his padlock key out from his pocket . . .

> **OLIVIER**
> Yes . . . I'll be right there . . .

Philippo picks up a crate with a few lunchboxes, sandwiches, and cans from a table near the entrance of the changing room while Olivier, who has opened his locker, pretends to look for something . . . Just after Philippo leaves, Olivier reclimbs the locker to access the window . . .

17. Int. Staircase/Hallway to the Canteen—Day

Olivier climbs the steps of a staircase, holding his lunchbox and his thermos in his hands, he slows down as he arrives at the top of the staircase. Off-camera, we hear noises and voices coming from the canteen. He takes a few steps, looks at the entrance of the canteen . . . arriving from the other end of the hallway, a group of welding apprentices, he quickly goes back down the staircase . . . lets the group in the hallway pass at the top of the stairs, turns back, again climbs the staircase . . . watches the entrance of the canteen where the welding apprentices enter . . . Footsteps approach from the bottom of the staircase, Olivier, who had been hiding behind the corner, drops down and pretends to tie his shoelace . . . the person coming up the staircase passes him, heads to the canteen . . . Olivier gets up, looks toward the entrance of the canteen . . .

18. Int. Hallway/Job Training Center—Day

Olivier, still holding his lunchbox and thermos in his hands, walks down the hall . . . comes to a door, knocks, half-opens it, then enters . . .

19. Int. Canteen Kitchen/Job Training Center—Day

A female cook (forty years old) is serving, in exchange for twenty francs, bowls of soup to the apprentices, who appear in the opening of a service window that connects to the canteen.

OLIVIER
Can I eat here? . . .

COOK
There's no room in there?

OLIVIER
There's too much noise . . .

Olivier puts his lunchbox and thermos on a corner of the table, takes the rubber lid off the lunchbox, opens the box, all while watching the serving window, the opening of which is partially blocked by the faces of the apprentices and the back of the cook. He takes a piece of sausage from his lunchbox, begins to take his knife from his pocket, lets it fall back in. He goes to the sink, which is nearer to the serving window and which gives him a better view of the canteen.

OLIVIER
Can I borrow a knife?

He takes a knife that is sitting on the edge of the sink.

COOK
Take a clean one from the cupboard.

OLIVIER
No, it's all right, I'll just . . .

He turns on the faucet while watching the serving window out of the corner of his eye, cleans the knife . . . turns off the faucet . . . the last apprentice takes his bowl of soup, the cook has bent down to take out some storage containers . . .

COOK
That little Jonathan, it's been three days that he's come without anything to eat. I slip him what's left in the pot.

Olivier picks up a dishcloth, moves to better see through the serving window.

OLIVIER
Does he pay?

COOK (*off-camera, busy transferring the soup to a container*)
No!

OLIVIER (*who is still looking through the serving window while wiping his knife*)
We're not teaching him anything by giving him charity.

COOK (*off-camera*)
I know, but . . .

As the cook says these last words, Olivier suddenly turns his back to the serving window, tense, mechanically wiping the knife . . .

AN APPRENTICE (*off-camera*)
Can I have some soup?

COOK (*off-camera, while serving him*)
Twenty francs . . . Are you new? . . .

APPRENTICE (*off-camera*)
Yes . . . Thank you . . .

We stay on Olivier who listens without turning around, the knife and drying cloth in his hands . . . then turns around to look at the serving window, through which we see part of the apprentice's body from the back, moving away . . .

20. Int. Wood Shop/Job Training Center—Day

OLIVIER (*to Raoul*)
Get the square.

Olivier glances toward the windows, behind which some apprentices are passing . . . He approaches the workbench where Raoul is, passes the machines where the other three apprentices are working. Raoul puts his frame on the bench, puts the set square in the frame, looks at it . . .

RAOUL
Almost.

OLIVIER
Almost is not square. You have to remake the two mortises.

He takes apart the frame, points at a sheet of paper pinned above the workbench.

OLIVIER
What is written there? . . .

Raoul brings his face to the paper.

OLIVIER
Number one, at the bottom.

RAOUL (*reading with difficulty*)
Before . . . turning on the mortiser, *claen* . . .

OLIVIER
No. I explained it to you: *e a*, it's not *a e* . . .

RAOUL
. . . Clean the surface of the machine where the wood will be placed . . .

OLIVIER
If there is even a sliver, that's enough for your wood to not be perpendicular. Go make them again.

Raoul goes to the machine. Olivier takes his thermos, serves himself a cup of coffee, drinks it all on his way to the tenoning machine where Philippo, another apprentice, is working. This one loosens the tenon, brings it to his workbench, followed by Olivier, is about to place the tenon into the mortise of his frame . . .

OLIVIER
First check the measurements.

Philippo verifies the measurements with his two-meter ruler. Olivier glances toward the windows . . . puts his cup on the bench.

PHILIPPO
It's good.

Philippo places the tenon between the two mortises of the frame, lightly fits them together, picks up a hammer to reinforce them, and, the moment he raises the hammer to hit them, Olivier's hand restrains his arm. He looks at Olivier, surprised . . . then, understanding what Olivier means, he picks up a small piece of wood from the floor, places it on the wood of the frame and hits it with the hammer . . .

OLIVIER
You have a badly finished mortise. Take it apart.

Philippo dismantles the frame. Olivier has picked up a mallet and a chisel all while looking toward the windows, passing on the other side of which are four welding apprentices carrying a metal table . . . Philippo has come over to Olivier with his mortise which he sets in the vice, forcing Olivier to move so he has room to maneuver . . . Olivier gives the mallet and the chisel to Philippo, who finishes the mortise. Olivier looks at the mortise, gives it a few taps with the chisel, loosens the vice, shakes the shavings from the mortise, gives the wood to Philippo, who reassembles his frame under the watchful eye of Olivier, who glances at the windows . . .

OLIVIER
The square . . .

Philippo takes the set square, places it in the frame . . .

PHILIPPO (*pleased*)
Just right.

OLIVIER
Good. You can hang it up.

Olivier goes to his toolbox while glancing at the windows, he picks up the folder sitting on top, goes back over to Philippo, who finishes putting a nail above a pinned sheet of paper and hangs his frame. Olivier has taken a sheet of paper with a sketch on it from the folder, shows it to Philippo, who takes it.

OLIVIER
Go choose your wood.

Olivier, alone, pins the sketch to a window frame. He takes out another sheet from the folder with a sketch of a window shutter on it, while glancing at the windows, pins the sheet up . . . He goes to close the folder . . . stops mid-gesture, picks up the woodworking chisel that is on the bench.

OLIVIER (*to the apprentices, heading for the door*)
I'm going to sharpen the chisel!

He leaves.

21. Int. Staircase/Hallway/Job Training Center—Day

Olivier, the chisel in hand, goes down a staircase, walks down a hallway . . .

22. Ext. Courtyard/Job Training Center—Day

Off-camera, grinding sounds. Olivier crosses the courtyard, passing under a plastic canopy . . . looks sideways at the window adjacent to the door, enters . . .

23. Int. Welding Shop/Job Training Center—Day

Olivier crosses the workshop toward the bench grinder, greets the welding instructor from afar by holding up his chisel, approaches the stone drum with water, gets it up and running, begins sharpening his chisel, bends down to pick up the jerrycan can of water, pours the water into the drum tank, sets the can down, looks, partially hidden by metal shelving, toward an area where the glow from welding can intermittently be seen: four faces concealed by welding masks made of opaque glass face the object, which is welded by another apprentice, face masked . . . One of them hits the solder with a sharp-ended hammer, the one holding the rod with pincers begins welding again . . . Olivier closes his eyes and looks away . . . grinds again for a brief moment, stops the drum and carries his chisel toward the door. The moment he opens it, he bumps into the back of a welding apprentice, in overalls, hauling a small, two-wheeled cart holding two canisters to weld . . .

> **APPRENTICE**
> Thank you, sir.

Olivier, frozen, doesn't respond . . . watches him maneuver the cart with some difficulty through the door, which he is holding open . . . The apprentice passes right next to him without our being able to see his face, moves away with his back to us, pushing his cart toward the back of the shop. Olivier follows him with his gaze, closes the door behind him, takes a step to move away, goes back to look through the window adjacent to the door . . .

24. Int. Hallway/Catherine's Office—Day

Olivier, the chisel still in his hand, knocks on a door . . .

> **CATHERINE** (off-camera)
> Yes.

Olivier enters, sees Catherine busy on the phone, wants to leave, she signals him to come in while continuing her phone conversation. Olivier enters without closing the door, waits a moment, then starts to leave again . . .

> **CATHERINE** (*off-camera, into the phone*)
> Give me a minute? . . .
> (*to Olivier*)
> What's up?

Olivier, who is on the other side of the door again, reenters . . .

> **OLIVIER**
> . . . I wanted to tell you . . . the boy, the new one . . . I can take him. There are two who are already doing well, so . . .
>
> **CATHERINE**
> Go get him, I'll tell his instructor.
>
> **OLIVIER**
> Now? . . .
>
> **CATHERINE**
> Rino told me he's not catching on, it's best if he switches right away.
>
> **OLIVIER**
> OK . . .

Olivier closes the door . . .

25. Ext. Courtyard/Job Training Center—Day

Olivier, the chisel still in his hand, descends the staircase . . . crosses the courtyard, passing under the plastic canopy . . . glances through the window next to the door . . . enters . . .

26. Int. Welding Shop/Job Training Center—Day

Olivier closes the door behind him . . . Before going any further, he looks toward the back of the shop . . . toward the grinders . . . advances . . . goes over to the instructor who is teaching two apprentices how to grind the rusted edges off a metal table . . . They exchange a few words, which the noise from the grinders prevents us from hearing . . . Olivier moves away from the instructor, past an apprentice in the process of welding . . . carries on toward a door . . . knocks . . . waits . . . enters . . .

27. Int. Changing Room/Welding Shop—Day

Olivier slowly pushes the door closed behind him, looks over one side of the changing room . . . toward the open door of the bathroom . . . takes a few steps to look behind the row of metal lockers . . . pauses . . . Lying down, asleep on a bench, his back turned to us, the apprentice who had thanked Olivier for holding the door of the welding shop open as he transported the cart with the canisters. Olivier looks at him . . . the apprentice's head rests on a plastic bag overflowing with clothes . . . Olivier makes a move like he is going to leave or see if there is anyone behind the door . . . looks again at the apprentice sleeping on the bench . . .

A beat.

Olivier bangs the handle of the chisel against a metal locker . . . The apprentice does not budge . . . Olivier knocks again, harder . . . The apprentice shifts, turns over, looks at Olivier, who is looking back at him . . .

> **OLIVIER**
> It still interests you, carpentry? . . .

> **APPRENTICE**
> Yes . . .

> **OLIVIER**
> Get up and get your things.

> **APPRENTICE** (*who gets up*)
> Are you the carpentry instructor?

> **OLIVIER**
> Yes.

28. Int. Staircase/Hallway/Job Training Center—Day

Olivier climbs the steps of a staircase, walks down a hallway followed a few meters behind by the apprentice, who, in one hand, holds his sneakers, in the other, his plastic bag of clothes and his jacket . . .

29. Int. Changing Room/Wood Shop—Day

Olivier, in the narrow corridor, faces the metal lockers. He opens one locker while watching, through the open door of the changing room, the apprentice greeting the four woodworking apprentices in the shop . . . The apprentice

comes toward the changing room. Olivier leaves the corridor next to the lockers and goes near the entrance where the space is larger . . . The apprentice enters . . .

> **OLIVIER** *(indicating the open locker at the back of the corridor)*
> Your locker, get yourself a padlock. Put your things away.

The apprentice goes to the locker in the back . . . Olivier opens the padlock of another locker at the start of the row, pulls out some new overalls, looking at the sizes marked on the collar . . .

> **OLIVIER**
> You're about one meter sixty-five, sixty-four?

> **APPRENTICE** *(putting away his things)*
> Yes, sixty-four.

Olivier throws a pair of overalls on a chair situated among the lockers.

> **APPRENTICE** *(touching the overalls he has on)*
> And these? . . .

> **OLIVIER**
> You can give them back to Catherine. Not the same pockets as carpentry overalls. Hold those up to you.

The apprentice moves away from his locker, picks up the new overalls from the chair, holds them up to himself . . . they fit.

> **OLIVIER**
> Get changed.

30. Int. Wood Shop—Day

The apprentice, in carpenter's overalls, is next to Olivier, who opens a locker near a workbench. He takes out a two-meter ruler, a carpentry pencil, a pair of gloves, and a pair of protective goggles, which he places on the bench.

> **OLIVIER**
> These are yours. Put your initials on them so you'll recognize them.

APPRENTICE
My what?

OLIVIER
Your initials. The first letter of your first name and the first letter of your last name. Do you know how to write? . . .

APPRENTICE
Sort of . . . I'm better in math.

Olivier hands him a black marker.

OLIVIER (*pointing to a spot on the ruler*)
Write your initials here.

The apprentice writes his initials while Olivier watches.

OLIVIER
Unfold it.

The apprentice unfolds the ruler . . .

OLIVIER
Straight. Otherwise it will break . . .

Olivier takes the ruler.

OLIVIER
At each hinge, in the little hole, put a drop of oil. The oilcan is there.

The apprentice fetches the oilcan . . . puts a drop of oil into the hinges . . . Olivier watches him . . . After some time, he goes to the other woodworking apprentices building a base frame, kneels next to the base frame, takes his ruler from his pocket, measures the spacing between the slats . . .

OLIVIER
The bottom is good but not the top.
(*to Omar*)
Give me your jig.

Omar gives him his jig, Olivier measures it.

OLIVIER *(to Omar)*
Three millimeters too short.
(to Steve)
Remake it. Measure it with the set square!

Steve goes to cut the jig.

OLIVIER *(to Philippo and Omar)*
Pull the nails out of the slats.

Philippo and Omar lift the frame to pull out the nails.

OLIVIER *(to Raoul, who has a slat in his hand)*
Do you understand where the mistake was?

RAOUL
More or less . . . but why does the jig have to be ten and a half centimeters? . . .

Olivier stands up next to the base frame, stopping Raoul and Omar from taking the nails out of the slats.

OLIVIER *(to Raoul)*
The frame is two hundred centimeters, it must have sixteen slats two centimeters wide, that makes thirty-two centimeters taken up by the slats. The remainder is one meter sixty-eight to be divided by sixteen, which makes . . .

RAOUL
Oh yes, I understand . . .

PHILIPPO
Cool, Raoul!

RAOUL
Shut up.

Olivier takes the jig that Steve has brought over to him.

OLIVIER *(showing Raoul on the frame)*
In deferring to the ten-and-a-half-centimeter jig each time, you don't need to measure . . . understand?

RAOUL
Yes . . .

Olivier measures the jig that was cut by Steve.

OLIVIER
OK.

Olivier gives the jig back to Steve . . . glances at the apprentice . . . watches Philippo and Omar pull the nails from the slats, assisted by Steve and Raoul, who are holding the base.

OLIVIER
I won't be able to drive you all home, I have errands to run . . .

He looks at the apprentices again for a moment, then goes to the new apprentice, who finishes putting oil on his ruler . . . puts the oilcan on the bench . . .

OLIVIER
Fold it up . . .

The apprentice folds up the ruler . . .

OLIVIER
Unfold it.

The apprentice unfolds it.

OLIVIER
You put it in your pocket, here . . .

The apprentice folds the ruler and puts it in the pocket of his overalls that runs along the side of his thigh . . .

OLIVIER
Put the oilcan back where it belongs.

The apprentice puts the oilcan back in its place, comes back to Olivier, who has picked up a woodworking chisel.

OLIVIER
Put your initials on the pencil.

The apprentice writes his initials on the pencil . . . Olivier takes out his own pencil from a pocket of his overalls . . . He shows how to sharpen the pencil with the chisel . . .

OLIVIER
Without forcing it . . .

He gives the chisel to the apprentice, who tries to do what he was shown . . . Olivier watches . . .

31. Int./Ext. Car/City—Day

Olivier, still dressed in his work clothes, driving his car, rolls along, attentive . . . slows down . . . About a hundred meters in front of him: a stopped bus . . . Olivier stops . . . car horns from behind him, he moves ahead, passes the bus . . . slows down while watching his rearview mirror . . . parks partly on the sidewalk . . . looks in the rearview mirror . . . lets the bus pass him . . . proceeds . . . follows the bus for about a hundred meters . . . the bus stops . . . Olivier slows down . . . still watching the bus . . . suddenly Olivier accelerates, turns onto a street perpendicular to the one he was on while taking one last look at the bus, parks.

32. Ext. Square/Street/City—Day

Olivier, partially hidden by the angle of a house and a street sign, looks around . . . advances . . . walks on the sidewalk . . . suddenly stops, takes a few steps back, hides in the entryway of a house . . . at the end of the street, at an intersection, the apprentice looks upward, presumably at a street sign . . . From his plastic bag, he takes out a paper, unfolds it, looks at the paper . . . the streets in front of him . . . starts walking again and disappears around the corner of the street. Olivier comes out from the entryway of the house, walks quickly toward the corner of the street, and suddenly turns around having seen the apprentice retracing his steps . . . Olivier crosses the street to the opposite sidewalk . . .

APPRENTICE (*yelling, off-camera*)
Sir! Sir!

Olivier, as if he hasn't heard anything, keeps walking. The apprentice comes running up to him.

APPRENTICE *(off-camera)*
Sir!

Olivier, compelled to stop, turns around . . .

APPRENTICE *(with his paper in hand)*
I'm lost, I can't find Molinay Street . . .

OLIVIER *(unsettled)*
Which street?

APPRENTICE
Molinay Street, I . . .

OLIVIER
 . . . It's on the right at the intersection, after the railway tracks, the street that goes uphill . . .

APPRENTICE
Thank you.

Olivier moves away at a fast pace . . . glances backward, where he sees the apprentice walking toward the intersection . . .

33. Ext. Underground Passage/Street—Day

Olivier runs into an underpass . . . climbs the stairs of an access ramp covered by a wall . . . arrives at the top . . . looks around . . . takes a few steps toward the back of a building . . . The apprentice approaches a car, out of which comes a man of about thirty, whom the apprentice asks for a cigarette . . . The man gives him a cigarette, lights it . . . They go to the back of the car, pull out a box spring and two metal bedposts . . . The man carrying the bed frame and apprentice the bedposts, they cross the street in the direction of an apartment building . . . The man leans the box spring against a wall near the entrance, takes a key from his pocket to unlock the door. The apprentice puts the bedposts down on the other side of the door, he goes back across the street, looks in the open trunk of the car, takes out a rolled-up mattress, closes the trunk, goes back across the street carrying the mattress, enters the apartment building . . . emerges without the mattress, picks up the two metal bedposts . . . Olivier watches . . .

34. Int./Ext. Car/Highway—Day

Olivier, still in overalls, wearing his jacket, behind the wheel of his car. He

drives fast smoking a cigarette, letting the ashes fall into the chest pocket of his overalls . . . At one point, he undoes his belt . . .

35. Int./Ext. Car/Highway/Service Station—Day

The car slows down, passes the gas pumps without stopping . . . Olivier looks through the side window at the windows of a small checkout area/shop . . . He stops the car . . . cuts the engine . . . refastens his belt . . . waits a moment like he can't decide whether or not to get out . . . lights a cigarette . . .

36. Ext./Int. Counter/Shop—Day

Olivier is in front of the glass door, he pushes it . . . enters . . . In front of him, the back of a customer busy paying for gas . . . The customer leaves, Olivier takes a few steps . . . Behind the checkout counter: Magali.

> **MAGALI**
> What are you doing here? . . . You have a job site nearby?

> **OLIVIER**
> . . . No . . . Can I have a water? . . .

Magali takes a bottle of water from a shelf, gives it to Olivier through an opening.

> **OLIVIER**
> I'm happy for you . . . the baby . . .

He gives her a hundred francs.

> **OLIVIER**
> Is Robert happy? . . .

Magali makes the change from the register.

> **MAGALI**
> Yes.

Olivier throws his cigarette in the ashtray near the window. He opens the bottle of water.

OLIVIER
Do you know yet if it's a girl or a boy? . . .

MAGALI (*handing him the change*)
No . . . I don't want to know.

OLIVIER (*taking the change*)
Thank you . . .

He takes a swig from the bottle . . .

OLIVIER
Francis . . . Francis Thirion . . . He is out . . . He came to the center . . .

Magali looks at him, unable to speak.

OLIVIER
. . . to pursue training in carpentry . . .

MAGALI
That can't be true . . . How do you know it's him?

OLIVIER
I read it on his admission sheet . . .

A customer comes in. Olivier moves out of the way to let the customer get to the register. He drinks from his bottle while the customer pays for his gas. The customer leaves. Olivier goes back to the counter . . .

MAGALI
What did you tell the center?

OLIVIER (*crushing his cigarette*)
Nothing. I didn't need to say anything, there was no space for him. I already have four apprentices . . .

MAGALI
And if he comes back? . . .

OLIVIER
. . . He's been placed somewhere else.

MAGALI
Where?

OLIVIER
I don't know . . . It's strange that you came to my house the same day
that he came to the center . . .

MAGALI
You saw him?

OLIVIER
No . . . For a moment I thought maybe I should take him . . .

MAGALI
What for?

OLIVIER
Well . . . to teach him carpentry . . .

MAGALI
You're crazy . . . He killed our son and you want to teach him . . .

She is on the verge of tears, is turned around toward the shelves. Olivier tries
to go to her, but the glass door is locked.

OLIVIER
I didn't say I did it, I just thought about it for a moment . . .

A young motorcyclist comes in wearing his helmet. Olivier moves aside. The
young motorcyclist approaches the counter. Magali comes back behind the win-
dow, holding back her tears . . . She rings him up. The young motorcyclist heads
toward the exit. Olivier goes back to the counter . . . Magali wipes her nose . . .

OLIVIER
I'm sorry . . . I didn't want to . . .

MAGALI (*while wiping her nose*)
Don't talk about that again . . .

OLIVIER
. . . I shouldn't have come here . . . I'm sorry.

A customer pushes open the door . . .

OLIVIER
OK, I'm going . . . goodbye . . .

Olivier leaves.

37. Ext. Service Station—Day

Olivier goes to his car, he is about to get in when Magali rejoins him . . .

> **MAGALI**
> Why don't you just leave the center?

Olivier looks at her without responding.

> **MAGALI**
> Go back to working with your brother, he's always asking you to.
>
> **OLIVIER**
> I'm happy at the center, I feel useful . . .
>
> **MAGALI**
> And if he comes back? . . .
>
> **OLIVIER**
> He's somewhere else, I told you. Don't worry about that anymore. Goodbye.

He gets into his car.

> **MAGALI**
> Olivier . . .

Olivier turns toward her.

> **MAGALI**
> Are you OK? . . .
>
> **OLIVIER**
> Yes.

38. Int./Ext. Car/Street Near Francis's Apartment Building—Evening

Olivier, alone, behind the wheel of his car, driving slowly toward the apartment building where the apprentice (from now on called Francis) lives . . . the car almost comes to a stop in front of the door of the building, Olivier looks up toward the top windows . . . He parks a little further away on a perpendicular street . . . cuts the engine . . . stays there a moment looking lost in his thoughts . . . gets out of the car.

39. Ext. Entrance of Francis's Apartment Building—Evening

Olivier approaches the entrance of the apartment building . . . comes to the door . . . looks at the panel with the intercoms and buzzers . . . two buzzers do not have names . . . He presses one of the buzzers without a name . . . waits . . .

> **WOMAN'S VOICE** (*off-camera, through the intercom*)
> Hello? . . . Hello? . . .

> **OLIVIER**
> Am I speaking to the new tenant? . . .

> **WOMAN'S VOICE** (*off-camera, through the intercom*)
> No. The bell below.
> (*she hangs up*)

Olivier presses the other buzzer without a name . . . waits . . . presses a second time . . . waits . . .

40. Ext. Street—Evening

Olivier goes back to his car, puts the key in the lock, opens the door, and suddenly starts running for a hundred meters . . . stops, panting, bent over, hands on his knees . . . again he starts running at full speed . . . stops near his car . . . panting, his body doubled over, his hands on the exterior of the car . . .

41. Int./Ext. Hot Dog Stand—Evening

Olivier faces a counter, behind which a server is opening a bun and putting a sausage inside.

> **SERVER**
> Sauerkraut?

> **OLIVIER**
> Yes.

> **SERVER**
> Mustard?

> **OLIVIER**
> Yes . . .

The server finishes the hot dog, hands it to Olivier, who gives him fifty francs. Olivier says goodbye to the server, goes to the door, opens it, and, as if sur-

prised by what he just saw, makes a move to close it again . . . opens it, steps out, and runs into Francis, who is approaching the entrance of the stand . . .

> **FRANCIS**
> You're hungry too.
>
> **OLIVIER** *(mumbling)*
> Yes . . .

Francis passes him and enters the stand. Olivier crosses the street to get back to his car, gets into the car, sits down, starts the engine . . . cuts it, gets back out of the car, closes the door, leans against the car eating his hot dog . . .

A beat.

Francis exits the stand . . . Olivier watches him come toward him . . .

> **FRANCIS** *(a bag of fries in hand)*
> Do you want a fry?
>
> **OLIVIER**
> No . . .
>
> **FRANCIS**
> They're good.

Francis is near Olivier, eating his fries . . .

> **FRANCIS**
> It's funny how you could tell how tall I am . . . Steve says you can tell distances just by looking.
>
> **OLIVIER**
> Just from practice . . .

A beat.

> **FRANCIS**
> How far is it from . . . the wheel of the car to that post, there? . . .
>
> **OLIVIER** *(eating his hot-dog)*
> . . . Three meters forty-five . . .

Francis takes his ruler out from the pocket of his overalls, handing his bag of fries to Olivier . . .

> **FRANCIS**
> Can you hold this?

Olivier holds the bag in his hand. Francis, squatting, measures the distance from the wheel of the car to the post . . .

> **FRANCIS**
> Three meters forty . . . six . . .

He gets up with the ruler and moves a bit further away . . .

> **FRANCIS**
> From my feet to your feet? . . .

> **OLIVIER**
> . . . Five meters . . . seventy, seventy-five . . .

Francis measures, squatting again . . . gets closer to Olivier . . . slides the ruler along the asphalt until the end of it touches Olivier's shoe . . . who looks at Francis down near his feet . . .

> **FRANCIS**
> . . . Five meters . . . seventy-three . . . seventy-five . . .

He gets up while folding up his ruler . . .

> **FRANCIS**
> You're good . . .

Francis takes back his bag of fries, eats some, leans against the side of the car. Olivier finishes his hot dog . . .

Silence . . . suddenly interrupted by Olivier, who gets back into his car.

> **OLIVIER**
> Goodbye.

Francis, who was leaning against the side of the car, stands up . . .

FRANCIS
See you tomorrow.

The car pulls away.

42. Int. Wood Shop—Day

Olivier, in overalls and belt, runs in place, lifting his legs as high as possible, followed by the four apprentices who imitate him . . . Olivier stops, puts his hands on his hips, and rotates his trunk from the left to the right, imitated by the apprentices . . . Francis enters the workshop, his jacket over his overalls, his plastic bag in hand . . .

OLIVIER
We start at eight thirty!

FRANCIS
I didn't wake up.

OLIVIER
I don't care. You must be on time!

Francis runs toward the changing room. Olivier spreads his legs, bends down to touch the floor with his hands, imitated by the apprentices. Francis joins them, imitates Olivier . . . who now lies belly down and starts a series of pushups . . . imitated by the apprentices . . . including Francis . . .

Olivier, next to a workbench, drinks a cup of coffee from his thermos . . . goes, while putting on his gloves, over to the apprentices, who are picking up ladders that hang on a wall. They are also wearing gloves.

OLIVIER
Balance them between the fifth and sixth rung . . .

The apprentices carry the ladders on their shoulders, sometimes narrowly avoiding getting caught on one another . . .

OLIVIER *(to Francis)*
Between the fifth and sixth.

Francis, who carries his ladder awkwardly, puts it down . . . puts his shoulder between the fifth and sixth rungs . . . goes with the others to a wall, against which they lean their ladders.

PHILIPPO
How much space between the ladders?

OLIVIER
Three meters.

The apprentices calculate the three meters using steps.

OLIVIER
You want them at eight meters high. The extension is on the seventh rung.

The apprentices open their ladders . . .

OLIVIER
What is the slope?

STEVE
Ten percent.

Olivier approaches Francis, who is having trouble with his ladder. He looks at him . . .

OLIVIER
One more rung! . . . You incline to ten percent of its height. Ten percent of eight meters, how much is that?

Francis doesn't know the answer . . .

OLIVIER
Ten percent, that means divide by ten.

FRANCIS
. . . Eighty centimeters.

OLIVIER
. . . Between the base of the ladder and the wall.

Francis moves his ladder away from the wall . . .

OLIVIER
That's too much.

Francis brings his ladder in by about twenty centimeters . . .

Olivier is next to some wooden beams placed on the ground, surrounded by the apprentices.

> **OLIVIER**
> The overalls tightly fastened so nothing will get caught . . .

He lowers himself down, one knee on the ground.

> **OLIVIER**
> To pick it up without breaking your back . . .

He puts the beam on his shoulder in a sort of balance . . .

> **OLIVIER** *(getting up)*
> . . . A little more weight in the back, hold it with your hand . . .

He approaches a ladder, climbs.

> **OLIVIER**
> Hunch slightly . . . never hold the uprights because if your foot slips, you will slip with it. Always hold the rungs!

He climbs to the top . . . starts to come back down . . . The apprentices hoist a beam onto their shoulders, go to their ladders . . . paying some attention to avoid hitting one another with their beams . . . They climb . . .

> **OLIVIER** *(to Raoul)*
> Not upright!
> *(to Omar)*
> Stay closer to the ladder!

Francis picks up his beam. Olivier watches him . . . Francis starts to climb . . .

> **OLIVIER** *(to Steve)*
> Watch the wall, Steve! Hunch more!

He looks at Francis, who is now at about five meters high. He is being pulled backward by the weight of his too-tilted beam, doesn't dare let go of the rung to go higher.

OLIVIER
Pull the beam with your hand! Rebalance it!

Francis, tense from the effort and the fear of falling, is not able to rebalance the weight.

OLIVIER
Pull on it!

FRANCIS
It's too heavy!

Olivier climbs the ladder, behind Francis, a little lower, puts a gloved hand under the beam.

OLIVIER
Now pull! I have it!

Francis tries to pull but tips backward, his bottom on Olivier's head, one thigh on his shoulder . . .

OLIVIER
Go back up! Shit! Go back up!

Olivier, as if taken over by repulsion, forcefully pushes Francis up away from him with one hand, but to no avail, Francis gripping Olivier's head between his thighs to keep himself from falling.

OLIVIER (*yelling, pushing him*)
Let go of me . . . let go! . . .

Olivier quickly climbs down the rungs of the ladder with Francis on his shoulders, the beam still held by Francis with both hands.

Reaching the ground, Olivier bends forward to get Francis off him, who falls headfirst onto the ground with the beam . . .

OLIVIER (*irritated*)
What's the matter with you? Do you want to break my back? . . .

Francis, on the ground with the beam, doesn't move . . .

PHILIPPO
He's knocked out!

Philippo shakes him by the shoulder, Olivier and the other apprentices come closer. Francis comes to . . . gets up . . . Olivier is a short distance away . . .

OLIVIER
Well, we'll do it again.

The apprentices pick up their beams . . . Olivier looks at his belt, one attachment of which was torn during the accident, he undoes the metal buckle . . .

OLIVIER *(to Francis)*
Pick up your beam.

Francis tries to pick up the beam without putting his knee down.

OLIVIER
One knee on the ground!

Francis squats down, one knee on the ground, picks up the beam onto his shoulder, goes to his ladder . . . Olivier, also glancing at the others, watches him do it . . .

OLIVIER *(to Francis)*
Stay against the ladder!

Francis climbs almost to the top . . .

OLIVIER
Come down!
(to Steve, who has come down and goes to put his beam down)
One knee on the ground.

Francis comes down as Olivier looks on . . . Off-camera, the ringing of a telephone.

OLIVIER *(to Steve)*
Go answer it.

Olivier continues to watch Francis, who descends slowly . . . The other apprentices have come back down and set down their beams . . .

> **OLIVIER** *(to Francis)*
> Your hand on the rung!

> **STEVE** *(coming back to Olivier)*
> It's Mr. Dercau, or something like that.

Olivier goes to the phone on the wall . . .

> **OLIVIER**
> Hello . . . yes . . . Why? . . . He didn't give notice? . . . OK . . . goodbye.
> (he hangs up)

Olivier goes back over to the apprentices.

> **OLIVIER**
> I'll be back in an hour. Continue with your windows. Nobody on the machines except Steve, and you're not allowed to use the portable planer.
> *(to Francis)*
> Watch how Omar works and help him if he asks.

43. Int. Changing Room/Wood Shop—Day

Olivier takes off a glove, opens the padlock on his locker, puts his gloves inside, picks up his jacket, puts it on, puts it on while watching Francis's locker, left open . . . He goes to close his locker . . . glances at the door of the changing room, approaches Francis's locker . . . The plastic bag and Francis's jacket are on the bottom shelf . . . Olivier starts to rummage through the pockets of the jacket . . .

44. Ext. Near Francis's Apartment Building—Day

Olivier finishes parking his car . . . gets out of the car . . . walks down the street perpendicular to Molinay Street . . . walks down Molinay Street . . . approaches the entrance of Francis's apartment building . . . glances around him . . . approaches the door, holding a key ring with two similar keys in his hand, slides one key into the lock, it doesn't turn, he puts the other key in, opens, enters . . .

45. Int. Francis's Apartment Building—Day

Olivier closes the door behind him, he crosses the entrance hall . . . climbs the steps of a staircase without making noise . . . he hears a faint rubbing sound . . . he climbs some more stairs . . . stops, sees the back of a woman bent over cleaning the staircase . . . He turns around, goes back down the steps without making noise . . . crosses back through the entrance hall and leaves . . .

46. Int. Café—Day

At the corner of the bar, Olivier. Behind the bar, Dany, seventeen years old, his mother in the process of serving a beer to a customer.

> **MOTHER**
> He doesn't need your job anymore, I'm telling you.
>
> **OLIVIER**
> It's not my job, it's his.
>
> **MOTHER**
> He works here with me, isn't that clear!
>
> **DANY**
> Stay calm, Mom . . .
>
> **OLIVIER** (*to Dany*)
> Can I talk to you outside?

The mother moves closer to her son.

> **MOTHER**
> Why outside? I'm his mother, you can talk here!
>
> **OLIVIER** (*fiercely raising his voice*)
> He's the one I want to talk to! He's the one who didn't go to the construction site!

The customer has gotten up from his chair and puts his hand on Olivier's shoulder.

> **CUSTOMER**
> You'd better calm yourself!

Olivier turns around and grabs the customer by the scarf, tightening it around his neck. The customer, on the verge of being strangled, is stunned. Olivier, still tightening the scarf, pushes the customer into his seat.

> **OLIVIER** (to Dany)
> Are you coming?

Olivier turns away, walks to the exit of the café, glances back at Dany while opening the door . . .

47. Ext. Near the Café—Day

Olivier, next to Dany, whose gaze is lowered . . . silence . . .

> **OLIVIER**
> And if she goes back into treatment, what will you do?
>
> **DANY**
> If I'm there, she won't go back.
>
> **OLIVIER**
> You said that before when she wanted you to leave the center. You're going to be pulled down with her, that's what's going to happen.
>
> **MOTHER** (yelling, off-camera)
> Dany! Are you coming?
>
> **DANY** (to his mother)
> Yes, one second!
> (to Olivier)
> When she gets better, I can work again . . .
>
> **OLIVIER**
> Where? You think they're waiting for you? . . . Can't she let you live your life, your mother? . . .

Silence.

48. Int. Landing/Apartment Building—Day

Olivier finishes climbing the steps of a staircase . . . knocks on a door . . . We open, a Maghrebi child appears.

OLIVIER
Hello. Is Aziz here?

CHILD
Aziz!

Aziz appears, a boy of sixteen/seventeen. He shakes Olivier's hand.

AZIZ
Come in.

OLIVIER
No, I have to go back to the center. There is a spot working on the construction site for the new school, you interested?

AZIZ
Yes. Would I be working with Dany?

OLIVIER
No, you'd replace him. His mother wants him to stay with her.
(*saying goodbye and leaving*) Monday at seven thirty, I'll be there with your contract and to introduce you to the boss.

Olivier quickly descends the staircase.

49. Int. Francis's Apartment Building—Day

Olivier is near a door, from which he pulls the key from the lock, he pushes open the door . . .

50. Int. Francis's Studio Apartment—Day

Olivier delicately closes the door behind him, locks it . . . looks around . . . approaches the kitchenette . . . on the portable stove is a pan with the remainder of a stew stuck to the sides, an open can of coke, a fork . . . next to the portable stove: a jar of pepper, another of salt, a packet of margarine . . . he turns toward the corner of the apartment where the shower is, looks at it . . . goes to the window . . . looks through the window . . . turns to a table that has a stool in front of it, on the table is a half-empty bottle of milk, a glass with a few drops of milk at the bottom, an ashtray containing a few cigarette butts . . . he sits on the stool, looks in front of him . . . to the right . . . to the left . . . gets up, takes a few steps toward the unmade bed . . . on the ground are clothes and an alarm clock, on a stool: a radio and, on the radio, a box of medicine . . . He squats down next to the stool to look more closely at the

medication . . . looks at the bed, sits down on it . . . lies down . . . stays there a moment, eyes on the ceiling . . .

51. Int. Carpentry Workshop—Day

Olivier is close to Francis, watching him use his ruler to measure a long plank that is placed on trestles. Off-camera, the sound of the other apprentices nailing planks . . .

> **OLIVIER**
> Make a mark with your pencil . . . trace your saw line with the square . . .

Francis picks up the set square which is on the ground near a saw, draws the line on the plank . . .

> **OLIVIER**
> Cut it.

Francis takes the saw, starts to cut . . .

> **OLIVIER**
> Place yourself in front of the line.

Francis moves.

> **OLIVIER**
> No.

Olivier wants to touch Francis but holds back.

> **OLIVIER**
> Move over!

Francis moves aside, giving the saw to Olivier.

> **OLIVIER**
> Like this . . . In front of the line. Not like that, or you'll saw to the side. Your hand like this . . .

He gives the spot back to Francis, who starts sawing . . . Olivier watches him . . . Francis's neck and shoulder, his arm muscles, are tense from the concentration and effort . . .

Olivier, right up against Francis's back, watches him smooth down the edge of the plank with sandpaper . . . Francis slides the plank between two other planks, picks up a nail and a hammer, hits . . .

> **OLIVIER**
> The movement's in your wrist . . .

Francis hammers while accentuating the movement of his wrist . . . The other apprentices approach Olivier, dressed in their street clothes, their toolboxes over their shoulders. They say goodbye by shaking hands, saying *see you Monday* or *have a good weekend* . . .

> **OLIVIER**
> See you Monday . . . Be on time . . .

Francis turns around and says goodbye to them, also by shaking their hands . . .

> **PHILIPPO** (*to Francis*)
> Make sure you get paid double for overtime.

Francis smiles. The apprentices move away. Off-camera, we hear them close the door. Francis starts nailing again, Olivier looks on . . . They are alone . . . the place is silent . . . Francis picks up a short plank to finish making what looks like a toolbox. The plank is too wide.

> **OLIVIER**
> Sand it down . . . on this side . . .

Francis sands down one edge of the plank . . .

A beat.

> **OLIVIER**
> Why are you interested in carpentry? . . .

> **FRANCIS** (*continuing to sand*)
> I dunno . . . just am . . .

OLIVIER
Try it now.

Francis slides in the plank, which fits well . . . he picks up his hammer . . .

OLIVIER
In the place where you were, did you ever work with wood? . . .

FRANCIS
No . . . a few odd jobs . . .

Francis starts to nail . . . Olivier watches him . . . takes a few steps toward another bench, leans down to pick up a roll of shutter strapping, unrolls about a meter, takes his knife from his pocket, opens it, cuts the strap, glances at Francis who is still nailing, puts away the roll of strapping, closes his knife, goes back over to Francis . . . watches him finish nailing, the strap in his hand . . .

OLIVIER (*putting the strap onto the box*)
You put two wide-headed nails on each side, right in the middle, five centimeters from the edge . . .

Francis opens his ruler to measure the distance from the edge, makes a mark with his pencil, starts to turn the other side of the box toward him . . .

OLIVIER
Right in the middle! You have to measure that too.

Francis measures the other side . . . makes a mark, turns the box . . .

OLIVIER
What are you going to do this weekend? . . .

FRANCIS (*measuring*)
I dunno . . .

OLIVIER
Aren't you going to see people from your family? . . .

FRANCIS
No . . .

OLIVIER
Why? . . .

FRANCIS (*finishing his measurements*)
 . . . My mother's boyfriend, he doesn't want me to see her . . .

Olivier picks up two wide-headed nails, which he puts on the bench.

OLIVIER
And your father? . . .

FRANCIS
I don't know where he lives . . .

Francis picks up the strap, a nail, and his hammer, but he is not able to nail the strap on because it slides on the wood. Olivier holds the strap, trying to avoid having his hand touch Francis's hand . . . Francis hits the nail . . . Olivier turns the box, puts the strap in place, Francis hammers in the second nail under Olivier's gaze . . .

52. Int. Changing Room/Carpentry Workshop—Day

Olivier opens his locker, takes out his jacket . . . We hear Francis whistling while urinating behind the door of the changing room bathroom . . . Olivier puts on his jacket . . . closes his locker . . . takes a few steps toward the door of the changing room . . . Francis exits the bathroom . . . passes in front of Olivier while picking up the toolbox he left on the ground in front of the bathroom door . . . Olivier watches Francis go into the corridor in front of the lockers . . . enters the bathroom . . .

53. Int. Hallway/Job Training Center—Day

Olivier, in overalls, his jacket over them, his toolbox on his shoulder, walks down a hallway followed by Francis, in overalls, his jacket over them, his toolbox on his shoulder, into which he has placed his plastic bag . . .

54. Ext. Parking Lot/Job Training Center—Day

They walk on the asphalt in front of the center, suddenly Olivier moves away to go to his car.

OLIVIER
See you Monday.

Francis extends his hand, but Olivier is already several meters away.

FRANCIS
See you Monday.

Olivier gets to his car, opens the driver-side door while watching Francis walk away . . . He opens the rear door where he puts down his toolbox, watching Francis walk away . . . He whistles by putting his fingers between his lips . . . Off-camera, Francis hears him. Olivier gestures with his arms for Francis to come over to him. He puts his toolbox on the back seat . . .

OLIVIER
Do you want me to drive you home?

FRANCIS *(off-camera)*
Sure.

Francis appears, close to the car, opens the passenger-side door to get in . . . Olivier closes the rear door, takes a step toward the driver's side door, and the moment he goes to lower himself into the seat, sees something across the parking lot . . . he moves away from the car, walking about twenty meters . . . stops level with a car . . . it's Magali's. He is right next to her driver-side window . . . Magali rolls down the window . . .

OLIVIER
Are you spying on me? . . .

A beat.

MAGALI
. . . Is that him? . . .

OLIVIER
No . . .

A beat.

Suddenly Magali gets out of her car to go to the car where Francis is, Olivier restrains her . . .

MAGALI
Let go of me!

She tries to break away, Olivier holds her more tightly.

OLIVIER
Calm down!

MAGALI
I want you to tell me his name! Let go of me!

She fights him, Olivier keeps her restrained, she manages to break away, takes one more step in the direction of Olivier's car where Francis is.

OLIVIER
It's him . . .

Magali doesn't move . . . She seems to faint . . . Olivier takes a quick step, catching her as she collapses . . . He walks her back to her car . . .

FRANCIS (who has gotten out of the car)
Do you need help, sir?

OLIVIER
No!

They are next to Magali's car . . . Olivier opens the front door, which was left ajar, supporting Magali as he sets her into the seat . . . She seems to come to . . .

OLIVIER
I have some coffee in a thermos, I'll get it.

Olivier runs to his car, opens the rear door to retrieve the thermos from his toolbox. Francis, sitting in front, turns around.

FRANCIS
Everything all right? . . .

Olivier grabs the thermos without responding, he runs to the other car, squats next to Magali while opening the thermos, pours some coffee into the cup . . .

MAGALI
Who do you think you are? . . .

Olivier gives the cup to Magali.

OLIVIER
Here.

MAGALI
No one would do that . . .

OLIVIER
I know . . . Drink . . .

Magali takes a swig . . .

MAGALI
Then why are you doing it?

OLIVIER
I don't know . . .

55. Int./Ext. Car/City—Day

Olivier behind the wheel of the car. Francis is in the passenger seat, his tool-box on his knees . . . The car drives down a commercial street . . .

OLIVIER
Where do you live? . . .

FRANCIS
Um, Molinay Street . . .

OLIVIER
At the bottom of the street? . . .

FRANCIS
Yes . . .

The car rolls along . . . Silence . . . The car approaches an intersection, stops at a red light . . . Silence . . . It starts moving . . . crosses a square, comes to an intersection with a stop sign. Olivier looks left, right . . .

OLIVIER
Tomorrow, I'm going to a lumberyard. You could come with me to learn how to recognize different kinds of wood? . . .

He says this without looking at Francis, minding the cars driving along the road with the right of way . . .

> **FRANCIS**
> . . . OK.

The car starts moving . . .

> **OLIVIER**
> The others have already gone. This will put you at the same level as them.

The car rolls along, passes a bridge . . . Silence . . . The car goes down several streets . . . takes Molinay Street . . .

> **FRANCIS**
> It's here . . . in front of the big thing for rent . . . here.

The car slows down as it comes to the apartment building where Francis lives.

> **OLIVIER**
> I'll come pick you up at nine.

The car stops. Francis opens his car door then turns toward Olivier.

> **FRANCIS**
> Thank you . . .

Francis holds out his hand . . . Olivier seems to hesitate a moment before shaking his hand . . .

> **FRANCIS** (*getting out of the car*)
> See you tomorrow . . .

56. Ext. Street/City—Evening

Olivier is about to cross the street, his jacket over his overalls, a folder under his arm. Cars are passing by in both directions . . .

57. Int./Ext. Copy Service/City—Evening

Olivier appears behind the glass of the door of Copy Service, a cardboard box in his arms. The employee opens the door for him.

He leaves, walks on the sidewalk carrying the box . . .

58. Int./Ext. Car/Molinay Street—Evening

Olivier behind the wheel of his car, which slows down as he approaches the apartment building where Francis lives . . . He parks the car along the sidewalk, cuts the engine . . . takes a bound document from the cardboard box placed on the backseat . . .

59. Ext. Entrance of Francis's Apartment Building—Evening

Olivier approaches the entrance . . . pushes the buzzer without a name . . . waits . . . someone answers . . .

> **VOICE OF FRANCIS** (*through the intercom*)
> Yes? . . . Hello? . . . Hello? . . .

Olivier doesn't speak right away.

> **OLIVIER**
> . . . It's Olivier . . . I brought you a woodworking manual, so you can prepare for the visit tomorrow . . .

> **VOICE OF FRANCIS** (*through the intercom*)
> Do you want to come up or should I come down? . . .

> **OLIVIER**
> . . . I . . . I'll come up.

> **VOICE OF FRANCIS** (*through the intercom*)
> It's on the second floor . . .

The buzzing of the automated lock on the door, Olivier pushes the door open . . .

60. Int. Entrance/Staircase/Francis's Apartment Building—Evening

Olivier takes a few steps, the lights go on in the staircase . . . He walks toward the staircase, climbs the steps . . . Suddenly, he turns around, goes back down the staircase, re-crosses the hall, turns around again . . . goes to put the manual on one of the steps at the bottom of the staircase, when he spots Francis standing at the top of the first flight of stairs . . . He puts the manual on the step.

OLIVIER
I'm in a hurry.

He turns around and leaves.

61. Int. Olivier's Apartment—Night

Olivier, in a t-shirt and underpants, is lying on his back, successively lifting one leg in an oblique motion then the other, in a more and more sustained rhythm . . . he stops, exhausted, his breath labored, his face covered in sweat . . .

Still in his t-shirt, on a piece of board placed on the table, he finishes cutting, with the help of a blade, a piece of leather . . . Using a hole-punch and a hammer that he takes from his toolbox, he stamps out three holes in the leather . . . takes his large leather belt and puts the new piece of leather at the point where the piece that tore off had been attached . . . He takes a rivet from a small box on the table and attaches the piece of leather to the belt, hitting the rivet with his hammer . . . He takes another rivet from the small box, puts it into one of the holes in the belt, picks up his hammer, hits the head of the rivet a few times . . . pauses as if he's heard a noise . . . he listens, without moving . . . he goes to the front door . . . opens it abruptly, looks into the hallway . . . There is no one there . . . He closes the door, locks it . . . goes back to the table . . . and starts hitting the rivet with the hammer again . . .

62. Ext. Courtyard/Job Training Center—Day

Olivier, in carpenter's overalls, his jacket over them, the belt around his waist, pulls a trailer, assisted by Francis who is pushing from the rear, him also in carpenter's overalls, his jacket over them. They follow along the plastic canopy, heading toward the open gate . . .

63. Ext. Parking Lot/Job Training Center—Day

Olivier holds the trailer by its tongue as they approach the back of his car, assisted by Francis, who is supporting the trailer from the other side . . . Olivier attaches the trailer . . . squats to reinforce the electric plug into the socket, then attach the security chain as Francis looks on from behind . . .

64. Int. Toolshed/Courtyard of Job Training Center—Day

Olivier opens a locker, takes out a rope, which he makes a few knots in, then wraps it around his arm, which is bent at a right angle . . .

65. Ext. Parking Lot/Job Training Center—Day

Olivier opens the trunk of his car, puts the rope as well as a large plastic tarp inside, closes the trunk, goes to the driver-side door, opens it, sits down next to Francis seated in the passenger's seat, closes the door, starts the engine . . .

66. Int./Ext. Car/Highway—Day

Olivier at the wheel. He watches the road . . . at times glancing at Francis, seated in the passenger seat, busy reading the manual open on his knees . . . The sound of the engine, the tires on the road . . .

> **OLIVIER**
> So? . . .

> **FRANCIS**
> I dunno . . . Does it say? . . .

> **OLIVIER**
> No, but you can guess by looking at the ages of the mature trees underneath the photos . . .

Francis looks at different pages of the manual. Olivier looks ahead . . . at times glancing at Francis, focused on the pages of the manual . . .

A beat.

> **FRANCIS**
> Soft woods come from trees that grow fast, and hard from trees that grow more slowly . . .

> **OLIVIER**
> . . . Yes . . . the coniferous and the deciduous . . .

> **FRANCIS**
> At Fraipont, we chopped down a hundred-twenty-year-old tree so that it wouldn't fall on the roof . . .

> **OLIVIER**
> What kind? . . .

> **FRANCIS**
> I dunno . . .

> **OLIVIER**
> How do you know it was a hundred and twenty years old?

FRANCIS
From the circles in the trunk.

OLIVIER
Those are called rings. Who taught you that? . . .

FRANCIS
A guy I was in Fraipont with . . .

A beat.

OLIVIER
How old were you when you went to Fraipont?

FRANCIS
Eleven, I think . . .

OLIVIER
You don't remember when you were locked up? . . .

FRANCIS
Yes . . .

OLIVIER
Then why did you say *I think*?

FRANCIS
It was a long time ago, so . . .

A beat . . .

FRANCIS *(pointing through the side window)*
What kind of trees are those, there?

OLIVIER
Where?

FRANCIS
Those big ones.

OLIVIER
Beeches . . .

Francis looks in the manual . . .

FRANCIS
A hard wood . . .

OLIVIER
Yes . . . to make some furniture, some staircases . . . as well as some handles of tools because it's very smooth, the hand can slide . . .

The car continues rolling along . . . They don't say anything more . . .

67. Int./Ext. Car/Road/Path—Day

The car rolls along . . . Olivier puts on the blinker, turns onto an asphalt path at a steep slope . . .

FRANCIS
Is it here? . . .

OLIVIER
No . . . I'm going to show you something . . .

The car moves about a hundred more meters, comes to the concrete bank of a canal. We hear the sound of a waterfall . . . The place is deserted . . . The car stops, Olivier gets out. Francis does the same . . .

68. Ext. Bank/Dam—Day

Olivier walks along the canal. Francis walks next to him. Off-camera, we hear the sound of a waterfall . . . Olivier takes out his pack of cigarettes, pulls one out, goes to light it . . .

FRANCIS
Can I have one? . . .

OLIVIER
Don't you have your own? . . .

FRANCIS
Not any more . . . I buy the small packs . . .

Olivier comes to a halt, gives him a cigarette. Francis takes a lighter from his pocket, lights his cigarette . . . Olivier has also lit his and walks in front of Francis. They come to a dam built from solid wood beams side-by-side, over which falls a mass of water. The noise is overpowering. They have to raise their voices to be heard.

OLIVIER (*pointing to the beams*)
What kind is that?

Francis looks, indicates that he doesn't know . . .

OLIVIER
Hard or soft?

FRANCIS
Hard . . .

OLIVIER
Why?

FRANCIS
To hold back the water.

OLIVIER
So that it doesn't soak into the wood. It's oak, it takes a long time to grow. The wood is very dense, compact.

They don't say anything more . . . taking a drag from their cigarettes from time to time, watching the water fall over the tops of the wooden beams into eddies of the canal . . .

69. Int./Ext. Car/Road/Small Town—Day

Olivier at the wheel. The car goes down a road . . . stops at an intersection near a small town . . . Olivier looks at Francis . . . who is asleep, his head resting against the side window . . . The car starts moving again, taking a road that goes through town . . . becomes a country road . . . It rolls along. Olivier looks at Francis, still asleep . . . Suddenly Olivier looks in the rearview mirror then brakes abruptly. Francis is thrown forward against the dashboard. He is awake.

OLIVIER
A rabbit.

FRANCIS
I had fallen asleep . . .

OLIVIER
Didn't you sleep last night? . . .

FRANCIS
I did, but I'm taking medication to help me sleep . . .

A beat . . .

FRANCIS
Is it still far? . . .

OLIVIER
Forty kilometers . . .

A beat . . .

OLIVIER
. . . What did you do to get locked up at Fraipont at eleven years old? . . .

Francis doesn't respond.

OLIVIER
Hey! . . .

FRANCIS
What? . . . I was falling asleep again . . .

OLIVIER
What did you do to get locked up at Fraipont at eleven years old? . . .

FRANCIS
A stupid mistake . . .

A beat.

OLIVIER
What kind of stupid mistake? . . .

FRANCIS
A robbery . . .

OLIVIER
. . . They put you away just for a robbery? . . .

FRANCIS
. . . Yes . . . then with other stuff . . . Can I go in the back to sleep? . . .

OLIVIER
Yes . . .

Francis turns around and, sliding between the two front seats, gets in back . . .

> **OLIVIER**
> Hand me my box.

Francis passes him his toolbox, which his thermos is in, Olivier puts it on the passenger seat . . . Francis is curled up on the bench seat . . . Olivier drives . . . one moment looking in his rearview mirror . . . again ahead of him . . . the sound of the engine, the tires on the road.

70. Ext. Service Station/Car—Day

Olivier picks up the gas nozzle, approaches the car . . . while filling the tank, he watches Francis through the rear window, lying on the seat, asleep . . .

71. Int./Ext. Car/Small Town—Day

Olivier at the wheel, the car climbs a road . . . enters a small town . . . crosses the town square . . . slows down . . . parks . . .

> **OLIVIER**
> Aren't you hungry? . . .

Francis doesn't respond, he is sleeping. Olivier turns around, looks at Francis asleep on the back bench seat.

A beat.

Olivier gets out of the car, does a few knee bends, his hands on his hips . . . approaches the rear window of the car, watches Francis sleep . . . knocks on the window . . . Francis doesn't move . . . Olivier opens the front door of the car again, leans into the car.

> **OLIVIER** (in a louder voice)
> Aren't you hungry?

Francis wakes up . . .

> **FRANCIS**
> Are we there?

OLIVIER
No. Are you hungry?

FRANCIS
. . . Sure.

Olivier closes the car door, walks through the square . . . is joined by Francis who runs up . . . They walk toward some shops lining the square . . .

72. Int. Bakery/Small Town—Day

Olivier and Francis are in front of the counter. Behind, the shopkeeper.

OLIVIER *(to Francis)*
What do you want?

FRANCIS
I dunno . . .

OLIVIER *(to the shopkeeper)*
An apple turnover.

A beat.

FRANCIS
Me too . . .

Olivier takes his turnover, gives her a hundred-franc bill.

SERVER
For both? . . .

OLIVIER
No . . .

The shopkeeper gives Olivier sixty francs in change, hands a turnover to Francis, who searches for money in one of his pants pockets . . . in the other . . . finds a fifty-franc coin, which he gives to the shopkeeper . . .

73. Int. Café/Small Town—Day

Olivier and Francis are seated at a table eating their turnovers.

The café owner brings them their drinks, setting down a coffee for Olivier and a Coke for Francis . . . They eat . . . When Olivier takes a sip of coffee, Francis takes a sip of Coke . . .

A beat.

> **FRANCIS**
> . . . Would you be willing to be my mentor? . . .

Olivier looks at him . . . takes a sip of coffee . . .

> **OLIVIER**
> Don't you already have one? . . .

> **FRANCIS**
> No . . .

> **OLIVIER**
> And your caseworker, it's up to him . . .

> **FRANCIS**
> That's not the same thing, he's someone from Fraipont . . . I'd prefer someone from outside . . .

Olivier wipes his hands with the paper the turnover was wrapped in . . .

> **FRANCIS**
> You'll do it? . . .

> **OLIVIER**
> I don't know . . . I have to think about it . . .

He takes a sip of coffee . . . Francis has finished his turnover, wipes his hands with the paper it was wrapped in . . . takes a sip of Coke . . .

> **FRANCIS**
> Want to play a game of foosball? . . .

Olivier finishes drinking a mouthful of coffee . . .

> **OLIVIER**
> Why do you want me to be your mentor? . . .

FRANCIS
. . . You're the one who is teaching me my trade . . .

Olivier and Francis stand, each on one side of the foosball table. Olivier watches Francis, who, leaning down, drops the balls into the repository . . . resets the numbers on his score counter . . .

FRANCIS
Your counter . . .

Olivier pushes back the numbers on his counter.

FRANCIS
Can I call you Olivier? . . .

OLIVIER
Why? . . .

FRANCIS
The others, they call you Olivier . . .

OLIVIER
. . . If you want . . .

Francis puts the ball in play . . . They play . . . After some time, Francis scores a goal. He smiles, happy, moves a number on his counter, picks up new ball . . .

OLIVIER
What else happened along with the robbery? . . .

FRANCIS
. . . There was a death . . .

They play . . . Olivier holds the ball with one of his players.

OLIVIER
You killed someone? . . .

FRANCIS
Yes . . .

They continue playing . . . Francis scores a goal . . . He smiles, moves a number on his counter.

FRANCIS
At Fraipont, I was the champion.

He feeds another ball into play. They play . . .

74. Int. Bathroom/Café—Day

Olivier washes his hands over a small sink . . . takes a paper towel from the dispenser . . . dries his hands while looking at his face for a moment in the mirror above the sink . . . he takes off his glasses, rubs them with the used, wet paper towel, throws it in the garbage, takes another from the dispenser, wipes the lenses of his glasses . . .

75. Ext. Small Town Square—Day

Olivier walks across the square in the direction of a truck with a trailer . . . He removes a pack of cigarettes from his pocket, takes one out, stops to light it, walks along the back of the trailer, disappearing onto the other side . . .

76. Ext. Small Town Square—Day

Olivier walks along the trailer . . . comes to his car . . .

FRANCIS (*leaning against the car*)
Can I have another one? I'll pay you back Monday . . .

Olivier takes the pack from his pocket again, gives a cigarette to Francis, who lights it. Olivier opens the front passenger door of the car to take out his toolbox . . .

OLIVIER (*picking up his toolbox*)
Why did you kill someone? . . .

FRANCIS
 . . . I dunno . . .

Olivier passes by Francis with his toolbox, goes to open the back door . . .

OLIVIER
What do you mean, you don't know? . . .

FRANCIS
I don't want to talk about that . . . it's in the past . . .

Francis is sitting in the passenger seat and slams the door. Olivier opens the back door and puts his toolbox on the bench seat . . . He slams the door, walks around the car, opens the driver side door, sits at the wheel . . . watches Francis take a drag from his cigarette . . . closes the door, turns on the car . . . pulls out in reverse . . .

77. Int./Ext. Car/Country Road—Day

The car rolls along, Olivier at the wheel, Francis next to him . . . They do not speak . . .

A beat.

FRANCIS
Is it still far? . . .

OLIVIER
No, two, three kilometers . . .

A beat.

OLIVIER
Why did you kill them? . . .

Francis doesn't respond . . .

OLIVIER
You asked me to be your mentor, I have the right to know, don't I?

Francis doesn't respond . . .

OLIVIER
What were you stealing?

A beat.

FRANCIS
A car radio . . .

OLIVIER
You killed someone for a radio? . . .

FRANCIS
. . . A boy I hadn't seen was in the back, he wouldn't let go of me, and I grabbed him by his neck until he let go . . .

A beat . . .

OLIVIER
You strangled him . . .

FRANCIS
He wouldn't let go of me.

OLIVIER
You strangled him.

FRANCIS
I didn't want to, I was afraid of getting caught.

OLIVIER
You still did it, otherwise he wouldn't be dead!

FRANCIS
Yes but . . .

OLIVIER
Don't say *yes but*. You did it, yes or no?

FRANCIS
. . . Yes.

The car rolls along . . . Suddenly Olivier brakes . . .

OLIVIER
I passed it . . .

He makes a U-turn . . . drives two, three hundred meters . . . The car turns, taking the entrance road to a lumberyard, overlooking a parking lot where several trucks are parked alongside piles of logs and tree trunks. On the other side of the parking lot: a large warehouse with slatted walls. Olivier parks the car . . . Olivier and Francis are about to get out of the car . . .

OLIVIER
Do you regret what you did? . . .

FRANCIS
Obviously.

OLIVIER
Why obviously? . . .

FRANCIS
Five years in lock-up. That's something to regret.

Francis gets out of the car, the manual in hand.

FRANCIS
I'm going to take a quick pee.

Olivier gets out of the car.

78. Ext. Parking Lot of Lumberyard—Day

Olivier is out of the car, opens the back door to take out his toolbox while watching Francis, urinating, partially hidden by the back of a truck . . . He walks to the entrance of the warehouse, pulls a key from his pocket, slides it into the lock to open the door. He is rejoined by Francis, who comes running up to him . . .

FRANCIS
You have the key?

OLIVIER
It's my brother's place.

Olivier opens the door.

FRANCIS
It's his?

OLIVIER
Yes . . .

They enter . . .

79. Int. Warehouse of Lumberyard—Day

They walk down an aisle of the large warehouse. Around them: stacks of planks of two, three, five meters in height, saws, wood chips, sawdust . . .

> **OLIVIER**
> First we'll choose the wood for the center.

They walk along the stacks of planks separated from one another by slats . . . Olivier makes a stop.

> **OLIVIER**
> We separate the planks so that there is air between them and they can dry. If you build a door with wood that hasn't dried . . .
>
> **FRANCIS** *(interrupting Olivier)*
> It will shrink.
>
> **OLIVIER**
> Yes. And there would be gaps between all the boards.

They resume their walk toward the back of the warehouse . . . They take a narrower path between two stacks of planks, Francis walks behind Olivier . . . Olivier stops next to the last stack of planks . . .

> **OLIVIER**
> What's this?

He lets Francis come closer . . .

> **FRANCIS**
> Pine . . .
>
> **OLIVIER**
> Which pine? . . . Look in the manual.

Francis looks at the photocopied samples in the manual . . .

After a beat.

> **FRANCIS**
> Oregeon pine . . .

OLIVIER
Do you say *Peugeot* or *Peugot*?

FRANCIS
Peugeot.

OLIVIER
Why?

Francis doesn't know how to answer . . .

OLIVIER
When there's an *e* between the *g* and the *o*, it's pronounced *geo*, when there isn't, it makes *go* . . .

FRANCIS
Oregon . . .

OLIVIER
It's a region of America.
(he touches the wood)
Is this a soft wood or hard? Without looking at the manual. Run your nail over it.

Francis runs his nail over the plank, which leaves a mark.

FRANCIS
Soft.

OLIVIER
Yes . . . And this one, what is it? . . .

Olivier has pointed to a pile of planks a bit further on . . .

They approach it . . . Francis looks at the wood . . .

FRANCIS
It's also a pine . . .

OLIVIER
Which? . . .

Francis looks in the manual . . . Olivier is next to him, a little behind him, along his back . . .

OLIVIER
Look at the grain of the wood . . .

Francis looks at the wood more closely . . . looks in his manual . . .

FRANCIS
It's red fir . . . Douglas . . .

OLIVIER
Yes, from Canada . . . We'll take three planks of that and three of the Oregon . . .

Olivier puts his toolbox down and starts to climb up onto the pile of fir planks . . . He is three, four meters high, slides the large plank on top to the side, picks it up by the middle, more or less balanced, then slowly lowers it down . . .

OLIVIER
You have it? . . .

Francis, who has put down his manual, catches the end of the plank.

FRANCIS
Yes.

OLIVIER
Let it hit the ground . . .

The end is on the ground, the six-meter plank is positioned vertically, held at the top by Olivier . . .

OLIVIER
Move away while holding it.

Francis moves toward the end of the path while holding the plank, which drops lower and lower to the ground . . . Olivier picks up another plank . . .

Olivier and Francis, each on one end, lift a plank and lay it on the table of an electric saw. Francis measures with his ruler, which he places on the plank at a length of three meters, marks a mark with his pencil . . . They bring the plank to the blade and Olivier turns on the saw . . . he cuts the plank, puts one half of it on top of the other half with Francis's help. They lift the planks,

carry them a few meters away, placing them on the other planks they already cut . . . Olivier lifts all of the planks from one end, holding them in his arms. Francis tries to do the same with his end, just manages. They walk down the aisle that leads to the exit . . .

80. Ext. Parking Lot of Lumberyard—Day

They walk, carrying the planks toward the trailer attached to Olivier's car . . . They put the planks into the trailer . . .

81. Int. Warehouse of Lumberyard—Day

They are walking down an aisle of the warehouse . . . down the narrower path toward the Oregon pine . . . Francis walks behind Olivier . . . Each of them goes to one end of the three six-meter planks of Oregon pine . . . lift them . . . walk with them in their arms, avoiding the planks that stick out from the piles . . .

They walk, carrying the planks . . . arrive at the electric saw . . . put them down . . . lift one, which they lay on the table of the saw . . . Francis measures with his ruler, makes a mark with his pencil . . . they bring the plank to the blade. Olivier turns on the saw . . . he cuts the plank, puts half of it on top of the other half with Francis's help. They lift the planks. Olivier is behind Francis.

> **OLIVIER**
> The boy you killed, it was my son . . .

Francis turns around . . . moves away from Olivier, letting the planks fall . . . He can't escape down the aisle that leads to the exit because it's on the other side of Olivier . . . Suddenly he turns around and runs toward the back of the warehouse . . .

> **OLIVIER**
> Come back!

Francis disappears down an aisle. Olivier runs to the aisle Francis rushed into, running after him down another aisle that, at a point, becomes narrower for a few meters because of a pile of longer planks. Francis runs through this pathway. Olivier also tries to run through but his body gets stuck between the planks.

OLIVIER
Don't be afraid! Come back!

Olivier turns around, runs down another, wider aisle . . . For a moment, be-
tween two piles of planks, he sees Francis running down the aisle that leads
to the exit . . . He runs, taking a perpendicular aisle . . . sees Francis running
toward the exit . . .

82. Ext. Parking Lot of Lumberyard—Day

Olivier runs out of the warehouse into the parking lot near the trucks, he
runs up to the road, looks . . . comes back to the parking lot, looks behind a
truck . . .

OLIVIER (*yelling*)
Where are you? . . . Show yourself! . . .

Olivier walks around a truck . . . looks under the trailer of a second truck . . .
goes over to a pile of logs . . . cannot climb over it . . . He climbs onto the
bumper of a truck, then onto the edge of the trailer, holding onto a metal
post with one hand, looks toward the top of the pile of logs . . . Barely visible
through a space between the logs, a section of Francis's back . . .

OLIVIER
I see you! . . . Come down from there!

Francis doesn't move . . .

OLIVIER
Come down! . . .

Francis still doesn't move . . . Olivier climbs down the truck, approaches the
pile of logs, and looks up toward the top of the pile, which is two, three me-
ters . . . he pulls himself up the narrow side of the log pile with the help of
posts that are holding the logs in place . . .

OLIVIER
Come down! . . . I won't do anything to you.

FRANCIS (*yelling*)
I don't believe you! Let me leave!

Olivier's head is above the top of the pile of logs, a few meters from Francis, who has come out from between the logs and is scrambling on all fours toward the other side of the pile, which is against a wall . . .

OLIVIER
Come down . . . I just want to talk to you . . .

FRANCIS (*yelling*)
I was locked up for five years! I paid for it! Leave me alone!

Olivier's torso breaches the top of the pile, he makes a move to climb a bit higher . . . Francis goes back toward the space he had been hiding in, picks up a log, ready to throw it at Olivier . . .

OLIVIER
Put that down! . . .

Francis looks at him, the log in his hand . . .

OLIVIER
Put it down! . . .

Olivier makes a move to hoist himself up onto the top of the pile, Francis throws the log at him. Olivier barely avoids being hit by letting himself fall. Francis runs toward the other side of the pile to jump down, but Olivier, who has stood up, runs to the spot below Francis. Francis runs to the other side. Olivier, below, runs to the same place. Francis picks up another log. Olivier recedes behind a truck trailer. Francis throws the log at Olivier, who has just enough time to protect his face but stumbles and falls behind the trailer. Francis jumps down from the log pile. He slides under the truck on all fours. Olivier sees Francis's feet disappear under the truck. He turns around, runs after Francis, who is running, arrives near Olivier's car, moves around it to escape from Olivier . . . Olivier moves around the car, straddling the tongue of the trailer . . . Francis turns again . . . Suddenly Olivier climbs onto the hood of the car to get to the other side . . . Francis moves away from the car, runs toward a field that slopes down on the other side of the road . . . Olivier jumps down from the car, pursues Francis . . .

83. Ext. Field/Country—Day

Francis slides quickly under the fence, runs down the slope of the field where some cows are grazing . . . Olivier straddles the fence, runs after Francis . . .

84. Ext. Ditch/Country—Day

Francis is about a dozen meters ahead . . . He slides under a fence at the bottom of the field, disappears into a ditch that separates the field from a wooded area . . .

Olivier jumps over the fence . . . Francis slips while coming out of the ditch . . . Olivier is close to him, Francis manages to evade him, runs into the woods . . .

85. Ext. Woods/Country—Day

Francis runs between trees, over fallen branches . . . Olivier is right behind him, they run, their breathing labored, panting . . . Suddenly Francis makes an abrupt move to one side, goes around a tree trunk, and starts running back toward the field . . . Olivier has passed to the other side of the trunk . . . manages to catch up, throws himself on him, they fall to the ground . . . Francis tries to defend himself with his hands and feet, but Olivier is able to get the upper hand . . . He is on top of Francis, who is fighting back, he holds down his legs and his chest . . . tries to catch Francis's hands, his forearms, which Francis is holding in a crossed position below his face to protect his throat . . . Olivier, in a violent move, turns Francis over to face him . . . Francis tries to bite his wrist . . . Olivier manages to uncross Francis's forearms, pinning them, for a brief moment, against Francis's torso, then suddenly grabs Francis's throat with his two hands . . . Francis grabs Olivier's wrists with his hands, trying to separate them . . . Olivier, his breathing tense, looks at Francis, who looks at him . . . After some time, Olivier's head and shoulders come closer to Francis . . . Olivier lets go of Francis's throat, his hands come to rest partly on the ground and partly on Francis's head, who is turned away, his arms circled around his head and neck as if he is trying to protect himself . . . Olivier stays in this position for a moment, then slowly moves away from Francis on all fours . . . sits up, gradually catches his breath . . . After some time, Francis gets up, sits next to Olivier, also catching his breath . . . We stay with them, seated, catching their breath . . . Olivier gets up and moves away through the trees toward the lumberyard, leaving Francis . . .

86. Ext. Parking Lot of Lumberyard—Day

Olivier puts the planks into the trailer, onto the large plastic tarp that he unfolded . . .

The moment he picks up a plank that was leaning against a truck and goes to slide it into the trailer, he sees Francis . . . at the end of an aisle, near a pole that is holding up the roof of the warehouse . . . Olivier stops moving, looks

at Francis . . . who looks at him . . . Olivier puts the plank into the trailer, on the tarp . . . picks up another plank leaning against the truck, puts it into the trailer . . . turns around to pick up the second-to-last plank leaning against the truck . . . Francis approaches him . . . He looks at Olivier, who looks at him . . . He hesitates about whether to make the gesture of picking up the last plank that is leaning on the truck . . . He does . . . Olivier puts his plank in the trailer . . . Francis puts his next to Olivier's . . . Olivier wedges the piles of planks against the sides of the trailer to steady them . . . Francis watches . . . starts to fold the large tarp over the planks . . . still Francis watches, hesitant to help . . . after some time, Francis helps Olivier wrap the tarp around the planks . . . He holds the tarp down with his arms and hands to prevent the wind from blowing it open while Olivier gets the rope from the trunk of his car . . . Olivier is next to Francis, he starts to tie the rope around the planks wrapped in the tarp, held in place by Francis.

Fade to black.

The Child

1. Int. Staircase/Hallway/Apartment Building—Day

Sonia, a young woman of eighteen years, climbs the steps of a staircase, walks down a hallway . . . She carries a newborn wrapped in a baby burnoose in her arms, covered with a sheet, its hooded head resting in the crook of her shoulder. From the wrist of the arm holding the baby hangs a plastic bag with a few things in it. With her other hand, she searches her jacket pocket, seemingly looking for a key . . . She stops in front of a door, puts the key in, turns it to open it and hardly has the door open when it is slammed shut by someone inside . . .

> **YOUNG WOMAN** (off-camera, from behind the door)
> What is it? . . .
>
> **SONIA**
> Huh? This is my place! Open up! . . . Bruno! Open up! Bruno! . . .

She tries to push the door open while turning the key, to no avail. Suddenly, the door opens, revealing the face of a young man who is unshaven, thin, shirtless. Sonia tries to enter, the young man blocks the door with his foot.

> **YOUNG MAN**
> What do you want?
>
> **SONIA**
> What are you doing in my apartment?

A young woman with dyed red hair has appeared behind the young man's shoulder.

> **YOUNG MAN**
> Bruno rented it to me for the week.
>
> **SONIA**
> Where is Bruno?
>
> **YOUNG MAN**
> Dunno.

The young man tries to close the door, but Sonia pushes it back with her hand and knee . . .

> **SONIA**
> Let me in! . . . I need my phone charger! Let me in! . . .

She has managed to get her foot between the door and the doorframe, but the young man kicks her foot and, with the help of the young woman, is able to close the door. The baby, who has woken up, begins to cry. Sonia kicks the door.

> **SONIA**
> Open up!

She gives the door another kick.

> **SONIA**
> Open up! I need my phone charger. Open up!

While turning her back to the door and kicking it with her heel, she lifts her t-shirt under her jacket to give the baby her breast, but can't quite manage it . . .

> **SONIA** (*yelling*)
> Open up! . . . This is my home! I want my charger! . . .

She kicks the door, steps aside to set the plastic bag on the floor, lifts her t-shirt to give the baby her breast. Suddenly, the door opens, the charger is tossed on the ground, the door slams again. Sonia turns back around, she places the baby in a position where it can breastfeed . . . it stops crying . . . She takes a few steps to the spot where the charger landed, picks it up . . .

2. Ext. Payphone/City—Day

Sonia approaches a payphone hanging from a wall, sets down her plastic bag. Holding the breastfeeding baby with one arm, she takes a telephone card out of her jacket pocket, slides it into the machine, picks up the receiver, dials a number . . . waits . . . it picks up . . .

> **SONIA**
> . . . It's Sonia. I'm looking for Bruno. I'll call back. Don't leave a message, I don't have any battery left . . .

3. Ext. Bingo Pinball[1] Café—Day

Sonia, the baby's head in the crook of her shoulder, peers through the window of a café, moves to another window, looks in . . .

4. Ext. Staircase/Landing on the Meuse—Day

Sonia, the baby's head in the crook of her shoulder, descends a staircase . . . walks on the landing, comes to the remains of a crane with several old shipping pallets stacked against it. She glances behind her as if making sure she's alone.

> SONIA
> Bruno? . . . Bruno? . . .

She sidesteps the stack of pallets, moves one pallet aside, leans forward to look inside . . .

5. Ext. Telephone Booth/City—Day

Sonia is in the middle of dialing a number . . . waits . . . it picks up . . .

> SONIA
> . . . It's Sonia, did you get my message? . . . Do you know where he is? . . . Did he tell you anything? . . . About me and the baby . . .

6. Ext. Lot/Backs of Houses—Day

Sonia crosses a large dirt lot where a few cars are parked here and there. The backs of working-class houses are damaged, sometimes even abandoned. She knocks twice on a door, waits, knocks once more . . .

> SONIA
> It's Sonia . . .

After a beat, the door opens, a boy of thirteen/fourteen years appears, Mika, in pants, t-shirt, who lets her in.

[1] A type of pinball machine in which gameplay corresponds to a number of bingo cards pictured on the cabinet. The bingo aspect affords players the opportunity to win additional credits or, in some cases, a cash payout.

7. Int. the Back of a House—Day

Mika is in the middle of sending a text from his cell phone. Near them is a moped that Mika is in the process of repainting with spray paint.

> **SONIA**
> He doesn't have his cell phone anymore? . . .
>
> **MIKA**
> We can't call him anymore. Too risky.
> *(a text alert, Mika looks at the screen)*
> They're down by the dam.

He starts to send another text.

> **SONIA**
> Do you know who those people at my place are?
>
> **MIKA** *(busy sending a text)*
> No . . . Abdel will drive you back . . . In front of the Pam Pam[2]? . . .
>
> **SONIA**
> Yes . . . The girl has red hair . . .
>
> **MIKA** *(still busy with a text)*
> Dunno . . .

8. Ext. Streets/Intersection/City—Day

Sonia with her baby, behind Abdel, who drives his moped at a rattling pace . . . stops near the wall of a gas station at an intersection. Sonia gets off. Abdel passes out of sight with a U-turn. Sonia moves along the wall, crosses the area where the pumps are, approaches a line of cars stopped at a red light . . .

> **SONIA** *(yelling)*
> Bruno! . . .

Bruno, twenty years old, thin, clad in an old jacket, doesn't hear her. He is next to one of the stopped cars, panhandling with a cardboard cup . . . he moves on to the next car while eyeing a café at the corner of the intersection beyond the line of cars . . . The driver doesn't roll down the window, he moves on to the next car . . .

[2] A Belgian fast food restaurant.

SONIA *(off-camera, yelling)*
Bruno! . . .

Bruno still doesn't hear. The driver of a car who has rolled his window down gives him a coin . . .

SONIA *(off-camera, yelling)*
Bruno! . . .

Bruno turns around, sees Sonia near the station . . . While keeping an eye on the café at the other corner of the intersection, he goes to her, happy to see her . . .

BRUNO
You're out . . .

SONIA
Yes . . .

She adjusts the newborn baby in her arms to show its face to Bruno . . .

SONIA
. . . He looks like you . . .

Bruno smiles but is on the lookout, keeps an eye on the café.

BRUNO
There's a guy who's supposed to be coming out of that bistro . . . What did you call him? . . .

SONIA
. . . Jimmy, like we said . . . he's sleeping . . .

She makes a movement with her arms to give the baby to Bruno, who hesitates before taking him . . .

BRUNO
He'll wake up . . .

SONIA
No . . . your hand underneath . . .

Suddenly, Bruno catches sight of an old man leaving the café, leaves the baby with Sonia, takes a cell phone from his pants pocket, pushes some buttons, brings it up to his ear, all the while watching the old man who is now crossing the street . . .

> **BRUNO** (*into the cell phone*)
> He just came out, he's crossing at the light! Mill around him! . . . No! No, don't take it! No! So much for that!

9. Ext. Landing on the Meuse/Bridge—Day

After climbing the wall of the embankment, Bruno takes his cigarettes and lighter out of one of the pockets of his old jacket, which he takes off and puts into a hole . . . from which he takes out a leather jacket rolled up into a ball . . .

> **SONIA** (*off-camera*)
> And to sleep?
>
> **BRUNO**
> At The Roof . . .

He jumps down and lands near Sonia, who is leaning against the wall, the baby against her shoulder . . .

> **SONIA**
> And me? . . . And Jimmy? . . .
>
> **BRUNO** (*putting on the jacket*)
> On the women's floor . . .

A beat.

> **SONIA**
> You still have the money?
>
> **BRUNO** (*looking for something in his jacket pockets*)
> No . . .

Not finding what he was looking for in his jacket pockets, he scales the wall again . . .

SONIA
You pissed it all away?!!

BRUNO (*off-camera*)
Yes . . .

He lands near Sonia again, with a small leather hat in hand to match the jacket, which he smooths back into shape . . .

SONIA
That's my place you rented out! You could have kept it for me.

BRUNO (*who puts on his small hat*)
I always find money. No reason to hang onto it. What do you think of this? It suits me well, doesn't it? . . .

SONIA
Stolen or bought with my money?

BRUNO
Impossible to steal. Can we go? . . .

He turns to move away. Sonia trips him, he falls, catches himself with his hands . . . They both laugh . . . Sonia is leaning against the wall again.

SONIA
Come close to me.

BRUNO
The others are waiting.

He lights a cigarette, she holds out her hand to signal that she wants a drag from it, he comes close to her, he hands her the cigarette, she takes a puff . . .

SONIA
I want to sleep with you.

BRUNO
We'll get the apartment back the day after tomorrow.

SONIA (*giving the cigarette back to Bruno*)
I've waited for you . . . I thought you would come see me. I called you every day . . .

BRUNO
I had to change the SIM card . . .

He takes a drag from the cigarette . . . Sonia takes it from him again . . .

SONIA
It wasn't too bad . . . He was born at one in the morning, Friday . . .

She is close to him, she takes a drag from the cigarette . . .

SONIA
Tomorrow we'll go to city hall so that you can recognize him as yours . . . also must find him a middle name . . .

She gives the cigarette back to Bruno . . . who takes a drag . . .

SONIA
Any ideas? . . .

BRUNO
No . . .

Sonia is walking ahead of Bruno, against him, he turns his back, she takes his hand, puts it on her stomach under her clothes, while keeping her hand on his . . .

SONIA
Do you see his eyes? . . .

Bruno, who is behind Sonia's shoulder, looks at the baby's head, wrapped in its burnoose.

BRUNO
He's asleep . . .

After a beat, Bruno wants his hand released . . .

BRUNO
Can we go? . . .

Sonia keeps holding his hand . . . Bruno takes a step to separate himself from her, Sonia still holds onto his hand, they play by twisting their hands, their arms, they laugh . . .

10. Int./Ext. Pallet Hideaway/Meuse Landing—Day

Crouched under the shelter of pallets stacked against the remains of the crane, Bruno and two boys of thirteen/fourteen, Steve and Thomas, are going through and taking from their bags and jackets some jewelry, a small digital video camera, banknotes, a few CDs, a portable CD player with headphones, a little wooden case with a metal enclosure. They lay the objects down on cardboard boxes that are covering the ground. At times we hear Jimmy crying off-camera.

> **STEVE**
> I had to remove more than one screw . . .

> **BRUNO** (*counting the money*)
> You wouldn't have had time to crack it. He was coming to the door.

> **THOMAS**
> I even heard him opening it.

Bruno finishes counting the money.

> **BRUNO**
> One thousand three hundred . . . (*distributing the money*) . . . one hundred thirty times two . . . two hundred sixty . . . and two hundred and sixty . . .

He puts the rest in his pocket, picks up the little wooden box, shakes it close to his ear to try to guess what's inside . . .

> **THOMAS**
> It's money, right? . . .

> **BRUNO**
> Maybe . . .

He inspects the lock, tries to force it with a little screwdriver that Steve gives him . . .

STEVE
The CD player, can I have it? . . .

BRUNO (*leaving the hideaway*)
For what?

STEVE
My sister's birthday . . .

Bruno fixes his eyes on him . . .

STEVE
I won't sell it, I swear . . .

BRUNO
Twenty euros . . .

Steve pulls the money that Bruno gave him out of his pocket, takes a twenty-euro bill, gives it to Bruno.

THOMAS (*to Bruno*)
And my share?

BRUNO (*handing him the coins*)
Four euros . . .

Bruno steps out of the hideaway, stands up straight, takes a few steps toward the crane in search of something he can use to force open the box . . . On her jacket laid on a corner of the crane's platform, Sonia is in the process of changing Jimmy. Bruno looks at her but remains preoccupied by his search . . . The two younger boys are out of the hideaway . . . Bruno forcefully hits the back of the box several times against the tapered end of a cable guide near the jaws of the crane, the two boys are beside him . . . he manages to lodge the metal head of the screwdriver under the cover, he twists the box until it gives way . . . he takes out what is inside: an envelope with something written on the back.

BRUNO
His will . . .

He opens the envelope, looks inside, rolls it into a ball and puts it back in the box.

> **BRUNO** (*to the boys*)
> Wire.

The boys go off in search of some wire, Bruno picks up a stone, which he puts in the box, Thomas comes back with a rusted piece of wire, Bruno takes it and wraps it around the box while walking down to the edge of the landing . . . he throws the box into the water, comes back to the crane and the pallet hideaway . . .

11. Ext. Entryway of Homeless Shelter *The Roof*—Evening

Sonia with the baby, Bruno holding the plastic bag with a box of diapers, face an intercom . . .

> **VOICE ON THE INTERCOM**
> . . . It's ten twenty, we close at ten . . .
>
> **BRUNO**
> We missed the bus . . . I'm Bruno, I've stayed here before . . .
>
> **VOICE ON THE INTERCOM**
> If I start making exceptions, every . . .
>
> **SONIA** (*interrupting him*)
> We have a baby, we can't stay outside . . .

Silence . . .

12. Int. Staircase/Landing with Office/Dormitory—Evening

A man of about fifty, the caretaker, comes onto the landing followed by Sonia and Bruno . . .

> **CARETAKER** (*to Sonia, while picking a key from a table in his office*)
> It will be quieter in the small dorm, there's no one there today.

He opens the door, gives the key to Sonia.

> **SONIA**
> Can Bruno sleep with me?
>
> **MANAGER**
> No.

BRUNO
There's no one else here.

MANAGER
No. Tomorrow you have to leave by nine o'clock.

The caretaker waves goodbye as he goes back to his office. Sonia brings her lips to Bruno's mouth, they're kissing . . . she holds Bruno's hand, which he pulls away, twists her around playfully, he presses against her, kisses her . . .

SONIA
Wait . . .

She removes the baby's hood while bringing him close to Bruno's face.

SONIA
Good night, daddy . . .

Bruno, after a moment of surprise, kisses him on the top of his head . . .

BRUNO *(to Sonia)*
See you tomorrow . . .

He climbs the staircase.

13. Int. Men's Dormitory—Evening

Bruno, lost in thought, lies on a bed . . . We hear the presence of other people . . . After some time, he slips the little leather hat off his head, hides it under the pillow, pulls the covers that are at his feet over him . . . Again a look of being lost in thought, his eyes seem fixed on a point on the ceiling . . . Suddenly his cell phone rings, he finds it in his pants pocket, answers, turns toward the pillow so he won't be heard.

BRUNO *(into the cell phone)*
Yes . . . I have some things . . . yes . . . No, I'd rather do it right now . . . I'm coming . . .

He hangs up his cell phone, gets up without making any noise, slips on the jacket, which had been hanging on the edge of his bed, takes the stolen CDs and DV camera from under his pillow, slips them into his jacket, takes his little hat, leans down to pick up his shoes, moves away with quiet steps . . .

14. Int. Bingo Pinball Café—Evening

Bruno is facing a pinball machine, playing it. Next to him, near another machine, away from prying eyes, a forty-five-year-old woman inspects the small DV camera, the CDs . . .

> **BRUNO** (*while playing*)
> . . . Two thousand euros at Fnac[3] . . .
>
> **WOMAN**
> . . . I know . . .

She discreetly returns the CDs to him, which he slips into his jacket, inspects the DV camera a moment longer . . .

> **WOMAN**
> Four hundred . . .
>
> **BRUNO**
> OK . . .

The woman slips the DV camera into her coat pocket, removes a small wallet from her jacket pocket, counts out four hundred euros, which she slides into Bruno's hand. While playing a new ball, he quickly examines the bills to make sure it is the right amount, slips them into his pants pocket.

> **WOMAN**
> You need anything? . . .
>
> **BRUNO** (*while playing*)
> No . . . A new card for my cell phone.

The woman digs around in her jacket pocket.

> **WOMAN**
> I don't have one on me. In the car . . .
>
> **BRUNO**
> When I finish . . . I'm winning . . .

Bruno launches a new ball . . . The woman is next to him, watching the machine. Bruno is concentrated on the game.

[3] A French retail chain that sells electronic products.

> **WOMAN** (*off-camera*)
> I hear your girlfriend gave birth.
>
> **BRUNO** (*while playing*)
> Yes . . .
>
> **WOMAN** (*off-camera*)
> Boy, girl?
>
> **BRUNO** (*while playing*)
> A boy . . .

The ball comes back to the starting point. Bruno relaunches it . . .

15. Ext./Int. Street/Car—Evening

The woman, followed by Bruno, approaches her car and opens the trunk, where she hides the DV camera, then rummages through a bag looking for the SIM cards . . . Bruno is opening his cell phone to take out its SIM card . . . We notice, seated in the front passenger side, the silhouette of a man. The woman looks through her bag, her head covered by the hatchback door . . .

> **WOMAN**
> Are you taking care of the baby yourselves?
>
> **BRUNO** (*busy taking the card out of his phone*)
> Yes . . .
>
> **WOMAN**
> If you don't think you can handle it, there are people who pay to adopt . . .

The woman stands up, holding a case in her hand, she watches Bruno throw his SIM card on the ground.

> **WOMAN**
> Don't just throw it! What if someone found it! . . .

Bruno bends down to search for the SIM card while the woman takes another one out of her case. Bruno stands up.

> **WOMAN**
> Burn it with your lighter.

She leans into the trunk of the car to put away the case. Bruno burns the small SIM card with his lighter . . .

16. Int. Car Dealership—Day

Bruno, his cell phone to his ear, walks around looking at two, three sports cars on view in the showroom . . .

> **BRUNO** (into his cell phone)
> . . . I would like to know if the girl with the baby has woken up yet? . . . Can you tell her to wait for Bruno? . . . Thanks.

He hangs up, glances into the interior of a Spider convertible . . . walks toward a small office area where a man in slacks/a polo shirt is determining the gold content of some jewelry by putting drops of liquid onto the pieces . . .

> **BRUNO**
> How much to rent the Mazda by the entrance? . . .
>
> **MAN**
> It's leaving tomorrow.
>
> **BRUNO**
> Just for today.
>
> **MAN**
> Two hundred . . .
> (he has finished examining the jewelry, puts his materials away)
> A hundred for the rings, a hundred and fifty for the bracelet . . . minus two hundred for the Mazda? . . .
>
> **BRUNO**
> Yes.

The man takes a wad of bills from his pocket, hands a fifty-euro bill to Bruno . . .

17. Int. Stroller Store—Day

Among carriages and strollers, Bruno, accompanied by a saleswoman who is showing him how a corduroy bassinet attaches to its wheeled chassis . . .

> **SALESWOMAN**
> It's three hundred and fifty euros . . . because of the corduroy . . .

18. Ext. Stroller Store—Day

Bruno carrying a stroller, followed by the saleswoman carrying the corduroy stroller, he crosses the street in the direction of the Mazda, unlocks it remotely, starts opening the convertible roof . . . He tries to put the stroller behind the two seats, but it gets stuck . . .

> **BRUNO**
> . . . Too big . . .

He gives his stroller to the saleswoman, who passes him the one she has, he manages to fit it behind the two seats . . .

19. Int./Ext. Mazda/Highway—Day

Sonia, laughing, holds Bruno's right hand with both her hands while he is trying to turn off the car radio, which is playing music in the style of a Strauss waltz, while he drives at a high speed.

> **SONIA**
> He likes it! He's not crying! . . . Leave it! . . .

Bruno, also laughing, continues to try to turn it off, managing to switch to another station . . . Sonia tunes the radio back to the waltz and, leaning forward, holds Bruno's hand between her teeth so that he can't put it back . . . She moves her head, Bruno's hand between her teeth, in the rhythm of a waltz . . .

20. Int./Ext. Mazda/Parking Lot Along Highway—Day

Bruno, seated behind the wheel of the Mazda, which is stopped alongside a tow truck . . . Off-camera, we hear Jimmy's sometimes whimpery breathing . . . asleep in the bassinet behind the seats . . . at one point, Bruno turns around . . . looks at the baby in the bassinet . . . then looks in front of him again, thoughtful . . . Sonia appears in the side mirror.

> **SONIA**
> There is extra spicy sauce.
>
> **BRUNO**
> Mustard.

She goes away. He is alone again . . . We hear Jimmy's breath . . .

21. Ext. Rest Area/Highway—Day

They are chasing each other around the Mazda, holding half-eaten sandwiches in their hands . . . Sonia is trying to free her hand from Bruno, who won't let go, letting himself be pulled around the car by Sonia . . . He manages to pull her close to him, rubs his head against hers, his forehead against her forehead, the top of her head, her hair, with a certain amount of roughness but remaining playful . . . They stop . . . start eating the sandwiches again, somewhat out of breath . . . Sonia is leaning against the car.

> **SONIA**
> Tomorrow morning, we have to go to city hall . . .
>
> **BRUNO**
> For? . . .
>
> **SONIA**
> To register the baby . . . We also have to give him a middle name . . . After your grandfather? . . .
>
> **BRUNO**
> Nicolas? . . .
>
> **SONIA**
> Should we? . . .
>
> **BRUNO**
> Yes . . .

She puts her sandwich on top of the car, and, while looking at the bassinet to make sure Jimmy is fast asleep, she takes a can from the seat, shakes it, then suddenly pops it open in the direction of Bruno . . . who gets covered in liquid . . . She runs away, chased by Bruno . . . They both run, coming to a picnic table and benches attached to the ground, Bruno climbs over the table to catch Sonia, who is on the other side . . . she gets away, they run . . . he catches her again . . .

22. Int. Sonia's Apartment—Morning

Bruno and Sonia asleep in the bed. Near Sonia, the bassinet is on the ground, with Jimmy sleeping inside . . . We hear the doorbell ring . . . They continue to sleep . . . The doorbell again . . . Sonia wakes up, gets out of bed to open the door . . . We stay on Bruno, who, still asleep, turns to the side of the bed where Sonia was, closer to the bassinet where Jimmy is asleep . . . Sonia reappears next to the bed.

SONIA
It's Steve . . . Bruno!

Bruno doesn't wake up.

SONIA *(lightly shaking him)*
Bruno! . . . It's Steve . . .

Bruno wakes up . . .

23. Int. Entrance to Sonia's Apartment—Day

Steve, one of the thirteen-/fourteen-year-old boys seen splitting the take on the Meuse riverbank, is close to Bruno, still half-asleep.

BRUNO
I already told you, fuck . . .

STEVE
When will we get it? . . .

BRUNO
After the next job . . . Friday . . .

STEVE
How much did you sell it for?

BRUNO
Four hundred for the DV camera and two-hundred-fifty for the jewelry, which makes sixty-five each . . .

Steve is about to say something but stops when he sees a woman of about forty coming toward them . . .

WOMAN
Hello. Is this where little Jimmy lives? . . .

BRUNO
. . . Yes . . .

WOMAN
I'm the nurse from ONE[4]. Are the baby and the mother here? . . .

[4] Child services.

> **BRUNO**
> . . . Yes . . .

He moves aside for the nurse, who enters the apartment . . . disappears behind the door, which he pulls closed . . .

> **STEVE**
> With the wait, you could give us seventy . . .

> **BRUNO**
> Fine . . . Do you have a cigarette? . . .

Steve pulls a pack from his pocket, gives it to Bruno so he can take a cigarette . . .

24. Int. Sonia's Apartment—Day

Bruno, smoking a cigarette, finishes pouring some instant coffee into a beer glass, fills the glass with water from the tap while glancing momentarily at Sonia and the nurse, busy with Jimmy . . . He takes a spoon which he stirs his glass with, absentmindedly . . .

25. Int. City Hall—Day

Bruno and Sonia put their identification cards back into their pockets, which the city worker had placed on the counter. The bassinet, now mounted on the wheeled chassis, is nearby.

> **WORKER** (*handing a document to Sonia*)
> Sign here for your agreement . . .

Sonia signs the document with a pen the worker gives her . . . The worker slides the document to Bruno . . .

> **WORKER**
> You sign the other side . . .

Bruno, who takes the pen offered to him by the worker, hesitates for a moment, goes to sign.

> **WORKER** *(pointing with his finger)*
> . . . Higher . . . *of whom I declare myself to be the father* . . . there, yes . . .

Bruno signs . . .

26. Ext. Streets/City—Day

Sonia walks, pushing the stroller. Bruno walks alongside her . . .

> **SONIA**
> . . . You could at least go see.

> **BRUNO**
> Scam.

> **SONIA**
> She's the head nurse. If she says it's a thousand euros a month, that's what it is . . .

> **BRUNO** *(interrupting her)*
> I don't want to.

They cross the street . . .

> **SONIA**
> Doing odd jobs, it must be entertaining, it changes all the time . . .

> **BRUNO**
> I don't want to work, jobs are for assholes . . . Hey! . . .

He abruptly stops in front of a store window that they had almost passed.

> **BRUNO**
> That has a stripe like mine . . .

In the window, a leather jacket similar to the one Bruno has on.

> **BRUNO**
> Do you want it?

> **SONIA**
> It's expensive . . .

Bruno takes some bills from his pocket, counts them . . .

> **BRUNO**
> I only have two hundred and twenty left. Do you want it or not?

> **SONIA**
> Yes . . .

Bruno goes into the store . . .

27. Ext. Street Near the Store—Day

Sonia, playing with the collar, the opening of the jacket she has just put on, walks on the sidewalk like a model, striking poses, laughing, throwing suggestive glances at Bruno, who, near the stroller, on which her old jacket is placed, watches her, amused, seduced . . . He approaches her, puts his little leather hat on her head . . . She takes a step away, comes back toward him, holding back her laughter, she takes his cigarette, puts it up to her lips, swinging her hips. Bruno follows her, whistles with his fingers, she turns back around, pulling a gun made of her thumb and index finger from her jacket, she fires it at Bruno . . . pushes up the brim of her hat with the end of her index finger, bursts into laughter . . . as Bruno comes toward her, staggering more and more . . .

28. Ext. Street/Entrance of CPAS[5] Office—Day

Bruno looks through a window into the interior of the CPAS office, rejoins Sonia, waiting with the stroller in a line of people that begins inside the building and extends a dozen meters outside . . . He opens his pack of cigarettes, takes the last one out . . .

> **BRUNO**
> They only have one window open . . .

He lights his cigarette, throws the empty pack into a bin next to him . . . Sonia takes the cigarette from him to take a drag . . .

> **BRUNO**
> You could come back tomorrow.

> **SONIA**
> It would be the same thing.

[5] A Public Social Assistance Center that offers social services to Belgian citizens.

A beat.

>**BRUNO**
>I'll take Jimmy for a spin.

>**SONIA** *(passing him the stroller)*
>If he cries, hurry back, it means he's hungry.

>**BRUNO**
>OK . . .

29. Ext. Street/Intersection/City—Day

Bruno walks, pushing the stroller . . . he crosses a street . . . seeing two men coming in the other direction, he holds out his hand to panhandle . . . one of the men gives him something . . .

>**BRUNO**
>Thanks . . .

He continues to walk, pushing the stroller . . . holds his hand out to a woman . . . who passes by without giving him anything . . . He walks toward another woman . . . who gives him something . . .

He is near the front of a bookstore, opening a new pack of cigarettes, lights one, starts walking again while pushing the stroller . . . His cell phone rings . . . he takes it from his pocket . . .

>**BRUNO** *(while walking)*
>Yes . . . no . . . no . . . no, I left yesterday . . . Friday . . . I will have something Friday evening . . .

He hangs up, puts the cell phone in his pocket, continues walking while pushing the stroller . . . makes a sudden stop to take the cell phone from his pocket, starts dialing a number but changes his mind, puts the cell phone back in his pocket, crosses the street and walks faster, pushing the stroller . . .

30. Ext. Telephone Booth—Day

He slides a card into the unit, dials a number, waits, one hand holding the stroller handlebar.

BRUNO

Hello, it's Bruno . . . No, no, in a phone booth . . . I wanted to know about . . . adoption . . . the people who adopt, how much do they pay? . . . Yes . . . Can I call them? . . . When? . . . No, now . . . Yes, both of us . . .

He hangs up . . . takes a few steps with the stroller, lights a cigarette . . . starts walking again, pushing the stroller . . .

31. Ext. Entrance to an Underpass/City—Day

Bruno is leaning against the wall of an underpass, the stroller next to him . . . After some time, his cell phone rings, he answers it, turns toward the wall . . .

BRUNO

Hello . . . yes, it's me . . . yes . . . we decided, we want to do it right away . . . no . . . nine days . . . a boy . . . yes . . . yes . . .

32. Int./Ext. Bus/City/Suburb—Day

Bruno, one hand holding the metal handrail of the bus, the other the stroller handlebar . . . He looks lost in his thoughts . . . The sound of the bus rolling along . . .

33. Ext. Esplanade—Day

Bruno pushing the stroller across a large esplanade, open to the wind, in the direction of some apartment buildings . . .

34. Ext. Building Entrance—Day

Bruno, with the stroller, approaches the door of a building, his cell phone to his ear . . .

BRUNO

. . . Yes . . . almost . . . yes . . . I'm out front . . . yes . . .

The sound of the automatic lock opening on the door. Bruno pushes the door, still holding the cell phone with his other hand, pushes the stroller through . . .

BRUNO

. . . I understand . . . yes . . . yes . . . wait a second! . . . I, I wanted to know . . . the family where he's going, will it be a good place? . . . I mean, will they have money? . . . he . . . yes . . . no, no . . . OK . . . OK . . .

He hangs up, puts the cell phone in his pocket, goes to enter the building when the phone rings. He takes it back out, answers.

BRUNO

Yes? . . . what is it? . . . no . . . We, we're in the park . . . yes . . . yes . . . he's fine, no problem . . . yes . . .

He hangs up, puts the cell phone in his pocket, enters . . .

35. Int. Front Hall of the Apartment Building—Day

He walks toward the back of the hall, pushing the stroller . . . arrives near two elevator doors . . . pushes the button . . . the light doesn't come on . . . he pulls on one door . . . then the other . . . neither opens . . . he pushes the button again . . . waits . . . he decides to take the staircase . . . goes to climb the first steps carrying the stroller, changes his mind, puts the stroller along the wall at the bottom of the staircase, opens the cover of the stroller, picks up the sleeping baby awkwardly but delicately . . .

36. Int. Staircase/Landing/Apartment Building—Day

Bruno climbs the steps of the staircase, holding the baby wrapped in its burnoose in his arms . . . he passes a landing . . . climbs steps again . . . comes to another landing . . . climbs steps again . . . comes to a landing . . . takes a few steps into a hallway, plunging into the shadows, turns around, finds the light switch, continues down the hall . . . goes all the way to the end . . . looks at the door to his left, goes toward the one on the right . . . turns the handle, the door opens, he enters . . .

37. Int. Apartment/Apartment Building—Day

Bruno, the baby in his arms, closes the door behind him, enters into the small entryway, looks left toward a half-open door . . . continues to the living room . . . All the rooms are empty, uninhabited. No chairs, no table, no furniture, nothing on the walls, just a curtain in front of the window . . . Bruno takes a few steps up to the entrance of the small kitchen . . . also empty . . . He turns around, seems confused . . . He starts to remove his jacket while being

careful to not wake up the baby . . . He puts his jacket on the floor, makes a small, makeshift mattress on which he places the child, still asleep . . . He moves away toward the entryway, suddenly turns around, kneels near the child, puts his hand into the jacket pocket, retrieves his cell phone, gets up, moves away again toward the small entryway, opens the door that was half open, enters, closes the door behind him . . . This room is also empty, uninhabited. He advances to the window, spreads open the curtain, looks outside . . . closes the curtain, half-sits on the radiator . . . a long silence . . . he looks at the valve on the radiator . . . turns it . . . touches the pipe, the radiator with his hand to sense any heat coming out . . . his cell phone rings, he answers it . . .

> **BRUNO**
> . . . Yes . . .

He hangs up, leans against the radiator again . . . After some time, we hear the door of the apartment open off-camera . . . steps . . . silence . . . steps again . . . the door of the apartment close . . . Bruno, who listens without moving, gets up . . . walks toward the door, opens it . . . crosses the entryway, enters the living room, takes a few steps up to his jacket, upon which the baby is gone, but there is an envelope . . . which he picks up, opens, takes out the bills to quickly count them. He throws the envelope, slips the bills into his pants pocket while picking up his jacket . . .

38. Ext. Bus Stop/City—Day

Bruno gets off the bus with the stroller, on which the cover has been reset. While he is thanking a person who helped him get the stroller off the bus, his cell phone rings. He takes it from his pocket, and, while walking and pushing the stroller, he looks at the screen, cuts off the ringer, puts it back in his pocket . . .

39. Ext. Bridge/Staircase—Day

Bruno, pushing the stroller, walks at a fast pace . . . descends the staircase with the stroller in his arms . . .

40. Ext. Expressway/Ramp to the Riverside—Day

Bruno, on the shoulder of the road, holding the stroller, lets a few fast-moving cars drive by . . . He runs across, pushing the stroller . . . takes the access ramp to the riverside . . . His cell phone rings, he takes it from his pocket, looks at the screen, cuts off the ringer, puts it back in his pocket . . . the moment

he gets to the riverside, the phone rings again. He takes it out, looks at the screen, is about to cut the ringer off when he hears Sonia's voice calling him from a distance. He stops, looks toward the bridge, sees Sonia . . . answers.

BRUNO
. . . I see you . . . it was ringing then stopping . . . yes . . .

41. Ext. Bank of the Meuse/Near the Crate Shelter—Day

BRUNO
. . . In an hour, I'm going to the botanical gardens, I'll go to sleep on a bench, then I'll go to the cops to say he was stolen . . .

He lights a cigarette, takes a drag . . . Sonia, who is holding the stroller handle with both hands, looks at him, silent, not understanding what is happening . . .

After a beat.

SONIA
Where is he? . . .

BRUNO
I sold him, I told you!

SONIA
To who? . . .

BRUNO
I dunno . . . people who want to put him in a home where he will be happy . . . adopted . . .

A beat.

BRUNO
Why are you making a face like that? . . . We can make another one . . . We have money . . . look . . .

He takes money out of his jacket pocket . . .

SONIA
Where is he? . . .

BRUNO (*putting the money in his pocket*)
I don't know, I told you. It's over! Think about something else! . . .

Sonia collapses, fainting, bringing the stroller, which she was holding with both hands, down with her . . . Bruno looks at her, surprised, then goes to her, squats down, picks her up so that she is partly lying on his thigh . . .

BRUNO
Sonia? . . . Sonia? . . .

She doesn't wake up . . . He puts her delicately on the ground . . . runs to the river, goes down the few steps of a staircase that goes into the river, picks up some water in the palms of his hands, changes his mind, taking his little leather hat off his head, plunges it into the water . . . He goes back to Sonia carrying his hat filled with water, lays it next to Sonia, kneels, raises her so that her neck rests on his legs, takes some of the water from his hat with one hand, wets Sonia's face . . . taps her cheeks . . .

BRUNO
Sonia? . . . Sonia? . . .

Sonia opens her eyes, looks at him, absent . . . turns her head away . . . tries to get up . . . he tries to help her . . . she makes a gesture of pushing him away . . . she gets up by leaning on the overturned stroller . . . he empties his hat of the remaining water, shaking it, when Sonia collapses again . . . he rushes to her . . . squats down, he lifts her head, slightly slaps her to wake her . . .

BRUNO
Sonia? . . . What's with you? . . . Sonia?! . . .

He shakes her, she doesn't react . . . He puts his arms under her back and her legs, goes to pick her up when he notices his hat on the ground, he picks it up, coifs his hair, puts his arms back under Sonia's legs, lifts her, and, carrying her in his arms, takes a few steps, narrowly avoiding tripping over the stroller, then walks up the access ramp . . . arrives at the top . . . approaches the expressway, doing what he can to signal the cars passing at high speed . . . One car brakes, stops a dozen meters ahead of him . . . He walks toward the car, struggling under the weight of Sonia's body.

42. Ext. Payphone/Hospital—Day

Bruno is on a payphone in the lobby of the emergency room. He talks, making sure he is not overheard by the few people around him.

> **BRUNO**
> . . . No . . . she's going to tell them, it's too late . . . It's a hospital, when she tells them, they'll go to the cops . . . no, she's the one they'll believe . . . it's too late, I'm telling you, she's not going to change her mind . . . no, I swear . . . he must call me back as soon as possible . . . I didn't touch it . . . yes . . .

He hangs up, in leaving the payphone he knocks off his hat, which gets caught on the side of the booth, he picks it up . . .

43. Int. Hallway/Hospital—Day

Bruno walks quickly . . .

44. Int. Hallway/Emergency Room—Day

Bruno approaches the recovery area, the beds separated by white curtains, he pulls the curtain aside to enter . . . Sonia is lying down, her eyes closed, on a bed/stretcher, an oxygen mask over her face, a drip in her arm, two wires connected to a monitor . . . Bruno brings his face to hers . . .

> **BRUNO**
> Sonia? . . . Sonia? . . . Do you hear me? . . .

Sonia doesn't react . . . he looks at her . . . brings his lips to her temple, kissing it softly . . . his cell phone rings, he takes it from his pocket, answers it.

> **BRUNO**
> Hello . . . yes . . . no . . . she agreed before, but she's changed her mind . . .

A nurse appears.

> **NURSE**
> You can't use your phone here.

BRUNO *(to the nurse)*
I know.
(into the phone)
. . . One second . . .

He leaves the room, takes a few steps to a window.

BRUNO
I had a nurse next to me . . . yes, that's why she's in the hospital . . .
I didn't have anything to do with it . . . I . . . yes . . . I understand . . .
yes . . .

He hangs up, goes back to the room, enters. The nurse is busy checking the
monitor.

BRUNO
Will you be here when she wakes up? . . .

NURSE
Yes, with the doctor . . .

BRUNO
Could you tell her I was here . . . that Bruno went to fetch Jimmy and
will come back with him?

NURSE
I'll tell her that you are coming back with Bruno? . . .

BRUNO
No, I'm Bruno. I'm coming back with Jimmy, that's the baby she was
raving about when she was delirious . . . Tell her that everything is all
right, that I'll come back with Jimmy . . .

NURSE
I'll tell her . . .

BRUNO
Thanks.

He disappears behind the curtain he entered through.

45. Int./Ext. Bus/Suburbs—Day

Bruno seated, his head resting against a window of the bus, he yawns, rubs his eyes . . . looks in front of him . . . We hear the sound of the bus rolling along . . .

46. Ext. Alley/Courtyard/Garage—Day

Bruno, the cell phone to his ear, walks down an alley leading to a courtyard surrounded by garages.

> **BRUNO**
> . . . Yes . . . yes . . . I'm here . . . yes . . .

He hangs up, crosses the courtyard, walks toward a building comprised of a few garages, somewhat off to the side . . . he lifts the garage door of the last garage halfway, bends to pass under it, closes it . . .

47. Int. Garage—Day

Bruno, alone in the garage, faintly lit by the daylight passing through a strip of plastic along the roof. He is leaning against a wall, smoking a cigarette . . . Off-camera, we hear the sound of a car motor crossing the courtyard, approaches . . . is very close . . . stops . . . the sound of the door, of steps . . . the adjacent garage door, which we see raise open as light passing through the space between the top of the wall and the roof . . . the car moving into the garage . . . the motor shutting off, the garage door lowering . . . the sounds of doors, of steps . . .

> **VOICE** (off-camera)
> The money.
>
> **BRUNO**
> I got it.

He takes the money from his jacket pocket . . . looks upwards, a hand has appeared in the space between the top of the wall and the roof, which is supported by a metal structure. Bruno tries to give the money to the hand, but he is a bit too short.

> **BRUNO**
> It's too high . . . one second, I'm looking for something . . . aha . . .

He finds an old oil can, he puts it against the wall, puts a foot on it, hoists himself up, is able to give the money to the hand, which takes it and disappears . . .

> **BRUNO**
> The baby, he . . .
>
> **VOICE** (*off-camera, interrupting Bruno*)
> There's a bill missing.
>
> **BRUNO** (*panicky, rummaging through his pockets*)
> That's impossible . . . I didn't touch it! . . . Oh, I got it! . . .

He retrieves the hundred-euro bill from the other pocket of his jacket. He climbs back onto the oil can.

> **BRUNO** (*giving the money to the hand*)
> I didn't do it on purpose, changing which pocket the money was in, there was one that . . .
>
> **VOICE** (*off-camera, interrupting Bruno*)
> Your phone.
>
> **BRUNO**
> My SIM card? . . .
>
> **VOICE** (*off-camera*)
> Your phone.

Bruno climbs back onto the oil can and gives his telephone to the hand, which takes it then disappears . . . Off-camera, the sound of a garage door raising open . . .

> **VOICE** (*off-camera*)
> When you can't hear the sound of the car, you leave. Not before, understand?
>
> **BRUNO**
> Yes . . . Is the baby there? . . .

Off-camera, the sound of the car's motor, the sound of doors . . . the car leaving the garage . . . the car maneuvering . . . driving away . . . Bruno bends down to open the garage door, passes under it . . .

48. Int./Ext. Adjacent Garage/Courtyard—Day

Bruno is entering the garage. At the back, asleep in a baby carrier, Jimmy, still dressed in his burnoose and wrapped in a sheet. Near the carrier, a bottle of milk . . . Bruno bends down to pick up the child, thinks about taking the bottle but leaves it, stands up, takes a few steps, stops to put the baby against his torso under his jacket, which he closes, exits the garage, walks . . .

> **MAN** (*off-camera*)
> Hey! . . .

Bruno is turned around toward a man who appeared from behind the wall of a garage, but he keeps walking . . .

> **MAN** (*off-camera*)
> Wait! . . .

Bruno keeps walking, the man, about twenty-five years old, catches up to him, is at his height . . .

> **MAN**
> We want to see you tomorrow morning at nine, here in this courtyard.
>
> **BRUNO** (*still walking*)
> I don't know you.

The man puts his hand on Bruno's shoulder to stop him. Bruno tries to move away, but the man holds him by his leather jacket. Bruno, holding the baby, doesn't try again . . .

> **MAN**
> The baby, you owe us for him.
>
> **BRUNO**
> I gave the money back.
>
> **MAN**
> We lost double that. We had already made an arrangement. Come tomorrow at nine. Got it?
>
> **BRUNO**
> . . . Got it.

49. Int./Ext. Bus/City—Day

Bruno, the baby asleep in his arms, seated near a window, looking lost in thought, after some time, he yawns . . . the sound of the motor, the bus rolling along . . .

50. Int. Hallway/Emergency Room/Hospital—Day

Bruno walks at a fast pace, carrying the baby in his arms . . .

He arrives at the emergency room entrance . . .

> **RECEPTIONIST**
> Sir! Sir!

Bruno has stopped, looking at the receptionist.

> **BRUNO**
> I'm going to my girlfriend . . .

> **RECEPTIONIST**
> Wait here! I'll call the nurse.

Bruno heads to a seat, sits down . . . sees the nurse, accompanied by a doctor and, a few meters behind, a man dressed in street clothes. Bruno gets up, walks toward the nurse.

> **BRUNO**
> She's awake? . . .

> **NURSE**
> Yes . . .

The nurse makes a gesture like she wants to be handed the baby . . .

> **BRUNO**
> I can hold him myself.

> **DOCTOR**
> I think this man would like to talk to you.

The man in street clothes takes out his police badge.

PLAINCLOTHES POLICEMAN
We want to hear what you have to say about a claim made by the mother of the child . . .

BRUNO
What kind of claim?
(addressing the nurse)
Is she still delirious?

A second plainclothes policeman coming from the waiting room has approached Bruno . . .

NURSE
I'll take the baby, if that's all right with you . . .

After a brief hesitation, Bruno opens his jacket and lets the nurse take the baby . . .

51. Int. Police Station—Day

Bruno, silent, faces the plainclothes policeman . . . A long silence . . .

BRUNO
. . . For revenge . . .

PLAINCLOTHES POLICEMAN
For what? . . .

BRUNO
. . . For him not being mine . . .

PLAINCLOTHES POLICEMAN
You're not the father of the child?

BRUNO
No . . .

PLAINCLOTHES POLICEMAN
Why did you register him as yours if you're not the father?

BRUNO
. . . Dunno . . . just did . . .

A beat.

PLAINCLOTHES POLICEMAN
Why did you tell her that you had sold him? . . . and not something
else? . . .

Bruno doesn't respond . . .

PLAINCLOTHES POLICEMAN
You could have told her he was stolen! . . .

BRUNO
. . . Stolen, sold . . . it's the same thing . . .

PLAINCLOTHES POLICEMAN
No. Stolen, they don't give you money. Bought, they do . . . You had
received money . . .

BRUNO
No.

PLAINCLOTHES POLICEMAN
You had shown it to her.

BRUNO
That's not true.

PLAINCLOTHES POLICEMAN
She said you had shown it to her.

BRUNO
She's lying.

PLAINCLOTHES POLICEMAN
It's you who's lying.

BRUNO
It's her! She wants me to go to jail so she can screw whoever she wants!

A beat.

PLAINCLOTHES POLICEMAN
From thirteen hundred hours when she saw you until sixteen hundred
hours when you returned to the hospital, where was the child?

BRUNO
. . . My mother's house . . .

A beat.

> **PLAINCLOTHES POLICEMAN**
> She lives where, your mother?

> **BRUNO**
> At Twenty-three B, Jonquilles.

52. Ext./Int. Entrance/Hallway/Emergency Room/Hospital—Day

Bruno crosses a courtyard to the emergency room entrance . . . walks down a hallway . . .

53. Int. Emergency Reception/Hospital—Day

Bruno is facing the receptionist, who has a receiver to her ear . . .

> **BRUNO**
> . . . It's important. Just two seconds . . .

> **RECEPTIONIST** *(into the phone)*
> He says it will only take two seconds and that it's important . . .

> **BRUNO**
> If she can't talk to me, ask her to give me her cell phone number. I had it on mine, but it was stolen! . . .

> **RECEPTIONIST** *(into the phone)*
> . . . All right . . .
> *(she hangs up)*
> She doesn't want to talk to you . . .
> *(to another person behind Bruno)*
> Yes, ma'am? . . .

> **BRUNO**
> Couldn't you call her back to get her cell phone number?

> **RECEPTIONIST** *(off-camera, busy with the woman)*
> She doesn't want to speak to you, sir!

Bruno stays next to the counter for a brief moment, turns, walks toward the exit . . .

54. Ext. Wall/Behind a House—Evening

Bruno climbs a wall, hoists himself over the top to see onto the other side, looks down . . . he lowers himself, jumps onto the sidewalk, walks along the side wall of the house . . .

55. Ext. Entrance to House—Evening

Bruno has pressed the doorbell, off-camera we hear a dog barking . . . Bruno waits . . . the door opens, revealing a man who doesn't seem happy to see Bruno . . .

Silence.

> **BRUNO**
> . . . I have to say something to my mother . . .

The man closes the door . . . Bruno waits . . . After some time, the door opens again, revealing a woman of about forty . . . Off-camera, we hear the dog barking . . .

> **BRUNO**
> I thought he wasn't home, I didn't see his car in the courtyard . . .

> **BRUNO'S MOTHER**
> What do you want? . . .

> **BRUNO**
> I just had a baby . . . a boy . . .

> **BRUNO'S MOTHER**
> What's his name? . . .

> **BRUNO**
> Jimmy . . .

The dog barks louder . . .

> **BRUNO'S MOTHER**
> Drop by on Saturday to show him to me . . . at three o'clock . . .

She goes to close the door . . .

BRUNO

. . . I wanted to ask you . . . I had a fight with the mother, and the cops want to know where the baby was this afternoon. I told them I was at your house. Are you OK with that? . . .

BRUNO'S MOTHER

What did you do? . . .

BRUNO

Nothing . . . I took the baby to show him to some friends, and I told her she wouldn't see him again unless she shut up. She called the cops . . .

BRUNO'S MOTHER

Why didn't you just say you were with your friends? . . .

BRUNO

. . . I didn't want to get them in trouble . . . Are you OK with it? . . .

BRUNO'S MOTHER

What time was he here?

BRUNO

Between one and four.

BRUNO'S MOTHER (*closing the door*)

All right.

56. Ext. Bank of the Meuse/Near the Crate Shelter—Day

Bruno, with the help of a piece of reinforced concrete, is straightening the rod from the hood of the stroller, which was damaged when Sonia fell and left behind when he took her to the hospital. He puts the rod on the platform of the crane and, against the rod, he is holding a piece of wood, which he hits with the piece of concrete . . . It seems straight, he goes near the stroller, tries to put the rod back into the hood, which is spotted with mud. He succeeds, returning the hood to its original shape . . .

Bruno approaches the bank, pushing the stroller, stops at the edge, removes his jacket, his t-shirt. He is bare-chested. He descends a few steps to the river, dips his t-shirt into the water, goes back up the steps, rubs the dirty part of the hood with his wet t-shirt . . . also rubs the spokes of the wheel, the tire . . .

57. Ext. Hospital Exit—Day

Sonia, carrying the baby in her arms, a plastic bag in her hand, descends the stairs of the hospital exit, walks on a sidewalk . . . Bruno, who has been sitting

on a low wall, the stroller next to him, has stood up and walks, pushing the stroller, toward Sonia, who walks ahead of him . . . he approaches her . . . she hears him, turns around, stops . . . She starts walking again . . .

>**BRUNO**
>Do you want to put him in? . . .

Sonia doesn't respond, keeps walking, he follows her . . .

58. Int./Ext. Bus/City—Day

Bruno, holding the stroller, clears a path amid the few passengers on the main platform of the bus . . . he stashes the stroller in a corner of the platform, secures it, goes toward the seats at the front of the bus . . . Sonia is seated in a single seat, holding the baby in her arms. He sits a few meters behind her . . . When the baby whimpers, Sonia searches for something in her plastic bag, which falls. Bruno gets up to pick it up, but Sonia grabs it before he can get to it . . . He goes to sit back down . . . comes back to Sonia, who takes the bottle from the bag to give to the baby.

>**BRUNO**
>Can I have your cell phone? . . . Mine got stolen . . .

Sonia doesn't respond, stays focused on the baby, whom she is feeding with the bottle . . . Bruno sits back down . . . lets his body sink into the seat, his head resting between the window and the headrest . . . He yawns . . . looking lost in thought . . . We hear the sound of the bus rolling along . . .

59. Int. Staircase/Hallway/Sonia's Apartment—Day

Bruno, carrying the stroller, climbs the steps behind Sonia, who holds the baby and the plastic bag . . . There is less than one flight of stairs between them . . . Sonia arrives at the hallway, walks to the door of her apartment. Bruno, with the stroller, climbs the final steps . . . Sonia takes the key from her jacket pocket, opens, enters, goes to close the door when Bruno, who rushes to the door pushing the stroller, puts his foot between the door and the doorframe . . . Sonia holds onto the door for a moment . . . She lets go . . . She goes to the kitchen . . . Bruno comes in with the stroller, closes the door, takes a few steps toward the bed, sits down, lets himself fall backwards onto it, lying on his back, his legs hanging off the bed, his feet on the ground . . . he yawns . . . Sonia, who has cleared the small table, comes toward the bed holding the baby in her arms. She takes a pillow from the top of the bed . . .

BRUNO
. . . Can I make a call with your cell phone? . . .

Sonia doesn't respond . . . She puts the pillow on the small table . . . puts Jimmy there, undresses him to change him . . . Bruno, still in the same position, is half-asleep . . . Sonia approaches the bed, the baby in her arms, pulls on the blanket . . . Bruno wakes up . . . She looks at him, pulls on the blanket again, making him move . . . He gets up . . . sits on a chair . . . watches Sonia make up the bed, using the blanket and two pillows to prepare a corner of it for Jimmy . . . She puts the baby down . . . She goes to the kitchen, pours some water in a pot, puts it on the burner, lights it . . . Bruno watches her . . . She opens a packet of instant soup, pours its contents into the pot, picks up a tomato, which she cuts into pieces with a small kitchen knife, letting the pieces fall into the pot . . . mixes it with a spoon . . . Bruno approaches . . . She puts down the small knife, takes a slice of bread from a bag, puts the bag back, opens a container of margarine . . . Bruno takes the bag of bread, she takes it from his hands . . .

BRUNO
I'm hungry . . .

He tries to take the bag back, which she has placed near the burner, she has grabbed the small knife and cuts his hand with it . . .

BRUNO
Ouch! . . . You . . . You . . .

He touches his bleeding hand . . . She tries to cut him again, which he narrowly avoids by recoiling . . . Silence . . .

She is on the verge of tears, of an explosion . . .

BRUNO
. . . What did I do to you? . . .

Silence.

BRUNO
I . . . I thought we could make another one . . .

Sonia is heading to the table, puts the hand with the knife down on it, as if to hold herself up . . .

SONIA
Give me my key . . . and get out of here . . .

Bruno looks at her . . . Sonia, her eyes fixed on the table, breathes like she's trying to calm herself down . . . seems to be holding back tears . . . Bruno takes the key from his pants pocket, puts it on the table.

SONIA
Out! . . .

BRUNO
Sonia . . .

He takes a step toward her . . . She tries to reach him with the knife . . . He manages to grab her arm, she turns around, forcing him to let go of her, he is up against her, on her back, manages to grab her arms . . . They struggle hand to hand, in silence . . . Sonia, exhausted, offers no more resistance, she is bent over, Bruno against her, still holding her arms . . .

SONIA *(in a weak voice)*
Get out of here . . . get out! . . .

Bruno releases one arm, then the other, takes two steps back toward the door, near the stroller, puts his hand on the door handle . . . bends down to pick up his hat, which fell during the melee, opens the door to leave . . .

SONIA *(in a weak voice)*
Take that . . .

Bruno comes back for the stroller, takes it, and leaves . . .

60. Ext. Street/City—Day

Bruno, pushing the stroller, walks, crosses a street, mounts a curb onto a sidewalk by tilting the stroller, walks . . .

61. Int. Secondhand Store—Day

Bruno with the stroller, which is being examined by one of the salespeople from the store, a man of about sixty. Around them, a number of used objects, bicycles, motorbikes, a window exhibiting some jewelry, crystal, etc., a few other clients examining the items . . .

SALESMAN
Fifty . . .

BRUNO
It cost three hundred and fifty, it's hardly used, two days . . .

SALESWOMAN (*off-camera, to the salesman*)
I'm going out.

SALESMAN (*to the saleswoman*)
Did you tell Antoine to come down?

SALESWOMAN (*off-camera, while moving away*)
Yes.

SALESMAN (*to Bruno*)
Fifty, no more . . .

BRUNO
Eighty? . . .

The shop owner shakes his head no . . . Bruno waves goodbye, moves away, pushing the stroller toward the exit . . . at one point, allowing the saleswoman to put on her coat, he slows down until the path is clear. While opening the door to leave, he looks back inside the store, seeing the saleswoman taking several packets of banknotes, which she slides into a small plastic bag . . .

62. Ext. Street/City—Day

Bruno, pushing the stroller, walks slowly, looking through a shop window . . . he lights a cigarette . . . the saleswoman, in her coat, passes behind him, carrying a used shopping bag in her hand . . . Bruno follows her, pushing the stroller . . .

63. Ext. Square/City—Day

Bruno, pushing the stroller, slows as he comes to the corner of a wall . . . stops, looks at the saleswoman, the used shopping bag in her hand, walking

on a sidewalk about twenty meters away . . . Bruno rounds the corner of the wall . . . the saleswoman, after looking to see if the path is clear, crosses the street and enters a bank . . .

64. Int. Another Secondhand Store—Day

Bruno, next to the stroller, in conversation with the salesman, who opens the top of the stroller to inspect the cushion, takes out Sonia's old jacket, mechanically, he hands it to Bruno, who takes it . . .

> **BRUNO**
> You're going to sell it for at least two hundred or two hundred and fifty . . .

> **SALESMAN**
> No. One hundred and fifty max . . .
> *(a beat)*
> Sixty . . .

> **BRUNO**
> Eighty . . .

> **SALESMAN**
> . . . Sixty-five, no more . . .

> **BRUNO**
> OK . . .

The salesman takes a wad of bills out from his pocket . . .

> **BRUNO**
> . . . And the jacket? . . .

The salesman looks at it while taking sixty-five euros from the wad . . .

> **SALESMAN**
> . . . One euro . . .

He gives the sixty-five euros to Bruno, who puts the jacket on top of the stroller, for which the salesman gives him a one-euro coin . . .

65. Int. Bingo Pinball Café—Evening

Bruno enters, heads to the bar, greets the bartender.

> **BRUNO**
> . . . Two grilled ham and cheese sandwiches.
> (*pointing to the people playing pinball*)
> Will they be on them much longer?

> **BARTENDER** (*looking at the dials*)
> Two credits on one.

> **BRUNO**
> I'll take fifty.

He takes the bills from his pocket . . . The man we saw in the garage courtyard is approaching him.

> **MAN**
> Hi . . .

Bruno looks at him without responding . . . goes to put two twenty-euro bills and one ten-euro bill on the counter when the man grabs him brusquely by the wrist, Bruno turns and tries to hit him with his other hand, but the man punches him in the stomach. Bruno doubles over without letting go of the money in his hand. The man holds Bruno, who is on his knees, his arms around his stomach, he pulls him up, drags him toward the exit . . .

66. Ext. Parking Lot/Near Bingo Pinball Café—Evening

A corner of the parking lot, out of sight. Bruno pinned against a wall by the man, who has twisted his arm behind his back . . .

> **MAN**
> Open . . .

The man takes the fifty euros from Bruno's hand, forced, finally open . . . The man gives the fifty euros to an older man who stands nearby, he rummages through his jacket pockets, takes out a pack of cigarettes with a lighter, which he lets fall onto the ground, rummages through the pants pockets . . .

> **BRUNO**
> No! . . . I need that to eat! . . . I . . .

Bruno manages to turn around, rushes on the man, striking him, the man frees himself and lands a punch to his stomach. Bruno collapses . . . The man rummages through his pants pockets again, takes the fifteen euros in bills and the one-euro coin, gives them to the older man . . .

> **OLDER MAN** (*counting the money*)
> You owe us four thousand nine hundred thirty-four more euros . . . Five thousand minus sixty-six, OK? . . .

Bruno doesn't respond, he is on the ground, leaned against the wall, holding his stomach . . .

> **OLDER MAN**
> We will be back here every Sunday at noon, and you can pay us back at your own pace, OK? . . .
>
> **BRUNO**
> I can't . . .
>
> **OLDER MAN**
> Yes, you can. You'll just steal for us instead of stealing for yourself . . . Will we see you Sunday? . . .

Bruno doesn't react . . .

> **OLDER MAN** (*to the younger man*)
> Get him up.

The younger man pulls Bruno up, presses him against the wall.

> **OLDER MAN**
> Do we have a deal? . . .

Bruno doesn't respond. The younger man gives him a kick to the stomach. Bruno stifles a cry, doubles over . . .

> **OLDER MAN**
> Do we have a deal? . . .

Bruno marks his agreement by a nod of his head . . . The men take off, leaving Bruno, who tries to take a breath, hurts, holding his stomach with one hand . . .

67. Ext. Staircase/Hallway and Sonia's Apartment—Evening

Bruno, grimacing from the pain, climbs the last steps of the staircase . . . he walks, limping, up to the door of Sonia's apartment, knocks . . . No one answers . . . He knocks again . . . Silence . . .

> **BRUNO**
> Sonia . . . Open up . . . I want . . . I want to say I'm sorry . . . Sonia? . . . Do you hear me? . . . Sonia? . . .

He stays for another moment in front of the door then turns toward the staircase, goes down . . .

68. Ext. Street/Near the Entrance to Sonia's Apartment Building—Evening

Bruno leaves the building, takes a few steps to cross the street, sees someone passing by on the sidewalk, goes up to him . . .

> **BRUNO**
> Could you spare any change, please, I don't have . . .

The passer-by ignores him . . . Bruno comes back, still limping, toward the entrance of the building, crosses the street to a low wall where he sits . . . takes his pack of cigarettes and his lighter from his jacket pocket while watching Sonia's building, lights a cigarette, takes a drag but grimaces in pain, rubs his abdomen with one hand, tries to take another drag from the cigarette but hurts . . . He throws the cigarette . . . looks around . . . sees Sonia coming down the street behind him. She carries the baby in her arms, a bag of groceries in her hand. He goes over to her, still limping . . . She changes sidewalks . . .

> **BRUNO**
> Sonia . . .

Sonia continues on her way . . .

> **BRUNO**
> Wait! Sonia . . .

He quickens his steps, catches up with Sonia . . .

BRUNO
. . . I'm sorry, Sonia! . . .

SONIA (*continues to walk*)
Shut up and stop following me!

He passes her, throws himself at her feet, keeping her from moving forward . . .

BRUNO
I need you, Sonia. I didn't want to hurt you . . . Don't leave me . . .

Sonia, immobilized, tries to move away.

SONIA
Move away from there! . . . Let go of me! . . .

BRUNO (*holding her*)
You gave me up to the cops, we're through, is that it? . . . Let me come back . . .

She makes a movement with one leg, he lets go . . . She moves away toward the apartment building, he gets up, follows her . . .

BRUNO
We can start at zero, I'll get a job, do you hear me, Sonia? . . .

She enters the apartment building, he follows her . . .

69. Int. Staircase/Hallway/Sonia's Apartment Building—Evening

Bruno climbs the steps of a staircase . . .

BRUNO
. . . I will change, Sonia, I promise! . . . Sonia! . . . Wait! . . .

He arrives at the top of the staircase. Off-camera, we hear Sonia opening the door to her apartment.

BRUNO
Sonia, listen to me! . . . Don't close it! I'm not going to try to come in. I promise! . . .

Sonia is in the doorway holding it partially open, watches him . . . Bruno comes closer . . .

> **BRUNO**
> . . . I love you, Sonia . . .

Sonia seems touched by what he has said, she stays there a moment without speaking.

> **SONIA**
> You lie . . . You lie as easily as you breathe . . .
>
> **BRUNO**
> That's not true, I . . . Sonia! . . .

She has gone in and closed the door. He waits a moment, immobile . . . takes a step to get even closer to the door . . .

> **BRUNO**
> Sonia, do you hear me? . . .

She doesn't respond . . .

> **BRUNO**
> I'd like . . . just a little money . . . Sonia, do you hear me? . . . I'm hungry, I promise you, I'm hungry . . . If you don't want to open up, slide a bill under the door, I'll pay you back . . . Sonia? . . .

He waits another moment . . . starts back toward the staircase . . .

70. Ext. Crate Shelter/Bank of the Meuse—Evening

Bruno, on all fours, slides himself into the crate shelter, opens a cardboard box, into which he inserts himself . . .

71. Ext. Street/School Courtyard—Day

Bruno smokes a cigarette while looking for someone through the gap between two bars of the front gate of a school courtyard, where about a hundred teenagers are playing basketball, soccer . . . A teenage boy runs by the gap, Bruno calls to him, the teenage boy stops . . .

BRUNO
Do you know Steve? He's short, he's in mechanics . . .

TEENAGE BOY
With the earrings? . . .

BRUNO
Yes.

TEENAGE BOY
He isn't in gym, he's in the workshop.

BRUNO
Could you go find him, I really need to talk to him . . . Tell him it's Bruno . . . Bruno! . . .

The boy disappears. Bruno takes a puff from the cigarette . . . looks through the gap . . . he sees Steve, in overalls, running to the front gate . . .

BRUNO
Hi!

STEVE
Where have you been? . . .

BRUNO
I had to hide. Can you come tomorrow at one o'clock with the scooter?

STEVE
If I give money to my brother, five euros an hour. Our money, you got it?

BRUNO
You'll get it. To do the job, I need you with the scooter . . .

TEACHER (*off-camera, yelling*)
Steve, here right now!

STEVE (*turning around, yelling to the teacher*)
I'm coming, sir!

BRUNO
Tomorrow at one at the bridge, OK?

STEVE
The money for the scooter . . .

BRUNO
It will have to be after, ten euros an hour . . .

72. Ext. City—Day

Bruno, smoking a cigarette, walks . . . we stay on his face . . . the cigarette which he has just finished smoking . . . his vacant expression, lost in thought . . . the walls, shop windows, sides of houses, silhouettes of passers-by, cars . . . blurred behind his face . . .

73. Ext. Bank of the Meuse/Bridge—Day

The water of the river, which flows slowly, curving around a thin bar of reinforced concrete, held by Bruno, seated on the edge of the bank . . . He moves the bar in the water without intent, mechanically . . . he looks at his watch . . . continues to play with the bar in the water . . .

Bruno is up, he throws the bar into the water like a javelin and runs toward the wall of the riverbank . . . Off-camera, we hear the sound of a scooter approaching. Bruno quickly climbs the wall up to the hole, takes his cigarettes and his lighter from the pocket of his leather jacket, takes off his jacket, puts it in the hole, takes out the old jacket that he had put there, puts it on, slips his lighter and his cigarettes into a pocket, goes to jump, changes his mind, takes off his little leather hat, which he puts in the hole, jumps down . . .

74. Ext. Street Corner/City—Day

Bruno seated behind Steve on the scooter, which is stopped . . . Bruno, taller than Steve, looks over Steve's head from time to time, trying to see something or someone that we don't see . . .

> **STEVE**
> What time is it? . . .

> **BRUNO** (*looking at his watch*)
> . . . Thirty-five after . . .

Bruno takes out his pack of cigarettes, pulls one out . . . Suddenly he pinches his nose, standing up on his legs and retreating.

> **BRUNO**
> Did you fart or what? . . .

> **STEVE**
> No . . .

As that moment, Steve, still sitting on the seat, involuntarily lets out a musical fart. Bruno bursts into laughter . . . cannot stop laughing . . . Steve, who also laughs, backs up to get closer to Bruno . . .

> **STEVE** (*through laughter*)
> It's the sauerkraut at school . . .

Bruno, who recedes while gesturing to Steve not to come any closer, laughs, laughs, laughs to the point of tears . . . folded in two, leaning against a wall . . .

75. Ext. Street/City—Day

Bruno and Steve on the scooter, which rolls along slowly, almost staying in place . . . Bruno looks ahead, over Steve's shoulder . . . Walking about fifty meters ahead, on the sidewalk, the saleswoman, wearing her coat, carrying the used shopping bag in her hand . . . At a point, Bruno gets off the scooter, which keeps moving, passing the saleswoman . . . Bruno walks behind her . . . moves closer . . . suddenly he grabs her shopping bag and runs toward the scooter, which waits for him a bit further up . . . and takes off . . . A man putting groceries in the trunk of his car hears the saleswoman yell and runs after the scooter just as it's pulling away, but he is not able to catch it . . .

76. Ext. Bridge/Expressway—Day

Steve driving the scooter at high speed. Behind him, Bruno is digging through the shopping bag, taking a few old clothing items out and throwing them to the side of the road . . . he takes out one small plastic bag with the banknotes and another with the coins, shows them, elated, to Steve, they laugh . . . Bruno slips them into his jacket, throws the shopping bag to the side of the road . . . a car is coming up behind the scooter . . . seems fixed on it . . . Bruno glances quickly at the car . . .

> **BRUNO** (*yelling to Steve*)
> The car behind us! It's the guy who was running after us! . . . Cross! . . . Now! . . .

The scooter crosses the expressway, passing a few meters in front of a car coming the opposite direction, honking . . . They drive away on the shoulder . . . the car that is following them continues on the expressway . . .

> **BRUNO** (*yelling to Steve*)
> Pass the street then stop and we'll make a U-turn!

The scooter passes a narrow street that runs perpendicular to the expressway . . . brakes, makes a U-turn, continues onto the street . . . Bruno looks behind him . . .

>**BRUNO** *(to Steve)*
>We got him!

The scooter speeds down the narrow street . . . Bruno turns around . . . the scooter comes to a red light . . .

>**BRUNO**
>It's OK! Run it!

They turn right, running the stoplight, drive down a road . . .

>**BRUNO**
>Go right! The sign! . . .

Steve takes a right, they drive along an industrial path that rejoins the street perpendicular to the expressway . . .

>**BRUNO**
>Stop! . . .

Bruno jumps from the scooter, running to the spot where the path rejoins the street, looks toward the expressway, runs back to the scooter at full speed.

>**BRUNO**
>He's at the intersection!

Steve, helped by Bruno, makes a U-turn with the scooter, they speed away . . .

77. Ext. Expressway/Meuse Landing—Day

The scooter, driven by Steve, crosses the expressway and rolls onto the soft shoulder of the road . . .

>**BRUNO** *(who is turned around)*
>He's stuck behind a truck! Go for it!

The scooter drives down an access ramp blocked by industrial junk . . . They arrive in front of a barrier prohibiting access to vehicles, they get off the scooter, slipping it underneath the barrier, running and taking off on the scooter toward the landing . . . An abandoned truck trailer loaded with rolls of iron wiring blocks the path . . . a narrow pathway remains between the trailer and the riverbank, they rush through, getting off the scooter, which can't pass through because of a roll of iron wire on the ground.

> **BRUNO**
> We'll go on foot!

Bruno passes in front of Steve, who tries to pass through with the scooter anyway.

> **BRUNO**
> Come on, leave it!

> **STEVE**
> No!

Bruno backtracks, helps Steve carry the scooter, but it is caught in the rolls of iron wiring . . .

> **BRUNO**
> Come on!

He takes Steve by the arm . . . who follows him . . . They jump from the ramp onto the riverbank. Bruno notices a half-buried concrete platform, he takes the two plastic bags with the money out of his jacket and hides them under the platform in the dirt. They run toward a sheet metal fence protecting the engines of an abandoned ore transporter . . .

78. Ext. Transporter/Meuse—Day

They hide behind the fence, short of breath, panting . . . Bruno, without making himself seen, pokes his head out to look . . .

> **BRUNO** (*to Steve*)
> . . . He's climbing the wall . . .

> **STEVE**
> He's going to see the scooter . . .

BRUNO
No, he's going toward the staircase . . . There's another guy! . . . They're coming down . . .

Bruno turns around, lies down to look underneath a chassis supporting the engines . . .

BRUNO
This way! . . . Quick!

They both crawl . . . arriving on the other side, at the edge of the river, where there are the remains of a conveyer belt once used to transport the ore from the boats to the trucks . . . Suddenly the sound of a stone thrown against a metal object! . . . Bruno looks toward the river, the end of the transporter leans and sinks below the water level of the river . . . Bruno descends the end of the transporter in a backwards walk, crouched, holding the bars of the frame of the conveyor belt with his hands . . . Steve imitates Bruno . . . Bruno enters the water . . . keeping one hand hooked on the frame of the transporter . . . Steve also starts to get into the water . . .

STEVE
It's cold . . .

Bruno takes him by the arm and forces him to descend faster. Entering deeper into the water, Steve makes a move to get back out. Bruno keeps him in the water.

STEVE
It's too cold! . . .

BRUNO
Shut up! . . .
(*a low voice*)
We have to get to the other side! . . .

Steve is in the water next to Bruno, gripping onto parts of the frame . . . Bruno slides himself under the transporter unit, followed by Steve . . . They are both in the water up to their torsos, holding a bar of the frame, which is now above their heads, with their hands.

STEVE (*in a low voice, trembling*)
I'm not going to be able to hold on . . .

At this moment, a stone hits the fence they had been hiding behind . . .

>**STEVE** *(in a low voice)*
>They've seen us . . .

>**BRUNO** *(in a low voice)*
>No, they're throwing stones because they're afraid to come and look . . .
>They're losers . . .

Steve, trembling, seems to no longer have the strength to stay above the water . . . Bruno helps him by putting an arm under his armpit . . . We hear a stone thrown against a metal object, but further away . . .

>**BRUNO**
>They're leaving . . .

Suddenly, Steve's hands let go of the bar of the frame, he panics, thinking he is drowning, grabs at Bruno, at his jacket, at his hair . . .

>**STEVE**
>Mommy! . . . Mommy! . . .

Bruno, keeping one hand hooked on the frame, does what he can to hold Steve out of the water . . .

>**BRUNO**
>Not my hair! . . . My neck, your arms around my neck!

Bruno helps him put his arms around his neck, Steve calms himself, still trembling, sobbing . . .

>**BRUNO**
>Hold me tight, we're going to get out . . .

Bruno moves by gripping the frame, Steve is on his back, hanging on his shoulders, his head . . .

>**BRUNO**
>Can your foot touch the thing? . . .

>**STEVE**
>Yes . . .

> **BRUNO**
> Your hand on the pipe . . .

Bruno helps him place his hand . . . then to get out of the water . . . Steve is on his knees on the conveyor belt, trembling . . . dripping. Bruno tries to get out of the water, but Steve must move forward for him to be able to climb onto the conveyor belt.

> **BRUNO** (*pushing him with one hand*)
> Move forward . . .

Steve, trembling, doesn't move. Despite Steve's presence, Bruno manages to climb up onto the conveyor belt . . .

> **BRUNO**
> Get up . . .

Steve doesn't move, as if he's paralyzed, he cries . . . Bruno bends down, is close to him . . .

> **BRUNO**
> What's the matter? . . .

> **STEVE** (*through his tears*)
> I can't move . . .

Bruno gently takes one of Steve's hands . . .

> **BRUNO**
> . . . Give me your hand . . . don't be afraid . . . let go . . . the other hand . . .

Steve is gripping both of Bruno's hands . . . Bruno puts his feet on the rings mounted on the posts, through which electric cables once ran, propels himself backwards toward the rear, pulling Steve, who moves forward on his knees . . .

79. Ext. Landing—Day

Bruno walks, carrying Steve on his back . . . he walks as fast as he can . . . approaches a corrugated iron shed . . .

80. Int. Shed/Landing—Day

Bruno, soaked, puts Steve down, also soaked, shivering cold. He puts his feet on the ground, still holding the back of Bruno's jacket, who is exhausted by the effort, catching his breath . . .

> **BRUNO** (*still turned with his back to Steve*)
> Are you OK? . . .
>
> **STEVE**
> No . . .

Bruno turns around and helps Steve sit on the ground, his back leaning against a pillar . . . He takes off his shoes . . .

> **BRUNO**
> . . . You have to warm up the blood . . .

Bruno has taken off Steve's soaking socks, rubs his foot energetically . . .

> **BRUNO**
> Can't stay here, if they tipped off the cops . . . You feel anything? . . .
>
> **STEVE**
> A little, yes . . .

Bruno rubs the other foot . . .

> **BRUNO**
> Warming up? . . .
>
> **STEVE**
> A little . . . here, my legs . . .

Bruno lifts up Steve's pant legs, rubs his calves energetically . . .

> **STEVE**
> My brother, he expects the scooter at three o'clock. He's going to beat me up . . .
>
> **BRUNO** (*still rubbing*)
> We'll pay him . . . Keep rubbing, I'll quickly go get the money and scooter . . .

Bruno gets up and goes toward the opening of the shed . . .

 STEVE
 Wait!

Bruno turns around . . .

 STEVE *(trying to get up but can't)*
 I'll go with you! You're going to take off with the money! . . .

 BRUNO
 Are you dumb or what? . . . I'll be back.

Saying these last words, Bruno leaves the shed . . .

 STEVE *(off-camera)*
 Come back, hey!

81. Ext. Landing—Day

Bruno running, walks one step toward where he hid the money . . . He bends down and takes the bags with the money from under the partly buried cement platform, slips them into his wet jacket, stands up, goes toward the access ramp . . .

Bruno holding the scooter by the handlebars, pulls to try to free it from the wires, which are snagged on the footrest and the rear wheel . . . Failing to do so, he bends down to the rear wheel of the scooter to remove the wires . . . The sharp end of one of the iron wires has punctured the tire of the rear wheel, which is flat . . . Bruno mutters a curse word as he takes the wire out of the flat tire, takes out another wire trapping the footrest, gets up, takes the scooter by the handlebars, takes a few steps to get out of the space between the truck trailer and the wall of the dock . . . Suddenly, he sees two uniformed police-men coming out of a van and descending the staircase which connects the expressway to the landing. He quickly takes a few steps backwards, lays the scooter down, hides behind the trailer . . . After some time, he looks and sees one of the policemen coming out of the shed holding Steve by his arm . . . The other policeman, who had gone to inspect the transporter, comes running back to the shed . . . They seem to argue with Steve, then, holding him, take him toward the staircase . . . The moment that they begin to climb the steps, Bruno hides behind the trailer . . .

82. Ext. Square/Street/Sonia's Apartment Building—Day

Bruno, his clothes still wet, walks, his hands on the handlebars of the scooter, which he pushes along next to him, he crosses a square . . . then a street, arrives near Sonia's apartment building . . . leans the scooter against the wall near the entrance . . .

83. Int. Staircase/Hallway/Sonia's Apartment Building—Day

Bruno climbing the last steps of the staircase, walks up to the door of Sonia's apartment . . . rests a moment in front of the door . . . knocks . . . No one answers . . .

> BRUNO
> . . . Sonia? . . .

He is in front of the door, no one responds . . .

84. Ext. Bridge/City—Day

Bruno, pushing the scooter, crosses a bridge that straddles the river . . .

85. Ext./Int. Waiting Room/Police Station—Day

Bruno pushes a door, enters a waiting room with a service window . . . There is no one in the room or behind the window . . . He sits on a bench, waits . . .

> POLICEMAN (off-camera)
> Yes? . . .

Bruno gets up, goes to the window, behind which is now a policeman . . .

> BRUNO
> . . . There's a boy named Steve . . . who was arrested by the police an hour ago . . . I want to know if he is here . . .

The policeman looks at a piece of paper near him . . .

> POLICEMAN
> Steve . . . Lambion? . . .

BRUNO
Yes . . .

POLICEMAN
He's on the third floor with the detective. Are you family? . . .

BRUNO
No . . . but I have something important to tell him . . .

POLICEMAN
Tell it to me, I'll tell the detective.

BRUNO
I have to tell him myself . . .

POLICEMAN (*off-camera, picking up the phone*)
. . . I'll have to ask the detective . . .
(*into the phone*)
There's someone here who wants to talk to the boy . . . no . . .
(*to Bruno*)
You can talk to him in front of the detective.

BRUNO
OK . . .

86. Int. Elevator/Hallway/Police Station—Day

Bruno accompanied by the policeman in the elevator, going up . . . stops, the door opens, the policeman exits, followed by Bruno, they walk down the hallway . . .

87. Int. Detective's Office—Day

Bruno is in the office, behind him the policeman has disappeared by closing the door. Behind a table, the detective and, facing her, Steve, seated, dressed in dry clothes a bit too big for him . . .

DETECTIVE (*to Bruno*)
You can talk to him . . .

A beat.

BRUNO (*to Steve*)
. . . I brought back the scooter . . . it's here in front, in the station's parking lot.

A beat.

Bruno takes the two plastic bags with the banknotes and coins from his jacket, puts them on the table . . .

DETECTIVE (*off-camera*)
Are you the ringleader?

BRUNO
Yes . . .

88. Int. Hallway/Visiting Room/Prison—Day

Bruno, in regulatory detention attire, walks down a hallway accompanied by a guard . . . he arrives near a glass door that is opened by a guard who is on the other side, in the visiting room. Bruno crosses the visiting room where other prisoners are seated at tables with their visitors . . . he slows down as he approaches the table where Sonia is sitting . . . sits on a bench . . . Sonia is on the other side of the table facing him . . .

A long silence . . .

SONIA
. . . You want a coffee? . . .

Bruno makes a sign with his head to say yes, without looking Sonia in the eyes . . . Sonia gets up . . . walks up to a machine that dispenses drinks . . . takes a coin from her jacket pocket, which she puts into the machine, pushes a button, gets the first coffee, puts in a second coin, pushes the button, gets the second coffee . . . She walks toward the table with the two cups of coffee . . . puts them on the table . . . sits . . . Bruno makes a sign with his head to say thank you . . . Sonia drinks a mouthful of coffee . . .

A beat.

Bruno takes his cup in his hand.

BRUNO

And . . . Jimmy? . . .

SONIA

. . . He's doing well . . .

Bruno goes to drink . . . he cries . . . he puts his cup down, their hands wrapped around their cups are close to each other . . . Bruno melts into tears, takes Sonia's hand as she takes his . . . Bruno lifts his gaze toward Sonia, who looks back at him, also in tears . . . They both cry . . . Tears, tears, and more tears, of life . . .

Fade to black.

Lorna's Silence

1. Int. Bank Branch—Day

Lorna, a young woman of twenty-five, speaking French with a Central-European accent (we will later learn that she is Albanian), slides some banknotes into the opening of a service window . . . The employee takes them, counts them . . .

> **TELLER**
> . . . Three hundred forty . . .
>
> **LORNA**
> Yes. Can I see the manager?
>
> **TELLER**
> He'll be here tomorrow. Do you want to make an appointment?
>
> **LORNA**
> Yes. At twelve thirty if possible . . .

The teller slides a document to be signed through the window opening. Lorna takes it, takes a pen from the pen holder . . .

> **TELLER**
> Twelve thirty . . . The purpose of the appointment? . . .
>
> **LORNA**
> The loan I've already spoken to him about. I'm going to be a Belgian citizen, I'll be able to do it.

Lorna signs the document, returns it to the employee . . .

2. Int. Phone and Internet Center—Evening

Lorna is at a phone station, a handset to her ear, listening to what is being said . . . After a beat . . .

> **LORNA** (*in Albanian*)
> . . . Yes . . . fourteen thousand . . . yes . . . in a month, if everything goes as planned . . . When will we see each other? . . . All right, yes . . . I'm going to hang up . . . Yes . . . I love you . . . me too . . .

She hangs up, goes to the counter to pay the Pakistani cashier for the call.

CASHIER
. . . Seven euros ten cents . . .

She goes to pay when her cell phone rings . . . She takes it while looking at the screen . . .

LORNA (*in French*)
What is it? . . . I know, it's the third time you've called me.

She hangs up, opens her wallet to take out the money, and pays the cashier . . .

3. Int. Mini Mart—Evening

Lorna moves between the aisles, she already has a basket of tomatoes, bread in her shopping basket . . . she picks up a carton of six eggs . . . rice . . . a few apples.

4. Int. Entrance Hall/Lorna and Claudy's Apartment Building—Evening

Lorna, a plastic bag filled with groceries in her hand, enters an apartment building, walks to the back of the hall where the mailboxes are located. She opens one, looks inside; there is nothing . . . she goes back to the staircase . . .

5. Int. Staircase/Landing/Lorna and Claudy's Apartment—Evening

Lorna, the plastic bag of groceries in her hand, climbs the staircase, arrives on the landing, takes the key out of her jacket pocket, unlocks . . .

6. Int. Living Room/Lorna and Claudy's Apartment—Evening

Lorna approaches Claudy, who gets up from an armchair, a lit cigarette in his hand . . . He is a young, thin man, twenty-five/thirty years old. There is music playing at a rather high volume through a mini stereo. Lorna takes the rice out of the plastic bag, gives it to Claudy . . .

CLAUDY
Thank you . . .

LORNA
One euro fifty . . .

Lorna puts the plastic bag of groceries on a small table. Claudy takes an envelope from his pocket, picks out a five-euro bill and gives it to Lorna, who takes her wallet out of her purse. She takes out a few coins . . .

LORNA
. . . Three euros fifty . . .

Claudy takes the money, goes to the kitchen area with his rice. Lorna hangs her jacket and her purse on a hook near the front door. She keeps her wallet in her hand, goes into the bedroom adjacent to the living room . . .

7. Int. Bedroom/Lorna and Claudy's Apartment—Evening

Lorna is near a double bed, opens, with a key that she takes out of her pants pocket, the drawer of a small dresser, on top of which we see an alarm clock and a framed photo of her and Claudy holding each other around the shoulders, head against head. She pulls the drawer open, drops her wallet into it, locks it . . .

8. Int. Bathroom/Lorna and Claudy's Apartment—Evening

Lorna is in the shower in the bathroom. She washes her hair . . . rinses . . . she gets out of the shower, dries her hair . . . Off-camera, we hear Claudy's music . . . She combs her hair in front of the mirror, the bath towel over her shoulders . . . looks at herself in the mirror for a moment . . .

Wearing a long t-shirt that she uses as a nightgown, her hair still wet, she turns the key to open the bathroom door, exits . . .

9. Int. Living Room/Bedroom/Lorna and Claudy's Apartment—Evening

Lorna goes to her bedroom.

LORNA
I'm going to sleep!

CLAUDY (*off-camera*)
Can we play a game?

LORNA
No!

She goes into her bedroom . . .

LORNA
Are you coming?

Claudy comes to the bedroom and, with Lorna, lifts the mattress off the bed in order to take out another mattress from underneath. It is made of foam, composed of two parts connected by a piece of fabric. The moment Claudy folds it in half to carry it, his cell phone rings, he takes it out of his pocket, answers it while looking at the screen . . .

CLAUDY (into the phone)
I said no! That means no!

He hangs up and leaves the room carrying the mattress. Lorna takes a sheet and a blanket from the wardrobe, and one of the two pillows from the bed . . .

10. Int. Living Room/Lorna and Claudy's Apartment—Evening

Lorna, carrying the blanket, sheet, and pillow, goes to Claudy, who is in the process of lighting a cigarette while sitting down in the armchair facing the small table, on which there are playing cards arranged in a winning hand and a bowl of rice water. She puts the blanket, sheet, and pillow down on the mattress, which is on the floor next to the small table.

LORNA
Good night.

CLAUDY
You don't want to play?

LORNA
No.

She goes back to the bedroom, enters, closes the door . . .

CLAUDY (off-camera)
Did you hear what I told him?

LORNA
Yes . . .

11. Int. Bedroom/Lorna and Claudy's Apartment—Evening

Lorna closes the door, turns the key in the lock . . . She sets an alarm on her cell phone, plugs in the charger, puts it down on the small dresser near the photo, sets the alarm on the clock, opens a drawer of the dresser, takes out a box of wax earplugs, opens it, puts an earplug in one ear . . .

> **LORNA**
> Turn down the music!

The volume is not lowered, she gets up, turns the key, opens . . .

> **LORNA**
> The music, softer!

> **CLAUDY**
> Sorry . . .

He cuts the music. Lorna locks the door, puts a second earplug in the other ear, turns out the light, slides into bed . . .

After a beat . . .

> **CLAUDY** (*off-camera*)
> Lorna . . .

Lorna doesn't respond . . . Off-camera, we hear Claudy approaching the bedroom door . . .

> **CLAUDY** (*off-camera, speaking louder*)
> Lorna!

> **LORNA**
> What? . . .

She takes an earplug out . . .

> **CLAUDY** (*off-camera*)
> I want to talk . . . open up . . .

> **LORNA**
> No . . . Tomorrow I have to get up at six . . .

CLAUDY (*off-camera*)
I'm not going out tonight . . . I'm quitting . . .

LORNA
You say that every week, let me sleep.

She puts her earplug back in . . .

CLAUDY (*off-camera*)
This time I'll hold out, but you have to help me . . . Lorna, swear you'll help me . . . I can't do it all alone . . . Are you gonna help me? . . .

Lorna doesn't respond, she is in the midst of drifting off . . .

A beat.

CLAUDY
Lorna, answer me . . . Will you help me? . . .

Lorna seems to be asleep . . .

12. Int. Living Room/Lorna and Claudy's Apartment—Morning

Lorna, dressed, in the kitchen area, finishes making tomato sandwiches for her lunch, she wraps them in aluminum foil . . . Claudy is next to her.

CLAUDY
. . . I only ask because I need it . . . to give me a goal for the day.

LORNA
I don't know when I'll be back, I told you! . . .

She goes to the bedroom . . . He follows her . . .

CLAUDY
I don't care, give me an hour . . . anytime . . .

13. Int. Bedroom/Lorna and Claudy's Apartment—Morning

Lorna bends over, unlocks the small dresser, from which she retrieves her wallet.

CLAUDY
Five o'clock? . . . Six . . . Nine o'clock? . . . Seven o'clock, OK? . . . Seven o'clock?

LORNA
If you want . . .

She gets up, leaves the room . . .

14. Int. Living Room/Lorna and Claudy's Apartment—Morning

Lorna picks up her wrapped sandwiches and an apple, puts them in her purse, goes to fetch her jacket . . .

LORNA
Don't forget to put your mattress back.

She puts on her jacket. Claudy rushes to the front door . . .

LORNA
What are you doing?

CLAUDY
I can't go out. Lock me in and leave with my key.

He opens the door and puts his key in the outside lock . . .

LORNA
And if you want to leave?

CLAUDY
No. I can't go meet the others, otherwise I'll crack . . .

Lorna passes through the door . . .

LORNA
I'm not doing this.

CLAUDY
Why not?

LORNA
In half an hour you're going to want to leave, and I'm going to have to come back to unlock it.

CLAUDY
No, I swear, I . . .

She turns on her heels and starts going down the stairs . . .

CLAUDY (*off-camera*)
Lorna! . . . Lorna! . . .

She continues down the stairs.

15. Int. Dry Cleaning Plant/Storefront—Day

In the plant, in the back of a storefront, a few women, including Lorna, are in the process of cleaning and ironing clothes. Lorna, wearing an apron over her clothes, is working the attachment of a steam machine over a coat on a hanger . . . She moves the hanger holding the coat to where the other clean clothes are . . . She heads to a door in the back of the plant.

16. Int. Changing Room/Dry Cleaning Plant—Day

Lorna sets the numbers of her padlock code, opens her locker, takes out her purse, from which she retrieves her apple, she closes her locker, starts eating the apple while returning to the floor . . .

17. Int. Dry Cleaning Plant—Day

While eating her apple, Lorna pulls a few hangers holding clothes to the steam machine. She starts to clean the first one . . .

18. Int./Ext. Fabio's Taxi—Day

Lorna, wearing her jacket over her work apron, is seated next to Fabio, a man of thirty years, who is driving his taxi at a high speed.

LORNA
He told them that I get a break at noon and that I could come back.

FABIO

You should have told him that you could only come home in the evening.

LORNA

I told him that, but he doesn't understand anything. He was all panicked, he's trying to quit again . . .

Lorna is interrupted by the voice of the dispatcher on the two-way radio, to whom Fabio responds.

LORNA

He says that this time he's sure he wants to quit. He asked me to help him . . .

FABIO

He says that and tomorrow he'll be stoned stiff.

LORNA

If he ever succeeds, what do we do?

FABIO

Like we planned, we'll give him an overdose. It won't be the first time a junkie who quit relapses and dies of an overdose.

Silence.

FABIO

These cops really bug me! Nothing for six months, then *wham!* you're about to get your Belgian citizenship and they're on top of us! . . .

The car arrives at Lorna and Claudy's apartment building, slows down.

LORNA

Will you wait for me?

FABIO

No, I have to go to the airport. Make sure they see the photo.

Lorna gets out of the car, runs to the entrance of the building . . .

19. Int. Landing/Living Room/Lorna and Claudy's Apartment—Day

Lorna turns the key, enters the silent apartment, which seems empty . . .

> **LORNA**
> Claudy? . . .

No one answers, she goes to the bedroom . . .

20. Int. Bedroom/Lorna and Claudy's Apartment—Day

Lorna finds Claudy sitting on the bed, his legs under the covers, the pillows under his head, a bowl of rice water in his hands . . .

> **CLAUDY**
> I didn't feel well, I wanted to see you . . .

> **LORNA**
> Get out of my bed . . .

> **CLAUDY**
> You said I could . . .

> **LORNA**
> On top but not in . . .

Lorna takes her cell phone out of her jacket pocket to make a call, but she is interrupted upon seeing Claudy spill the rice water on the bed as he stands up.

> **LORNA**
> Look at what you did! Shit! Go get some water!

She makes a call on her cell phone . . .

> **LORNA** (*into the phone*)
> There were no police, it was just so I would come . . . yes . . .

She hangs up . . . takes the container of water out of Claudy's hands.

> **LORNA**
> Never do that again.

CLAUDY
I didn't feel well . . .

LORNA
I don't care . . .

She takes a towel from the windowsill, starts cleaning the sheet, the mattress . . .

LORNA
I'm going to be late . . . I won't even have time to eat . . .

CLAUDY
Do you want me to make you some toast?

LORNA
No.

The moment Lorna responds, the doorbell rings. Lorna stops cleaning . . .

CLAUDY *(to the door)*
Who is it?

MAN *(off-camera)*
Yvon. Do you want anything?

CLAUDY
Get out of here!
(to Lorna)
He already came twice this morning . . .

Lorna removes the sheet from the bed to let it dry on the radiator . . .

CLAUDY
Can you bring back some Buscopan from the pharmacy? . . . It's for my cramps . . .

Lorna doesn't respond, finishes spreading the sheet over the radiator, leaves . . .

21. Int. Living Room/Lorna and Claudy's Apartment—Day

Lorna goes to the sink, turns on the faucet to rinse the cloth . . .

CLAUDY
It's seventeen or eighteen euros . . .

He takes a twenty-euro bill out of his envelope . . .

LORNA
Why is it that I have to do these things for you?

CLAUDY
You know why. If I go out, I'll see the others again, and I'll relapse.

Lorna dries her hands . . .

LORNA
Well, that's none of my business! You got your money for the marriage, and you're going to get double for the divorce. You can't ask me for anything else. Nothing!

She has walked toward the door, goes to leave . . . Claudy follows her, stepping in front of her . . .

CLAUDY (*on the verge of tears*)
I don't care about the money! I'm just asking you to help me . . .
(*he gives her the twenty-euro bill*)
Buy me the Buscopan . . .

LORNA
Go buy it yourself.

She goes to open the door, he throws himself at her feet, on his knees, in tears . . .

CLAUDY
Help me, Lorna . . . help me . . . I can't leave . . . help me . . .

LORNA
Get up! Get up!

Claudy stands up . . . Lorna seems troubled by seeing Claudy in this state . . .

LORNA
Write the name of the medication on a piece of paper . . .

She watches Claudy take a few steps toward a shelf to pick up a pen, come near her, and try to write the name of the medication on a piece of cardboard from the box of the card game on the table . . . his hand trembles . . .

> **CLAUDY**
> I can't do it . . .

Lorna takes the pen and bends over to write . . .

> **CLAUDY**
> Buscopan . . .

She writes on the cardboard . . . She stands back up, he hands her the twenty euros . . .

> **CLAUDY**
> You'll lock me in?

> **LORNA**
> No.

She leaves . . .

22. Int./Ext. Apartment Building/Front of Apartment Building— Day

Lorna races down the last steps of the staircase, walks in a hurry, exits the building . . . goes to cross the street in front of the building . . .

> **CLAUDY** (off-camera, yelling)
> Lorna! Lorna!

She turns around, looks toward the open window where Claudy stands . . .

> **CLAUDY** (yelling)
> My key!

He throws the key to the apartment at Lorna, but it falls onto the tarpaulin top of a large truck parked near the building . . .

CLAUDY (*yelling*)
It fell on top of the truck! . . .

Lorna sees a bus arriving and slowing down, she runs toward the bus . . .

23. Ext. Street/City—Evening

Lorna wearing her jacket, her purse on her shoulder, crosses an intersection where there are people, a lot of traffic, headlights . . . she walks down a street . . .

24. Int. Staircase/Boarding House—Evening

Lorna climbs the steps of a staircase . . . her cell phone rings, she takes it from her pocket, looks at the screen, turns it off . . . she continues climbing the stairs, arrives at a landing, knocks at the boarding house door . . .

YOUNG WOMAN (*off-camera, with a foreign accent*)
Who is it?

LORNA
Lorna . . .

A young woman opens the door . . .

LORNA
Can I sleep here tonight? . . .

YOUNG WOMAN
Tonight's not good . . . I'm with someone . . .

Lorna remains unresponsive, seems lost.

YOUNG WOMAN
What's . . . the matter? Is something wrong? . . .

LORNA
Yes . . . goodbye . . .

Lorna leaves the landing, descends the staircase . . .

25. Int. Phone and Internet Center—Evening

Lorna enters a cubicle, picks up the receiver . . . dials a phone number . . . It's an answering machine that picks up . . .

> **LORNA** (*in Albanian*)
> It's me . . . I wanted to talk . . . goodbye . . . I'll call tomorrow . . .

She hangs up . . . remains in front of the phone for a moment, pensive . . .

26. Int. Entrance to a Small Hotel—Evening

Lorna is in front of the service counter of a small hotel, behind which stands a man.

> **LORNA**
> There's nothing cheaper?

> **MAN**
> I have a small room for thirty-five euros on the ground floor with a sink but a communal toilet.

> **LORNA**
> OK . . . Do I pay now? . . .

The man gives her a key.

> **MAN**
> If you want . . .

Lorna takes out her wallet to pay . . .

27. Int. Room/Small Hotel—Evening

Lorna is sitting on the edge of a single bed, she has removed her shoes, finishes taking off her socks . . . removes her pants, which she hangs on a hook on the back of the door where her jacket is already hanging, she takes off her sweater, her bra from underneath her t-shirt . . . she passes between the bed and the wall to get to the sink, rinses her face in front of the small mirror . . . takes the washcloth laid on the sink, dries her face while trying out the bed . . . she stays there a moment, pensive . . . gets up, takes her pants from the hook on the door, puts them on . . .

28. Ext. Streets/City—Evening

Lorna, her purse on her shoulder, crosses an intersection . . . walks down a commercial street along store windows, some of which are lit . . .

29. Ext. in Front of a Pharmacy—Evening

Lorna pushes the buzzer of a pharmacy, the metal shutters of which are closed. The window behind is lit. A young woman appears, opens a sort of service window in the shutter . . . Lorna has taken the piece of cardboard out of her jacket.

> **WOMAN**
> Yes? . . .

> **LORNA**
> I would like Buscopan, please.

> **WOMAN**
> Do you have a prescription?

> **LORNA**
> No . . .

> **WOMAN**
> Are you in a lot of pain?

> **LORNA**
> It's not mine, it's . . . my husband, he has cramps . . .

> **WOMAN**
> I'm going to give it to you, but normally after hours you need a prescription.

> **LORNA**
> Thank you . . .

The woman goes into the pharmacy, Lorna waits for her, her face close to the metal shutters . . .

30. Int. Living Room/Lorna and Claudy's Apartment—Evening

Lorna coming into the apartment, she closes the door behind her . . .

> **CLAUDY** (*off-camera, in a weak voice*)
> Do you have the Buscopan? . . .

LORNA
Yes.

She has taken the Buscopan from her bag, gives it to Claudy, who is seated on his mattress.

CLAUDY
Thanks, I thought you weren't coming back . . .

Lorna takes off her jacket, she goes toward the bathroom . . .

CLAUDY (*off-camera*)
Can you get me a glass of water? . . . I can't get up . . .

Lorna picks up a glass, fills it from the faucet, takes it to Claudy, who is in the process of opening the bottle of Buscopan.

CLAUDY
. . . Everything hurts, thanks . . .

31. Int. Bedroom/Lorna and Claudy's Apartment—Evening

Lorna, wearing the t-shirt she sleeps in, sets her wakeup time on her cell phone, she plugs it in to charge . . . off-camera, we hear Claudy's moans . . . she listens . . . We don't hear anything more . . . She sets the alarm on her clock, opens a drawer of the dresser, takes out her earplugs . . . again we hear the moans and calls for help from Claudy . . . She opens the door of the bedroom, which had been locked . . .

32. Int. Living Room/Lorna and Claudy's Apartment—Evening

Lorna goes to Claudy, who is on all fours near his mattress, unable to move and apparently suffocating, his face and his hair soaked with sweat . . .

LORNA
What's wrong with you? . . .

Claudy makes a gesture with his hand.

LORNA
Some water? . . .

Claudy nods his head yes. Lorna goes to fill a glass from the faucet . . . coming back to Claudy, she hands him the glass of water, but he is not able to take it . . . She leans over, brings the glass up to Claudy's lips, who drinks as best as he can . . . his spasms fade . . .

CLAUDY
. . . My back . . . rub it . . . it hurts . . .

Lorna doesn't react right away . . .

CLAUDY
Lorna . . .

Lorna massages his upper back . . .

After some time.

CLAUDY
. . . It's better . . . I'm going to sit . . .

Lorna goes to leave him to return to her bedroom.

CLAUDY
Wait! . . . Call my doctor.

He takes his cell phone out of his pants pocket with some difficulty.

LORNA
Why don't you call him yourself? . . .

CLAUDY
Help me, Lorna! Help me!

He hands her the cell phone . . . She takes it . . .

CLAUDY
Under *M*, Mayro . . . Tell him that I quit and that I want to go to the hospital . . . he should admit me . . .

LORNA
Right now? . . .

CLAUDY
Yes . . .

Lorna pushes the buttons on the cell phone, waits . . .

LORNA *(into the phone)*
. . . Good evening . . . I am Claudy Moreau's wife . . . yes . . . he asked
me to call because he is off drugs . . .

CLAUDY
Tell him I have been for around thirty hours . . .

LORNA *(into the phone)*
. . . He wants to be admitted to the hospital and . . . yes . . . I'll hand
you over to him . . .

She passes the cell phone to Claudy, who is seated on the ground.

CLAUDY *(into the phone)*
Hello . . . yes . . . no, this time it's true, I swear . . . I've held out for thirty
hours already . . . I have seizures, I suffocate . . . yes . . . I've decided . . .
yes . . . *(he hangs up)*
(to Lorna)
He's going to admit me. Call a taxi . . .

He gives his cell phone back to Lorna. She takes the cell phone, dials a
number . . .

LORNA *(into the phone)*
Fabio? . . . It's Lorna . . . Claudy is going to the hospital to stop taking
drugs . . . can you drive him . . . I don't have the number? . . . yes . . .
two and four threes . . . What? . . . yes, I'll call back . . .

She hangs up, dials another number . . .

CLAUDY
Lorna . . . help me . . .

While calling, she helps Claudy get up . . .

LORNA (*into the phone*)
Hello . . . can we have a taxi at Seventeen Marihaye Street? . . . Third floor . . . yes . . . (*she hangs up*)
(*to Claudy*)
He'll be here in five minutes.

She gives the cell phone back to Claudy, who is in the process of putting on his jacket carefully, as if he is afraid of hurting himself . . .

CLAUDY
. . . Put it in my pocket . . . my sneakers, I can't get them on . . .

Lorna lowers herself down to help him tie his sneakers, she has to undo the knots in the laces . . . Claudy, weak, shivering, holding himself up with one hand on the peg of a coat rack . . . She helps him tie the first shoe, tries to undo the knot in the laces of the second . . .

CLAUDY
Leave it like that . . . Go get dressed quickly.

LORNA
I'm not going with you, I'm going to sleep.

CLAUDY
No . . . no . . . not all alone, I can't . . . You have to come with me . . .

Lorna continues to undo the knot, seemingly not paying attention to what he says.

CLAUDY
Lorna, you have to come with me . . . Lorna? . . .

LORNA
Shut up!

She has undone the knot, opens the sneaker . . .

33. Int. Staircase/Lorna and Claudy's Apartment—Evening

Lorna and Claudy wearing their jackets, slowly descending the staircase . . . Claudy leans on Lorna, he grimaces in pain, stops to rub his thighs . . . he hurts . . . they resume the descent . . . at one point Claudy loses his balance, Lorna holds him up, but they both fall into a seated position on the steps . . . She helps him get back up . . .

34. Int. Emergency Room/Hospital—Evening

Lorna is at the reception desk, where the receptionist is in the process of inputting data.

> **RECEPTIONIST**
> It is absolutely necessary. Can you bring it tomorrow?

> **LORNA**
> Yes.

Lorna crosses the waiting room where there are a few people, approaches Claudy who is seated on a bench, doubled over, his hands between his legs, his head lowered . . .

> **LORNA**
> Your money.

She hands him the envelope . . . He doesn't raise his head . . .

> **CLAUDY**
> . . . Hold on to it . . . I don't need it here . . . Give me twenty euros for my cigarettes . . .

She takes out a twenty-euro bill.

> **LORNA**
> I have to bring your social security card tomorrow. Where is it?

> **CLAUDY**
> On the shelf with my stuff . . .

He head remains lowered, shivering, speaking as if he is very cold . . .

> **LORNA**
> Your twenty euros . . .

> **CLAUDY**
> Put it in my pocket . . . Is there someone who will take care of me?

Lorna slips the twenty euros into his jacket pocket . . .

LORNA
The receptionist said a nurse is going to come . . . I'm going . . .

CLAUDY
Lorna! . . . Can you bring my player and my CDs tomorrow? . . .

LORNA
Yes.

Lorna has barely taken a step away when he gets up.

CLAUDY
Lorna! . . . don't leave me all alone . . .

LORNA
You're not all alone, the nurse is going to come . . .

CLAUDY
Wait here with me . . .

Lorna looks at him . . . She goes back to him . . . They sit on the bench . . .

35. Int. Bedroom/Lorna and Claudy's Apartment—Morning

Lorna is still asleep in her bed. The doorbell rings . . . The doorbell rings a second time with more insistency . . . She wakes up, looks at the time on her alarm clock located on the small dresser where there is the photo of Lorna and Claudy . . . Without making a sound, she gets out of bed, tiptoes into the living room . . .

36. Int. Living Room/Lorna and Claudy's Apartment—Morning

Lorna picks up Claudy's mattress, which is on the ground next to the small table, the pillow, which is on the armchair, and, walking on her tiptoes, goes back to the bedroom. The doorbell rings again . . .

37. Int. Bedroom/Lorna and Claudy's Apartment—Morning

LORNA
Yes? . . . Who is it?

MAN (*off-camera*)
The police . . .

LORNA

I'm putting clothes on . . . one minute . . .

She tries to stow the mattress away under the mattress of the bed, but it is too difficult, she puts it underneath the bed, puts Claudy's pillow down next to hers . . . She puts on her pants . . . leaves the bedroom . . .

38. Int. Living Room/Lorna and Claudy's Apartment—Morning

Lorna approaches the front door while looking around to make sure everything seems to be in order, she opens the door . . . there are two policemen on the landing . . .

FIRST POLICEMAN

Hello, ma'am, we are officers from this precinct. *(he shows his badge)* Are you Mrs. Moreau?

LORNA

Yes . . .

POLICEMAN

You made a request to obtain Belgian citizenship following your marriage. The prosecutors have asked us to verify that you and your husband actually live together . . .

LORNA

We live together, but my husband has been in the hospital since yesterday evening.

POLICEMAN

Which hospital?

LORNA

The CHU[1], the psychiatric ward.

POLICEMAN

We'll verify that, may we come in? . . .

Lorna lets them enter. The second policeman has a document in hand and a pen . . .

POLICEMAN *(to Lorna)*

Could you open the fridge?

[1] University Hospital Center.

Lorna opens the fridge.

> **LORNA**
> There's not much, but my husband wasn't eating anymore . . .

> **POLICEMAN** (*to Lorna*)
> That's fine, we have what we need.
> (*to the other policeman*)
> O.K.
> (*to Lorna, indicating the armchair*)
> Does it turn into a bed?

> **LORNA**
> No . . .

The policeman verifies that the armchair does not turn into a bed . . .

> **POLICEMAN**
> Wardrobe?

> **LORNA**
> In the bedroom.

She leads him . . .

39. Int. Bedroom/Lorna and Claudy's Apartment—Morning

> **POLICEMAN** (*to the other policeman*)
> Double bed, OK.

Lorna has opened the wardrobe . . .

> **LORNA**
> That's mine . . . and my husband's things . . .

> **POLICEMAN** (*to the other policeman*)
> OK.
> (*to Lorna*)
> Do you have a photo album from your wedding?

> **LORNA**
> We have this photo here. (*she shows him the photo on the small dresser*)

POLICEMAN *(to the other policeman)*
OK.

They emerge from the bedroom, go toward the bathroom . . .

40. Living Room/Bathroom/Lorna and Claudy's Apartment—Morning

Lorna opens the bathroom door, the policeman enters, Lorna stays in the doorway, the other policeman beside her . . .

POLICEMAN *(to the other)*
Two toothbrushes, two washcloths, one razor. OK.
(to Lorna)
He left in a hurry, your husband?

LORNA
Yes . . .

The policemen leave. Lorna is dressed, she is next to Claudy's shelf, she picks up his portable CD player, puts it into a plastic bag that is in her hand, takes a few CDs, which she also puts into the bag . . . She goes to the front door, takes her jacket from the hook, puts it on . . . While putting it on, she looks toward the table . . . she heads toward the table, picks up Claudy's playing cards, makes a small pile, puts them in the cardboard box which is missing one end . . .

41. Int./Ext. Fabio's Taxi/Hospital Entrance—Day

The taxi driven by Fabio comes to a stop, Lorna gets out of the car . . .

FABIO
I'll wait for you here or in the taxi parking.

LORNA
OK.

Lorna, the plastic bag containing Claudy's things in hand, walks toward the entrance of the hospital . . .

42. Int. Psychatric Ward/Hospital—Day

Lorna is in front of the reception desk of the ward, facing a nurse . . .

LORNA
Claudy Moreau . . .

NURSE *(looking at her registry)*
Room 129, since yesterday, but it's not visiting hours.

LORNA
 . . . I'm here because yesterday we forgot his card . . . *(she tries to give her Claudy's social security card)*

NURSE
That's for the registration desk on the ground floor . . .

LORNA
All right . . . Can you give him this, it's his things.

NURSE
Are you his wife? . . .

LORNA
Yes . . .

NURSE
You can go give it to him . . .

LORNA
No, that's OK . . .

NURSE
Yes, you can go but don't stay long . . . Room 129 . . .

LORNA
Over there? . . .

NURSE
Yes, at the end on the right . . .

Lorna walks down the hallway, the plastic bag in hand . . .

43. Int. Hallway/Claudy's Room—Day

Lorna approaches the door of Claudy's room . . . She is in front of the door, knocks gently . . . No one answers . . . She knocks once more . . . No answer . . . Softly, she half-opens the door . . . enters . . . closes the door . . .

LORNA
Claudy? . . .

Claudy is lying on the bed, his back turned to her, seemingly asleep since he does not respond with a word or by moving his body . . . She walks up to a small table at the foot of the bed, puts the plastic bag down, making as little noise as possible . . . She goes to turn around, changes her mind, takes a few steps to the other side of the bed . . . looks at Claudy's face as he sleeps . . . She leaves . . .

44. Ext. Service Station/Expressway—Day

Lorna is next to Fabio, who gives her a twenty-euro bill after sliding the diesel gas pump into the hole of the tank. Lorna takes the bill, walks toward the station shop . . .

45. Int. Shop/Service Station—Day

Lorna picks up two containers of windshield-washer fluid from a shelf . . . goes toward the cashier . . . her face . . . she gets in line behind several customers who are waiting to pay . . .

46. Ext. Service Station/Expressway—Day

Lorna is next to Fabio, bent under the lifted hood of his taxi . . . he has already opened one container, finishes unscrewing the cap of the tank for the windshield washer fluid.

> **FABIO**
> . . . How?

> **LORNA**
> Do the divorce, as he was led to believe . . .

> **FABIO**
> No. We chose a junkie so that we would not have to go through a divorce . . . Anyway, it would take too long . . .

Fabio slowly pours the fluid into the tank . . .

> **LORNA**
> And if the Russian was OK with delaying the marriage . . .

> **FABIO**
> We agreed that it would be in June, and I'm going to keep my word . . . Throw on the windshield wipers, the handle on the right . . .

Lorna sits at the wheel of the car, turns on the windshield wipers, which squirts fluid onto the windshield . . .

> **FABIO** (*off-camera*)
> OK! . . .

Lorna gets out of the car . . . she approaches Fabio, in the process of pouring the fluid . . .

> **LORNA**
> I'm still going to find out if there's a way to get a quicker divorce . . .

A beat.

> **FABIO**
> Who's going to pay the three thousand euros to the junkie the day of the divorce?

> **LORNA**
> You can take three thousand out of the ten thousand that I'll get from the Russian . . .

> **FABIO**
> Are you screwing the junkie, or what?

> **LORNA**
> No . . . I'm with Sokol, I screw him . . .

> **FABIO**
> Then why do you want to go back on the deal?

Fabio has put the first container on the ground, opens the second . . .

> **LORNA**
> I'm not going back on it . . . but if he stops for good and then has an overdose, it's going to look odd . . .

> **FABIO**
> I already told you it won't. Almost all junkies who stop start up again . . .

He begins to pour . . .

FABIO

A divorce, it's too risky with the investigations, it's better that you're a widow . . .

47. Ext. Near A Station/City—Evening

Lorna gets off a bus, walks fast, runs at moments while crossing a square where there is a lot of traffic . . . She approaches the station . . . searches for someone . . . that she cannot find . . . she goes to enter the station when she notices the person she was looking for further down on the sidewalk, she accelerates her pace . . .

LORNA *(yelling)*
Sokol!

Sokol, a man of twenty-five/thirty, bearded, leaves a group of five or six men and comes toward Lorna . . . They hug, happy to have found one another . . .

LORNA *(in Albanian)*
I was afraid that you'd left. The beard suits you!

She strokes his beard, presses him against her . . .

LORNA
Look!

She takes out her wallet, pulls out her Belgian ID card, shows it to Sokol, who takes it and looks at it . . .

SOKOL
You're Belgian . . .

They hug again . . .

We find them a little apart, near the entrance to a parking lot . . .

SOKOL *(in Albanian)*
 . . . Near Cologne, in a nuclear plant. One minute in the reactor, a thousand euros . . .

LORNA
Isn't it dangerous?

SOKOL
No . . . just don't do it every month.

LORNA
Are you going to pass through here again?

SOKOL
No, we'll return directly through Italy. Here . . .
(he takes some money out of his jacket, gives it to Lorna)
One thousand two hundred. How much is in the account?

LORNA *(who takes out her wallet to put the money inside)*
Almost twenty thousand . . .

SOKOL
Let me see the card again!

She takes the plastic card out of the wallet, he looks at it, he gives it back to her . . .

SOKOL
I look forward to being here with you.

LORNA
Still have to wait for the Russian . . .

SOKOL
Yes.
(lighting a cigarette)
Did you look at locations for the snack bar?

LORNA
I'm going to do it next week. The banker told me that he had one or two addresses . . .

Suddenly she squeezes him in her arms, kisses him . . . then starts to cry.

LORNA
Tell me you love me . . .

SOKOL
. . . I love you . . . what's the matter? . . .

LORNA
Nothing . . .

Off-camera, we hear the blows of a vehicle's horn . . .

A beat.

SOKOL
That's the van . . . I have to go.

He caresses her face . . . They start to walk, entwined, down the sidewalk in the direction of the van . . .

LORNA
. . . The junkie . . . he's in the hospital to quit . . .

SOKOL
Again!

LORNA
It's the first time at the hospital. I wonder if we should get a divorce instead of . . .

SOKOL
Did you talk to Fabio about it?

LORNA
He doesn't want to make the Russian wait, but I inquired, there's a way to divorce more quickly if I file a complaint that my husband hits me.

SOKOL
Wouldn't there be an investigation?

LORNA
Yes, but apparently it works every time . . .

SOKOL
And if it fails, everything will be up in the air. Let Fabio decide.

Honks from the van . . . Sokol responds with a gesture that he's coming.

LORNA
I would prefer if he didn't have to die . . .

SOKOL

It's too late, we agreed . . . he's just a junkie . . .

He goes to kiss her . . .

SOKOL

You can't crack, we're too close to the end . . . If you feel things are not going well, call me . . .

LORNA

All right . . .

He kisses her . . . She watches him leave toward the van . . .

48. Int. Lorna and Claudy's Apartment—Evening

Lorna, in the t-shirt she sleeps in, finishes washing a bit of laundry in the sink, goes to put it on the radiator in the bedroom to dry . . . comes to the kitchen, picks up a glass, fills it with water from the faucet . . . She drinks a mouthful . . . looks around her, the apartment . . . goes to drink another mouthful when she puts down the glass and takes a few steps toward the bedroom door, she stops near the doorframe and suddenly bangs her arm violently against the edge of the doorframe at bicep-level, then the other arm . . . She grimaces in pain as she does it . . . She looks at the marks on her arms . . . crosses the living room and knocks her arms again against the corner of Claudy's shelf, she hurts, she starts again . . .

49. Int. Examination Room/Police Station—Day

Lorna in an examination room, in a bra, in the process of being photographed by a policewoman . . . Lorna has marks from the blows on her biceps and shoulder.

POLICEWOMAN

Turn your arm . . . a bit more . . .

She moves the camera up to her eye and takes the picture . . .

50. Int. Office/Police Station—Day

Lorna is sitting next to a table, behind which a detective finishes registering her complaint . . . He drums his fingers on the keyboard of his computer . . . then reading back over his screen . . .

DETECTIVE
. . . Seventeen Marihaye Street, at the conjugal residence . . . circumstances . . . a state of drug withdrawal . . . heroin . . . Wednesday, November 3, 2007 . . . twenty-one hundred hours. . . . now he is hospitalized, you said? . . .

LORNA
Yes, since Wednesday night, that night . . .

DETECTIVE
You should have come that night . . .

The detective turns on the printer . . .

DETECTIVE
The complaint will be sent to the judge, but I think that for an acceler-, ated divorce procedure, this will not be sufficient . . .

LORNA
Why?

DETECTIVE (*looking at his printer*)
. . . The places where you were hit, you could have made the bruises yourself . . .

LORNA
He did it! He wanted drugs!

DETECTIVE
There was no witness, and this was the first time . . .

He takes both sheets that come out from the printer with the details of the complaint . . .

DETECTIVE
Sign here . . .

Lorna takes the pen the detective hands her, she signs . . .

51. Ext. Courtyard-Park/Hospital—Day

Lorna and Claudy seated on a bench next to a wall of the hospital. Claudy smokes a cigarette . . .

LORNA

. . . Because I need the money, and the sooner I'm free to remarry, the sooner I'll get it . . .

CLAUDY

A real marriage?

LORNA

No, like us. With a foreigner who is paying to become Belgian . . . I'm helping you get clean, me! That wasn't part of the deal. You can help me, too, right? . . .

Claudy stands up to put his cigarette out in the public ashtray attached to the wall of the hospital, Lorna follows him . . .

LORNA

Do you agree to do it? . . .

CLAUDY

. . . I don't want it to be on record that I'm violent . . .

LORNA

You're already on record as a drug addict and a thief . . .

CLAUDY

That's not the same thing, I've never hit a woman . . .

LORNA

And getting the three thousand euros from the divorce more quickly, doesn't that interest you?

Claudy lights another cigarette . . .

CLAUDY

I can wait . . . I have my CPAS[2]. Maybe I'll find a job again . . .

A beat.

LORNA

If you accept, I'll help you to not relapse, even after the divorce . . .

Lorna and Claudy come to a crossing of two paths, partly hidden by a tree. Lorna takes a step backwards to look down a path . . .

[2] Public assistance.

LORNA
There are people coming! Do it!

Claudy doesn't budge . . . Lorna takes another step backwards to see down the path.

LORNA
They're coming! Hit! Hit me!

Claudy looks at her but he can't bring himself to hit her . . .

52. Int. Claudy's Room/Hospital—Day

Lorna and Claudy, seated on the edge of the bed, finishing a game of cards . . . which Claudy wins . . .

CLAUDY
Never play a club if you haven't seen a king go by!

Claudy picks up the cards from the bed to shuffle them . . .

LORNA
Three ten, I'm going.

CLAUDY
One more game!

LORNA
We said three hours.

She is headed toward the door of the room, opens it, looks down the hallway, closes it, comes back toward Claudy while messing up her hair . . .

LORNA
She's there.

She violently pulls at the collar of her blouse, wrinkling it, tearing off one or more buttons.

LORNA
Go ahead . . . Get up!

Claudy doesn't react . . .

> **LORNA**
> You said that if I played cards you would hit me! Do it! . . .

Claudy stands up, she waits . . . Claudy slaps her . . .

> **LORNA**
> With your fist! There . . . *(she indicates her eyebrow)*

A beat.

> **CLAUDY**
> I can't . . .

Suddenly Lorna throws her head against the metal cart holding the television. She is injured, she is bleeding from the forehead . . . Claudy is stunned . . . She quickly goes to look at her injury in the small mirror of the room's bathroom, she cries out several times and leaves the room running.

53. Int. Nurse's Reception Desk/Psychiatric Ward—Day

The nurse has sat Lorna down on a chair, blood runs down her face . . . The nurse comes back with a disinfectant compress, which she puts on Lorna's wound.

> **NURSE**
> Press without moving . . .

The nurse has opened a small metal drawer to get something else . . .

> **LORNA**
> He hit me, and my head banged the metal shelf the television is on.

The nurse removes the compress, applies adhesive bandages.

> **NURSE**
> These are bandages that will stitch up the wound . . . You should go file a complaint with the police.

> **LORNA**
> I'm going to . . . Would you agree to be a witness if they ask for one?

> **NURSE**
> Of course . . . He didn't seem like the violent type . . . You can never trust appearances . . .

The nurse continues to apply the bandages.

> **LORNA**
> What's your name?

> **NURSE**
> Monique Sobel . . . I'm going to wipe off the blood . . . Alright? . . .

> **LORNA**
> Yes . . . Can you write down your name and your phone number on a paper? . . .

> **NURSE**
> Of course . . .

The nurse has picked up a medical wipe, passes it over Lorna's face to wipe off the blood . . .

54. Ext. Exit of Police Station—Day

Lorna, the bandage on her forehead, leaving the police station, walks on the sidewalk along several police vehicles . . . takes a perpendicular street . . . She has hardly taken a few steps down this street when the voice of a man coming up behind her calls her first name . . . She turns around. The man, a little nervous (surname Spirou), whom she seems to know, approaches her . . .

> **SPIROU**
> Fabio wants to see you, he is at the Domino . . .

Lorna looks at him a moment without saying anything, Spirou turns around, Lorna follows him . . .

55. Int. the Domino Café—Day

Lorna is seated at a table with Fabio, who has a coffee in front of him . . .

LORNA

. . . There was a girl at the dry cleaner who did it, and it worked.

FABIO

You're making me worried, Lorna . . .

LORNA

I haven't done anything to you.

FABIO

You're not going to do that.

LORNA

And if it worked?

FABIO

You're not going to do that! You're his wife, you take care of him as well as possible, the rest is my business.

LORNA

You don't trust me anymore?

FABIO

I have to, I need you . . .

Spirou approaches the table with two coffees, one of which he puts in front of Fabio, the other in front of Lorna, he returns to the bar . . .

FABIO

Do not forget that you need me too. Let's hope that I don't blow my chance with the Russians because of you. It's my first shot with them. I can't miss it.

LORNA

I don't want to mess it up, I want my money too . . .

FABIO

I recognize you again when you talk like that . . .

Fabio has picked up his cup of coffee, raises it while bringing it toward Lorna's cup, which she also has raised, they bump the cups against each other . . . taking a swig of their coffee. Spirou comes over to sit at the table with a Coke . . .

FABIO

Who's the guy you saw at the station the other evening?

Lorna looks at Spirou . . .

> **LORNA**
> That's Sokol.

> **FABIO**
> With the beard? . . .

> **LORNA**
> Yes, he let his beard grow.

56. Int. Dry Cleaning Plant/Storefront—Day

Lorna, the wound almost healed, carries a dozen articles of clothing on hangers and puts them on a rail . . . goes to get a plastic bin full of clothes, puts it next to the cleaning and ironing machine . . . takes an article of clothing from the bin . . . starts cleaning it . . . She is called by the owner from the corridor leading to the storefront . . .

> **OWNER** (*off-camera*)
> Lorna! There's someone in the front for you!

Lorna puts her tool away, goes toward the corridor leading to the storefront . . . She is surprised to see Claudy, who is standing next to the front door, a plastic bag containing his things in hand . . . the owner is behind the counter in the middle of serving a customer . . . Lorna opens the door of the storefront to go outside with Claudy . . .

> **LORNA** (*to the owner*)
> Sorry. I'll be two minutes.

57. Ext. in Front of the Dry Cleaners Storefront—Day

> **CLAUDY**
> I wanted to surprise you . . .

> **LORNA**
> Does this mean you're better? . . .

Claudy lights a cigarette . . .

CLAUDY
Yes . . . If I'm ever not doing well, I have a number at the hospital I can call . . .

LORNA
You've got to hang on . . . Well, I have to get back to work . . .

She goes to reenter the storefront . . .

CLAUDY
I need the key to the apartment.

LORNA
 . . . I'll go fetch it.

CLAUDY
And money for my cigarettes! . . .

She reenters the dry cleaners . . .

58. Int. Changing Room/Dry Cleaning Plant—Day

Lorna finishes positioning the numbers on her padlock code, opens the locker, takes the key from her purse . . . takes the envelope with Claudy's money from her jacket pocket . . .

59. Ext. in Front of the Dry Cleaners Storefront—Day

Lorna appears behind the glass door of the storefront . . . she opens it, closes it behind her . . .

LORNA
Here . . .

She gives the key and the envelope to Claudy, goes to reenter . . .

CLAUDY
Wait! I'm only taking ten euros for my cigarettes . . .

Lorna waits while he takes the money from the envelope . . .

CLAUDY
Can we eat together at noon to celebrate my release?

LORNA
I can't, I have too much work.

CLAUDY
I'm going to make a meal tonight, that will keep me busy. That OK? . . .

He takes another ten-euro bill from the envelope . . .

LORNA
If you want . . .

He gives the envelope back to Lorna, she pushes on the door of the storefront . . .

CLAUDY
What time are you coming home?

LORNA
I don't know . . . around seven . . .

She reenters the storefront . . .

60. Ext. Intersection/Street/City—Evening

Lorna, wearing her jacket, her purse on her shoulder, crosses a busy intersection . . . walks down a street . . .

61. Ext. Avenue/Lorna and Claudy's Apartment Building—Evening

Lorna gets off a bus . . . crosses the avenue . . . walks on the sidewalk in the direction of the apartment building . . .

62. Int. Front Hall/Lorna and Claudy's Apartment Building—Evening

Lorna heads toward the back of the hall where the mailboxes are found . . . she opens hers, there is nothing . . . she turns back toward the staircase . . .

63. Int. Staircase/Landing/Lorna and Claudy's Apartment—Evening

Lorna climbing the last steps of the staircase . . . rings the doorbell of the apartment . . .

> **CLAUDY** (*off-camera*)
> Who is it? . . .
>
> **LORNA**
> Lorna . . .

We hear Claudy turn the key in the lock . . .

64. Int. Living Room/Lorna and Claudy's Apartment—Evening

Lorna hangs her jacket on the hook near the door, takes her wallet out of her purse . . .

> **CLAUDY** (*off-camera*)
> There was a letter for you in the box, I put it on your bed . . .

Lorna goes toward the bedroom, passes close to Claudy, who is in the process of cooking something on the stovetop, she enters the bedroom . . .

65. Int. Bedroom/Lorna and Claudy's Apartment—Evening

Lorna puts her wallet down on the small dresser, picks up the envelope from the bed, opens it, takes out the letter, reads it . . .

> **CLAUDY** (*off-camera*)
> I made macaroni with ham and gruyère, you'll see, it's good . . .

Lorna has continued reading the letter . . . she is next to the bedroom door . . .

> **LORNA**
> It's a letter from the judge . . . the divorce is going to work . . .

She folds the letter, picks her wallet up from the small dresser . . .

66. Int. Living Room/Lorna and Claudy's Apartment—Evening

Lorna is in the process of putting on her jacket, she is next to Claudy, busy making his pasta . . .

>**LORNA**
>If I tell you I'll be back in an hour, you can wait, can't you? . . .
>
>**CLAUDY**
>We said we would eat to celebrate my release . . .
>
>**LORNA**
>And I say we will do it in an hour! . . .
>
>**CLAUDY**
>. . . All right . . .

Lorna leaves the apartment . . .

67. Ext. Square in Front of the Station/Café—Evening

Lorna crosses the square where there is a lot of traffic . . . enters a café . . .

68. Int. Café—Evening

Lorna searches for someone . . . takes a few steps toward a nook where there are a few pinball machines . . . Spirou is in the middle of a game . . .

>**LORNA**
>Isn't Fabio here?
>
>**SPIROU**
>He's waiting for you in his taxi . . .

Lorna retraces her path through the café, exits . . .

69. Ext. Square/Fabio's Taxi—Evening

Lorna is against Fabio's taxi, next to the driver-side door, window open. Fabio is seated behind the wheel, in the process of reading the letter from the judge . . .

LORNA
I haven't done anything more, I swear. It's following up on my complaint . . .

A beat.

FABIO (*still reading the letter*)
. . . It's too late for the Russian, he will not be able to wait . . .

LORNA
Ask him, it's only another month . . .

FABIO
That means you'll remarry a week or two after your divorce. That stinks.

LORNA
Why? My husband hits me, I could have met another man while waiting for the divorce . . .

Silence . . .

FABIO
And the three thousand euros to the junkie, it's you paying . . .

LORNA
Yes, out of the ten thousand from the Russian . . .

FABIO
OK . . .

He gives the letter back to Lorna . . .

FABIO
I'm going to call him, maybe he'll agree, a month . . .

We hear a call to the car on the taxi's two-way radio, Fabio answers . . .

FABIO
I'm at the station . . .

LORNA
Will you call me when you've done it?

FABIO
Yes . . .

Lorna moves away, crossing the square . . .

70. Ext. Avenue/Lorna and Claudy's Apartment Building—Evening

Lorna gets off a bus . . . crosses the avenue . . . walks on the sidewalk in the direction of her apartment building . . . Off-camera, we hear Fabio's taxi honking . . . he makes a U-turn . . . Lorna looks in the direction of the car . . . which pulls up next to her . . . Fabio rolls down his window, he slows down without fully stopping . . .

FABIO
I just had the Russian on the phone, he's OK with it . . .

Fabio rolls up the window while starting to turn around . . . Lorna seems happy . . . she stands still a moment then sets out walking toward her apartment building . . .

71. Int. Landing/Lorna and Claudy's Apartment Building—Evening

Lorna climbs the last steps of the staircase, she doesn't have the key, she rings the doorbell . . . Claudy opens it . . . behind him, a young man . . .

CLAUDY
Can you give me my money? . . .

LORNA
Can I come in? . . .

She enters, passing in front of Claudy . . .

LORNA (*to the young man*)
Get out of here with your shit! . . .

CLAUDY
My money!

LORNA
First he leaves!
(*to the young man*)
You get out. I have to talk to him . . .

CLAUDY
You have nothing to say to me. Give me my money!

LORNA
First I want to talk to you . . .

CLAUDY (*to the young man*)
Wait for me downstairs.

YOUNG MAN
Ten minutes, no more.

CLAUDY
I'll be there . . .

The young man leaves, Lorna closes the door . . .

LORNA
Are you going to start up again?

CLAUDY
My money!

LORNA
Why don't we call the number the hospital gave you? . . .

CLAUDY (*interrupting her*)
Give me back my money!

LORNA
I don't want you to relapse . . .

CLAUDY
You have your divorce, you don't care if I relapse! My money!

Claudy rushes on Lorna to take the envelope from her jacket. She turns around to stop him . . .

LORNA
I'm going to give it to you . . .

She puts her hand into the inside pocket of her jacket.

LORNA
I forgot it in my locker at the dry cleaners, I . . .

CLAUDY
You're lying!

He grabs Lorna's jacket, they struggle . . . Claudy manages to pull Lorna's hand (which is holding the envelope of money) out of her jacket, they fall to the ground, Lorna throws the envelope, it slides across the floor . . . Claudy goes to look for it underneath the armchair. Suddenly Lorna rushes toward the front door, locks the door, removes the key, when Claudy comes at her, they fight again, the key falls to the ground, Claudy tries to untwist from Lorna to grab the key, but Lorna shoves him roughly, he falls backwards, his head hits the wall, he is somewhat groggy . . . Lorna picks up the key, rushes toward the window, opens it, and throws the key outside . . . She is out of breath . . . looks at Claudy on the ground, holding his head, also out of breath . . . Silence. Lorna takes off her jacket . . .

CLAUDY
The key . . .

LORNA
I threw it out the window . . .

She removes her shoes, removes her socks, her sweater, her bra, her pants, and her panties . . . She approaches Claudy, who gets up . . . he looks at her . . . removes his sweater, his pants, his underpants. They are both naked . . . Lorna brings her body to Claudy's body . . . They are hugging . . . Lorna's eyes are filled with tears . . . Claudy pulls her against him, caresses her, she presses herself against him, in tears, they are kissing, passionately caressing one another . . .

72. Int. Hardware Store—Morning

Claudy approaches some used bicycles that are positioned against one another along one wall of the store . . . He comes back toward the counter, in front of which Lorna is standing and behind which the locksmith is in the process of fabricating two keys with his milling machine and file . . .

CLAUDY

They still ride well, those bikes?

LOCKSMITH
Which?

CLAUDY
The blue . . .

LOCKSMITH
Yes . . . Fifty euros . . .

The locksmith has finished the two keys, which he places on the counter.
Claudy takes out his envelope of money, he gives fifty euros to the locksmith . . .

CLAUDY (*to the locksmith*)
I'll take the bike . . .

LOCKSMITH
 . . . Sixty euros for unlocking your door, ten for the two keys, that
makes seventy . . .

CLAUDY
Half each . . .

LORNA
It was my fault, the door . . .

CLAUDY
It was my fault too . . .

Lorna has taken her wallet from her jacket. They pay, and each takes their
key . . .

73. Ext. Streets/City—Morning

Lorna and Claudy walking next to one another, Claudy pushing his bike, on
which he tests the brakes . . . He smokes a cigarette . . .

CLAUDY
I'm going to ride all day long, I won't have to ask myself what to do . . .
Can I come by and say hi at noon?

LORNA
No. I have too much to do on Fridays, I have the front.

CLAUDY
Not to eat with you. Just to give me a goal in the middle of the day. I'm
going to ride, come see you at noon, then leave again . . .

They have stopped at a red light.

LORNA
OK . . .

CLAUDY
. . . I need to see you . . . it helps me to hold on . . . OK, I'm going . . .
Here . . .
(he passes her the envelope with his money in it)
I prefer . . .

Lorna takes the envelope, which she puts in the inside pocket of her jacket.

CLAUDY
See you soon.

LORNA
Yes.

Claudy mounts his bike, rides off . . . Lorna, who was going to cross the pedestrian path, changes her mind and runs after Claudy, she catches up with him, he accelerates, she matches his speed for a brief instant before she is outpaced, stops, out of breath, watches him ride away . . .

74. Int. Lorna and Claudy's Apartment—Day

Lorna, alone in the apartment, wearing her jacket as if she has just come in, is looking through the few clothes Claudy has on the shelf . . . she finds a crumpled shirt, stained, which she puts back in its place . . . a t-shirt torn at the collar, which she puts back in its place . . . several mismatched socks . . . She finds two matching ones folded on another shelf, she rolls them one inside the other, takes them . . . she goes into the bedroom, opens the wardrobe, leans down to pick up a pair of underpants, which she places on the bed . . . then folded pants, which she unfolds in front of herself to see their condition . . .

75. Int. Clothing Department/Department Store—Day

Lorna, a plastic bag in hand, is in the men's clothing department . . . She chooses a shirt . . . heads toward the cashier . . .

76. Int. Morgue/Hospital—Day

Lorna is near the desk of an employee of the morgue, she puts her plastic bag on the desk, takes out the shirt, from which she removes the protective plastic, a few fasteners . . .

MORGUE EMPLOYEE
The family came by a little after you. They will take care of the funeral expenses.

Lorna has given the shirt to the employee, who puts it on a numbered hanger.

LORNA
I told you I would do it . . .

MORGUE EMPLOYEE
I told them, but they refused . . .

Lorna gives him the pants, the underpants, the socks, which he puts on the hanger and in a small net attached to it.

LORNA
Can I see him one last time? . . .

MORGUE EMPLOYEE
You already identified him . . . I can't . . . Besides, the police are no longer here . . .

LORNA
I'm his wife . . .

The morgue employee takes the hanger with the clothes . . .

MORGUE WORKER
Come on . . .

He walks toward a hall, followed by Lorna . . . they disappear behind a door . . .

77. Int. Bedroom/Lorna and Claudy's Apartment—Evening

Lorna, wearing her jacket, finishes taking her clothes out of the wardrobe in the bedroom . . .

FABIO
Why don't you stay here? The police are going to think you took off . . .

Lorna doesn't respond, she continues putting her clothes into a bag that is on the bed . . .

FABIO
Do you hear what I'm saying, Lorna?

LORNA
The police have my phone number.

She opens a drawer of the small dresser to take out some things, puts them into a cardboard box placed on a chair near the bedroom door. While doing this, she notices something in the living room, she goes toward it, passing in front of Fabio . . .

78. Int. Living Room/Lorna and Claudy's Apartment—Evening

She approaches Claudy's shelf, next to which Spirou is squatting . . .

LORNA
Give it to me!

SPIROU
What?

LORNA
Give me the player!

SPIROU
He won't be using it anymore.

FABIO
Give it to back to her!

Spirou takes Claudy's CD player out of the inside pocket of his jacket, gives it to Lorna, who takes it and puts it in the cardboard box on the chair in her bedroom. She heads toward the bathroom . . .

79. Int. Bathroom/Lorna and Claudy's Apartment—Evening

Lorna enters the bathroom, starts to collect her toiletries . . .

FABIO (*off-camera*)
Where are you going to go?

LORNA
Where I was before.

FABIO
You were renting that place.

LORNA
I made an arrangement with the girl.

Lorna continues to collect her things . . .

FABIO (*off-camera*)
Are you going to keep sulking at me for a long time?

Lorna doesn't respond, finishes putting away her things . . . exits the bathroom, Fabio blocks the way . . .

FABIO
You're not taking his razor and his other stuff?

LORNA
No.

Fabio lets Lorna pass . . .

FABIO (*to Spirou*)
Go take the junkie's stuff.

80. Int. Bedroom/Lorna and Claudy's Apartment—Evening

Lorna packs her toiletries away into the cardboard box. Fabio follows her . . .

FABIO
If I had told you that the Russian wasn't OK with waiting, you would have let him go, I sensed it . . . I helped you hold out . . . You should be thanking me instead of sulking . . .

Lorna has folded the bath towel, which she packs into her bag. Fabio approaches her, handing her money . . .

FABIO
Here, for work that wasn't planned . . . a thousand euros . . .

LORNA
What work? . . .

She speaks to him without lifting her head, packing the t-shirt she sleeps in into the bag . . .

FABIO
Taking care of him when he was trying to quit, that took some work, didn't it? . . .

Lorna doesn't respond, closes the bag . . .

FABIO
I don't like the fact that you're refusing it, that makes it seem like you're not with us anymore . . .

Lorna doesn't react, he roughly grabs her wrist . . .

FABIO
Are you still with us?

LORNA
 . . . Yes.

She tries to free herself, he holds on.

FABIO
You've been with us from the start, don't forget that. It's because you didn't tell him anything for six months that we were able to do what we planned. OK? . . .

LORNA
Yes . . .

Fabio lets go of her wrist . . . Lorna goes near the chair to close the box . . .

FABIO
I'll keep the thousand euros for you. It's yours when you want it.

He picks up the photo that is on the small dresser.

> **FABIO** (to Spirou)
> Take that.

Spirou comes to take the frame with the photo, which he puts into his plastic bag.

81. Int. Landing/Staircase/Lorna and Claudy's Apartment—Evening

Fabio carrying the cardboard box, and Spirou, plastic bag in hand, descend the first steps of the staircase. Lorna has put her bag at her feet, she is in the process of locking the door. Off-camera, we hear Fabio and Spirou greeting people who greet them in the staircase.

> **PLAINCLOTHES POLICEMAN** (off-camera)
> Mrs. Moreau!

Lorna turns around. Two plainclothes policemen are on the staircase.

> **PLAINCLOTHES POLICEMAN**
> We have a few more questions to ask you. We have the results of the autopsy . . .
>
> **LORNA**
> Yes . . .

She reopens the door of the apartment.

> **FABIO** (to Lorna)
> I'll take your bag.

He gives the box to Spirou.

> **FABIO** (to the policemen)
> I'm a friend, I came to help her. She doesn't want to stay here by herself . . .

He takes Lorna's bag.

> **FABIO** (to Lorna)
> We'll wait for you in the car.

82. Int. Living Room/Lorna and Claudy's Apartment—Evening

Lorna is seated in Claudy's armchair next to the small table, the plainclothes policemen in chairs, one of them taking notes . . .

LORNA
. . . No.

PLAINCLOTHES POLICEMAN
Were there any enemies who could have wanted him dead?

LORNA
No . . .

PLAINCLOTHES POLICEMAN
He had quit, was he depressed?

LORNA
No . . .

PLAINCLOTHES POLICEMAN
He never brought up suicide?

LORNA
No . . .

PLAINCLOTHES POLICEMAN
You had asked for a divorce because he hit you . . .

LORNA
Yes . . .

PLAINCLOTHES POLICEMAN
He knew you were going to get it?

LORNA
Yes . . .

PLAINCLOTHES POLICEMAN
Since when?

LORNA
. . . When I received the letter from the judge, three days ago . . .

PLAINCLOTHES POLICEMAN (*to the other policeman*)
The dealer, he said what day?

OTHER POLICEMAN (*consulting his notes*)
Tuesday evening, three days ago . . .

PLAINCLOTHES POLICEMAN (*to Lorna*)

That same evening your husband had called a dealer to buy heroin. Could there be a connection with the news of the divorce? . . .

Lorna doesn't respond, she is on the verge of tears . . .

PLAINCLOTHES POLICEMAN

According to the dealer, it was you who prevented your husband from buying them.

LORNA

Yes . . .

PLAINCLOTHES POLICEMAN

Alone, in a moment of depression, could he have relapsed and voluntarily or accidentally taken an overdose? . . .

A beat.

LORNA

I don't know . . .

83. Ext. Near Funeral Parlor—Day

Lorna looks in the direction of someone or something that we don't see. After some time, she walks toward the entrance of a funeral parlor, next to which a hearse is parked. Two cars pulling into the small adjacent parking lot, from which six or seven people get out . . . Lorna approaches them and addresses a woman of about fifty.

LORNA

. . . Are you Claudy's mother?

WOMAN

No, she is . . .

She points to a woman who has gotten out of the other car. Lorna goes toward her.

LORNA

Hello, ma'am. I'm Lorna, Claudy's wife.

CLAUDY'S MOTHER
Hello . . .

LORNA
I wanted to give this back to you . . .

She takes the envelope with Claudy's money out of her jacket pocket, she gives it to the woman, who takes it.

LORNA
It's the money he had left.

CLAUDY'S MOTHER
Did he talk about me?

LORNA
No . . .

A man of about thirty has come over to Lorna and Claudy's mother. We had seen him just a moment before, exiting the other car. He is accompanied by a little girl, presumably his daughter.

CLAUDY'S MOTHER (*to Lorna*)
My son . . . His brother.
(*to her son*)
Claudy's wife.

The son greets her without shaking her hand.

SON (*to his mother*)
What's that?

The mother seems to avoid answering her son.

LORNA
It's Claudy's money, what he had left . . .

SON (*to Lorna*)
You're his wife. It's yours.

He takes the envelope from his mother's hands and gives it back to Lorna, who hesitates to take it.

LORNA
For the little girl.

SON
We don't need his money or yours.

Lorna does not extend her hand to take the envelope, he lets it fall to the ground and, leading his mother and his daughter, disappears into the funeral parlor. Lorna picks up the envelope from the ground.

84. Int. Changing Room/Dry Cleaning Plant—Day

Lorna changes in the changing room, she hangs her jacket on a hook in her locker, puts on her work apron, knots it . . . She closes her locker, goes to put the padlock on, reopens the locker, slides a hand into the jacket to take out the envelope containing Claudy's money, she slips it into the pocket of her apron, she closes the locker . . .

85. Int. Dry Cleaning Plant—Day

Lorna is busy working with the ironing machine . . .

LORNA (*to another worker*)
I'm too hot, I'm going to get some air for two minutes . . .

She leaves the plant . . .

86. Ext. Back Courtyard/Dry Cleaning Plant—Day

Lorna closes the door behind her, looks at the ground as if searching for something . . . near her feet, there is a slot between two cobblestones, she bends down, takes the envelope from her pocket, slides it into the space, but it is not deep enough . . . She gets up, looks toward the other end of the courtyard where part of the surface has been badly maintained . . . She goes over to the border of the patio, which is made of slabs of slate stuck into the ground, she moves one of the slabs aside with her hand to make a gap between the edge of the slate and the ground, she slides the envelope into the gap, then, with her hand, pushes the dirt back against the slate . . .

87. Int. Lorna's Room—Day

Lorna, dressed, half-lying on her bed, is dozing off in the arms of Sokol, seated on the bed, his back against the wall . . . He finishes drinking a cup of coffee . . . which he places on a chair near the bed, next to a coffee pot . . .

After some time.

> **SOKOL** (in Albanian, in a low voice)
> Lorna?

Lorna, dozing, doesn't respond . . . He starts to stroke her, putting a hand under her sweater, he caresses her breasts . . .

> **LORNA** (in Albanian)
> No . . . Just hold me in your arms, that feels good . . .

> **SOKOL**
> . . . You called me, I came . . . a thousand kilometers . . . I leave again tonight . . .

A bit annoyed, he gets up, Lorna raises herself up to let him pass, then lies back down on the bed . . . Sokol goes to the window, where there is a small table, he picks his cigarettes up from it, lights one . . .

> **SOKOL**
> What should we do? . . .

Lorna doesn't respond . . .

> **SOKOL**
> Are you asleep?

> **LORNA**
> No . . .

Silence. Sokol comes to sit on the bed near Lorna's legs . . . He takes a few drags from his cigarette . . .

> **SOKOL**
> You shouldn't trouble yourself with that . . . A junkie prefers his junk to his life, he would have relapsed anyway, and, one day or another, he would have died . . .

He gets up to go ash his cigarette into an ashtray . . . Lorna is still lying on the bed . . .

> **SOKOL** (*off-camera*)
> Should we go look at the places you found for a snack bar? . . .

A beat.

> **LORNA**
> OK . . .

88. Ext. Commercial Street/City—Day

Lorna and Sokol looking through the glass door of a ground-floor commercial property for sale . . . They press their faces against the glass . . . off-camera and reflected in the glass, people busy doing their shopping.

> **SOKOL** (*in Albanian*)
> What is the door at the back?
>
> **LORNA** (*in Albanian*)
> A hallway with bathrooms. We only have the room for the snack bar . . .

89. Ext. Street/City—Day

Sokol hoists himself up on a door that closes off access from an alley running along the side wall of a shop for sale . . .

> **SOKOL** (*in Albanian*)
> There's a little yard . . .
>
> **LORNA** (*in Albanian*)
> We could make a patio in the summer . . .

He climbs back down to Lorna, who looks through a gap between the pieces of newspaper that are covering the windows of the storefront . . .

> **LORNA**
> It looks bigger, it's better . . . It will take some work . . .

SOKOL
It's not too bad . . .
(he looks with Lorna through the gap between the pieces of newspaper)
The good thing is, it's multiple floors, we could live there or rent . . .

They press their faces against the glass as we hear dance music nearby, they turn around, seeing a group of people leaving a café where the music is coming from . . .

LORNA
Should we get a drink? . . .

90. Int. Café—Day

Lorna and Sokol are standing near the bar, drinking a beer. There are a lot of people laughing, yelling, dancing . . .

SOKOL *(in Albanian)*
I like it here! . . .

LORNA *(in Albanian)*
Do you have to leave tonight? . . .

SOKOL
Well, yes, the van leaves at six . . . Should we dance? . . .

Lorna puts her glass down on the bar, they make their way a few meters into the crowd, start dancing to rock and roll amidst the other couples . . . Lorna laughing as she dances, Sokol spins her around . . .

91. Int. Landing/Staircase/Lorna's Room—Evening

Lorna, wearing a new jacket, her purse on her shoulder, comes out of her room . . . she closes the door . . . puts the key into the lock, locks the door . . . She descends the staircase . . .

92. Ext. Street/Café—Evening

Lorna walks down the sidewalk of a busy street . . . enters a café . . .

93. Int. Café—Evening

Lorna is standing near a table where Fabio is seated with two other men. Fabio makes the introductions.

> **FABIO** (to the two men)
> Lorna . . .
> (to Lorna)
> I'd like to introduce you to Andrei Aslikov and his friend Kostia, he speaks Russian and French . . .

The two men greet Lorna and hold out their hands to her, which she shakes . . . Fabio invites her to sit at the table.

> **FABIO** (to Lorna)
> What do you want to drink?

> **LORNA**
> A beer.

> **FABIO** (to the two men)
> Would you like something?

Kostia asks Andrei if he wants something to drink.

> **KOSTIA** (to Fabio)
> No, neither do I . . .

> **FABIO** (to the waiter)
> One beer!

Andrei asks Kostia something in Russian . . .

> **KOSTIA** (to Fabio)
> He would like to see her Belgian identification card.

Lorna takes her ID out of her wallet and gives it to Andrei, who examines it with Kostia, who notes the number on the card . . .

> **FABIO** (to Lorna)
> Do you have the papers? . . .

Lorna takes a paper from her purse and gives it to Fabio. Meanwhile the waiter has arrived with the beer, Fabio is about to speak but doesn't, waiting for Lorna to take her beer and for the waiter to move away . . .

> **FABIO** (*showing the paper to Kostia*)
> This is the official paper which says that her husband is dead, that she is a widow, free to marry . . .

Kostia has taken the paper, reading it attentively . . .

94. Int./Ext. Fabio's Taxi/City—Evening

Lorna, seated next to Fabio, who is driving.

> **FABIO**
> They gave me the advance, five thousand . . .

Fabio slides his hand into his jacket pocket, takes out a brown envelope, which he gives to Lorna.

> **FABIO**
> You can take your share . . .

Lorna opens the envelope, she takes out the money: only twenty-euro bills bound in packets of twenty-five.

> **FABIO**
> That's the price they sell their cartons of cigarettes for in Moscow. Twenty euros instead of forty . . .

Lorna takes three bundles, she closes the envelope, returns it to Fabio . . .

> **FABIO**
> Do you want the thousand euros you wouldn't take before?

Lorna doesn't respond . . . she puts the three bundles into her jacket pocket . . . Fabio takes out two five-hundred-euro bills, he puts them on the armrest between the two seats . . .

> **FABIO**
> I told you I would keep them for you, and I kept them . . .

Lorna doesn't react . . . she watches the road in front of her . . . After some time, the car slows down as it arrives at the house where Lorna's room is . . . it stops . . . Lorna opens the car door . . .

FABIO
See you soon . . .

Before getting out, Lorna takes the two five-hundred-euro bills from the divider.

LORNA
See you soon . . .

95. Ext. Street/In Front of the Future Snack Bar—Day

Lorna walks at a rapid pace, she seems happy . . . She arrives near the storefront seen previously for sale . . . She turns a key in the lock.

96. Int. Future Snack Bar—Day

Lorna finishes typing a number into her cell phone (a new one), very excited . . . She holds it up to her ear, waits for someone to answer while she looks around . . .

LORNA (in Albanian)
It's me! . . . I'm in our snack bar! Yes! . . . I just got in! Yes! . . . I bought a new cell phone. I can make foreign calls . . . What? Yes, I signed it this morning, yes . . . I'm happy! Our snack bar, Sokol!
(she cries with joy)
Wait, I'll measure.

She goes against the wall and marks her steps while walking to the opposite wall . . .

LORNA
One . . . two . . . eight . . . nine steps, more or less seven meters long . . .

She marks her steps to sense the width . . .

LORNA

One . . . four . . . and a half . . . more or less three and a half meters before the counter, we can make a corner with tables, two or three . . .

She walks, holding the cell phone against her ear, toward a hallway.

LORNA

Yes . . . a little corridor . . .
(*she opens the door*)
. . . the bathrooms . . . a small room for merchandise . . . a hallway that leads to the staircase . . .

She climbs a narrow staircase up to the first floor above the snack bar . . . She opens a door that is facing the staircase.

LORNA

. . . I'm on the first floor now, in front of the staircase . . . a small bathroom with a shower and toilets . . .

She opens a door to her left . . .

LORNA

. . . Next to that . . . a living room, a room with a kitchen area and a bedroom next to it . . . I can see the garden or what will be the patio . . . yes . . . I'm going up to the second . . .

She leaves the room, starts to climb the next flight of the narrow staircase . . .

LORNA

. . . On the second floor, there should be a big room like the living room that we could make into our bedroom, and next to it . . .

While talking, she seems more and more out of breath, she stops, as if overtaken by malaise, her hand holding the phone is along the side of her body, her other hand on the banister . . .

LORNA

Wait! . . . Wait!

She tries to catch her breath . . . sits on a step . . .

LORNA

Sokol . . . No . . . no . . . it's all right . . . I was so happy . . . I didn't eat this morning or this afternoon, I bought the phone to call you, and I came straight here . . .

She tries to get up but feels that something is not right, she sits, feels off . . . her voice is very weak . . .

LORNA

It . . . It must be a panic attack . . . I'll call you back . . . yes . . . yes . . .

She hangs up, laying the phone onto the step, one hand holding the rail of the banister, the other hand on her face, her forehead, her haggard eyes, breathing deeply . . .

97. Int. Waiting Room and Changing Room/Hospital—Day

Lorna gets up from a seat in the waiting room, she has a paper in hand, she walks toward a changing room, the door of which is held open by a nurse. Lorna enters the room, gives her paper to the nurse . . .

NURSE

Undress completely and put this on. I'll call you.

She gives Lorna a hospital gown (which ties in the back and goes down to the knees) and leaves through a door that leads to the doctor's office. Lorna starts to undress, hanging her coat on a peg next to a small mirror . . . she sits on a stool to finish removing her pants, gets up to hang them on the peg . . . sees herself in the small mirror . . . continues undressing . . .

98. Int. Doctor's Office—Day

Lorna, wearing the hospital gown, is seated facing a desk, behind which a doctor sits, making notes about what she says . . .

LORNA

No . . .

DOCTOR

. . . Any surgical operations?

LORNA
No . . .

DOCTOR
Any chronic illnesses, illnesses that last or come back, for which you've been treated? . . .

LORNA
No . . .

DOCTOR
Are you currently taking any medications?

LORNA
No . . .

DOCTOR
Your last period? . . .

LORNA
One month and three weeks . . .

DOCTOR
OK . . . Are you seeing me for a routine exam or for a particular reason?

LORNA
I want an abortion . . .

DOCTOR
OK . . . a voluntary interruption of pregnancy . . . We'll have to do an ultrasound exam to determine the exact stage of your pregnancy, then we'll make an appointment for the procedure, which, in any case, can't legally be performed until after the eight-day waiting period allowing you to reflect on your decision.

The doctor stands up . . .

DOCTOR (*off-camera*)
Come lie down here . . .

Lorna doesn't stand up . . .

DOCTOR (*off-camera*)
Ma'am? . . .

After a moment, Lorna gets up, walks toward the examination table . . . stops . . . suddenly falls into the doctor's arms, presses herself into him, crying . . . The doctor is surprised, distraught . . . Suddenly Lorna separates herself from him and walks toward the changing room . . .

> **DOCTOR** (*off-camera*)
> Don't you want to do the ultrasound? . . .

Lorna doesn't respond, enters the changing room, closes the door with the latch . . .

99. Int. Changing Room/Hospital—Day

Lorna, still in tears, removes the hospital gown, puts her bra back on, starts to put her shirt back on . . .

> **DOCTOR** (*off-camera*)
> Ma'am? . . .

Lorna doesn't respond. She makes one or two more gestures to dress, lets herself fall onto the stool, crying . . .

> **DOCTOR** (*off-camera*)
> Do you hear me, ma'am? . . .

A beat.

> **LORNA**
> I'm not going to get an abortion . . .

> **DOCTOR** (*off-camera*)
> . . . Even if you don't get the abortion, it's better to do the ultrasound to know how your pregnancy is progressing . . .

Lorna, still in tears, sits on the stool, doesn't seem to hear the doctor's voice . . . she starts buttoning her shirt . . . she gets up to take her pants from the wall peg . . .

100. Ext. Back Courtyard/Dry Cleaning Plant—Day

Lorna, wearing her work apron, leaves the plant, walks to the patio . . . after a quick look around, she bends down, moves the slab of slate away from the border of the patio, lifts it, digs up the envelope with the money, puts the slate back, takes the money from the dirty envelope, which she balls up and throws aside before putting the money in her apron . . .

101. Int. Service Window/Bank—Day

Lorna is facing an employee behind a window.

TELLER
In your name?

LORNA
No, in the name of the child I'm having . . .

TELLER
We can only open an account in the name of a person who exists . . . already born . . .

LORNA
He will be born in seven and a half, eight months . . .

TELLER
Yes, but he's not born yet . . . What I can do is reserve an account number for an account that can be opened when he is born . . .

LORNA
All right . . .

She takes Claudy's money out of her jacket pocket . . .

LORNA
Can I put this in it? . . .

TELLER
No, only after the birth. You can make a deposit into the account you already have with us and after the birth you can tell us to transfer it . . .

LORNA
My account will be going to pay back the loan for the snack bar, I want an account where all the money will go to him . . .

TELLER
A second account in your name, then?

LORNA
All right . . .

TELLER
First, I'll reserve the account number for the child's account . . .

He taps on the keyboard of his computer . . .

TELLER
First name . . . none yet . . . last name? . . .

LORNA
Moreau . . .

102. Int. Lorna's Room—Evening

Lorna is asleep on her bed, dressed . . . A knock on the door . . . She doesn't react . . . A more forceful knock . . .

FABIO (*off-camera*)
Lorna! . . . Lorna! . . .

Lorna wakes up . . .

LORNA
Yes? . . .

She stands up, still half-asleep, takes a few steps toward the door, opens it . . .

FABIO
We have a meeting with the Russian! Did you forget?

LORNA
I was sleeping . . .

She goes to the sink in the corner of the room . . .

FABIO (*off-camera*)

I called you on your cell phone, and I rang downstairs. Luckily there was a guy who was leaving . . .

Lorna is in the process of rinsing her face, drying it . . .

FABIO (*off-camera, into his phone*)

Hello . . . it's Fabio . . . yes . . . Can you tell Andrei that we'll be there right away . . . Yes, I know . . . I'm having a problem with my taxi . . . yes . . . sorry . . . (*he hangs up*)

While Fabio has been on the phone, Lorna has moved beside him to pick up her leather boots. She sits on the bed to put them on . . .

FABIO (*off-camera*)

Hurry up! . . .

Lorna finishes putting on the first boot, starts putting on the second . . .

LORNA

I'm having a baby . . .

FABIO

What do you mean? . . . You're sure? You've seen a doctor?

LORNA

Yes . . .

FABIO

What about the Russian! You should have been careful! That idiot, Sokol! And you! Shit!

Lorna has to take off her boot because there is a problem with the zipper . . .

FABIO

You'll get an abortion next week. I'll loan you the money. Hurry up!

LORNA

And if I want to keep it?

FABIO

The answer is no. The deal with the Russian, it's not for a marriage to a pregnant woman.

LORNA
I'm not asking him to accept it as his.

Lorna puts on the boot, gets up to go get her jacket.

FABIO
Doesn't matter! That's not what's planned!

103. Int. Café/Dance Floor—Evening

A café with a small dance floor. Lorna, Fabio, Andrei, Kostia are at a table amid other tables also occupied by customers. Fabio and the two Russians drink beer, Lorna eats a ham and cheese sandwich and also drinks a beer . . . There is dance music . . .

FABIO (*yelling toward the front door*)
Micky!

A man who has just entered the café comes over to their table . . .

FABIO (*to Kostia*)
I want to introduce you to Micky, one of the two witnesses for the marriage . . .

Kostia translates for Andrei . . . Micky shakes their hands, kisses Lorna on the cheek . . .

FABIO (*to Kostia*)
He distributes newspapers. I've worked for him, and so has Lorna. Total confidence. Sometimes the police ask the witnesses questions, so they have to be reliable . . .

Kostia translates for Andrei. Micky sits near Fabio . . .

FABIO (*to Lorna*)
It would be good if you two danced, so that people see you.
(*to Kostia*)
It would be good for Andrei to dance with her, so that people see them . . . If she tells the police that she met him here, the bartender or someone else will say that it's true . . .

Kostia translates for Andrei . . . who gets up to invite Lorna to dance. She gets up and follows him to the small dance floor . . . It's music for a slow dance. They start dancing . . . Lorna sees Fabio going toward the bathroom . . .

> **LORNA**
> You OK if I have a child, baby? Me . . .

> **ANDREI**
> Baby Andrei? . . . marriage, yes . . . sex, yes . . . no baby . . .

> **LORNA**
> No, my baby, not with you . . . you just marriage.

He doesn't understand.

> **LORNA**
> It's nothing, we'll talk about it another time . . .

Andrei puts two fingers in his mouth to whistle for Kostia . . .

> **LORNA**
> No! . . .

She is not able to stop him from whistling. Kostia joins them. Without giving Lorna time to tell him what she said, Andrei speaks to him in Russian . . .

> **KOSTIA** (*to Lorna*)
> He wants to do the marriage but no child.

> **LORNA**
> I don't want a child with him. I said that if by chance I was pregnant with someone else's baby, would he still marry me? Just a question . . .

Kostia seems surprised by what Lorna is saying. He translates for Andrei, who responds in Russian. Lorna glances toward the bathroom door to make sure that Fabio hasn't come out.

> **KOSTIA** (*to Lorna*)
> He's not OK with it because he would have to pay for the child. He wants everything to continue as planned.

LORNA

Me too. I wasn't asking him to recognize the child as his so that he would pay. It was just a . . .

Fabio has appeared behind Lorna.

FABIO

What's going on?

LORNA

Nothing . . .

KOSTIA

She asked if Andrei would marry her if she is pregnant.

FABIO *(to Lorna)*

Why did you ask that?

LORNA

I just did. It's my life. Things happen.

FABIO

If that happens, you get an abortion.
(to Kostia)
Tell him not to worry. There will be no child if he doesn't want one, he can have her examined by a doctor before the marriage.

Kostia translates for Andrei, who says something to him in Russian.

KOSTIA

He is OK with the doctor, a friend of his . . .

FABIO

OK. We'll let you dance.

They move away, leaving Andrei and Lorna to begin dancing again . . .

104. Ext. Street/Near the Dance Café—Evening

Lorna is on the sidewalk. Fabio, a little further down, says goodbye to the Russians, who get in their car . . . Fabio comes back to Lorna . . .

FABIO

I told you not to talk about it.

LORNA
I just wanted to know what they thought . . .

They walk toward Fabio's taxi parked further down. The Russians' car starts off-camera, passes them, honking, they reply with a wave of their hands . . . Suddenly Fabio grabs Lorna by the arms, squeezes her tightly, putting his face in hers . . . It hurts her . . .

FABIO
Don't do that ever again! Ever! Understand?

LORNA
Yes . . .

FABIO
You do what I say and nothing else! Nothing!

LORNA
Yes . . .

He lets go . . . They walk a few meters, arriving at the taxi.

FABIO
Tomorrow morning you're going to the hospital to get an abortion. I'll go with you.

Just as Lorna reaches the passenger-side door, she crouches, moaning in pain, holding her stomach . . . Fabio comes near her . . .

FABIO
What's wrong with you?

She moans in pain . . .

105. Int. Emergency Room/Hospital—Night

A nurse pushes the gurney Lorna is lying on into the emergency room where Fabio sits, waiting . . .

NURSE (*to Fabio*)
The doctor who examined her is coming.

The nurse leaves the room.

FABIO
Did you ask for an abortion?

Lorna doesn't respond . . . She seems absent . . .

FABIO
Lorna? . . . Did you ask for the abortion? . . .

LORNA
. . . No . . .

FABIO
Why?

Lorna doesn't respond . . .

FABIO
Do you have Sokol's phone number?

LORNA
. . . In my phone, in my jacket . . .

Fabio gets up to take Lorna's cell phone from her jacket, hanging from a peg by the entrance of the room . . .

LORNA
Sokol isn't the father . . . It's Claudy . . .

FABIO
. . . The junkie? . . . You screwed the junkie? . . .

LORNA
His name is Claudy . . .

FABIO
Shut up! . . .

He copies Sokol's number into his cell phone. The curtain of the recovery room opens, a female doctor appears.

FEMALE DOCTOR *(to Fabio)*
Good evening . . . Are you her husband? . . . her partner? . . .

FABIO
A friend, I brought her here in my car.

FEMALE DOCTOR *(to Lorna)*
Do you feel better with the sedative?

LORNA
Yes . . .

FEMALE DOCTOR
As I just showed you on the ultrasound, you are not pregnant. You refuse to admit it because you are a bit upset. I think it would be wise for you to stay under observation for three days while we do a few tests . . . Is that all right with you? . . .

LORNA
Yes . . .

FEMALE DOCTOR
That's good . . . I'll have a room set aside for you. We'll come and get you . . .

FABIO
A private room if possible.

FEMALE DOCTOR
That should be possible.

FABIO
Thank you . . .

The female doctor leaves, pulling the curtain closed.

FABIO
Why did you say you were pregnant?

LORNA
I am . . .

FABIO
The doctor said you aren't. She knows better than you.

LORNA
No . . .

106. Int./Ext. Elevator/Hallway/Hospital—Night

Lorna, seated in a wheelchair, in the elevator. A nurse is nearby, holding the chair. Fabio is next to her . . . The elevator doors open, the nurse pulls the chair out of the elevator . . . A nurse (Monique Sobel) goes to enter the elevator . . .

> **LORNA**
> . . . Ma'am! . . .

The nurse (Monique Sobel) turns toward Lorna.

> **LORNA**
> Do you remember me? . . .
>
> **NURSE (MONIQUE SOBEL)**
> Ah! . . . good evening . . .

The elevator doors are closing, the nurse puts her hand out to stop them . . .

> **LORNA**
> And Claudy, do you remember him? . . .
>
> **NURSE (MONIQUE SOBEL)**
> Your husband, yes . . . I'm sorry, but I really have to go . . .
>
> **LORNA**
> Will you come see me?
>
> **NURSE (MONIQUE SOBEL)**
> Yes . . .

She has entered the elevator . . . the doors close . . . The nurse pushes Lorna's chair, parks it against the side of the hallway.

> **NURSE**
> Wait here, I'll go see what room they've put you in.

The nurse starts to move away . . .

> **FABIO**
> Can I stay in the room with her?
>
> **NURSE**
> Yes, if you want . . . There's a recliner.

107. Int. Lorna's Room/Hospital—Day

Lorna is seated on her bed, dressed in her clothes, she puts on socks . . .

> **LORNA** *(in Albanian)*
> I don't want to go back to Gramsh . . .

> **SOKOL** *(off-camera, in Albanian)*
> It's the best solution.

A beat.

> **LORNA**
> Ask him if I can stay.

She has gotten up, passes in front of Sokol, who is leaning against the windowsill.

> **SOKOL**
> He doesn't want that, he doesn't trust you, you talk too much . . .

Lorna sits at a small table at which a meal has been served, partly turning her back to Sokol . . .

> **SOKOL**
> He told me you were going to tell the nurse everything . . .

> **LORNA**
> She knew Claudy, I wanted to tell her . . .

> **SOKOL** *(interrupting her)*
> Be quiet!

Lorna takes the cover keeping the food warm off the plate . . .

> **LORNA** *(on the verge of tears)*
> If you loved me, you would understand why I want to keep the child . . .

> **SOKOL**
> There is no child! Stop imagining things! . . .

Lorna turns toward him . . .

LORNA
I didn't mean to be unfaithful, I . . .

SOKOL
Don't talk about that anymore!

Silence . . . Lorna pours water into a glass . . . she turns to offer it to Sokol . . .

SOKOL
No . . .

The door of the room opens, Fabio appears, wearing his jacket, he has a document in a plastic protector in hand . . .

FABIO *(to Lorna)*
Fill this out but don't sign it, the bank director wants you to sign it in front of him . . .

He puts the document down on the small table, pulls out one sheet . . .

FABIO *(in Italian, to Sokol)*
Look . . .

He approaches Sokol, who has stood up from his chair, he shows him the sheet . . .

FABIO *(in Italian)*
Because she cancelled the loan, they are taking this amount against the deposit and this amount because she cancelled the purchase . . .

SOKOL *(in Italian)*
Those dogs . . .

Fabio puts the page back into the document.

FABIO *(in Italian, to Sokol)*
As soon as the doctor comes, call me.

Fabio leaves . . . Lorna has begun to eat . . .

LORNA (*in Albanian*)

You're just like him, there's only one thing you care about, getting your money back . . .

SOKOL

You made him lose his money with the Russians, he wants to get it back, that's normal.

LORNA

I'm talking about you . . . you're going to take back what you put down for the deposit, and I will never see you again.

SOKOL

I'll come see you in Gramsh . . .

LORNA

No . . . you won't . . .

108. Ext. Street/Bank—Day

Lorna and Sokol leaving the bank and walking toward Fabio's taxi, parked nearby.

109. Int./Ext. Fabio's Taxi—Day

Lorna is seated in the backseat of the car next to two bags with her belongings, she has taken the bank envelope containing the money out of her purse, gives it to Fabio, who is seated behind the wheel, Sokol is seated in the passenger seat. Fabio opens the envelope, takes a large amount of the money out to count it . . . gives the rest to Sokol, who also starts to count his share . . .

FABIO (*to Lorna*)

. . . I'm also taking back the thousand euros I gave you as a bonus.

SOKOL (*in Albanian, to Lorna*)

Did I put in four thousand six hundred? . . .

Lorna doesn't respond . . .

SOKOL

Was it four thousand six hundred that I put in?

LORNA

You would know better than me.

Fabio has taken his money, he starts the car while Sokol is still in the process of counting his share . . . After some time, he gives the envelope back to Lorna with the rest of the money, she puts it back in her purse . . .

110. Ext. Highway/Parking Lot—Day

Fabio's taxi rolls along the highway, puts its blinker on, and takes the exit leading to a parking lot . . . disappears behind some trees bordering the parking lot . . .

111. Int./Ext. Fabio's Taxi/Parking Lot Off the Highway—Day

Sokol has picked up the bag that was at his feet, puts it on his knees, he turns toward Lorna . . .

> **SOKOL** *(in Albanian)*
> I'll stay in Milan for a month, then I'll come see you in Gramsh . . .

Lorna doesn't respond, she looks at him . . . He turns around to open the car door and get out . . .

> **LORNA**
> Sokol . . .

Sokol turns toward her, the door already half-open . . .

> **SOKOL**
> What? . . .

Lorna doesn't respond, looks at him . . .

> **SOKOL**
> See you soon . . .

He exits . . . Through the window of the car, we see him head toward an international transport truck . . .

112. Int./Ext. Fabio's Taxi/Highway/Road—Day

Lorna is seated in back near her luggage . . . Fabio drives . . . The noise of the engine, the friction of the tires against the asphalt . . . The car exits the highway . . .

FABIO

We're going to Spirou's place, he's going to drive you . . .

LORNA

He knows the way? . . .

FABIO

He has a map. I explained how to get to Tirana, after that, you can tell him . . .

The car continues to drive along . . .

113. Ext. Courtyard/Garages—Day

A courtyard surrounded by carports. Lorna is out of Fabio's taxi, puts her bags in the back of Spirou's car, who closes the car door. She goes to open the passenger-side door.

FABIO

Give me your phone.

LORNA

Why?

FABIO

Give it to me!

Lorna takes her cell phone, which is in her jacket, gives it to Fabio, who opens it and takes out the SIM card.

LORNA

And if I have to make a call?

FABIO

Ask Spirou.

He returns her phone, she climbs into the car . . .

114. Int./Ext. Car/Country Road—Day

The car rolls along . . . passes under a bridge . . . an access road to the highway . . .

LORNA
Why didn't you go onto the highway? . . .

SPIROU
I have to find gas.

The car rolls along . . .

The car approaches a service station . . .

LORNA
There's a service station, I'll go to the bathroom while you put gas in . . .

She sees that Spirou is not slowing down . . .

SPIROU
I know a cheaper one . . .

A beat.

LORNA
I need to pee, stop . . .

SPIROU
You can't wait until the station?

LORNA
No . . .

The car continues to roll along . . .

115. Ext. Shoulder/Country Road—Day

Lorna picks up her purse to get out of the car, stopped on the shoulder . . .

SPIROU
Leave your bag, you don't need it to pee . . .

Lorna leaves her bag at the foot of her seat, she gets out of the car, walks toward some bushes . . . We hear the engine of the car . . . Lorna is behind the bushes looking at the ground, as if searching for the right spot . . . She squats while pulling down her pants and panties, she pees. On the ground,

she spots a few stones the size of her fist, she picks one up, slips it into her jacket pocket . . . She puts on a low voice, addressing her belly, her child . . .

> **LORNA**
> . . . They want to kill us . . . don't be afraid, I'll protect you . . .

She stands up while dressing, goes back to the car, sits in her seat, closes the door . . . The moment when Spirou glances toward the side window to see if there is a car coming down the road, she hits him on the head with the stone, once, twice . . . Spirou collapses, his head against the side window . . . she quickly gets out of the car, wants to backtrack, as if to search for something she may have forgotten in the car, but pursues a course behind the bushes in the direction of a forest.

116. Ext. Forest—Day

Lorna leans against the trunk of a tree, out of breath . . . She looks in front of her, as if searching for the best direction in which to make an escape . . . She glances behind her . . . She stays against the tree trunk a moment longer, catching her breath . . .

> **LORNA**
> We're going to keep running . . . it's safer . . .

She starts to run toward a path, follows it for a moment, turns off toward a slope where the vegetation is denser, climbs the slope . . .

117. Ext. Forest/Hunting Lodge—End of the Day

Lorna is in the process of forcing open the boarded-up shutters of a hunting lodge . . . The wood that she uses as a lever to detach the shutter breaks, she picks up another, detaches the shutter, breaks the glass with the wood, opens the window, enters . . .

118. Int. Hunting Lodge—End of the Day

She finds some matches on the plank serving as a windowsill . . .

> **LORNA**
> We're going to be able to make a fire . . . I'm cold . . .

There is a wood stove, a table, two benches, a few candles, some logs . . . a plastic container . . . She opens the container, breathes over the opening to smell the odor of the liquid inside . . . she closes it . . . She goes to see the logs, looks at them . . .

> **LORNA**
> . . . I'm going to find some kindling to light a fire . . .

She leaves through the window . . .

119. Ext. Forest/Near the Hunting Lodge—End of the Day

She walks slowly, her head lowered, sometimes bending down to pick up twigs . . . We hear the trilling of a bird in the distance . . . She straightens up . . .

> **LORNA**
> Do you hear that? . . .

Silence . . . We hear the trilling of the bird again, which seems closer . . . Lorna looks toward the branches of trees where the bird might be . . . She starts picking up twigs again . . . We hear the trilling of the bird in the distance again . . . Lorna continues to pick up twigs, her head tilted toward the ground . . . She cries . . . murmurs through her tears . . .

> **LORNA**
> . . . You're going to live . . . I won't let you die . . . ever . . . I let your father die . . . you will live . . .

She continues to pick up brushwood . . . collapses in sobs . . . After some time, she stands up, she seems lost . . . She bends down again to pick up the twigs that fell out of her hands when she collapsed . . .

> **LORNA**
> . . . You will be happy . . . I will do everything for you, everything . . .

She continues to pick up the twigs . . .

120. Int. Hunting Lodge—End of the Day

Lorna adds the kindling to the fire, which is beginning to take . . . she watches the fire . . . picks up a log and puts it on the flames . . . She reattaches the shutter she forced open with a piece of rope . . . She puts her balled-up jacket on the floor near the stove, lies down, laying her head on the jacket . . .

> **LORNA**
> . . . We're going to sleep . . . we'll go on tomorrow morning . . . we'll find something to drink and to eat . . . we'll go ask at a house . . . there will be someone who will give it to us . . . sleep well . . .

She stays like that, lying . . . asleep . . . one hand on her face, the other posed on her belly . . . We hear only the sound of her calm breathing, the sounds of nature in the distance, of fire near her belly.

The end.

BIBLIOGRAPHY

The Bible, King James Version.

Adorno, Theodor. *Minima Moralia: Reflections on a Damaged Life*, trans. E.F.N. Jephcott. London: Verso Books, 2005, p. 247.

Antelme, Robert. *On Robert Antelme's The Human Race: Essays and Commentary*, trans. Jeffrey Haight. Evanston: The Marlboro Press, 2003, p. 24.

Arendt, Hannah. "The Jew as Pariah: A Hidden Tradition" in *The Jewish Writings*. New York: Schocken, 2007, p. 289.

Arendt, Hannah. *The Human Condition*. Chicago: University of Chicago Press, 1958, pp. 246–247.

Aristotle. *Poetics*, trans. W.H. Fyfe. Cambridge: Harvard University Press, 1932, 1453b.

Auster, Paul. *In the Country of Last Things*. New York: Penguin Books, 1988, pp. 113–114.

Bachelard, Gaston. *Water and Dreams: An Essay on the Imagination of Matter*, trans. Edith R. Farrell. Dallas: The Dallas Institute of Humanities and Culture, 1983, p. 187, 195.

Balmary, Marie. *Le Sacrifice interdit*, quotation trans. Christiana Hills. Paris: Grasset, 1982, p. 332.

Banks, Russell. *Affliction*. New York: Harper & Row, 1989, p. 2.

Bazin, André. *Jean Renoir*, quotation trans. Jeffrey Zuckerman. Paris: Gérard Lebovici, 1989, pp. 102–103.

Bloch, Ernst. *The Principle of Hope*, vol. 2, trans. Neville Plaice, Stephen Plaice, and Paul Knight. Cambridge: MIT Press, 1986, p. 881.

Bloch, Ernst. *The Spirit of Utopia*, trans. Anthony A. Nassar. Stanford: Stanford University Press, 1977, pp. 146–147.

Bloch, Ernst. *Traces*, trans. Anthony A. Nassar. Stanford: Stanford University Press, 2006, pp. 21–22.

Bond, Edward. *In the Company of Men*, in *Bond Plays, 5*. London: Bloomsbury Methuen Drama, 1996, p. 385.

Camus, Albert. *The Plague*, trans. Stuart Gilbert. New York: Vintage International, 1991, p. 308.

Canetti, Elias. *Crowds and Power*, trans. Carol Stewart. London: Gollancz, 1962, p. 277.

Chalier, Catherine. *Traité des larmes. Fragilité de Dieu, fragilité de l'âme*, quotation trans. Natasha Lehrer. Paris: Albin Michel, 2003, p. 203.

Char, René. "Furor and Mystery," trans. Mary Ann Caws in *Selected Poems of René Char*, ed. Mary Ann Caws and Tina Jolas. New York: New Directions, 1992, p. 17.

D'Arzo, Silvio. *The House of Others*, trans. Keith Botsford. Evanston: Marlboro/Northwestern University Press, 1995.

Dostoyevsky, Fyodor. *Notes from a Dead House*, trans. Richard Pevear and Larissa Volokhonsky. New York: Vintage International, 2016, p. 199.

Duras, Marguerite. *Practicalities*, trans. Barbara Bray. New York: Grove Weidenfeld, 1990, p. 89.

Faulkner, William. *Light in August*. New York: Vintage International, 1990, pp. 226, 258.

Flaubert, Gustave. *Madame Bovary*, trans. Geoffrey Wall. New York: Penguin Books, 2003, p. 263.

Flaubert, Gustave. *Sentimental Education*, trans. Robert Baldick, rev. Geoffrey Wall. New York: Penguin Books, 2004, p. 13.

Freud, Sigmund. *Civilization and Its Discontents*, trans. James Strachey. New York: W.W. Norton, 1962, p. 92.

Freud, Sigmund. *Writings on Art and Literature*, trans. James Strachey. Stanford: Stanford University Press, 1997, p. 156.

Green, André. "Pourquoi le mal?" in *La Folie privée. Psychanalyse des cas-limites*, quotation trans. Sean Gasper Bye. Paris: Gallimard, 1990, p. 398.

Grossman, Vasily. *The Road: Short Fiction and Articles*, trans. Robert and Elizabeth Chandler. New York: New York Review Books, 2010, p. 173.

Havel, Václav. *Letters to Olga June 1979–September 1982*, trans. Paul Wilson. New York: Henry Holt, 1989, pp. 257–258.

Hegel, G.W.F. *Aesthetics*, vol. 1, trans. T.M. Knox. Oxford: Clarendon Press, 1975, p. 298.

Hegel, G.W.F. *Phenomenology of Spirit*, trans. A.V. Miller. Oxford: Oxford University Press, 1977, p. 9.

Hegel, G.W.F. *System of Ethical Life and First Philosophy of Spirit*, trans. T.M. Knox. Albany: State University of New York Press, 1979, p. 233.

Hölderlin, Friedrich. "Socrates and Alcibiades" in *Friedrich Hölderlin: Poems and Fragments*, trans. Michael Hamburger. London: Anvil Press, 2004. p. 105.

Kierkegaard, Søren. *The Sickness Unto Death*, trans. Howard V. Hong and Edna V. Hong. Princeton: Princeton University Press, 1980, pp. 39–40.

Kundera, Milan. *The Joke*, trans. Michael Henry Heim and fully revised by the author. New York: HarperCollins, 1992, p. 8.

Levinas, Emmanuel. "The Other in Proust," trans. Seán Hand, in *The Levinas Reader*, edited by Seán Hand. Cambridge: Basil Blackwell, 1989, p. 162.

Levinas, Emmanuel. *Difficult Freedom: Essays on Judaism*, trans. Seán Hand. Baltimore: Johns Hopkins University Press, 1990, pp. 8, 17, 20, 62, 101.

Levinas, Emmanuel. *Entre Nous: On Thinking-of-the-Other*, trans. Michael B. Smith and Barbara Harshav. New York: Columbia University Press, 1998, p. 104.

Levinas, Emmanuel. *Existence and Existents*, trans. Alphonso Lingis. Boston: Kluwer Academic Publishers, 1988, p. 59.

Levinas, Emmanuel. *Outside the Subject*, trans. Michael B. Smith. London: Athlone Press, 1993, pp. 142–143

Levinas, Emmanuel. *Proper Names*, trans. Michael B. Smith. London: Athlone Press, 1996, p. 40.

Lichtenberg, Georg Christoph. *Schriften und Briefe*, vol. 1, ed. Wolfgang Promies, quotation trans. Adrian Nathan West. Munich: Carl Hanser Verlag, 1968, p. 564.

Mandelstam, Osip. *Complete Poetry of Osip Emilevich Mandelstam*, trans. Burton Raffel and Alla Burago. Albany: State University of New York Press, 1973, p. 136.

Marinetti, Filippo Tommaso. "Manifesto of Futurism" in *Futurism: an Anthology*, ed. and trans. Lawrence Rainey. New Haven: Yale University Press, 2009, p. 51. Originally published in *Le Figaro*, February 20, 1909.

Mauvignier, Laurent. *Loin d'eux*, quotation trans. Shaun Whiteside. Paris: Éditions de Minuit, 1999, p. 58.

Michaux, Henri. "L'Avenir de la poésie" in *Œuvres complètes*, vol. I, quotation trans. Caite Dolan-Leach. Paris: Gallimard Pléiade, 1998, p. 968.

Michaux, Henri. "Chosen Hands" in *Darkness Moves: An Henri Michaux Anthology*, trans. David Ball. Berkeley: University of California Press, 1994, p. 288.

Michaux, Henri. "The Portrait of A." in *A Certain Plume*, trans. Richard Sieburth. New York: New York Review Books, 2018, p. 73.

Michaux, Henri. *Selected Writings: The Space Within*, trans. Richard Ellmann. New York: New Directions, 1951, pp. 233, 291, 297.

Morante, Elsa. *History: A Novel*, trans. William Weaver. New York: Alfred A. Knopf, 1977, p. 671.

Morrison, Toni. *Song of Solomon*. New York: Vintage International, 2004, p. 331.

Morrison, Toni. *Sula*, New York: Vintage International, 2004, p. 83.

Picard, Max. *Zerstörte und Unzerstörbare Welt*, quotation trans. Madeleine LaRue. Zürich: Eugen Rentsch Verlag, 1951, p. 41.

Proust, Marcel. *Within a Budding Grove*, trans. C.K. Scott Moncrieff and Terence Kilmartin, rev. D.J. Enright. New York: Modern Library, 1992, pp. 170–71, 226, 318, 679.

Rimbaud, Arthur. *A Season in Hell and The Drunken Boat*, trans. Louise Varèse. New York: New Directions, 1961, pp. 37, 41, 87, 89.

Sartre, Jean-Paul. *What Is Literature?*, trans. Bernard Frechtman. New York: Philosophical Library, 1948, p. 114.

Sartre, Jean-Paul. *Notebooks for an Ethics*, trans. David Pellauer. Chicago: University of Chicago Press, 1992, p. 494.

Shakespeare, William. "As You Like It" in *The Norton Shakespeare, Second Edition*, edited by Stephen Greenblatt. New York: Norton, 2008, p. 1664.

Shakespeare, William. "King Lear: The Folio Text" in *The Norton Shakespeare, Second Edition*, edited by Stephen Greenblatt. New York: Norton, 2008, pp. 2415, 2435, 2467.

Shakespeare, William. "Sonnet 13" in *The Norton Shakespeare, Second Edition*, edited by Stephen Greenblatt. New York: Norton, 2008, p. 1950.

Shakespeare, William. "The Tragedy of Macbeth" in *The Norton Shakespeare, Second Edition*, edited by Stephen Greenblatt. New York: Norton, 2008, p. 2585.

Shakespeare, William. "The Winter's Tale" in *The Norton Shakespeare, Second Edition*, edited by Stephen Greenblatt. New York: Norton, 2008, pp. 2920, 2924–2925.

Steinbeck, John. *Of Mice and Men*. New York: Penguin, 1993, p. 73.

Steiner, George. *A George Steiner Reader*. New York: Oxford University Press, 1984, p. 114.

Weil, Simone. "The Iliad, or the Poem of Force" in *War and the Iliad*, trans. Mary McCarthy. New York: New York Review Books, 2006, p. 3.

Weil, Simone. *The Notebooks of Simone Weil*, trans. Arthur Wills. New York: Routledge, 2004, p. 198.

Welles, Orson. *Orson Welles: Interviews*, ed. Mark W. Estrin. Jackson: University of Mississippi Press, 2002, pp. 198–199.

Wittgenstein, Ludwig. *Tractatus Logico-philosophicus*, trans. C.K. Ogden. New York: Routledge, 1990, p. 189.

THE AUTHOR

Luc Dardenne is a filmmaker. *On the Back of Our Images* is his first book. With his brother Jean-Pierre Dardenne, he has directed:

1978 *Le Chant du rossignol*

1979 *Lorsque le bateau de Léon M. descendit la Meuse pour la première fois*

1980 *Pour que la guerre s'achève, les murs devaient s'écrouler*

1981 *Leçons d'une université volante*

1982 *R... ne répond plus*

1983 *Regarde Jonathan (Jean Louvet/son oeuvre)*

1987 *Falsch*

1987 *Il court . . . il court le monde*

1992 *Je pense à vous*

1996 *La Promesse*

1999 *Rosetta*
(Palme d'Or and Prix d'interprétation feminine for Émilie Dequenne, Cannes Film Festival)

2002 *Le Fils* [The Son]
(Prix d'interprétation masculine for Olivier Gourmet, Cannes Film Festival)

2005 *L'Enfant* [The Child]
(Palme d'Or, Cannes Film Festival)

2008 *Le Silence de Lorna* [Lorna's Silence]
(Best Screenplay Award, Cannes Film Festival)

2011 *Le Gamin au vélo* [The Kid with a Bike]
(Grand Prix, Cannes Film Festival; Best Screenwriter, European Film Awards; nominated for Best Foreign Language Film, Golden Globes)

2014 *Deux jours, une nuit* [Two Days, One Night]
(nominated for Best Performance by an Actress in a Leading Role for Marion Cotillard, Academy Awards)

2016 *Le Fille inconnue* [The Unknown Girl]

2019 *Le Jeune Ahmed*

THE TRANSLATOR
(DIARIES)

Jeffrey Zuckerman is an award-winning translator of numerous French authors, including Jean Genet, Hervé Guibert, Jean-Jacques Schuhl, Ananda Devi, and Jakuta Alikavazovic.

For their assistance at various points throughout this translation, grateful acknowledgment is made to Jennie Dorny at Éditions de Seuil who has been nothing short of a modern-day Hermes as she has shrewdly guided this book's translation into English; to Marcel Imhoff, Anjuli Raza Kolb, Charles Le Blanc, Johan Siebers, Peter Thompson, Andrei Vasilenko, and Alex Zucker for their assistance in sourcing various quotations; to Charles Woolley for his further insights into Deleuze's philosophical vocabulary; to Benjamin C. Dreyer for his sage advice in handling French and English titles throughout the diaries; to Allison M. Charette and Sam Axelrod for their eagle eyes in the book's final stages; and to Tim Kinsella, Jason Sommer, and Sammi Skolmoski at Featherproof Books for all the blood, sweat, and tears they have shed in bringing this extraordinary labor of love into English.

And, of course, Luc and Jean-Pierre Dardenne. Thank you, both of you, for your images, every one of them.

THE TRANSLATOR
(SCREENPLAYS)

Sammi Skolmoski is a writer and artist from Chicago.

The goal with the translation of the screenplays was to keep them as close to the original French as possible. After all, the way in which Luc and Jean-Pierre express their visions to paper, their unique style, verbiage, and explorations of time and scene through expansions and contractions of language, through fragments and rolling gestures, are precisely what is fascinating about experiencing the screenplays on the page. Where a literary editor might have slashed extraneous phrases for brevity or another translator may have allowed herself some breadth of poetic interpretation, I remained literal. These screenplays are an invitation to sit inside of Luc and Jean-Pierre's careful process, to examine the bones beneath the flesh of their films.

Many thanks to the Dardenne brothers for their beautiful and consuming words and images. I have endless appreciation for their generosity in pulling back the curtain, as well as the trust they placed in Featherproof, Jeffrey Zuckerman, and myself throughout this process. I must also thank the Luminarts Cultural Foundation for their ongoing enthusiastic support of my work, even when I pivot sharply.

featherproof BOOKS

*Publishing strange and beautiful fiction and nonfiction
and post-, trans-, and inter-genre tragicomedy.*

fp27 WEEPING GANG BLISS VOID YAB-YUM *by Devendra Banhart* $17.95

fp26 ON THE BACK OF OUR IMAGES, VOL. I *by Luc Dardenne* $21.95

fp25 THE SPUD *by Brielle Brilliant* $14.95

fp24 MAMMOTHER *by Zachary Schomburg* $17.95

fp23 FROM THE INSIDE *by John Henry Timmis IV* $14.95

fp21 I'M FINE, BUT YOU APPEAR TO BE SINKING *by Leyna Krow* $15.95

fp20 THE INBORN ABSOLUTE *by Robert Ryan* $60

fp19 MAKE X *by various artists* $30

fp18 THE TENNESSEE HIGHWAY DEATH CHANT *by Keegan Jennings Goodman* $13.95

JNR170.3 ALL OVER AND OVER *by Tim Kinsella* $14.95

fp16 ERRATIC FIRE, ERRATIC PASSION *by Jeff Parker & Pasha Malla* $14.95

fp15 SEE YOU IN THE MORNING *by Mairead Case* $13.95

fp14 THE FIRST COLLECTION OF CRITICISM BY A LIVING FEMALE ROCK CRITIC *by Jessica Hopper* $17.95

fp13 THE MINUS TIMES COLLECTED: TWENTY YEARS / THIRTY ISSUES (1992–2012) *edited by Hunter Kennedy* $16.95

fp12 THE KARAOKE SINGER'S GUIDE TO SELF-DEFENSE *by Tim Kinsella* $14.95

fp11 THE UNIVERSE IN MINIATURE IN MINIATURE *by Patrick Somerville* $14.95

fp10 DADDY'S *by Lindsay Hunter* $14.95

fp09 THE AWFUL POSSIBILITIES *by Christian TeBordo* $14.95

fp08 SCORCH ATLAS *by Blake Butler* $14.95

fp07 AM/PM *by Amelia Gray* $12.95

fp05 BORING BORING BORING BORING BORING BORING BORING *by Zach Plague* $14.95

fp04 THIS WILL GO DOWN ON YOUR PERMANENT RECORD *by Susannah Felts* $9.95

fp03 HIDING OUT *by Jonathan Messinger* $13.95

fp01 SONS OF THE RAPTURE *by Todd Dills* $12.95

fp00 THE ENCHANTERS VS. SPRAWLBURG SPRINGS *by Brian Costello* $12.95

Available at bookstores everywhere, and direct from Chicago, Illinois at

www.featherproof.com